Ernest L. Blumenschein

The Oklahoma Western Biographies
Richard W. Etulain, General Editor

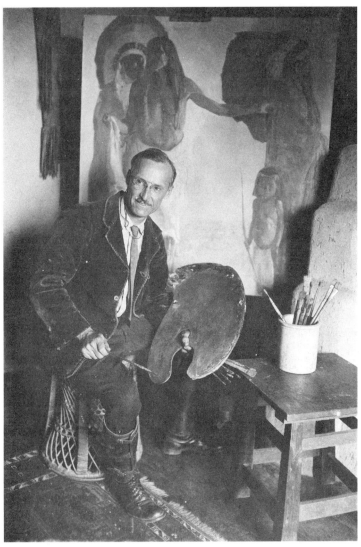
Blumenschein in his studio, ca. 1923. Courtesy of the Taos Historic Museums, Taos, New Mexico.

Ernest L. Blumenschein
The Life of an American Artist

By Robert W. Larson and Carole B. Larson

University of Oklahoma Press : Norman

Also by Carole B. Larson
Forgotten Frontier: The Story of Southeastern New Mexico (Albuquerque, 1993)

Also by Robert W. Larson
New Mexico's Quest for Statehood, 1846–1912 (Albuquerque, 1968)
New Mexico Populism: A Study of Radical Protest in a Western Territory (Boulder, Colorado, 1974)
Populism in the Mountain West (Albuquerque, 1986)
Shaping Educational Change: The First Century of the University of Northern Colorado at Greeley (Boulder, Colorado, 1989)
Red Cloud: Warrior-Statesman of the Lakota Sioux (Norman, 1997)
Gall: Lakota War Chief (Norman, 2007)

Library of Congress Cataloging-in-Publication Data

Larson, Robert W., 1927-
Ernest L. Blumenschein : the life of an American artist by Robert W. Larson and Carole B. Larson.
pages cm — (Oklahoma Western biographies ; volume 28)
Includes bibliographical references and index.
ISBN 978-0-8061-4334-7 (hardcover : alk. paper) 1. Blumenschein, E. L. (Ernest Leonard), 1874–1960. 2. Painters—United States—Biography. I. Larson, Carole. II. Title.
ND237.B717L37 2013
759.13—dc23
[B]
2012042394

Ernest L. Blumenschein: The Life of an American Artist is Volume 28 in The Oklahoma Western Biographies.

The paper in this book meets the guidelines for permanence and durability of the Committee on Production Guidelines for Book Longevity of the Council on Library Resources, Inc. ∞

1 2 3 4 5 6 7 8 9 10

In memory of
Carole

Contents

Illustrations

Illustrations

Preface

This study of Taos painter Ernest L. Blumenschein carefully examines those facets of his life experiences and character that made him one of the major artists in the American West during the twentieth century. My late former wife, Carole, and I had long been enamored of the artist colonies of Taos and Santa Fe and curious about why so many noted artists came, of all places in the world, to this part of New Mexico and stayed there to paint American subjects. These included indigenous people as well as the landscape of the American Southwest. Blumenschein, a midwesterner who trained as an artist in Cincinnati, New York City, and Paris, wanted to find a distinctive place in his American homeland to do fine-art painting. The result was his and fellow artist Bert Geer Phillips's discovery of Taos during their exploratory trip to the Mountain West in 1898.

Carole and I researched the life of "Blumy," as his fellow artists called him, stressing his upbringing in Dayton, Ohio; his parents' influence on him, particularly his domineering father; his study of art in Paris; his marriage in that city to the already well-established artist Mary Shepard Greene; and his early career as a successful illustrator of books and

major magazines. In many ways Blumenschein was a citizen artist who believed in the reforms advocated in the articles he illustrated, especially those relevant to the nation's economy and its laws as they affected the welfare and rights of minority groups such as American Indians (particularly the Pueblos, whom the artist championed through his art and published remarks). Prior to Ernest and Mary's move to Taos, she gave birth to their daughter, Helen, who would become an artist in her own right. With his small family and his deep immersion in art, Blumy began his long and widely recognized career as a fine-art painter, whose figurative and landscape paintings helped him to achieve exceptional prominence among the American artists of his day.

Our study also describes how the great historical events and movements of the time, such as the Panic of 1893, World War I, the Great Depression, and World War II, affected the artist and his family. Although this is a biography not an art book, analytical discussions regarding his paintings and illustrations are absolutely necessary to understanding what motivated this man to work as hard as he could to be the best at what he did.

While I was married to Carole, we made numerous trips to New Mexico, with our daughter, Helen, and son, Matthew, and Taos was our favorite place, with Santa Fe a close second. Like Blumenschein, Carole was from back east, but her parents, Maxwell and Margeth Lang, moved to Albuquerque when she was a girl, along with her sister, Nancy Davis, who would become a successful commercial artist. Carole was irrevocably attracted to the Land of Enchantment. When she moved to Roswell, New Mexico, in 1977, she honed her already well-developed writing skills as a reporter who sometimes wrote editorials for the *Roswell Daily Record*. She also chronicled Southeastern New Mexico on the kitchen table in her Roswell home, producing her well-received *Forgotten Frontier: The Story of Southeastern New Mexico*, which was published by the University of New

Mexico Press in 1993. Following this publication, she began her research for this biography of Ernest L. Blumenschein, completing the first nine chapters before her death in 1998.

Our relationship had always been close, and I received her extensive research materials after her untimely passing. Being preoccupied with my biography of the Lakota Chief Gall for the University of Oklahoma Press, I did not discover these completed chapters until several years later. After carefully perusing them, I concluded that they were too good not to be published. Fortunately, the University of Oklahoma Press agreed with me and felt that the final seven chapters of the biography, which I have written, along with Carole's, would provide a complete study of his life.

In Carole's preface, composed in 1996, she discussed her meeting with Blumenschein in a visit to his home when she was only fourteen years old. In her own words she was "riveted by his powerful persona the instant he stepped into his courtyard and invited her and her family" into his house and studio. "He was wearing a plaid flannel shirt, and he had what seemed to be a deep, gruff voice." He showed her parents the family's "paintings on the wall, several on easels." As he walked them out of the house and into the bright New Mexico sunlight, Carole's "fearless" little sister asked what the old neglected-looking wooden outhouse on the property was used for. Blumenschein, "eyebrows lowered over his piercing eyes and fixing his penetrating gaze directly upon the intrepid eleven-year-old, said, 'little girl, has anyone ever told you that you ask too many questions?'" Carole was glad that her "customary shyness had been [her] saving grace" at this moment.

In her preface she also acknowledged several people who had helped her in her research prior to 1996. These included Rosemary Klopfer, head librarian at the Roswell Public Library, who provided her with "invaluable assistance in obtaining a wide variety of materials from far-flung sources."

Preface

Also important in the research process was Wesley Rusnell, curator of art at the Roswell Museum and Art Center; Jerry Klopfer, head librarian at the New Mexico Military Institute in Roswell; Phyllis Cohen, director of the library at the New Mexico Museum of Art in Santa Fe; Skip Keith Miller, administrator of the Kit Carson Museum in Taos (and later curator of the Blumenschein home in Taos); Teresa Ebie, registrar at the Roswell Museum and Art Center; Clark Funk, businessman and lifelong resident of Taos; and Sandra Jaramillo-Macias, senior archivist at the State Records Center and Archives in Santa Fe.

I would like to express my deep appreciation to those who helped me in the researching, writing, and editing of the Blumenschein manuscript. They include Tomas Jaehn, historian for the Fray Angélico Chávez History Library in the New Mexico History Museum in Santa Fe. Much appreciated was his assistance in perusing ten boxes of correspondence and newspaper and magazine items relevant to the Blumenschein family. Also helpful was Daniel Kosharek, the photo archivist at the New Mexico History Museum. The assessment of New Mexico art and Ernest Blumenschein's role in it by Ana Archuleta of the Gerald Peters Gallery in Santa Fe was important too. In Taos Heidi Smith of the Blumenschein Studio Gallery, as the family home is now called, provided information that helped me better understand Ernest, Mary, and Helen Blumenschein's way of life. The cooperation of Darlene Dueck, curator of the Anschutz Collection of the American Museum of Western Art, and Annie McDaniel, curator of Taos Historic Museums, is also much appreciated. Essential to my research in the Blumenschein Papers at the Archives of American Art at the Smithsonian Institution in Washington was Margaret Zoller.

In Denver, where my wife, Peggy, and I live, the Denver Public Library Reference and Western History/Genealogy departments greatly assisted me, especially Denis Hagen and Wendell Cox from Western History and Becky Russell

and Joseph Cahn from Reference. Christopher C. Brown, the government documents librarian at the University of Denver, was willing to help me in various ways. Yasmaine Ford Faggan, secretary for the Department of History at the University of Denver, typed the first half of Carole's and my manuscript, and Anna Lee Halsig, who operates a professional secretarial office in Denver, typed the second half. My wife, Peggy, who was invaluable to me throughout the preparation of this study, typed changes and revisions for the final manuscript.

Finally, I am grateful to Charles E. Rankin, editor-in-chief of the University of Oklahoma Press, who along with his staff has done an especially effective job making our study presentable to future readers. I also owe much to acquisitions editor Kathleen A. Kelly and copyeditor Melanie Mallon, who provided invaluable advice in the editing of the manuscript. Aiding them, particularly in the acquisition of art reproductions for the book, were Anna Maria Rodriguez and Megan Whobrey. Debbie Lindblom's excellent work on the index is gratefully acknowledged too. I am also indebted to Steven Baker, managing editor of the University of Oklahoma Press, for his role in the overseeing the copyediting of the manuscript, and Connie Arnold, acquisitions administrative assistant, whose work was important throughout the entire process. I was especially happy to work with Richard W. Etulain again, who has been doing an outstanding job as the general editor of The Oklahoma Western Biographies series.

Robert W. Larson
Denver, Colorado

Ernest L. Blumenschein

Prologue

Reconstructing a Moment in Time

In fall 1899, a slender, energetic young American painter named Ernest L. Blumenschein arrived in Paris. His thoughts were surely focused on being back again at the great art capital of the world. Having studied in Paris from 1894 to 1896, he was determined to make the most of this second opportunity to study painting in the one place where both the past and the future of art were manifest.

It was a pivotal time in the lives of hundreds of young American artists flocking to Europe at the turn of the century. It was an equally pivotal time for the ambitious twenty-five-year-old Blumenschein, who was struggling to gain professional footing in this world of long-established cultural values. This was an exciting time of rapid change in the old social order, which had been prolonged during the nineteenth century by the forces of monarchy, capitalism, industrialization, imperialism, and a rigid class system. Nevertheless, despite the shortcomings of the European world at the end of the nineteenth century, the conservative values of the old culture remained largely intact. In fact, members of the flourishing fine-art community in Paris had

3

been subservient to the academic authority exercised by the city's art establishment. Yet western Europe, at the height of its prestige and power, was trembling on the verge of sweeping change that would culminate in its partial disintegration in the aftermath of World War I.

Neither a revolutionary nor a defender of the old order, Blumenschein, an outwardly confident but inwardly diffident German American of middle-class origins, was groping toward the resolution of an old dilemma, even as he furthered his training abroad in the craft he had chosen for his life's work. This dilemma involved the debate over what should constitute art—the styles of the New World, which had a growing attraction for him, or the aesthetic ideals of the Old World, a predilection for the premodernist emphasis on mastery of technique in art and on the recognizable links with the relevant past and present.

Paris had an overabundance of options for the artist to pursue. The city had several prestigious art schools, the most renowned of which was the government-sponsored École des Beaux-Arts. This school, located in the Latin Quarter, across the Seine River from the Louvre, was staffed by art professors appointed by the forty elected life members of the elite French Académie. Acceptance in the school was largely confined to France's most promising artists; rarely were foreign art students admitted. Consequently, Blumenschein, during his first stay in Paris, studied at the Académie Julian, second only to the École des Beaux-Arts in the exclusivity of its art classes. Throughout the city, however, in independent art studios, such as those in the Montmartre Art district in northern Paris, working art students could learn the techniques of the growingly popular impressionist school of art. Vincent van Gogh was one of those artists who took a studio in the Montmartre in 1886, while during the 1890s, the American impressionist artist Mary Cassatt lived there, as did her famous mentor, Edgar Degas. The in-

fluence of these artists on the observant Blumenschein was probably not great at this time, but it would grow in later years as he matured as an artist and became more experimental in his paintings.

Art students at the École des Beaux-Arts had the inside track in displaying their art in the large public exhibits that were part of an artist's life in Paris. The most important was the officially sanctioned annual Salon, which exhibited two thousand to three thousand paintings each year. These exhibits were always well attended; in 1884 almost three hundred thousand people toured one of the Salon's annual art shows.

The combined authority of the École and the Salon, buttressed by the French government and the art establishment in Paris, favored the neoclassicist art styles, which traced their beginnings to Greek and Roman cultures. Both emphasized traditional art themes, focusing on history, religion, mythology, and other subjects that would eventually be transformed into a romantic realism in their selection and execution.

French art in the late 1800s, when Blumenschein began his studies in Paris, remained focused on the neoclassicism of the previous century, in which the stylistic emphasis was on contour and strong design. The French artist Jacques-Louis David is considered by some to be the greatest neoclassical painter, whose history-oriented past spanned the Greek and Roman worlds as well as more contemporary historical movements, such as the French Revolution and the events of the Napoleonic era. Linked to neoclassicism was romanticism, with its highly personalized qualities, which seemed to be a matter of attitude on the part of the artist. According to art historian William Kloss, the paintings of artists like the Spaniard Francisco Goya, the Frenchman Ferdinand Victor Eugéne Delacroix, and English landscape painter Joseph Mallard William Turner are among the major

representatives of the increasingly popular romantic school of art during the nineteenth century. Two of Blumenschein's instructors at the Académie Julian were traditional artists. One was Jean-Joseph Benjamin-Constant, who painted great historical events in the neoclassical style, along with portraits of French aristocrats and members of the British royal family, such as Queen Victoria. The other was Jean-Paul Laurens, a member of the French Academy who painted both murals and paintings of major historical events and those figures who played important roles in them. Not all French painters who were favored or at least recognized by the city's art establishment painted the great events and elite personalities of the past. Jean Francois Millet, one of the landscape painters who settled in the northern French village of Barbizon, along with Jean Baptiste Camille Corot, a familiar visitor to the village, painted realistic scenes of the present and enjoyed a well-deserved acclaim as a result.

The major challenge to traditional art in Europe and eventually in the United States came from the impressionist and post-impressionist painters. The first impressionist art exhibit in Paris was held in 1874. The paintings on display exhibited such techniques of the new art form as thicker paint application, broader brush strokes, and a less visible outline of the subjects. Impressionist artists, instead of focusing on historical and mythological subjects, tended to concentrate on the everyday themes of contemporary life and nature.

By the 1890s, during Blumenschein's first two years as a resident artist in Paris, this new art form was gaining wide recognition. Eventually impressionist art would overtake the once-dominant traditional art, with its classical, and later neoclassical, emphasis in popularity and prestige; not only has impressionism's influence in fine arts never faltered, but it has also spawned new movements and trends in modern

art. Those impressionist and post-impressionist painters living in Paris during the late nineteenth and early twentieth century included such well-known names as the heretofore mentioned van Gogh and Degas, plus the names of such major artists as Edouard Manet, Claude Monet, Paul Cézanne, Camille Pissarro, Henri Matisse, Paul Gauguin, and Henri de Toulouse-Lautrec.

In late summer 1899, as Blumenschein's ship landed on the French side of the English Channel, he was undoubtedly well aware of these two competing schools of art. He was already partially committed to the traditional school, having had Benjamin-Constant and Laurens as his teachers during his first stay in Paris. But Blumenschein, a perfectionist in his craft, was still exploring various pathways to success. During his early days as an art student in the United States, he had attended the Cincinnati Art Academy, and later, when he moved to New York City, he picked as his school the less-conformist Art Students League over the better-known and more traditionally European National Academy of Design. Indeed, by 1899 he was probably more convinced of the possibilities of using American rather than European art subjects for his paintings than he was for adopting the much newer art techniques of impressionism.

It is difficult to know what people are thinking when they arrive at an important destination for an extended stay, especially if they feel that the change will significantly affect their life's career. Of course, just being back in Paris after a three-year absence would exhilarate most serious artists; indeed, Blumenschein's memories of the beautiful city were no doubt at the forefront of his mind. The young art student's nostalgic recollections would undoubtedly include the spired skyline of Paris and the stately charm of its wide boulevards, lined as they were with ornate stone facades of centuries-old buildings. Other reminiscences would include the promenade of Parisians on particularly bright afternoons,

when elegantly attired members of the bourgeoisie would mingle with colorfully dressed bohemian artists, musicians, and writers.

Even Paris's wintry days, with their rain-laden weather, were more tolerable because of the cozy comfort of the sidewalk cafes, where the musical French language would mix with dozens of others spoken in the intimacy of private conversations. The renowned Louvre and the art districts of the Montmartre and the Latin Quarter might also have provoked fond recollections for Blumenschein. Even the austere ambience of those bare artist studios, reached by long flights of stairs, damp and cold in the winter and steamy and hot in the summer, were an inextricable part of the Paris scene for many artists anxious to establish themselves in their chosen field.

As he gazed out his train window on the way to Paris, Blumenschein was almost certainly a much more confident artist than he had been during his previous stay. In the course of his three years in New York City, after leaving Paris, he had established himself as a successful illustrator for such famous U.S. magazines as *McClure's, Century Magazine, Harper's, Atlantic Monthly,* and the *Saturday Evening Post,* just to name a few. His illustrations included portrayals of domestic events, outdoor life, portraiture, and character sketches. His work as an illustrator brought him a more steady income and contributed to his growing self-confidence, but this financial success did not dim his strong desire to be a purely fine-art painter. His purpose in returning to Paris, in fact, was to someday join the ranks of the finest artists of his generation.

Paris, the world's most prolific art center during the last decades of the nineteenth century, had caused a burst of creative new ideas to appear in the art world, which not only manifested themselves in a thriving diversity of art styles but also sparked a growing public interest in art. These promising trends helped to sustain a proliferation of paint-

ers, art museums, schools of art, and profitable art galleries. Throughout much of western Europe at this time, strengthened democratic institutions, as well as relevant economic progress in the economic spheres, had resulted in an expansion of the middle class. Although Britain and Germany had most often led the way in improvements for working people—such as union rights, limited working hours, increased wages, and expanded voting rights—that helped create the middle class, France, too, had a prosperous and growing middle class by the turn of the century. It was only natural that, wherever these developments occurred, growth in the numbers of people with more leisure time and more money would translate into a greater public appetite for the arts and for other venues of culture and entertainment.

One insight new to Blumenschein since his last stay in Paris was his discovery of a truly American subject for artists, whether they leaned toward the classicist school or the impressionist school. In 1898, he and Bert Geer Phillips, another artist who had studied at the Académie Julian, took a wagon trip to the Southwest to view a genuinely American landscape. Having heard from another Académie Julian student, Joseph Henry Sharp, an older more experienced artist, about the beauty and attractiveness of the small Hispanic community of Taos, New Mexico, they paid it a visit, almost by accident, when they needed to repair a broken wagon wheel. Both artists were instantly delighted with the multicolored landscape of the surrounding countryside, with its mesas and canyons, punctuated by the wooded and snowcapped Sangre de Cristo Mountains. Blumenschein saw Taos as a future home for him and other like-minded artists; Phillips was so impressed with the place that he never left it. Each of them were especially excited about the nearby Taos Pueblo and yearned to paint the Indians living there.

Blumenschein was facing a situation that demanded a degree of introspection, which had not been common for the instinctively restless and physically active young artist. He

really wanted to be an independent fine-art painter, yet his commercial work made his 1899 stay in Paris possible (although he undoubtedly felt a flicker of pride for his success as a commercial illustrator, producing high-quality genre scenes).Still influenced by notions of social correctness and social position he had learned from his domineering father, and psychologically adverse to sharp breaks with the past, Blumenschein now had to adapt himself to two potentially conflicting goals for his success as an artist: commercial art and fine-art painting. This inner tension might have contributed to the kind of dynamic creativity that can grow out of inner conflict and strictures on total personal freedom. In fact, throughout his art career, he exhibited some of that self-discipline and patience that allows an individual to maintain a functioning self while living over time with frustrating ambiguity.

Never was Blumenschein more aware of the ironies of this situation then during the early months of his second sojourn in Paris. He wrote more frequently and more openly to his best friend, Ellis Parker Butler, a noted writer from New York, than to anyone else. In this correspondence he often exposed those dark frustrations about this conflict that raged within him. On January 16, 1900, for instance, he confided to Butler, "My illustration [work] was no doubt of benefit but it put me far behind in color, leaving undeveloped the *color muscle* which needs years of careful training."

Almost as if he were afraid of being swept away on the tides of the new and competitive ideologies of art, Blumenschein chose to remedy his perceived shortcomings as a painter by throwing in his lot with the traditionalists. For him their standards were proved and had stood the test of time. In much the same manner, he viewed with skepticism the atmosphere of incipient social upheaval he found in the art districts of Paris, where entrenched bourgeoisie and bohemians of varying degrees of talent jostled for space in the arena of public opinion. It was a time of eclectic values, dis-

sident movements, and revolutionary impulses, all fermenting within an overall social structure of conservatism and traditionalism still intact despite the rumblings from below.

The young artist responded to the evolving, unpredictable social scene of the European art world, as well as to Europe's increasingly turbulent political world, according to his own psychological needs. These included a need to clearly define himself, to prove his ability to make discerning judgments, to avoid being drawn into an unknown sphere of action, and to solidify a sense that his own cultural background was superior to others'. To put it another way, he wanted to demonstrate his commitment to universal absolutes as criteria by which both art and society were to be judged. Writing to Butler on November 7, 1899, he deplored what he saw as the current lack of such absolute standards. "There is not choice of thoughts, no standard of life (at least in the Latin Quarter). Everything that's natural is to be listened to, consequently vulgar ideas are as common as better ones. . . . My effort is to rise above the common vulgarities and beastliness."

Blumenschein clearly perceived his stance on art styles to emulate and hedonistic atmospheres to avoid as essential to furthering his artistic ambitions; in truth, it had become a necessary survival mechanism. His views were a natural outcome of his background, particularly his family history, for he was the product of a specific, quintessentially American culture and psychology.

1

From Family and Place, 1874–1893

Ernest Blumenschein's lineage combined two distinct strands of America's historical development. On his mother's side, he traced his ancestry to the earliest English settlements on the East Coast. On his father's side, he was the first American-born son of a German immigrant. Thus, his bloodline brought together two aspects of the American experience that have given rise to some of the most powerful and enduring images shaping the nation's perception of its origins and expansion. No internalized imagery is more central to the public consciousness of American history than that of the landing of the *Mayflower*, followed in succeeding generations by waves of hardy, hopeful immigrants who built the nation westward as they strove to better their own lives.

Even in his temperament, Blumenschein reflected his dual heritage, exhibiting something of the moral rectitude of early New England as well as the penchant for self-discipline of Old World Germany. The link with Germany was direct and unadulterated. The family of Blumenscheins to which he belonged traced its roots to Hans Blumenschein, Jr., listed in the court records of 1653 as a resident of the small village of Brensbach, which is located near the city of Darmstadt, south of Frankfurt, in the central German state of Hesse. Over the subsequent two hundred years, numerous

male members of the family were professional musicians, as shown in church and court records.

One of these professional musicians was Johann George Blumenschein, who had established a small orchestra in Darmstadt. In 1852, fearing induction into the military as it expanded in the turbulent years following the failed revolutions of 1848, Johann Blumenschein decided to emigrate to the United States. Among the family members who accompanied him was his small son, Wilhelm Leonard, who had been born in Brensbach on December 16, 1849, and who would become the father of Ernest Blumenschein. Johann Blumenschein and his family settled in the already sizable German community of Pittsburgh, Pennsylvania, where German was spoken in many homes, including that of the Blumenscheins. Wilhelm Leonard, called Leonard from early childhood, grew up speaking English and German with equal facility.

No doubt motivated by a conviction that business offered better financial prospects than did music, the Blumenscheins urged young Leonard to become a businessman. During high school he worked at Harne's Dry Goods Store and after graduation accepted a job as cashier for the company. But music was in his blood, and no amount of trying could make him content with what he saw as the mundane practices of the world of commerce. Frustrated and unhappy, he managed to put away enough of his earnings to finance a trip abroad to study music. By 1869 he was in Leipzig, Germany, where he studied three or four years, receiving diplomas for his work. With his studies greatly facilitated by his fluent German, Leonard studied music theory, composition, conducting, piano, and violin. Leipzig had been home to many composers, including Johann Sebastian Bach, Robert Schumann, and Felix Mendelssohn. During the 1870s Richard Wagner lived in Leipzig while composing *The Ring*. The city was famous for its fine concert performances, many of which Leonard Blumenschein attended.

In 1872, when he was twenty-two, Leonard took time from his studies for a cruise down the Rhine on an excursion boat. During the leisurely journey through the lush river valley, Leonard met a fellow American who also was in Europe in pursuit of the arts—twenty-one-year-old Leonora Alferetta Chapin of Springfield, Massachusetts. Drawn to each other immediately, the two quickly discovered they had much in common. Leonora (or Nora to her family) was an accomplished pianist, though she was studying painting during her travels in Europe, with a female relative acting as her chaperone.

On her father's side, Leonora was a descendant of Deacon Samuel Chapin, who was born in Paignton, England; Chapin was the inspiration for Augustus Saint-Gauden's sculpture *The Puritan*. In 1635 he immigrated to America with his wife, five children, and father. Settling first in Roxbury, Massachusetts, Samuel Chapin relocated in 1642 to Springfield, in south Massachusetts, where he became a respected church figure. Following his death, the town honored him with a stone monument and statue. One of Samuel's descendants was Harvey Chapin, born in 1796, who married Sarah Anne Stocking, related on her mother's side to the British aristocracy as a niece of Sir Thomas Beldon. Harvey and Sarah Anne Chapin were the parents of Lorenzo B. Chapin, who was born on November 3, 1823, in Springfield. On November 1, 1846, he married Maria Louise Allen in Enfield, Connecticut.

Leonora, the only child of Lorenzo and Maria Chapin, was born on December 30, 1848, in West Springfield. Lorenzo Chapin was an alcoholic, and the couple's unhappy marriage ended in divorce a year after Leonora's birth. Both remarried, but Maria Chapin was widowed within a few years. In 1865 when Leonora was seven years old, her mother was married for the third and last time to John Hull. As a stepfather, Hull was a responsible parent but also a strict disciplinarian. The oddly self-revealing poetry he occasionally

wrote, some of which is quoted in the semi-controversial *Paintbrushes and Pistols*, by Sherry Clayton Taggett and Ted Schwarz, illustrates his firm conviction that the only way to deal with his "charming" but willful stepdaughter was to employ forms of physical punishment; this included beatings to curb her emotional outbursts and her tendency to "run away" from home.

Leonora was bright, sensitive, and artistic. She attended several local schools, displaying a talent for both music and art. After graduating from Maplewood School, a women's seminary near Pittsfield, Massachusetts, she taught piano at her parents' home and sang in the choir at the Episcopal church attended by her family. She had high hopes for the future when she fell in love with a man whose courtship indicated that a marriage might ensue, but he ended the romance suddenly by choosing another woman, leaving Leonora devastated. Even stolid John Hull had to acknowledge the reality of his stepdaughter's emotional pain. When he suggested that a trip abroad might give her "a new perspective on life," Leonora seized the opportunity for a measure of independence and rapidly formulated a private plan to use her time in Europe to learn all she could about painting. The family's understanding was that Leonora would concentrate on music studies in Leipzig. Sharah Hatfield, an older family member, agreed to accompany Leonora.

Buoyed by her growing pleasure with painting, Leonora must have seen it as a fortuitous stroke of fate when she met Leonard, a kindred soul who loved the arts as she did. Leonard, too, was convinced that he and Leonora were well suited for each other. Returning to America, Leonard Blumenschein and Leonora Chapin were married on August 5, 1873, at the home of Leonora's parents in Springfield in a Methodist ceremony performed by the Reverend R. R. Meredith. Almost immediately after the wedding, the couple moved to Pittsburgh, where they settled down to married life in a small house on Smithfield Street.

Ernest Leonard Blumenschein, their first child, was born on May 26, 1874, in Pittsburgh. Two years later, on August 2, 1876, another son, George Sylvester, was born. By this time the city in which Leonard Blumenschein would spend his earliest years was rapidly emerging as one of the nation's leading industrial centers. All around the tightly knit German community where the Blumenscheins lived, new neighborhoods, businesses, and busy thoroughfares were springing to life, as workers poured into Pittsburgh to take thousands of jobs being created by an expanding steel manufacturing industry, much of it inspired by the Scottish American industrialist Andrew Carnegie. Certainly life in the noisy, dirty, chaotic city was a far cry from the bucolic daily life of Massachusetts small towns, where Leonora had lived and gone to school.

The Blumenscheins still aspired to a life centered on cultural activities, so they welcomed an opportunity to leave Pittsburgh when Leonard was offered the position of director of the Dayton Philharmonic Society in Dayton, Ohio, a small city in western Ohio on the Miami River, about fifty miles north of Cincinnati. He accepted the offer with alacrity, even though Leonora was pregnant with their third child. No doubt hoping to reach their new home before the birth, Leonard and Leonora left Pittsburgh in mid-1878 with four-year-old Ernest and two-year-old George. They traveled west by way of the Ohio River, the great natural transportation route linking Pennsylvania to its neighboring state to the west. When they reached Portsmouth, Ohio, on the north bank of the river, about a hundred miles east of Cincinnati, on June 24, 1878, Leonora gave birth to a daughter, Florence.

Traveling with two small sons, a newborn, and all their household goods made the journey difficult for Leonard and Leonora. They reached their destination with relief and moved into a house at 514 West Fourth Street in Dayton.

Within a few months of their arrival, Leonard accepted a second position in addition to his leadership of the city orchestra. He was named organist of the Third Presbyterian Church of Dayton. He also began his teaching career as a private instructor to scores of young musicians who came to his home for lessons.

By the time the Blumenscheins moved to Ohio, the state had built a thriving economy based on agriculture, mining, and manufacturing. In 1803 it was the third most populous state in the country and blessed with an abundance of natural resources. Rural in 1850, Ohio was steadily becoming industrialized by 1880. Its major urban areas were Cleveland, Columbus, Cincinnati, Toledo, Akron, and Dayton.

Dayton itself was brimming with optimism during the 1880s. Serving city residents as well as those of outlying farm communities, Dayton's numerous merchants were increasingly prosperous. And the city's manufacturing sector was taking on greater significance. In the 1870s inventor John Ritty of Dayton designed a "mechanical money drawer," which displayed dollar amounts and rang a bell when pulled open. In 1884 businessman John Patterson arrived in Dayton, bought Ritty's rights to the invention, and established the National Cash Register Company, which experienced substantial growth through sales in the United States and abroad over many decades.

The Blumenscheins lived in an area of Dayton where the residents were primarily of German descent, many of them recent immigrants. For the most part they were Protestant or Catholic, with a few families of German Jewish ancestry residing in the neighborhood. Leonard Blumenschein had been raised as a Lutheran, but in Dayton he and his family attended the Presbyterian church where he was organist. Even so, Ernest Blumenschein was sufficiently intrigued by the possibility of Jewish descent in his family to remember distinctly in a January 1927 interview that his

father had on several occasions "denied that we had any Jewish blood."

The Dayton neighborhood where Ernest Blumenschein lived throughout his childhood years had neatly kept frame houses, swept walkways, and carefully tended small gardens. The residents insisted on a strict adherence to moral values they shared, whatever their religious affiliation. Alcohol and dancing were frowned on by Catholics and Protestants alike, and Protestants permitted no sporting activities on Sundays. By every indication, Leonard Blumenschein, a man of conventional social attitudes himself, was content with the atmosphere he was providing for his children.

As for his career, he had good reason to believe he had chosen well in coming to Dayton. Within a few years of his arrival, the tall, slender, even-featured Leonard Blumenschein had become a respected figure in the community. His talents, though not distinguished enough to achieve prominence in a more competitive environment, were strong enough to ensure him an increasingly important role in the cultural life of Dayton and the surrounding region. He retained his position as philharmonic society director for thirty years. Newspaper stories about his major role in the city's orchestra usually referred to him by his full (anglicized) name, William Leonard, rather than Leonard. He conducted the Ohio Saengerfest in 1882 and 1884; the Indianapolis male chorus and orchestra's six concerts during 1883 and 1884; the Springfield Orpheus Society mixed chorus in 1885, 1886, and 1887; and the Cincinnati May Festival Chorus from 1891 to 1896.

Over the years he also composed numerous pieces, most of them performed at various times by groups he conducted. Among his compositions were fourteen anthems, fifty pieces for piano, seven secular quartets, and twenty songs. Altogether he wrote more than 150 works for choir, piano, and solo voice, according to Patricia Broder's study *Taos: A Painter's Dream*. By 1895, Blumenschein students,

many of whom came from surrounding towns to study with him, had presented 181 recitals in Dayton.

While life was close to exhilarating for Leonard during his early Dayton years, Leonora's experiences were more sobering. Glad though she was to be married, happy for her husband in his newfound success, fulfilled by motherhood, she nevertheless still harbored hopes for personal artistic accomplishment. Her husband discouraged her desire to paint, although her pictures hung on the walls of the Blumenschein home. Leonora's major obstacles were rooted not only in Leonard's nature but also in the social mores of the times, which gave primary authority to the husband.

In William Leonard, the head of household role was reinforced by his domineering personality. He was strict and demanding in all matters pertaining to his home, his wife, and his children. He was a perfectionist who let nothing pass without his instructions and criticisms. With little room for establishing her own priorities, almost no household help, and three small children to care for, Leonora spent her days living under constraints imposed by her husband. Not only was he controlling, but his erratic schedule of rehearsals and studio lessons at home often meant he was there to oversee all matters large and small. Leonora in some part of her being must have recognized that she had exchanged the domination of a stepfather for that of a husband.

Ernest Blumenschein began to draw at an early age. He had likely observed his mother sketching or painting on occasion, and a desire to imitate her might have prompted him to take pen in hand and make his own pictures. When he was six years old, however, whatever equilibrium existed in the family structure was abruptly shattered. Finding herself expecting her fourth child within a span of seven years, Leonora became depressed, experiencing feelings of anger and despair as her sense of entrapment and lack of control over her own life deepened. Her mental and physical health declined, and by the time a doctor was called to the

Blumenschein home, it was too late to help her. She lost the unborn child, and on February 15, 1881, at the age of thirty-three, Leonora Blumenschein died.

The death certificate listed the official cause of death as pneumonia. Yet the story that was passed on to family members, which became the unquestioned version, was that "Nora Blumenschein died in childbirth." If the cause of her death was in fact pneumonia, there would have been little reason to avoid stating that openly. Art historians Taggett and Schwarz have suggested in their study that Leonora's death might have been caused by a miscarriage brought about by a self-induced abortion; this act of desperation often resulted in blood-poisoning infections for which doctors had no remedies. Although self-induced abortions were not uncommon during the late nineteenth century, they were considered scandalous when they involved a "proper family," such as the one headed by William Leonard Blumenschein. But Taggett and Schwarz failed to cite specific documents to substantiate their assertions regarding Leonora's untimely death, and we never found records suggesting that an abortion was attempted. Thus, this particular conclusion is based primarily on circumstantial evidence.

Leonard Blumenschein's response to Leonora's death might have been that of a man who believes, but cannot openly admit, that his wife inadvertently caused her own death. He destroyed all of her paintings and made no attempt to perpetuate her memory. Reminders of her presence were put away, no stories of her were told, and every attempt was made to resume life almost as if nothing had happened. Three-year-old Florence was sent to live with her mother's parents, the Hulls, in Springfield, Massachusetts, while Ernest and George remained with their father in Dayton. In the months immediately following Leonora's death, Leonard saw to it that Ernest, now seven years old, began to study the violin. Ernest continued to draw, but his fa-

ther's actions probably deprived him of much influence and inspiration from his mother's artistic legacy; instead his attentions were effectively directed by his father toward music rather than art.

Within two years of Leonora's death, Blumenschein's father married again, this time choosing Jenny Kumlar of Dayton. Practical and aspiring only to be a traditional wife and mother, Jenny Blumenschein was both less emotional and less ambitious than her predecessor. Perhaps because she willingly acquiesced to her husband's often domineering ways, the new couple was able to provide a fairly happy home for Ernest and his brother. According to art historian Elizabeth J. Cunningham, sketches of the picnics and outings of Jenny's family indicate that she was from a stable family and could provide security for the two boys. Ernest looked to his father for approval and guidance, yet the presence of a mother in the household enabled his childhood development within the framework of a viable family unit. Leonard and Jenny had two children of their own, Jeanette, born in 1884, and Carl, born in 1886, when Ernest was twelve years old, further adding to the sense of family normality and completion.

Blumenschein's income was sufficient to provide a middle-class but not luxurious standard of living for his family. If there was no deprivation in matters of housing, clothing, and food, there was also little chance of being spoiled by a surfeit of material goods too easily acquired. Ohio winters could be harsh; the Blumenschein children walked to school no matter the weather. There were lessons from school to be done, chores to be performed, music lessons and practice, all overseen by their strict taskmaster father. The house was alive with students coming and going from the senior Blumenschein's teaching studio; the sounds of piano, violin, and voice often filled the air. It was a constantly active life, and Ernest Blumenschein's youthful years

combined school, sports, music, and church activities in an atmosphere of close interaction with parents and siblings, even if this interaction was not always free of strife or suppressed emotion.

Ernest was a dutiful but never an enthusiastic student during his years in the public schools of Dayton. Even so, his adequate report cards were far better than those of his younger brother George. Whether for reasons of temperament or ability, George proved far less amenable to his father's methods of child rearing than did Ernest. George failed in classes, often skipped school, and on several occasions ran away from home. By the time Ernest reached high school, it was clear to Leonard that his hopes were best vested in this eldest son. Ernest, though an indifferent scholar, at least became an able musician, with enough talent to play the violin in the school orchestra. Ernest was a good enough violinist, in fact, for both father and son to think in terms of yet another Blumenschein following in the family tradition by becoming a professional musician. Ernest, according to biographical notes he submitted to Mabel Dodge Luhan for inclusion in the Smithsonian Institution's archives in December 1946, had been intensely aware during his growing-up years that his "father hoped . . . [he] would become a musician."

The enthusiasm Ernest failed to show for academics he exhibited in abundance for sports. He enjoyed playing baseball so much that during his grade school years, he somehow managed to get away with joining the Catholic boys in his neighborhood for Sunday afternoon games, considered by Protestants to violate the Sabbath. Always a boisterously competitive participant, despite his relatively slender frame and modest height, Blumenschein played on his high school football team while simultaneously becoming captain of the school baseball team. When the first semiprofessional football team in Dayton was formed in 1890, Blumenschein joined the team while still in high school. During these

years he also began to play tennis, gradually improving his game and making it a regular part of his life.

But it was a school newspaper written, printed, and sold by Blumenschein and some of his friends that gave him an outlet for his creative energy and offered more opportunity for self-definition than either music or sports. Calling their weekly publication *Tom Foolery*, the creators of the unofficial little broadside had an ingeniously entrepreneurial way of distributing it. Just one copy of each issue was made and passed from hand to hand; each student who read it was charged five cents. Blumenschein was close friends with the other boys who produced *Tom Foolery*, among them Harry Conover, who, like Blumenschein, did pen-and-ink cartoons and was a musician, and Paul Compton, who also drew well and later studied architecture in Paris.

One of their fellow students was Paul Laurence Dunbar, later recognized as an important African American poet. He was one of the few black students in the school and, given race relations at this time, was generally ostracized by other students. His talent was self-evident, however, and Blumenschein later recalled, "His 1st published verses came out of my paper. They were slapstick humor." Dunbar also wrote the official class song for the 1891 graduation ceremonies, during which he and Blumenschein both received their diplomas from Central High School.

Adolescent and amateurish as it was, *Tom Foolery* gave Blumenschein and his friends a means of distinguishing themselves from the student body. Moreover, the work he did for the paper increased Blumenschein's confidence in his own ability. The paper offered a lively mix of cartoons, sports items, and juvenile political satire, with Blumenschein generally producing a full-page drawing for the front cover as well as numerous inside cartoons, with jokes written beneath them. The humor was typically puerile and sometimes included stereotypes of African Americans in the popular images and dialect of the day. But Blumenschein's sketches

over several years showed marked progress in his technical dexterity. A pen-and-ink cartoon sketch of a sword-carrying military officer done in April 1891 demonstrates his improving skill in depicting facial features. In short, *Tom Foolery* gave Blumenschein his first taste of what it meant to express an idea through the tangible, visual medium of art.

As an adult, Blumenschein came to recognize the insidious effects of the racism he had shared with his fellow students. After being treated largely as an outsider during his school years, Paul Dunbar, despite his frustrated ambition to become a lawyer or minister, eventually made his mark in life, but before that happened, from 1891 to 1895, he worked as an elevator boy in a Dayton hotel. Even though Blumenschein knew that Dunbar deserved, by virtue of his ability and character, to have the same opportunities he had, Ernest nevertheless accepted Dunbar's situation unthinkingly when he happened to see him at his post one day in 1892. "He was busy reading when I saw him in the elevator," recalled Blumenschein. "I kidded him and he confessed he was studying Greek literature. We white boys abused him during . . . [our] school days," he admitted. "I hope to be forgiven if regret will bring it about, for the pain we must have caused this fine sensitive talented Negro. . . . Most fittingly, my father composed music for the funeral of Paul Dunbar, to the words, I believe, of one of his poems."

Dunbar died in Dayton in February 1906 at the age of thirty-three. He was the author of several widely acclaimed volumes of poetry as well as a number of novels and short stories. He spent much of his time from 1884 to 1900 in Denver, Colorado, where his poems were published in the *Denver Post* and other state journals. From 1897 to 1898 he was an assistant at the Library of Congress in Washington, D.C. His last volume of verse was published in 1905, but Dunbar was not forgotten. Aside from the continued inter-

est in his poems and writings, he was remembered locally by the *Dayton Daily News*, which printed one of Dunbar's poems along with his photograph in its June 16, 1909, edition, which also commemorated the careers of Ernest Blumenschein and his father.

Throughout Blumenschein's senior year in high school, his father watched with growing concern as his son's passion for art grew and his commitment to music diminished. Fully aware that he could not openly dictate his son's future, Leonard Blumenschein nevertheless hoped that a professional evaluation of the boy's artwork might prove negative enough to show Ernest the folly of his youthful obsession. At his father's suggestion, Ernest sent a portfolio of his work to the editor of *Harper's Young People* magazine. In a letter dated June 4, 1891, the puzzle editor of the magazine told Ernest, "The art editor of *Harper's Young People* directs me to say that the specimens which you submit show enough talent to warrant, in his opinion, further study. . . . You show talent which is promising."

Ernest was understandably elated by this opinion from a neutral, knowledgeable observer, and his interest in art now seemed more realistic. He still believed he could become "a successful musician," but he "felt stronger the urge to art and painting." Neither his own desire nor the encouraging letter from *Harper's*, however, lessened the challenge of negotiating with a father who was a formidable foe by virtue of his powerful personality and strong convictions. Discussions between father and son regarding the younger Blumenschein's future were complex and fraught with barely suppressed emotions. The son had a deep respect for his father. Nothing, in fact, more vividly illustrates the psychological hold William Leonard had over his son than the outcome of the talks that took place that summer. Because of these discussions, Ernest's father finally requested directly that he continue his music studies. Ernest agreed to enroll

at the College of Music in Cincinnati. He won for himself only the right to take one or two classes in art in addition to the courses required for a music degree.

Ernest Blumenschein had turned seventeen in May 1891, shortly before his high school graduation. During his seventeenth year, he underwent a rapid maturing process, as a result of not only the strain in confronting his father but also a painful tragedy that unexpectedly struck the Blumenschein family. Just ten years after the Leonora Blumenschein's death, the two children of Leonard and Jenny Blumenschein, five-year-old Carl and seven-year-old Jeanette, both died of diphtheria. Perhaps a blow of such mind-numbing proportions was simply too overwhelming to permit unabashed grieving without fear of total breakdown. Perhaps a stoic acceptance was merely the accepted way among German Americans. For whatever reasons, the family rallied in a kind of stunned silence; even in later years, Ernest Blumenschein spoke rarely and then only briefly of the lost half-brother and half-sister who had been part of his daily life through many of his youthful years.

In fall 1891 Blumenschein moved to Cincinnati and began his music studies. Second only to Chicago among midwestern cities in the number and quality of its cultural institutions, Cincinnati had a population of close to two hundred thousand in 1890. Moreover, its advantages as a transportation crossroads and manufacturing center had contributed to the growth of a wealthy class that was highly civic minded and supportive of the arts. And, no small inducement to the young Blumenschein, it was home to the nation's first professional baseball team, the Cincinnati Red Stockings, organized in 1869. During his first year at the College of Music, Blumenschein kept his word to concentrate on music, earning high enough grades, in fact, to win a scholarship for his second year. This accomplishment was in sharp contrast to his high school grades, which had placed him in the lower third of his class. To his father's satisfac-

tion, this music scholarship had a mandatory requirement that he perform in one concert with the Cincinnati Symphony Orchestra.

During the second semester of the 1891–92 academic year, Blumenschein exercised his option to devote some of his time to art by enrolling in an illustration class at the Cincinnati Art Academy. Cincinnati had been a regional art center since the 1840s, when proud city residents began to promote local artists in the belief that "a new, national, thoroughly American art would develop in the West." The Cincinnati Academy of Fine Arts was established in 1838, and in 1881, the Cincinnati Art Museum was founded. Although this museum focused on European art, it developed a program, rather unusual for collectors and museum directors at this time, of purchasing the paintings of American artists.

The first Cincinnati painting purchased was *The Harvest Dance*, by Joseph Henry Sharp. Other artists of stature who lived in Cincinnati at this time included Frank Duveneck, Thomas Worthington Whittredge, and John Twachtman. In 1884 the Museum Association assumed control of the existing art and design schools, and in 1887 these schools were combined under the name Cincinnati Art Academy. When Blumenschein took classes there, the academy had a prestigious staff of thirteen artists, among them Sharp, Caroline Lord, Duveneck, Louis Lutz, Lewis Meakin, Vincent Nowottny, Fernand Lungren, Thomas Satterwhite Noble, and Henry Farny.

Taught by Lungren, the illustration class Blumenschein took was a pilot course taught outside the art academy. Blumenschein said this was his "first art training" and that its affect on his life could not be overestimated. The class brought him into contact for the first time with working professional artists, and when he won first prize in the class illustration competition, he was convinced "to devote all future studies to drawing and painting." He made rapid

progress under Lungren, who encouraged him to pursue art as a career. During Blumenschein's second year in Cincinnati, the artist embarked on an intensive regimen of formal art studies, following the academy guidelines, which prepared students in ink and pencil sketching, perspective, shading, and accuracy before color was used. Blumenschein advanced rapidly and was selected to study advanced oil painting under Art Department chair Thomas Satterwhite Noble, a highly successful portraitist.

Although most members of the teaching staff at the Cincinnati Art Academy had studied in Paris, Munich, or both, the German school had been the primary influence for some of the academy's most respected teachers. Frank Duveneck (1848–1919), born near Cincinnati, enrolled in the Munich Art Academy in 1870, already influenced by the French realist Gustave Courbet and his German follower Wilhelm Leibl. In 1875 he traveled again to Munich, this time convincing Farny and Twachtman to accompany him. Duveneck become a practitioner and advocate of naturalistic realism in art, using dark warm color tones and bravura brushstrokes, characteristic of the Munich style. From 1890 to 1892, Duveneck taught special classes in oil painting at the Cincinnati Art Academy, and among his students were many of the academy's instructors. The German influence that suffused the art academy can be seen in the style of Blumenschein's early work, which relied on a dark palette and the use of swatches of light color against a rich red-brown background.

At the end of the 1892–93 school year, Blumenschein went home to Dayton for the summer months, prepared to face his father in a spirit vastly different from that of the schoolboy he had been two years earlier. His desire for his father's approval was outweighed by his determination to pursue art. He announced his decision to the senior Blumenschein almost as a fait accompli, rather than as a subject open to debate. And he was able to tell his father that his

two principal instructors in Cincinnati, Lungren and Noble, believed strongly that he should go to New York for advanced training at the Art Students League, one of the nation's leading art schools. The elder Blumenschein reluctantly but gracefully acquiesced to the inevitable. Ernest later said that his irrevocable decision "broke father's heart but he was a good sport about it in the end."

After submitting examples of his work to the Art Students League, Blumenschein received a letter of acceptance for fall 1893. His father agreed to help support him financially, even though his income was not large. He asked only that Ernest take at least one class in violin while in New York. Blumenschein did not honor the request, but he tacitly acknowledged his father's influence by continuing, until after his father's death, to include a violin in self-portraits and group portraits that included him. William Leonard Blumenschein, despite his stubborn conviction that Ernest carried the Blumenschein gene for musical ability, must have remembered that his first wife, Leonora, had drawn and painted well and had shown the same passion for art now expressed by her first-born son.

2

The Finding of Self, 1893–1894

Of even greater consequence for Blumenschein than the geographical distance between Dayton and New York was the emotional distance from his father that inevitably resulted from his enrollment at the Art Students League in September 1893. Blumenschein had partly liberated himself during his two years as a student in Cincinnati, but even in New York he retained a strong sense of accountability to the father who was financially supporting him. Ernest's removal from frequent personal interaction with his controlling father, however, seems to have lessened the effects of parental pressure.

Even more significantly, Blumenschein now had sole responsibility for establishing his own credentials as well as achieving a new kind of freedom simply to be himself. In New York, unlike Ohio, being the violinist son of a musician father meant nothing except in the most incidental way. He began to emerge as an individual in his own right. In his rather infrequent letters home and in his actions as a nineteen-year-old aspiring illustrator on his own in the most densely populated city in the nation, Blumenschein gave no hint that he found the new circumstances anything other than highly satisfactory. When he stepped off the train in Grand Central Station, his violin was in hand; in his head were dreams of a career that would make Dayton, a domi-

neering father figure, and violin study nothing more than parts of a preparatory past.

The equanimity with which Blumenschein adapted to life in New York appears at first glance to be almost preternaturally mature, given the vast differences between an essentially small-town Ohio and the quintessentially urban metropolitan New York. But Blumenschein did not face the challenge of dealing with the entire city all at once; he was, in fact, insulated from most of its daunting dichotomies by his assured, though small, income and his immersion in an immediate environment of art students and teachers. Still, no one could remain in the teeming, ever-changing city of five boroughs for any length of time without becoming aware of its status as the nation's financial center and art and literary center, as well as the destination for thousands of immigrants each year.

The population of Manhattan alone was 1.5 million in 1890. In several of New York's rapidly growing boroughs, the residents were mostly of recent foreign origin; it has been estimated that during the 1890s, fewer than one-quarter of the city's residents were native born. During these same years, however, New York was home to some of the nation's wealthiest families, multimillionaires like the Vanderbilts and the Astors, whose unprecedentedly large fortunes had burgeoned during the booming post–Civil War industrialization era. Their ostentatious mansions on Fifth Avenue stood in stark contrast to the humble tenements that housed most of the city's poor and working-class families. Although control of much of the nation's commerce was in the hands of new money that had gravitated to the city, old wealth still prevailed in New York City's power structure. Excluded in the city's higher social circles were almost all of those with Jewish or eastern European backgrounds. The culture of western Europe was admired, with the art of Old Europe preferred over that of contemporary America.

The extravagantly elegant social activities of the moneyed elite were widely publicized in newspapers and magazines.

They created an image of a gracious, refined, glamorously exciting and prosperous New York that held sway throughout much of the nation. But there were dissenting journalistic voices, such as that of Jacob Riis, who in his 1890 publication *How the Other Half Lives* made a powerful case for the kind of economic and social legislation needed to lessen the harsh disparities in the living conditions that characterized New York. Reform in such areas as child labor, worker rights, education, health, and housing would come slowly and piecemeal over many years, which ended up providing great opportunities for artists, such as Blumenschein, to do illustration work for the books and magazine articles of crusading journalists like Riis.

In the meantime, standards for dress and comportment set by the wealthy continued to be seen as desirable and worthy of emulation by the middle and lower classes and even by the city's intellectuals and artists, who outwardly professed disdain for the rich, who ignored them. During his first year in New York, Blumenschein, influenced by the fashionably smart look of the young men in the very illustrations he was observing and studying, acquired both his urbane manner and his preference for formal business attire.

At the Art Students League on West 57th Street, however, Blumenschein found an environment relatively free of the formalities and hierarchical authority structure that characterized not only U.S. society during this era but much of the nation's art training system as well. It was not by accident that the Art Students League, recognized as one of the best art schools in the country, operated under principles at variance from those prevailing at most leading art schools. The Art Students League had been established in 1875 with the specific aim of offering artist-teachers and art students an alternative to the strict conformity to academic styles epitomized by the regimen at the famous National Academy of Design. This institution, founded by such noted American

artists as Samuel F. B. Morse, Asher Brown Durand, and the Great Britain–born Thomas Cole in 1826, had dominated art training in New York over many decades. Located in spacious quarters at 1083 Fifth Avenue, the National Academy of Design emphasized the classicist art style, which traced its origins to the Greeks and Romans. Highly valued in both classicist and neoclassicist art were qualities of order, serenity, idealism, balance, harmony, careful composition, and formality in the presentation of the human figure.

In addition to its overall adherence to these traditional art styles, the National Academy of Design employed teaching methods based on strict criteria for approval, close supervision by instructors, and a formal grading system for ranking the work done by art students. Convinced that the academy's training system stifled creativity and impeded personal artistic development, several established artists organized the Art Students League. This organization exemplified a spirit of acceptance for romanticism and impressionism, which would begin to influence American art in the 1880s. Of particular importance was the place given to romanticism, one of the predominant impulses of nineteenth-century American art. It was distinguished by a naturalistic realism often incorporating open emotionalism in the visualization of extreme feelings and states such as ecstasy, agony, fear, suffering, or death. Spontaneity was a valued attribute, as was subject matter of dramatic import, whether in scenes including the human figure or in pure landscape.

The Art Students League had around 450 students enrolled by the early 1890s, and its teaching staff of nine or ten artists included such leading American painters as William Merritt Chase, John Sartain, Kenyon Cox, John W. Alexander, and John Twachtman, who had been an instructor at the Cincinnati Art Academy. Students paid five dollars per month in tuition. They were encouraged to develop their abilities by working steadily on painting projects close

to their talented instructors, who often gave one-on-one advice and guidance. Self-discovery and hard work were stressed, while attendance records, deportment, examinations, and grades were given less importance. Illustration was not a neglected field at the Art Students League. Among the leading illustrators who taught classes at various times was Charles Dana Gibson.

As a student at the Art Students League, Blumenschein displayed appropriate awareness that he was still in the early stages of becoming a painter. He was more than willing to spend long hours practicing skills needed to learn his craft, understanding that he was far from ready to make a definitive statement on art through his paintings. Even so, his work, whether in ink, charcoal, or oils, began to reflect the realistic romantic style that had proven readily adaptable for illustration, the field he hoped to enter as soon as possible. At the same time, however, he took full advantage of New York's art museums and galleries to expand his horizons and educate himself in the history of American art. The prestigious Metropolitan Museum of Art in Manhattan played an important role in the young Blumenschein's ad hoc, informal art education. He began to see that the art he was being taught was part of an evolving national tradition, although he continued to believe that American art was a somewhat inferior offspring of its European parent.

Blumenschein began his study at the league in John Twachtman's preparatory antique drawing class. Twachtman was an ill-tempered but talented artist, whose sometimes brutal handling of students was probably due to his lack of proper recognition and his drinking problem. He was one of a group of artists known as the Ten American Painters, who were influenced in varying degrees by French impressionism. The artist Frederick Childe Hassam was probably the most dynamic of The Ten. Twachtman, one year before his death in 1902, complained of his own career

that although he had exhibited eighty-five paintings, he had not sold one of them. One of Blumenschein's fellow students who seemed adversely affected by Twachtman's lack of sympathy and understanding was Lionel Barrymore, who went on to become one of Hollywood's greatest actors. No doubt spurred in part by the bad atmosphere created by Twachtman's cranky disposition, Barrymore got into a fight with another student, which left the classroom in shambles, with broken easels and a scattering of paint. The two combatants were expelled from Twachtman's class, and the disenchanted Blumenschein left it two months later to take a similar class offered by the more sympathetic art instructor James Carroll Beckwith.

Blumenschein formed a friendship with Barrymore that lasted for years. In a 1909 letter to his friend Ellis Parker Butler, just prior to painting Lionel and his family in a group portrait, he described Barrymore as being "jolly good company, very entertaining. (we spend a good deal of time when together in giving imitations of orchestras)." Despite Blumenschein's frustration over Twachtman's methods as an instructor, he remained loyal to the Art Students League, even teaching classes there in his later years, after becoming a more established painter.

A case could be made that in the time of Blumenschein's training as an artist in New York City, American painting proved capable of expressing the character and temperament of the American people; this included their changing attitudes and feelings toward their natural environment. Even as the colonial period ended and the federal period began, American painting had been showing itself to be more than a mere reflection of its English origins. Nevertheless, European schools of painting over the course of the nineteenth century evoked emulative movements in the United States. American painters, however, rarely practiced these admittedly influential styles, whether they be French, German,

Italian, or English, without incorporating significant differences that reflected the United States' unique social, political, and topographical attributes.

Throughout most of the eighteenth century, art in America was significantly influenced by portraiture, whether done in the baroque, American primitive, or later American rococo style. Painters employed the charm and grace of their preferred styles to reveal the inner life of their subjects. Landscapes and still lifes occurred just enough to show that they were part of the American atmosphere. By the late 1770s, even as the American Revolution was altering forever the fate of the colonies, the neoclassicist style was beginning to prevail. With its enamel-like color and sculptural rendering of subject matter, it was being used by painters born on American soil to convey with powerful effect the heroic aspects of American patriotism. John Singleton Copley, John Trumbull, Gilbert Stuart, and Charles Willson Peale imaginatively fused the citizenship virtues of antiquity with the historic actions of America's nation builders.

By the 1820s neoclassicism had given way to the new romantic movement, exemplified in literature by the intuitive lyricism of William Wordsworth, Samuel Taylor Coleridge, Percy Bysshe Shelly, John Keats, and Johann Wolfgang von Goethe and in music by the compositions of Ludwig van Beethoven. In art romanticism was characterized by greater fluidity of line, freer composition, less reliance on idealization, and greater emphasis on naturalism and artistic interpretation of subject matter. An example of earlier romantic period painting in America is the much respected Washington Allston's *The Rising of a Thunderstorm at Sea* in 1804, illustrating a mood of solemn contemplation of the mysterious power of nature.

Painting became a widely practiced creative activity in the United States. Portraits were in high demand as the population grew and national boundaries expanded. The eighteenth-century aristocratic ideal, based on rank and

birth, was replaced in the nineteenth century by an egalitarian ideal, based on the free citizenry of a democratic nation-state. As an adjunct of this new preoccupation with the responsibilities and privileges of citizenship arose an intense identification with the land itself. The natural environment of the United States became a primary inspiration for many artists as they sought to celebrate, commemorate, understand, characterize, and interpret the great American wilderness, which was rapidly being altered by the building of towns and farms, factories and roadways.

Working in the style of romantic realism, Thomas Cole (1801–1848) explored the river valleys, wooded hills, meadows, and lakes of the Northeast. He translated sketches made on the scene during his summer and fall wanderings into vividly executed, richly detailed oil paintings during the winter in his studio in New York's Hudson Valley. His student Frederic Edwin Church followed Cole's lead in creating landscape canvases of impressive size and emotive power; their work formed what came to be known later as the Hudson River School. The famous Church's grandly conceived panoramic views of North and South America fulfilled their intent of eliciting awe from their many viewers. Such works as *Niagara Falls*, which Church painted in 1857, achieved near-universal recognition among Americans.

Asher B. Durand, a great admirer of Cole, devoted his long career to landscapes, faithfully recording the beauty of nature. Influenced by the Dutch landscape painters, he was an advocate of outdoor painting, a practice that led him to a growing fascination with the effects of changing light conditions. His exploration of light sparked interest among other painters, resulting in a body of work characterized by a nuanced modulation of color tones that became known as American luminism, a term invented in the 1950s by art historian John I. H. Baur and popularized by other art historians and dealers in the 1960s. Among the luminists were John Frederick Kensett, Thomas Worthington Whittredge,

Alexander H. Wyant, Sanford R. Gifford, and George Inness, painters whose work introduced a pensive, dreamy mood to landscape depictions.

Painters working in the romantic style during the 1860s and 1870s continued to be influenced in varying degrees by both the so-called luminist ideal at one end of the spectrum and the objectivist ideal at the other. But other forces were affecting painting styles as well. The notion that eternal truths were expressed in the beauty of untamed nature was taken to its furthest extreme by Church and artists such as Albert Bierstadt (1830–1902). The American West with its vast empty spaces, forbidding mountain ranges, cruelly arid deserts, and harsh climatic extremes had not yet been aesthetically assimilated by the American public when Bierstadt started to paint it.

After studying in Germany and Italy, Bierstadt took on the self-appointed task of conveying to the nation his conviction that the grandeur, sweep, and stunning contrast found in the U.S. landscape symbolized the greatness of the nation itself. His reverentially dramatic oil paintings of craggy mountain peaks, bathed in the aura of glowing sunsets, as life-giving waters tumbled through pine-filled canyons far below, were typical of his work. They were done from sketches made in such places as California's Yosemite Valley, which presented nature in its most spectacular and mystical form; nature was seen as a link to the sublime, a source of spiritual rather than material sustenance. One of his best was *The Rocky Mountains*, which he completed in 1863. Although his overwrought style had receded in popularity by the 1890s, Bierstadt acquired wealth and fame during his lifetime. Another landscape artist in this era was Thomas Moran (1837–1926), who worked extensively to paint the marvels of the Grand Canyon of the Yellowstone and the Grand Canyon of the Colorado. The creation of the national park system can be partly credited to the influence of his paintings.

Although American art was notably free of ideological rancor for most of the nineteenth century, almost every European style had enthusiastic advocates among American painters. German schools emanating from Düsseldorf and Munich were influential from the 1850s through the 1870s, but French art schools began to be admired in the late 1860s; by the 1880s, French schools were exercising the most visible influence on American painting styles. After studying in Paris, William Morris Hunt returned to America with high praise for such Barbizon school painters as Jean Francois Millet and Jean Baptiste Camille Corot, who were bringing a new warmth and immediacy to the portrayal of peasant farmers, fishermen, and the French countryside. The highly respected Hunt, who had painted murals for the New York state capitol in 1878, prompted recognition that French art was leading the way in innovative painting styles.

Nevertheless, when the first impressionist exhibit was held in Paris in 1874, American artists paid little attention to it. By 1886, however, when the last group exhibit of the impressionists took place, American painters were responding to the implications of this school's revolutionary set of ideas concerning subject matter, composition, brush strokes, and use of color. Many of the American painters who studied in Paris after 1875 applied such French-inspired techniques as broader brush strokes, thicker paint application, and less visible outlining of forms.

But except for Childe Hassam and Julian Alden Weir, the painters whose work came to be categorized as American impressionism never adopted the pointillism or broken strokes of the French. Nor did these painters from across the Atlantic consciously seek to achieve the spontaneous characteristics of the artists in France. The term *pointillism* is associated with the French artist Georges Pierre Seurat, who originally called it divisionism. The American impressionists, including Hassam and Weir, along with John La

Farge, John Twachtman, John Singer Sargent, Theodore Robinson, William Merritt Chase, and Mary Cassatt, modified impressionist ideas and techniques in the belief that a depiction of the American environment often required different solutions. La Farge, a friend of Henry Adams (who had also looked to Renaissance Europe for intellectual and spiritual inspiration), began as a naturalist painter. He gradually adopted impressionist ideas and finally turned to a luminous color palette in response to the mysticism of the Byzantine and baroque periods. Hassam was exposed to impressionism during his Paris studies in the 1880s but remained an academic painter until the 1890s, when he settled in New York to become a leading impressionist. Mary Cassatt remained in Paris and was part of the French impressionist group for much of her distinguished career; she comes closest of all American painters to incorporating the spirit of French impressionism. A friend and follower of Edgar Degas, she did some of her finest work in pastels during the 1890s, while living in Paris.

Moving beyond the constraints of any single art style were Winslow Homer (1836–1910) and Thomas Eakins (1844–1916). Although aware of contemporary influences, each painter moved from a conventional style toward an individualized sensibility, bringing to bear on the objective world a personal philosophical, emotional, and aesthetic response. Singularly free of sentimentality, the seascapes done by Homer during his years at isolated Prout's Neck, Maine, offer viewers the tautly uncompromised perspective of a single man unblinkingly confronting the ceaseless dynamic of nature. Eakins, on the other hand, achieved a holistic balance of aesthetic values and precisely rendered material realities. In such paintings as *The Agnew Clinic* (1881), his figures, even when fully clothed, reveal the understanding of the human body he had developed in his study of anatomy at the Jefferson Medical College in Philadelphia. The work of both artists provides a high point in nineteenth-century

American art. Blumenschein, whose strong pride in being an American would persist during his many years in Paris as an art student, would certainly have been keenly aware of these two major American painters.

Any assessment of the state of the American art world when Blumenschein was entering it, however, must begin with recognition that on the whole, this end-of-the-century period was relatively weak for art in terms of quality and sense of direction. The art world of the 1890s, centralized in New York to a degree not previously known, encompassed an eclectic array of stylistic impulses and influences that did not seem to strike a popular note with much of the American art community. The last quarter of the nineteenth century had seen a gradual diminishing of the instinctive bonding with society that had marked the relationship between American painters and their public between 1776 and 1876.

Having turned inward in absorption with tonalism, symbolism, and impressionism—each a manifestation of a kind of romanticized idealism—American painting was in need of an aesthetic rationale to renew its once vigorous relevance. The battle between realism and romanticism was already well under way in the world of literature, where such writers as Stephen Crane, Theodore Dreiser, Frank Norris, Mark Twain, and William Dean Howells had grappled with America's social realities and earned respectful attention from the public; but not until the first decade of the new century would American painting reclaim this kind of connection to the national ethos.

Shortly after his arrival in New York in 1893, Blumenschein confronted a situation that threatened his image of himself. For all his determination to pursue art, he had always wanted acceptance and approval. He wanted to follow his own bent, but, whenever possible, he wished to do so while winning approval, acclaim, and recognition in some form. He had retained his father's support and approval in

part by agreeing that the violin would continue to be a part of his life.

Blumenschein had little time for violin practice as a student at the Art Students League. From his first days in the city, he also relished the lively social life centered on student gatherings in intimate restaurants and pubs, where the presence of pretty girls was an added inducement for participation. Yet, viewing himself as a fairly accomplished violinist, even without the benefit of ongoing lessons, he unhesitatingly auditioned when the famed composer and conductor Antonín Dvořák was forming the National Conservatory Orchestra, which would present the world premier of his *New World Symphony* under the maestro's own baton.

Blumenschein, full of youthful confidence, thought of himself as a man of culture, with talents extending to both art and music. He knew that he was the son to whom his father looked for accomplishment and success. He thought of himself, even in his newfound freedom, as a son who was fulfilling his family's wishes. It must have been a sharp blow to his ego, and his self-image, when he was not given a position with the newly formed orchestra, although expecting success was unrealistic in view of New York's many fine and highly trained musicians who were devoting their full time to the music profession.

To the twenty-two-year-old Blumenschein, however, playing violin part time under a world-famous conductor apparently seemed entirely reasonable. Perhaps he informed his father in advance of what he was planning to do. In any case, the rejection demanded he acknowledge that he could not do and be everything—nor could he always please his father.

Not wanting to disappoint his father and stepmother, however, the young art student, according to Taggett and Schwarz, had written home, claiming that Dvořák had chosen him as first violinist. Although this incident had only a minor impact on Blumenschein's young life, his version of

this interaction with Dvořák would follow him throughout his long art career and even after his death. Magazine articles and catalog essays sometimes mention his violin performances under the Czech composer. A catalog essay published in conjunction with a Blumenschein retrospect held in Colorado Springs in 1978 maintained that Blumenschein used his income from playing violin to pay for his passage to France for art study. Even his daughter, Helen, wrote in her family history, *Recuerdos: Early Days of the Blumenschein Family*, published eighty-six years after this episode, that Dvořák chose her father "to be the first violinist when he was putting together an orchestra."

In a May 8, 1935, letter to his fellow Taos artist E. Irving Couse, Blumenschein mentioned in a talk about some of the prominent artists, writers, and composers he had encountered during his career that it had all begun with "Anton Dvorak, the great composer in whose orchestra I played at twenty." Two years before his death, Blumenschein was pictured in a November 1958 issue of the *Albuquerque Tribune* with Hans Lange, director of the Albuquerque Symphony Orchestra, while attending a reception following a show of his art work. In the story that accompanied this photograph, the reporter noted that the two men "reminisced" after discovering that each had worked under Dvořák, Lange in Europe, and Blumenschein in New York.

Although Blumenschein's name does not appear in any of the programs listing orchestra members, he did attend the world premier of the composer's *New World Symphony* (Symphony No. 9 in E minor, Opus 59). Moreover, in his 1927 interview with DeWitt Lockman, Blumenschein mentions playing the violin in connection with a conservatory headed by a woman named Thurber, which had supported young musicians in their musical pursuits. Art historian Elizabeth J. Cunningham has found in her research on this matter that Dvořák served as musical director for this New York conservatory and "conducted young people at conservatory

concerts." Given the artist's unquestioned talent as a violinist, he could very well have played the violin for the Czech composer at one of these concerts. Perhaps this was the venue that Blumenschein was referring to when he discussed his association with Dvořák in his reminiscing with Lange or in his letter to Couse.

While it would seem that the young Blumenschein of 1893 had wanted to bask in the glory of being a musician without paying the price of further formal study, this should not be taken to mean that his love of classical music was anything less than genuine and passionate. Already he thought in terms of a parallel between music and painting, with rhythm and harmony expressed in music by sound and in painting by colors and shapes. But his relationship to music was different in kind from his commitment to art; music was a means of validating his sensibility, his heritage, and his own worth in elitist cultural terms, while the tumultuous, competitive art world was where Blumenschein chose to fulfill his potential and carve out a place for himself.

Indeed, Blumenschein's apparent unwillingness to acknowledge the true nature of various episodes of his life, such as the one involving Dvořák, did not mar his attitude toward art— his own or anyone else's. In this sphere he exhibited a fairly consistent realism, which spurred him to coolly, sometimes bluntly, make objective assessments of what he was doing and what other artists were doing. His judgments were not, of course, always right, but they were always imbued with an almost compulsive honesty.

Lacking formal records of grades that might indicate Blumenschein's progress at the Art Students League, we can still gauge his overall success by two benchmarks. By the end of the 1893–94 year in New York, he had won an art competition at the school; even more important, he had been given his first illustration commission while studying at the league. He created eight illustrations for a story by J. Templis that was published by *McClure's* magazine in Febru-

ary 1895. But despite the enticement of more commissions if he remained in New York, Blumenschein concluded by the end of his first year at the Art Students League that he needed further study and that it should take place in Paris. In making this decision, he was swayed not only by his own restless nature but also by the example of his teachers and fellow students, many of whom had studied in Europe or were planning to do so in the near future.

Blumenschein was only dimly aware of the enormous changes that had taken place in America during the twenty years he had been alive, but he was certainly affected by the cumulative impact these changes had on the attitude and mood of the intellectual class in general and artists in particular. Among these changes were Reconstruction, the reintegration of the South into the national mainstream in the wake of the Civil War, and the de facto and de jure establishment of a racial color line as a substitute for slavery. Others included the country's rapid industrialization and urbanization; a growing disparity between the wealthiest and poorest Americans; an increasing preoccupation among the upper middle class with the acquisition of money and social prestige; and an emphasis on power as opposed to the acquisition of cultural and educational assets.

Also significant in the United States was a resultant movement among intellectuals and artists to look toward Europe as a source of inspiration in the liberal arts, which were seen as neglected and undermined by the commercial values of their own country. The expansionist egalitarianism that had characterized the United States during the 1840s and 1850s had been largely replaced with a survival of the fittest ethos, placing money at the apex of the nation's goals, honoring those who acquired the most wealth, and permitting outright governmental support for the large business interests the wealthiest people controlled.

By the early 1890s, however, the relentless drive toward conformity over individualism, technology over craftsmanship,

and the growing economic dominance of business cartels over smaller enterprises had resulted in an upsurge of social unrest. New political forces arose out of rural agricultural protest as well as urban worker discontent. From these forces would come the political reforms of the early 1900s, including antitrust law enforcement, food and safety regulations, conservation laws, and emerging labor unions. But as writers, artists, and social critics looked around them at early 1890s America, their mood was predominantly one of alienation and pessimism.

Disillusionment with American cultural values strengthened the trend toward art study in Europe, one that swept up Blumenschein along with many others. As a decidedly optimistic young art student, Blumenschein broached the subject of study abroad to his father in the summer of 1894. Having proved himself in many ways in New York, Ernest was cautiously hopeful, knowing his plans could proceed only with continued financial help from home. As he recalled with pride in later years, his father offered little resistance to the idea of his training in Paris and agreed to support his son for two years of further study.

That William Leonard Blumenschein had benefited from European study when he was younger no doubt strengthened his son's case, especially now that Ernest more than ever was the elder Blumenschein's sole hope for an heir who would carry the family's cultural heritage forward into the next generation. George Blumenschein, Ernest's younger brother, had gotten married at seventeen, in 1893, to Fannie Miller. He had little education and was working a series of menial labor jobs. Soon he had a small son to support at a time when he was already showing signs of emotional instability and alcohol addiction. Ernest's younger sister, Florence, was attending high school in Massachusetts, where she enjoyed a happy and well-adjusted life with her maternal grandparents, the Hulls. But as a daughter in a traditional nineteenth-century family, she was neither expected nor encouraged to pursue a professional career. Toward Ernest,

Blumenschein was notably undemonstrative, never openly affectionate, and never warmly supportive. But he was consistent in his concern for his eldest son's future, willing in his own way to listen to reason, and faithful to his promise of limited but assured financial support for Ernest's art study.

The Blumenschein family was fortunate in not being indebted in the mid-1890s, for the nation was in the grips of a severe depression marked by interest rates of 15 percent and above. A sharp economic downturn, brought about by the excesses of the 1880s, had begun shortly after the election of Grover Cleveland for a second split term as president in 1892. Despite pleas from farmers, debtors, and politicians from mining states in the West, and some of the president's own advisers, urging him to support expansion of the money supply through government purchase and minting of silver, Cleveland responded to the Panic of 1893 by opposing the Sherman Silver Purchase Act of 1890 and putting the country back on a strict gold standard. The economy would not recover for several years from the hardships brought on by this anti-inflationary move.

Indeed, when Blumenschein embarked by steamer for France in late summer 1894, he left behind a nation embroiled in political and economic turmoil, which culminated in the bitterly contested presidential election of 1896, pitting Populist, free-silver Democrat William Jennings Bryan of Nebraska against pro–big business Republican William McKinley of Ohio. McKinley won, and eventually things got better for the nation. Enough new gold was mined through the new cyanide process to allow for economic expansion; the export of manufactured goods and farm commodities increased; and prosperity was in sight again by 1898. But without doubt, Blumenschein, in France from 1894 through 1896, was away from his country during some of the most troubled years in American history up to that time. In late August 1894, however, as his ship moved

out into the Atlantic, and he watched the American skyline recede from view, Blumenschein's thoughts were presumably not about the fate of his country. He more than likely was looking to his own future in art illustration, a future he believed would be made secure by the training he would soon receive in Paris.

3

Seeking at the Source

Once in France, Blumenschein lost no time enrolling at the Académie Julian, located on the Rue de Dragon, bordering the Latin Quarter, on the left bank of the Seine in south-central Paris. The school, with more than six hundred students at branches throughout France, had a fine reputation and was well known among American painters.

Blumenschein long remembered his first view of the famous art school, where he was to spend many hours over the next two years. As had so many before him, he "passed under an arched entrance to a courtyard, turned and climbed a dark winding stairway of stone steps and proceeded down a long dim hall to a large door." The door opened onto a spacious, high-ceilinged room that served as a classroom studio. Students from nations around the world were crowded together in a clutter of easels, stools, and canvases, all working away furiously on drawings and paintings in various stages of completion. Their work was based on views of two models, one male and one female, both posing nude some twenty feet apart from each other at the front of the studio. The painting instructor strolled ceaselessly among the students, pausing here to explain a point, leaning in there to pick up a brush and demonstrate.

The room was noisy as students talked, hurled epithets, joked, laughed, and groused. The air was blue with smoke,

and as far up as the hand could reach, the walls were marked with hardened scrapings of paint from palettes. The smell of fresh paint mingled with that of stale tobacco. Many of the students wore heavy beards and sported long flowing neckties. They were attired in a wide variety of odd clothing, expressing national backgrounds, incomes, and social attitudes. Group singing erupted periodically as students of one nationality burst into exuberant renditions of songs in their own language; sometimes their lyrics were catchy enough to attract others and swell the chorus to a near-cacophony. In the midst of this seeming chaos, the students did serious work, while the models chosen for the day maintained their disciplined stillness with decorum worthy of the most reverent churchgoers.

Life at Julian's was paradoxical in other ways as well. Academic painting styles were taught, yet most of the students derided the art establishment and its teaching system even while studying under its auspices. The school had a lively sense of tradition, from initiation rites for newcomers to annual street festivals, yet each tradition seems to have been born of a healthy contempt for the traditions of society at large. Blumenschein concluded that his fellow students, ambitious artists one and all, were on the whole "a jolly lot; insolent, disrespectful, proud to defy most of society's conventions." Blumenschein's own attitude was that of a typical newcomer. He was curious, eager to learn, ready to accept small indignities for the sake of inclusion, and open to new experiences. If anything distinguished him from his fellow students, aside from an inbred sense of propriety, it was his unabashed siding with the minority of students who respected the French academic painting style and had every intention of practicing it in their subsequent careers.

The small studio apartment Blumenschein rented in the Latin Quarter had but one room and minimal furnishings. Nevertheless, it was a better arrangement than his first lo-

cation in Paris, where he had roomed with four other students, including Charles Ebert, who had studied with him at both the Cincinnati Art Academy and the Art Students League in New York. To Blumenschein's great satisfaction, his new place was superior to many of the apartments available to art students in Paris; it offered heat and contained such items as a table and a chair, luxuries not provided in poorer flats, which had room only for a large, though comfortable, bed.

No city in the world, however, offered more publicly accessible amenities than Paris did, and Blumenschein availed himself of these, as did his fellow students. He ate inexpensive meals at nearby cafes and took mesmerizing walks along wide tree-lined boulevards. He entered ancient churches, visited the city's impressive museums of art, and went to the public gardens, which blazed year-round with color. On his walks, he discovered side streets and courtyards and alleyways where iron gateways, wooden shutters, stone carvings, and endlessly varied window shapes made intricate patterns to please the human eye.

The commanding Cathedral of Notre Dame occupied a site on the Île de la Cité, which divides the twisting Seine River just north of the Latin Quarter. On the right bank of the Seine, northwest of the cathedral, Blumenschein found that treasure house of art—the Louvre. Established in 1793 as the Musée de la République, the Louvre was now the preeminent resource for artists and art lovers alike. And so it was for Blumenschein, who in later years noted with some irony that "so much of an artist's education is the study of masterpieces produced by the great artists of history, that it is hard for him to approach a subject without feeling the influence of someone who had painted a picture similar to the one he was about to execute." The architectural beauty of Paris was enhanced by an abundance of public art, including the commissioned sculptures, murals, and paintings

that graced such landmarks as the Luxembourg Gardens, the New Sorbonne, the Panthéon, Tuileries Garden, the Paris Opera, and the newly restored Hôtel de Ville.

As for the thousands of artists living in Paris, their studios were often identifiable by large north-facing windows, which could be found everywhere. Even so, the Latin Quarter, Montparnasse, and Montmartre were the city's most important art districts. Many of the artist studios in Montparnasse, in southern Paris, were makeshift accommodations, poorly lit and furnished, with no running water, often on a fourth or fifth floor, and usually accessible only by long flights of stairs. Art students usually rented the studio quarters for three months to a year.

Even for many professional artists it was common to have heat only from a corner stove, which was used for the simplest cooking. In the Latin Quarter as well as in other areas, however, the studio homes of the most successful artists were lavishly appointed, architecturally designed structures of impressive dimensions. During the 1880s and 1890s, growing numbers of artists settled in Montmartre, located in northern Paris, among small industrial enterprises and newly constructed apartment buildings. Free-standing houses surrounded by flowering gardens provided further evidence of the city's expanding size. Van Gogh took a studio in Montmartre in 1886, and in the 1890s both Degas and Cassatt lived there. On the Boulevard de Clichy was the windmill-shaped entertainment complex known as the Moulin Rouge, which had opened in 1889, the year the Eiffel Tower had been completed, to compete for the business generated by the Exposition Universelle. The Moulin Rouge was a highly successful venture, drawing all kinds of visitors, from royalty to the poorest Parisians. Toulouse-Lautrec became its preeminent observer in paintings and advertising posters.

The art schools of Paris, varying in size, reputation, and eligibility requirements, shared a common preoccupation

with mastery of the human figure as a central element in large formally executed paintings. The student was expected to acquire proficiency in reproducing real objects in the natural world with perspective and accuracy. One of the greatest benefits for Americans studying in Paris was the opportunity to work from life with models in the studio. During the 1880s and 1890s, art education in the United States reflected a negative attitude toward use of the nude model.

Although skill in the art of figure painting was the goal of many European and American artists during this period, those artists intending to work primarily in landscape found the art schools less important than working outdoors. Among those impressionists who abandoned formal studies at an art school was Camille Pissarro, who would travel each year to vary the subjects of his paintings.

Although most of the art schools, including the Académie Julian, were privately owned commercial enterprises, the most prestigious was the government-sponsored École des Beaux-Arts, which had been established in 1648; the forty elected life members who appointed the school's professors comprised one of the five assemblies of the French Académie. At this time, one of the few foreign students who had ever been admitted was Thomas Eakins, who had studied at the École des Beaux-Arts in 1866. Unlike the Académie Julian, which kept its doors open for classes six days a week, from early in the morning until late afternoon, the École des Beaux-Arts offered only morning classes. In fact, the ready availability of classes was one of the reasons the Académie Julian was second only to the École as a center for art study in the 1890s. Julian was also open to female artists as well as male and set no age limits on enrollment. Blumenschein studied at a branch where only male students were enrolled, but the Rue de Fauboug Saint-Denis branch offered separate classes for men and women.

Among the other flourishing art schools was the Académie Colarossi in Montparnasse, multinational in its

student body but with fewer Americans. Van Gogh and Toulouse-Lautrec were among the artists who studied at independent studio schools. Moreover, during the hot summer months, many art instructors and their students headed for rural retreats, like Pont d'Aven and Crecy-en-Brie, where it was cheap to rent and paint the French countryside; this practice would have a direct effect on the establishment of art colonies in America.

Along with public art and art schools, large public exhibits were integral to art life in Paris. In early May 1895, Blumenschein was one of several hundred thousand visitors to the annual Salon at the Palace of Industry on the Champs Élysées. Blumenschein quickly realized how important to one's reputation it was to have a painting accepted for exhibit in the Salon. The most important art patrons and gallery owners were always present. Traditional art in the form of highly realistic historical, religious, or genre painting was the standard for acceptance.

With the emergence of impressionism and post-impressionism, however, discontent with the official Salon began to grow. In 1884 Paul Signac and Georges Seurat were founding members of the Salon des Independents, which increased public understanding of the new styles but had a much narrower audience. A second salon began exhibiting in 1890 at the Champs de Mar, and many smaller independent salons sprang to life. Around this time the annual Salon began to lose its dominance as artists, dealers, and collectors challenged its authority. The competitiveness between academic and tradition-challenging artists heightened the brilliance and diversity of art in Paris. Despite its waning influence, however, the annual Salon on the Champs Élysées was the exhibit of choice for Blumenschein. With its rigid criteria for inclusion and its established legitimacy, the Salon offered a challenge he could not resist. Unobtainable for the moment, exhibiting there remained a goal as he followed the Julian regimen of diligently drawing torsos,

limbs, and facial features with growing accuracy, consciously striving to emulate the effect academic masterworks held up as the ideal.

Perhaps the most notable feature of the Académie Julian was its successful fusing of an informal studio environment with a formal teaching method that closely paralleled the highly structured training offered by the École des Beaux-Arts. Few would have predicted such an astute response to the needs of art students from Rodolphe Julian, the muscular, hard-driving Frenchman who founded his school in 1863 and remained director of its lucrative operations until his death. Born poor and possessing little education, he became a professional boxer in his youth. When he began to lose more bouts than he won, he turned to modeling for artists to earn a livelihood. As he became more knowledgeable about the bohemian art life of Paris, the restlessly ambitious Rodolphe impulsively decided to risk all by renting an empty studio and posting a sign outside, declaring its status as an art school. Beginning with one student and one model—himself—he effectively used his highly developed promotional skills to attract growing numbers of students and to entice some of the most respected artists of the day to serve as visiting instructors.

The good reputation acquired by the Académie Julian stemmed largely from the established artists on its teaching staff. Julian himself played an active role in maintaining the standards of this school. He visited the studios regularly, drawing while there, selecting the models' poses, and sometimes teaching classes. Still, the Académie Julian was not without its critics. Among them, according to John Milner in his study *The Studios in Paris*, was the American novelist George Moore, who had once studied at the school in the hope of becoming a painter. He wrote that he knew the "dark-eyed, crafty" Julian personally and had become convinced "that [the] great studio of Julian's is a sphinx, and all the poor folk that go there for artistic education are

devoured. . . . After two years all paint alike, every one has that vile execution."

Blumenschein, writing of his time at Julian's, lent some credence to Moore's views when he recalled the process involved in doing a class study. "I got out a canvas that was under way," Blumenschein wrote, "counted the fingers and toes on the principal figure, plumbed up his spinal column, made him seven and a half heads high, as per Académie Julian, put his weight on his feet and his feet on the ground, blew fixative on the drawing, and started to paint along the lines that I hoped would lead me some day to the gates of Rembrandt—or thereabouts." Outbursts such as Moore's were infrequent, however, and the reality was that for many young artists seeking recognition in a highly competitive field, the Académie Julian offered the prospect of a successful career.

Blumenschein's days in Paris soon fell into a regular pattern, mixing studio time and leisure time. Although no set course of classes was required at Julian's, all students were expected to pass through a natural progression. Before moving on to life studies with a model, a novice student drew from plaster casts of the human figure. And during their first year of study, newcomers to the school, called "nouveaus," were expected to act the part by performing such class chores as sweeping the studio, bringing in water, lighting the big coal stove, and even paying for refreshments for the class. The nouveau was also expected to submit with good humor to such boisterous initiation rites as being tied to a ladder and paraded through nearby streets.

Blumenschein managed to go through his first year without being unduly affected by these hallowed traditions, despite their sometimes callous disregard for individual dignity. He began his weekdays early, walking to the Latin Quarter studio, finding the closest place possible to the cast or model, and then getting in contact with his class instructor. He managed to keep his mind on his work even as

heavy-handed practical jokes periodically disrupted the class and the seemingly unending teasing and taunting went on among his fellow students. A studio class usually remained in session all morning, then resumed after a short midday break, continuing until late afternoon, when students began drifting away in small groups to meet at sidewalk cafes, where they discussed art and life in vehemently opinionated terms. Their dialogues at these cafes were made more enjoyable and more passionate by the glasses of wine and beer the students consumed.

Twice each week Blumenschein submitted his work for evaluation. If he did well, his work might be chosen for inclusion in a monthly competition, the winner of which was awarded a medal and one hundred francs. Blumenschein won three times, two for drawing nudes, one of which is pictured on page 24 in Peter H. Hassrick and Elizabeth J. Cunningham's art book on Blumenschein, *In Contemporary Rhythm*. He was struck by the fact that there was "no race feeling of any kind. A man of talent was respected." Objectivity prevailed in the judging, and prizes were given solely on the basis of merit to "German, Turk, Spaniard, Frenchman and American." The visiting artist-professors were also fair when judging the separate competitions they initiated to spur their students to do well. Each week a composition subject was assigned to the class, and each Saturday morning all entries were judged, with the winner given the valued privilege of choosing where to place his easel in the crowded studio.

Left to his own devices during evenings and on weekends, Blumenschein found ways to satisfy both his love of competitive games and his inevitable yearning to speak and hear his own language. Although he rapidly mastered the French phrases needed for survival, he naturally gravitated toward English speakers as his social life evolved. He found it surprisingly easy to find Americans and Englishmen with whom to associate, including the other five Americans who

had enrolled at Julian's on the Rue de Dragon when he did. American artists had been studying in Paris for years, the first important one being John Vanderlyn, who in the final years of the eighteenth century chose Paris over London for his studies abroad. Paris also abounded with traveling Americans during the 1890s, as a growing number of wealthy families had resources for extended European visits. Blumenschein soon located groups of Americans for regular bridge games, and he joined a tennis club, steadily improving his skills by playing every Sunday morning.

Americans from his hometown did not forget their talented native son. After arriving in Paris during a business trip for the National Cash Register Company, Henry Theobold of Dayton promptly looked up young Blumenschein and was graciously given a tour of the Académie Julian thorough enough to momentarily shock the earnestly main street American out of his middle-class complacency. Already Blumenschein was adding to the luster of the Blumenschein name. After his father was praised in a June 1895 *Cincinnati Enquirer* article for his longtime leadership of the Dayton Philharmonic Society, Blumenschein took center stage in an 1896 *Dayton Journal* article, in which he was lauded for his ambition and accomplishments in Paris. The newspaper also printed a letter written on May 14, 1896, by Dayton resident L. B. Gunkel, who had seen Blumenschein and viewed his artwork while visiting Paris. Gunkel praised Blumenschein as well as Ernest's boyhood friend George Compton, who was studying architecture in Paris.

Blumenschein was not immune to the charms of the French or American female populations. Outings in the glorious city with young women he met through art or at the American clubs were very much a part of his social activities; in later years he humorously recalled one date with a very tall girl, which included the satisfaction of kissing her from an advantageous height because he was standing on a tombstone in an old graveyard. For all his youth and vigor,

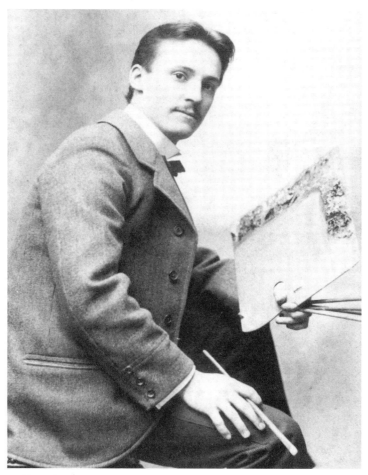

In his early twenties, Ernest Blumenschein, holding a paintbrush in one hand and a small easel in the other, looks relaxed as an art student in 1895, near the beginning of his long career as an accomplished painter. Helen Blumenschein Collection, Palace of the Governors Photo Archives, Santa Fe (NMHM/DCA), HP.2005.25.M.

however, Blumenschein's single-mindedness about his art contributed to a pervasive wariness about the dangers of female enticements. He viewed with particular alarm what he saw as the somewhat cynical willingness of the French to provide female companionship for vulnerable American art students. His strong opinions about this can be found in the Blumenschein Papers, housed in the Archives of American Art at the Smithsonian:

> [The] wise French thought that they had solved one of a young man's troubles by furnishing 'grisettes,' quite simply young women who would live with students for board, room and entertainments. . . . The American boys could find no happy medium. When one left school with a French girl on his arm, he practically gave up work for that winter. . . . At least half of the Americans fell for the girls: and that was the happy student days for them. The other half studied seriously and benefited by the great education France could give.

On the other hand, Blumenschein showed himself to be no prude when it came to student antics that intermixed outrageous satire with obstreperous partying. Notwithstanding his own admiration for Salon-endorsed painting styles, Blumenschein joined his fellow students in their annual street festival, a celebration that openly mocked the pretensions of Salon exhibitors. Students acted out famous paintings, often chosen for their inclusion of nudes, by using studio models or themselves as stand-ins for the figures in the paintings. Although the artists were often arrested by local police, the public thoroughly enjoyed the spirited parade, which was followed by an evening dance for the artists and their friends. Blumenschein made sketches of the 1896 student festival, which were published by *Harper's Weekly*, along with his written comments on the affair.

Nevertheless, the key difference between Blumenschein and many of his fellow students remained intact: he wanted to learn from the traditionalists in order to emulate them,

not repudiate them. The instructors with whom he chose to study were among the more conservative of the artist-teachers at the Académie Julian, and Blumenschein was one of the relatively few Julian students to openly aspire to participation in the official annual Salon. His primary instructors were Benjamin-Constant and Jean-Paul Laurens, both of whom had won commercial success and were regular Salon exhibitors. These two highly regarded tutors most influenced Blumenschein's subsequent painting style.

Jean-Joseph Benjamin-Constant (1845–1902) achieved his early success with large paintings of heroic historical events. He later became a widely acclaimed portraitist, and in the 1880s he painted commissioned portraits of members of the French aristocracy and the British royal family, including Queen Victoria and Queen Alexandra. He also became attracted to exotic subject matter, as did many academic painters of the time, and he often showed paintings in the Salon depicting dramatic scenes of Arab life. Indeed, Benjamin-Constant was one of the French Orientalists, along with such artists as Eugène Delacroix, whose interest in Arab exotica would later have a direct influence on Blumenschein's fascination with the exotic nature of the Taos Pueblo Indians and the adobe buildings of the Taos area, particularly as they are embodied in his 1916 painting *Church of Ranchos de Taos*. With the encouragement of Benjamin-Constant, said Blumenschein, he "became intrigued with Indian subjects. Read Fenimore Cooper—was enthralled with 'Last of Mohicans.'"

But Benjamin-Constant's influence on Blumenschein was strongest in the realm of portraiture. Under the tutelage of the great portraitist, Blumenschein acquired skills in figure and facial depiction that led to his own superior ability in the portrait genre. The renowned Benjamin-Constant, famous for his love affairs almost as much as for his art, was a target of criticism from some quarters in the mid-1890s. He was included by one critic in a list of those not expected

"to give us anything new. Their art is always the same, as far removed from life as it is from dreamland . . . an art steeped in antiquated conventionalities."

Jean-Paul Laurens (1838–1921) began his rapid ascent in French art with a successful debut at the Salon of 1863. A prominent member of the French Academy, he was made a chevalier in the Legion of Honor in 1874. In addition to his prolific production of grandiose historical paintings, he painted several large murals for public buildings, including dramatic works for the Panthéon and the Hôtel de Ville. Many of his paintings depicted events that involved battles, violence, and death, and he was acclaimed for the anatomical accuracy with which he portrayed human figures and animals. His paintings usually bore a message that went beyond their immediate subject, to interpret national histories and institutions. For example, the power of the Roman Catholic Church was represented in his well-known painting *The Men of the Holy Office*. It depicts a scene from the Inquisition, which had become especially controversial in the nineteenth century as a result of the anticlericalism bred by the French Revolution. Many of his works were popularized in widely distributed prints.

While Lauren's status was unassailable in the 1880s, by the mid-1890s, he, like Benjamin-Constant, was beginning to feel the sting of competing art styles; indeed, one critic dared to deride him for "his everlasting fondness for bric-a-brac." The influence of Laurens on Blumenschein's development was subtle but powerful. From Laurens, Blumenschein not only learned craft techniques for realistic representation, but more important, he absorbed the concept of designing a painting from the vantage point of a preconceived idea or theme believed by the artist to contain a truth, be it about a historical event or era, such as the Inquisition, or about a people and their culture.

Monsieur Rodolphe Julian, ever the hands-on administrator, never hesitated to act as a personal adviser to stu-

dents in his many studios. On more than one occasion, he advised certain favored young painters not to enter the Salon on the Champs Élysées until the quality of their work was high enough to ensure a positive response. The major audience for these aspiring artists included art critics, gallery owners, and collectors, whose opinions could determine a painter's rise or fall in the art world. Blumenschein seems to have escaped Julian's notice, for there is no evidence that he received any advice one way or the other, even as the ambitious young American was feverishly working on two paintings he intended to submit for exhibit in the annual Salon of 1896.

So determined was Blumenschein to make the best showing possible that he put the finishing touches on the second of his paintings barely in time to meet the entry deadline. To his immense pleasure, both works were accepted and, along with some two thousand other paintings, given a place on the walls of the Palace of Industry when the show opened in the first week of May. One Blumenschein painting was a traditional landscape done in watercolor and titled *The Lake*. The other, a more ambitious painting that had required work to the last moment, was titled *The Flute Player*. Done in oil, *The Flute Player* shows a pensive musician sitting at a table on which music sheets are propped against books stacked one on top of another. The shadowed scene, done in rich dark tones, is illuminated by candlelight. The wall behind the flute player holds paintings whose rectangular shapes provide a balancing counterpoint for the compositional lines of the seated figure.

The Flute Player can be considered Blumenschein's first significant major painting. The theme of music may indicate not only the ongoing influence of Blumenschein's musical background and his psychological allegiance to his musician father, but also Blumenschein's natural affinity for the notion of music as a pathway into the realm of soulful, introspective reverie. The painting has the feel of romantic

realism, but whether its subject is American or European is indeterminate. It is vaguely reminiscent of other paintings of the era; it could even have been an illustration for a story, as it seems to bear an unspoken narrative. It is not marked by the stamp of artistic individuality, but it is clearly a competent and visually attractive painting; indeed, *The Flute Player* was favorably received by viewers of the Salon exhibit. The *Herald* newspaper of Dayton, Ohio, took note of the artist's success:

> We are surprised and delighted to find that two of the pictures accepted and exhibited in the Salon of 1896 were the work of a Dayton boy, Mr. Ernest Blumenschein. When you consider that this is an exhibition by French artists, who are prejudiced against foreigners, and that of the works offered even by French artists, not one in ten is accepted, you will appreciate the honor conferred on a young and unknown American.

If the Paris art scene of the 1890s reveals any overall truth about the art world in general, it may be simply that any era has famous artists and important artists, and the two categories are not always embodied in the same artist. Paris had its famous artists, and Paris had its important artists, but only rarely did the most famous prove over time to be the most historically important. The individuality yet lacking in Blumenschein's work was in many ways similarly lacking in the paintings of some of the most well-paid and well-known Paris artists. In fact, originality, fresh insight, and a unique perspective were often found precisely in the paintings of the near-obscure, underpaid, and undershown impressionists, post-impressionists, nabis, symbolists, and others among Paris's tradition-defying, antiestablishment artist community.

Among those whose fame did not endure was E. A. Carolus-Duran, who in the mid-1890s was at the height of his long career as an academic painter of portraits and works

for museums. John Singer Sargent studied with Carolus-Duran and painted a portrait of him in 1879. Carolus-Duran's large studio was one of the finest in Paris, crowded with paintings, many in heavy frames ready for eager buyers for whom owning a Carolus-Duran was a status symbol. The open house he held one morning each week was always an elegant social occasion looked forward to by art patrons from France and elsewhere. Along with Benjamin-Constant, Laurens, Pierre Puvis de Chavannes, and a few others, the learned and luxury-loving Carolus-Duran belonged to that small circle of Parisian artists whose careers blazed with success but whose status dimmed posthumously.

Perhaps the wealthiest and most successful of this elite few was Jean Louis Ernest Meissonier, whose imposing studio was located in the affluent area northeast of the Arc de Triomphe. Within his architecturally classical studio domain, the meticulous, historical-minded Salon painter retained many of his paintings in order to increase market demand by limiting the supply. Meissonier did numerous preparatory studies for each of his detailed, highly finished works, and he is known to have destroyed even completed works by cutting them up with a knife if he believed they fell short of his standards. "He was the most famous artist of his day," according to art historian John Milner. "Within a hundred years of his death his reputation has evaporated almost entirely."

The nonacademic painters of the 1890s, working in a diverse range of styles, were as meticulous in design as a Meissonier but bent on blazing new aesthetic trails rather than meeting public expectations. For public exposure they depended more on such innovative galleries as Goupil & Cie, which employed Vincent van Gogh's brother Theo, than on a Salon exhibition. Moreover, their work was characterized by constant interaction between new ideas and established conventions. Degas, after studying at the École des

Beaux-Arts, adopted the impressionist commitment to portrayal of contemporary life, while retaining his commitment to many of the stylistic methods of the academic school. Cézanne, Gauguin, van Gogh, and Seurat broke more sharply from previous tradition, and their work paved the way for the two great art styles of modernism: expressionism and abstractionism. Georges Seurat, who died in 1891 at the age of thirty-one during a severe outbreak of diphtheria, fused his knowledge of optics and color chemistry with a painting style in which he juxtaposed dots and flicks of color to produce light-filled paintings. These were a new synthesis of impressionist purposes and traditional composition. In 1894 Gauguin briefly took a studio in Montparnasse after returning from Tahiti and forged ahead in his quest for a new relationship between the painted canvas and the objective world it represents.

Blumenschein is likely to have been aware of Gauguin's galvanizing presence in the city because another studio in the same house was occupied by the son of Jean-Paul Laurens. Pierre-Auguste Renoir, Gustave Moreu, and Pissarro were also painting in Paris during the time Blumenschein was studying at the Académie Julian. In Montmartre, a popular gathering place even for artists whose studios were located elsewhere, Blumenschein could have seen Henri de Toulouse-Lautrec (1864–1901) painting in the streets or at the Moulin Rouge at almost any hour of the day or night. When he died at the age of thirty-six, Toulouse-Lautrec had completed 737 paintings, 5,084 drawings, 300 prints, and 275 watercolors. Of all these prominent artists, Blumenschein would most likely have known the sculptor and painter Emile Antoine Bourdelle, who lived in his neighborhood in the Latin Quarter.

Blumenschein seems to have been surprisingly inattentive to these forces of artistic renewal. He virtually ignored many of the new art influences. This was certainly due in

part to the daily pressures of student life and his preference for the traditionalists, but he was also greatly influenced by a small group of friends, who were becoming increasingly committed to a new artistic purpose for their craft. They were not especially concerned with individuality or originality of style. These Americans in Paris were content for the most part with maintaining what they considered to be the universally valid classical art principles. But they were very much concerned with the originality and relevance of subject matter.

The notion that American art must make a statement separate from and beyond that of European art reflected an idea taking hold throughout the American art world; it was, in art historian E. P. Richardson's opinion, a backlash reaction to the fact that "the conspicuous effort from 1875 to 1900 had been to link our painting with that of Europe, and to make American talents part of [the] international life of art." Just as the training Blumenschein received in Paris affected the future style of his art, the friendships he formed there affected both the direction his life would take and the subject matter with which he would ultimately make his own art statement.

In fact, the subject matter these young Americans chose in realizing a uniquely American art provides a clue to why they adhered, for the time being at least, to the academic school of painting. They believed that American art would achieve its full potential only when the uniquely American realities of the West were fully explored by the nation's painters. They saw the American Indian as a key component in an aesthetic context that combined ecological and historical elements. And clearly, painting Indians as individuals or in groups would require mastery of portraiture skills and other skills directly related to the work of placing the human figure at the center of viewer attention. The academic school emphasized these skills. In both impressionist and

post-impressionist styles, the focus was more amorphous, on not just one but several elements being depicted, including landscape, climate, light, atmosphere, and emotion.

Some of Blumenschein's new friends, like Bert Geer Phillips, Joseph Henry Sharp, and Eanger Irving Couse, became longtime colleagues. Blumenschein first met the twenty-six-year-old Phillips in late 1894 (or perhaps early 1895), shortly after Bert arrived in Paris following a seven-month stay in England, during which he had painted, traveled, and enjoyed the hospitality of several wealthy families. Once in the French capital, he enrolled at the Académie Julian, where he joined the studio classes being taught by Laurens and Benjamin-Constant. It was easy to like the unassuming, open-minded, enthusiastic, and engagingly direct Phillips. Blumenschein liked him enough to begin spending many hours of leisure time with him, as they discussed painting and their goals for their art futures. Their friendship was cemented by the discovery that both "were more interested in the American Indian than in the French subjects that were so popular in those days," recalled Phillips in later years.

Although neither Blumenschein nor Phillips had been to the American West, and neither had had any substantive contacts with Indians, Phillips had been interested in the West and American Indian tribes far longer than Blumenschein. Growing up in the Hudson River Valley as the son of an architect, Phillips was strongly influenced by the books of James Fenimore Cooper and by stories about the great Indian scout Kit Carson. His boyhood reading engendered within him a yearning for adventure, yet he also became convinced that, despite his father's wishes, he wanted to be an artist rather than an architect. In 1884, at the age of sixteen, he went to New York and studied at both the Art Students League and the National Academy of Design. In 1889 he returned to his hometown, Hudson, where he painted until he left for England in 1894. His work often showed scenes

of village and pastoral life. Phillips was clearly already drawn to nonurban, preindustrial subject matter.

At thirty-six, Joseph Henry Sharp was an established painter and teacher when he came to Paris to study and paint in 1895. Although Blumenschein no doubt remembered him as a respected instructor at the Cincinnati Art Academy, he and Phillips both welcomed the opportunity to expand their horizons by learning from the more experienced Sharp, who had painted Natives of numerous tribes during his travels throughout the American West. Mutual interests and compatible personalities rapidly resulted in a close friendship among the three, with Sharp, known as Henry to his friends, exerting an influence on his colleagues that none of them could have then foreseen. Sharp possessed a strength of character forged during his difficult early years. Born in rural Ohio in 1859, his father died when he was twelve years old, and two years later the young Sharp came close to drowning after a fall from a high bridge. The accident left him totally deaf for the rest of his life. Sent to live with an aunt in Cincinnati, he learned to lip-read, keeping a pencil and pad by his side to be even more communicative. As he pursued a life in art, which was all he had ever wanted, he came to regard his deafness as an advantage; it enabled him to increase his concentration while keeping outside distractions to a minimum. He attended the Cincinnati Art Academy, studied in Belgium and at the Académie Julian in Paris in 1881 and 1882, painted American Indians in New Mexico, California, and the Northwest in 1883, studied in Munich in 1886, and then traveled through Italy and Spain with Frank Duveneck. After returning to the United States, he began teaching at the Cincinnati Art Academy in 1890, and in 1892 he married Addie Byram, a young woman of singular devotion, ready to follow wherever his art took him.

One of Sharp's idols was Henry Farny, whose studio was in the same building as Sharp's. Sharp often sought advice

from him about the best locations for painting American Indians, and it may have been Farny who suggested that the young painter would find rich material at the Taos Pueblo in northern New Mexico. Such seemingly kind advice might have actually been motivated by Farny's feeling he had a proprietary claim on the northern Plains Indians; he did not relish the prospect of a competitor in his chosen arena.

In 1893 Sharp arranged a painting trip with fellow artist John Hauser. After reaching Santa Fe, capital of the Territory of New Mexico, the two traveled north by horse-drawn wagon along the western side of the Rio Grande, then turned east across the river canyon and proceeded to Taos. Sharp knew immediately that he had found a place of enormous artistic potential. Remaining in Taos for most of the summer, he completed illustration commissions for *Harper's Weekly* and *Brush and Pencil*. His important painting *The Harvest Dance* was published in *Harper's* October 14 issue, becoming the first widely distributed view of the Taos Pueblo.

Sharp also wrote articles to accompany his illustrations. At the end of the summer he concluded, with some justification, that the Pueblo Indian culture was likely to endure longer than the rapidly vanishing Plains Indian culture. He decided to study further in Europe, then spend several years recording traditional tribal life on the Great Plains of North America before that way of life disappeared forever. Soon after Sharp arrived in Paris in 1895, Duveneck expressed his affectionate respect for him by painting *Portrait of Joseph H. Sharp*.

Yet another American of similar inclinations joined the Paris circle when Eanger Irving Couse, a thirty-year-old native of Michigan with a long-standing interest in western subject matter, arrived in Paris in early 1896. During his childhood in the remote reaches of lumber-producing Michigan, Couse had come into contact with Chippewas or Ojibwas and had taken with him a subsequent fascina-

tion with Indian culture when he went first to the Chicago Art Institute and then to the National Academy of Design in New York. He studied in Paris in 1887, and in 1891 he married art student Virginia Walker, daughter of a ranching family in the Washington State, thus strengthening his interest in the American West. Couse and his wife traveled and painted in Europe in the early 1890s, and in 1894 their son Kibbey was born in a French coastal village. After reaching Paris in 1896 and meeting Sharp, Blumenschein, and Phillips at the Académie Julian, Couse proved to be particularly receptive to the message about the future of American art coming from his new friends.

Enjoying leisurely meals in the cafes of Paris, or walking in spacious public gardens, Blumenschein, Phillips, and Sharp engaged in an easygoing, informal dialogue that touched now and again on the tantalizing open-ended issue of whether there was or should be an identifiably American art. The tenor of their talks was that if there was no style or subject matter in American art, there ought to be, and somehow their own futures should be bound up with a movement toward its development. In a period rife with resurgent ethnic nationalism and nation-state rivalries, Blumenschein and his friends were not alone in their interest in the relationship between a nation and its art.

In the United States, few of the Paris-trained artists had become great painters, while the accomplishments of Thomas Cole, Winslow Homer, and Thomas Eakins grew largely out of their personalized interpretations of their native country. In Munich the motivation for several secessions from the academic school of German painting was a desire to reduce the influence of foreign, mainly French, ideas on German art. Throughout the 1890s, in fact, the issue of whether the art produced in any given country had any relationship to the national characteristics of its people was the subject of discussion and controversy among many intellectuals. And beyond the question of whether there

was an identifiable French novel, or American novel, or a category of German painting uniting all styles produced in Germany no matter how different, there was that one vital, often divisive issue: should artists concern themselves with representing their nation, or should they rise above all personal identification in a common striving to embody truth in aesthetic form?

In a story titled "Collaboration," published in 1891, Henry James dealt with the issue in its starkest terms. His two protagonists speak for opposing sides in the debate over universal art versus national art. A young French poet and a German composer discover that each admires and respects the work of the other, bringing denunciation on the Frenchman from his fiancée's mother, whose husband had been killed in the Franco-Prussian War. The German composer is similarly vilified by his stepbrother, who withdraws a financial subsidy after the Frenchman and German decide to work together on an opera. In the end, knowing their collaboration as librettist and composer will advance the career of neither, the two are creating their opera convinced that "in art there are no countries." At the very time James was writing this tale, his fellow American, the critic, novelist, and editor William Dean Howells, was playing a strong role in "endeavoring to sever American fiction from the tradition of England" so that a uniquely American novelistic voice would be found. Clearly, there was no consensus on the role of art in a nation's life.

When Sharp, Phillips, Blumenschein, and eventually Couse spoke of art and their country, they were hardly dealing with the broadest philosophical implications of such a subject. But they were, at the very least, groping for a way to make their own art part of a new kind of independence for American painters. What they seemed to implicitly endorse was a vision combining supranational art-craft principles and nation-oriented subject matter and interpreta-

tion. The contribution of Sharp was to give specificity to the idea. He provided firsthand information about places and people possessing aesthetic and historical relevance for artists. Through the eyes of Sharp, an avid reader of American history who took careful notes when observing Native customs, the younger painters began to see American Indians as individuals belonging to discrete groupings with distinctive cultures.

As early as spring 1895, Sharp began telling the others about an especially memorable Indian people, the Tiwa speakers of the Taos Pueblo. Sitting with Blumenschein and Phillips in a coffee house in Montmartre one rainy afternoon, Sharp described in glowing detail his memories of Taos. He told of its historical origins, the magnificent high mountain valley in which the pueblo lay nestled, and the rituals and religious beliefs of the stoically independent Indians of the pueblo. Recalling the occasion, Blumenschein said Sharp told him that if he "should ever go West," he "should not fail to visit Taos." Sharp "told me of his visits to different tribes," said Blumenschein, but the description of Taos Pueblo somehow stood out from all the others. Unlike the Plains tribes, the Taos Indians had created a viable sedentary community; had coexisted with Spanish, Mexican, and American governments without losing their identity; and seemed far different from the stereotypical nomadic Indian raiders wearing feathered war bonnets.

In fall 1896 it was time for Blumenschein to end the Paris studies made possible by his father's financial support and begin earning his own way as a working illustrator. He and Phillips both booked passage to America, aware that each of them would be seeking to establish a career in New York upon their return to American shores. Sharp and Couse remained in Paris for several months, after which Sharp made a painting trip through Italy with Duveneck before returning to Cincinnati in 1897. Blumenschein had no plans to

"go West." Ambitious and realistic, he was ready and in fact eager to put to use the art training he had just received. But he was simultaneously a dreamer and a man of ideals, and, as he later noted, that place in northern New Mexico that had "a strange name" was not entirely forgotten.

4

Putting Purpose to Work, 1897–1898

If Blumenschein had any lingering nostalgia for Paris, it was quickly dispelled by the relentlessly assertive reality of New York, a physical and cultural entity that exerted a peculiarly magnetic hold on all who came within its field of force. If Paris could seem to be the center of the universe, New York insisted it was. If Paris was considered the most feminine of great cities, with its refined sensibilities and nuanced charms, New York was the ultimate in masculine feel; it was a tall, strong, increasingly aggressive metropolis, drawing movers and shakers in business, politics, and the arts into its expanding orbit. With a population nearing 3.5 million, and serving as the nation's gateway for 1 million immigrants each year, greater New York was notable above all else for its driving energy. Its magnetism manifested itself in a pulsating sense of movement. Its residents were ceaselessly determined to survive, to outdo, to make money, to start new enterprises, to form alliances, to gain influence and power, and to hold a place in the dynamic social spectrum. The city was a kaleidoscope of economic, ethnic, and political groups engaged in endless, ritualized conflict.

For all of that, it remained a livable city, one where the social niceties of the Victorian era were sufficiently intact to allow for a modicum of civility. Between the extremes of the West Side mansions and the ninety thousand humble

tenements of the East Side could be found countless neigh-
borhoods of genteel middle-class propriety. In one of the
more modest of these quiet enclaves, Blumenschein and
Phillips found a suitably affordable studio apartment after
deciding to pool their resources and share living quarters.
The American Art Annual of 1898 shows the artists' ad-
dress as 120 West 50th Street in Manhattan, close to Cen-
tral Park, where designer Frederick Law Olmsted had cre-
ated an oasis of green, expressing the philosophical belief
that nature could be brought into a beneficial state of do-
mesticated harmony with urban society.

The late 1890s were a propitious time for a young artist
to enter the field of illustration. For the nation as a whole,
the presidential election of 1896, though it had brought
the country perilously close to outright class warfare, had
a calming effect after Republican William McKinley won
decisively over the free-silver advocate, Democrat William
Jennings Bryan. The election results had shown that most
Americans believed that the free coinage of silver would
cause unsustainable inflation. With the gold standard firmly
in place, the last years of the century were characterized
by optimism and conservatism, bringing a corollary growth
and profitability for the nation's commercial sector. The
publishing industry was among the beneficiaries of the
restored viability of middle-class prospects. Magazines in
particular not only flourished but played an important role
in disseminating national (as opposed to regional) values,
ideas, and information to a public that without these na-
tional magazines would have been dependent primarily on
local newspapers.

Blumenschein had been right in believing that art study
at the Académie Julian would enhance his prospects for suc-
cess in the United States. Within days of his return to New
York in fall 1896, he obtained an illustration commission
from *McClure's*. Then commissions to illustrate both maga-
zines and books came with such frequency and regularity in

the ensuing years that sometimes he could not accept them all because of his heavy workload. In later years, Blumenschein expressed pride in his success being both immediate and lasting: the "commissions given me to illustrate for the first class magazines of *Scribner's, Harper's, Century* and *McClure's* . . . continued until I was forty."

As the artist's reputation grew, he became one of a number of sought-after illustrators whose work was used for the stories and novels of leading literary figures. In September 1897, he created two of eight illustrations for Rudyard Kipling's novel *The Day's Work*, published by Doubleday and McClure Company. Although his earnings did not place him in the top tier of famous illustrators, Blumenschein had, even as early as 1899, an income from illustration work that far exceeded that of the average American wage earner. His art was considered by *Harper's Weekly* to be worthy of publication in independent form rather than accompanying text on at least three separate occasions. Blumenschein also allowed *The Flute Player* to be used for a story published in the *Illustrated American*.

The years between 1890 and 1920 were the golden era of American illustration in the form of drawings and paintings. Photography, invented in the 1840s, was an expensive and laborious process, rendering it impractical for illustrating books, magazines, and newspapers. The invention of photoengraving, on the other hand, proved highly suitable as a mechanical process for reproducing artwork. It was in wide use by 1900. Photoengraving replaced the wood engraving process and enabled the rapid development of illustration as a field because now there was no limit to the number of high-quality reproductions that could be affordably published.

An illustrator was considered to have arrived at the peak of his career if he worked for the four most important magazines, *Century, Harper's, McClure's,* and *Scribner's.* Also prestigious were *Atlantic Monthly, Saturday Evening Post,*

Collier's, and *Ladies' Home Journal*. The best magazines operated under the premise that they were purveyors of the finest literature and art. Advertising was limited to the front and back pages of each issue. The artists who worked as illustrators for these magazines were respected and accepted into the art establishment. Among those who went on to achieve success as independent artists were Winslow Homer, William Glackens, John Sloan, Everett Shinn, and Blumenschein.

In most cases the relationship between illustrator and publisher was cordial and cooperative. "When your drawings were accepted," Blumenschein once wrote, "you went to the cashier and got your money at once in cash by check." Magazine editors set the guidelines for a commission but gave few specific directions, allowing maximum artistic freedom for their illustrators. Howard Pyle, who died in 1911, may have been America's greatest illustrator. He wrote, drew, and painted prolifically as well as being a dedicated teacher. He founded his own school at Chadd's Ford, Pennsylvania, and one of his foremost pupils, N. C. Wyeth (1882–1945), became a leading illustrator in his own right and the patriarch of a family of noted American painters.

Charles Dana Gibson (1867–1944) was perhaps the most famous and best-paid illustrator, noted for his pen-and-ink renderings of beautiful women. In 1904 *Collier's* gave him a $100,000 contract for one hundred illustrations over four years. Frederic Remington (1861–1909) studied briefly at Yale before going to the West to paint. In 1898 he was a war correspondent in Cuba and painted the *Charge of the Rough Riders at San Juan Hill*. He was a friend of Theodore Roosevelt and illustrated several of his books. In great demand as an illustrator, Remington was notable for his fine and accurate portrayals of horses. Another illustrator of renown, James Montgomery Flagg (1877–1960), made an impact during World War I with his famous poster of Uncle Sam pointing and saying "I Want You," for which Flagg

used himself as the model. In the postwar years of the early 1920s, however, the era of great illustrations came to an end as cameras became portable and printing photographs became easier.

Blumenschein and Phillips can hardly be expected to have foreseen the demise of illustration as a lucrative career. They certainly gave no hint that they saw it coming. Even as they happily accepted commissions, however, both instinctively made conscious efforts to further their skills as fine-art painters. Using every spare moment, they worked on their own paintings, which were at various stages of progress on easels set up in their studio. But it was not the skyline or waterfront of New York, or the elegant crowds in Central Park, or the gritty charm of the colorful immigrant neighborhoods that drew their eyes, as compelling as these subjects were to many of their fellow artists. No, for these two Paris-trained painters, neither French scenes nor American East Coast scenes elicited a deep response. American Indians were in their heads, and the American West occupied their artistic imaginations.

But painting Indians proved easier to talk about than do while living thousands of miles away from the West. When artists heard about Indians living hand-to-mouth in New York as former members of Buffalo Bill's hugely successful Wild West Show, they thought they had a solution to their problem; they promptly hired a few as models. But even with the aid of a full set of Indian regalia, which one of their models helpfully arranged for them to buy, it fast became clear that the pictures done in their studio of unhappy Indians far from their natural surroundings looked as artificial as they in fact were. Blumenschein and Phillips acknowledged to themselves that the paintings were a failure. "We knew that we must seek . . . [our] material in the real West," wrote Phillips when he told the story of these early years.

In late 1894, one year and three months after beginning his career as an illustrator, Blumenschein accepted a

McClure's commission that required travel more extensive than any he had yet undertaken on assignment. That he welcomed the commission is not in doubt, for the story he was to illustrate took place in the West and he eagerly anticipated replacing an imagined realm with an experienced reality. His destination was the Pima Indian Reservation in southern Arizona. In his own words, with train tickets and suitcase in hand, he "started just before Xmas. Arrived Fort Wingate, N.M.," where part of the Navajo Reservation was established in 1868, on "Jan. 2, 1898 via Santa Fe Railway. Introduction to New Mexico that day in blizzard. Temperature near 0—snow wasn't deep. Porter forgot to call—few people get off there."

Blumenschein's humorous reminiscences, the notes for which are housed at the Smithsonian, described those obstacles he encountered when he finally reached his destination. First he went to the fort:

> 3 miles away—letter of introduction to low officer who was so gruff that it scared the life out of me. Was assigned to eat in Officers Mess. But ate in kitchen for two weeks by mistake. Saw first Indians [Navajos], aside from Buffalo Bill Show, around the fort. During these two weeks was taken to a Navajo Medicine Ceremony—first Indian dance. Was greatly impressed with magnificence of scenery and picturesqueness of Navajos.

After traveling on to Arizona, Blumenschein found that "Pima didn't appeal as much as New Mexico Indians."

Back in New York by late January, Blumenschein went on with the work of fulfilling commissions and making arrangements for new ones. But when he and Phillips found time to talk, they returned again and again to an idea Blumenschein had proposed almost immediately after his return from Arizona. He wanted to plan a painting trip to the West that very summer, just five months away, and he wanted Phillips to join him. Phillips had not become enamored of the illustration life. He had not adapted as readily as had Blumen-

schein to commercial art and its inherent limitations. And he seemed not to have felt the need to prove to his family that art could be a financially successful venture.

For Blumenschein, of course, proving the viability of art as a career choice, even if that entailed commercial illustration, was a desired outcome, notwithstanding the fact that fine-art painting was his ultimate goal. Because Phillips was already more of a maverick than he was, Blumenschein encountered little resistance when he suggested several months of painting in total freedom, traveling along the eastern side of the Rocky Mountains from Colorado south through New Mexico and into Mexico. With surprising ease, said Blumenschein, "I induced Bert Phillips to save his money and accompany me the following summer."

Blumenschein said he had been "filled with enthusiasm about New Mexico," and no doubt he infected Phillips with some of his excitement. Life took on added zest for the two as they began to prepare for their great adventure. In April 1898, however, before they could leave, Blumenschein was asked by *McClure's* "to illustrate a story by William Allen White layed [*sic*] in Western Kansas." The magazine editor wanted him to interview White. So in May Blumenschein went to Emporia, Kansas, and discussed the story with the well-known author and small-town newspaperman, who told him it concerned "a county seat war and theft of court house." White and Blumenschein took a train to Liberal, Kansas, "the end of the road," and from there Blumenschein went on to Dodge City, famed as the terminal point for cattle drives and its history of frontier violence. As it happened "neither the story or illustrations were used," but for Blumenschein the trip led to "a life long friendship with W. A. White" and gave him fresh insight into the nation's period of westward expansion.

By the end of the nineteenth century, the American West was no longer virgin or frontier territory, no longer unsettled or unspoiled. Since the early years of the century, it had

been the subject of exploratory and scientific expeditions, government reports and surveys, and a substantial body of interpretive literature and art. American perceptions of the West were the result of the broadly blended cumulative messages from the lands west of the Mississippi. Yet the content of these messages had been shaped in part by what Americans east of the Mississippi wanted to hear and believe. Being artists did not in any way make Blumenschein and Phillips less susceptible to the same preconceived, less-than-objective notions held by most Americans. They carried these with them as they prepared to trod what for them was new physical and artistic ground.

Paintings of the West, whether their subject was the landscape, the Natives, or the settlers who advanced the frontier, had been no less influenced by a shifting set of ideological imperatives than other categories of information transmitted over time. Although portraiture was predominant during the colonial period, for example, a natural preoccupation with accurately recording geographical elements and native flora and fauna motivated much of the landscape art done during this time. This topographical imperative gave way during the federal period to a romanticization of the American environment. But as artists began to penetrate the nation's interior, many of them traveling with official expeditions, they moved between both impetuses. Some were compelled by a desire to record the physical environment, and by the nineteenth century, many were driven to idealize, generalize, and aggrandize their perceptions of the frontier environment. Both tendencies were an artistic response to public demand; people wanted to know what the West looked like, but they also wanted to elevate the American landscape to spiritual levels with national meaning.

Art depicting American Indians moved from relatively objective renderings in the 1830s and 1840s to a generalized portrayal of tribal society as primitive, savage, threatening, and ultimately doomed for extinction by the post–Civil

War era. This change of attitude became more pronounced as westward migration increased dramatically and resulted in confrontation with Indians in control of land the pioneers desired for settlement. Working with western subject matter in the pre–Civil War years, George Catlin, Karl Bodmer, and Alfred Jacob Miller provided an invaluable record of Natives as individuals, exhibiting specific racial and cultural characteristics. Catlin, who first saw American Indians in Philadelphia in the 1820s and later made the Natives of the West his life's work, was, in the words of art historian E. P. Richardson, "too hurried and careless in his observation" to fully achieve the authenticity he sought. But his work came closer to conceptual integrity than that of many painters who followed him.

To the detriment of painting the real West, the successors to Catlin included numerous artists who painted the ostensible West while working in East Coast studios. Even among those artists who did their work as resident westerners, most notably George Caleb Bingham, Charles Russell, and Charles Nahl, the impulse to respond to viewer approval of pictorial conventions that bolstered an idealized historical construct of the region remained strong. The heroic aspects of plowing and mining the lands of the West were emphasized. The bravery, adventurism, and sheer drama of cowboys, gunfighters, and the U.S. Cavalry were colorfully exaggerated. Similarly distorted, but this time with negative connotations, were the tribal traditions and fighting tactics of the American Indians. Taken together, the paintings of the West yielded a composite picture of a resourceful, confident American people extending to the western half of their vast continental nation the benefits of a civilization superior in every way to the untamed land and primitive culture that already existed there.

Occasionally, voices were raised to dissent from the notion that the settlement and gradual industrialization of the West was synonymous with progress and unequivocally

beneficial. Homesteaders went bust on arid land unsuited to crops, while eastern capitalists took large profits from western mines whose laborers earned miniscule wages. Fragile grasslands on the public domain were overgrazed, even as foreign-controlled ranching enterprises paid out big shareholder dividends on their investments in the American West. And the steady removal of Indians to reservations was fraught with inequities that did not go entirely unnoticed. The writer Helen Hunt Jackson, an early friend of Emily Dickinson, was stirred to indignation in the late 1870s while living in Colorado with her officer husband. In *A Century of Dishonor* (1881), she wrote compellingly of the Indians' plight. The failure of this nonfiction book to awaken the American conscience led her to write the novel *Ramona* (1884), which was highly popular and seen as a parallel to Harriet Beecher Stowe's *Uncle Tom's Cabin.*

Another widely held notion, the idea that North America had been colonized and developed solely by British and other western Europeans, was implicitly challenged with the 1844 publication of *The Commerce of the Prairies.* It was written by Josiah Gregg, who traded goods using the Santa Fe Trail from Missouri to New Mexico; the latter territory had been part of Mexico until the U.S. invasion in 1846. Gregg's book was a reminder for all who cared to listen that the English were not the only ones to have entered North America in the 1500s. While the English government established colonies on the East Coast, the Spanish government sent colonization expeditions north from Mexico to found permanent settlements, resulting in a large population of indigenous Hispanics in New Mexico. This area was further distinguished from other parts of the West by its sizable number of sedentary, agriculturist Pueblo Indians, whose way of life differed from that of the nomadic Plains Indians, who dominated American perceptions of this region.

However much New Mexico differed culturally from other parts of the West, its landscape exemplified precisely what artists had discovered early on, that nearly all western landscapes required different visual metaphors, totally unlike those that sufficed for the more pastoral, smaller scale, water-rich environments of the eastern half of the continent. In fact, by the time Blumenschein found himself responding with instinctive enthusiasm after even the briefest of contacts with one corner of New Mexico, the territory had already given rise to a set of distinctive pictorial conventions. These represented New Mexico's singular western physical realities as filtered through the lens of philosophical assumptions that united the scientists as well as the artists who observed and depicted the territory.

With the publication of Francis Bacon's *Novum Organum* in the seventeenth century, a tradition had begun that involved many scientists, theologians, philosophers, and ultimately artists, who saw their mission as revealing God through his divine creations. Many writers shared a deeply ingrained belief that God could be found in the natural phenomena of the world, whether they be oceans, clouds, volcanoes, waterfalls, thunderstorms, mountains, rivers, or deserts. When some writers and artists encountered the West, its vastness and stillness were seen as manifestations of the infinity of God.

The topographers who came to New Mexico between 1846 and 1890 played a critical role in shaping subsequent viewer perceptions of the territory's environment. They did so by selecting particular land features as focal points for their drawn-to-scale recordings. Imparted in this process was the imprint of their personal interpretations, which stemmed from an inclination to find intimations of the sublime in what lay before their eyes. Their attentions were drawn to such notable features of the New Mexico scene as its open spaces, long horizons, and great stretches

of flatness. These landscapes were broken repeatedly and dramatically by mountains and mesas that were often triangular in shape, with a base and slanted sides leading to an apex reaching skyward.

When topographer James H. Simpson arrived in 1849, he was immediately struck by "the generally geometric quality of the land." Other topographers of note were Richard Kern, one of three brothers from Philadelphia who were all fascinated with art and science and involved in exploration and discovery; James Abert, educated at Princeton and West Point; and Friedrich Möllhausen, a native of Germany who dedicated his life to sketching and writing in the West. All of them gave prominence to the geometric shapes of New Mexico's landforms. Moreover, all of them assigned to its spatial features a metaphysical meaning that had direct connection to such subjective human emotions as a sense of infinity, a feeling of loneliness, and an awe in the face of nature's enormity and timelessness.

Artists did not lag far behind topographers in finding that New Mexico epitomized the profoundly humbling and awe-inspiring character of the western landscape. And whether by coincidence or because of direct influence, the interpretive construct given New Mexico by its topographers, based equally on objective observation and subjective interpretation, was largely adopted by these incoming artists, many of whom worked for brief periods in New Mexico, while others stayed to paint for extended periods.

By the 1890s, the mystique of the Southwest in general and New Mexico in particular was an established fact in the minds of many who worked in the fields of visual perception. Thomas Worthington Whittredge painted in Colorado and in New Mexico between 1866 and 1870. Thomas Moran, born in England in 1837, migrated with his family to America in 1844, and over his long art career, he painted numerous western scenes in which he presented nature as a mystical force linking humankind with the divine creator.

Among the paintings he did while in New Mexico in the early 1880s were views of the Acoma and Laguna pueblos. Charles Craig painted in Taos in 1881, and W. L. Metcalf in New Mexico between 1880 and 1883. In 1890 Henry R. Poore spent time in Taos, where he painted *Pack Train Leaving Pueblo of Taos,* and early in 1898 Frank P. Sauerwein spent several months painting in Taos.

These artists were in a position to experience the atmospheric elements that distinguished New Mexico from other western areas, but Blumenschein had not yet differentiated that frontier territory from the rest of the West. For him, as well as for Phillips, the West was still little more than a romanticized geographical entity wherein one might find exotically aesthetic Indians and dashingly colorful cowboys. Indeed, the two did not plan either to begin or to end their travels in New Mexico; their trip was to be a foray into the Rocky Mountain West, ending, in fact, on the border of the United States with Mexico. They little dreamed that their experiences during this excursion would shape their future; with the confidence of the young, they believed their autonomous actions would shape their fate.

5

Encountering a Transforming Vision, 1898

At the age of twenty-four, Blumenschein stood at just over five feet, six inches. Although somewhat shorter than his father, he resembled the elder Blumenschein with his high forehead, deep-set eyes, and an aquiline set to his features. He carried himself with dignity, and his demeanor was serious enough to elicit respect, yet he was far from pretentious, accepting in good spirit the nickname Blumy, given him by Phillips and others in his circle of friends.

Tennis games and frequent walking kept him fit and trim, and he was not inclined to overindulgence in food or drink. In personality he was witty and cool rather than revealing and passionate; he kept something of himself in guarded reserve at all times, never speaking in terms so open that he would be vulnerable to either pity or contempt. He diminished the possibility of ridicule from others by exhibiting a dryly self-deprecating humor. And as a young American who had studied abroad and become a successful professional working in the nation's center for publishing and illustration, he could hardly have been called either unsophisticated or naïve.

Still, not even Blumenschein would have denied that he was woefully lacking in his knowledge of life on the land, including all things mechanical or related to horses, guns, or outdoor camping. Like Phillips, he was blissfully ignorant

about the ways of the West and what he would encounter after reaching Denver, on the high open plains just east of some of the highest ranges of the Rocky Mountains. Lack of practical experience did not deter Phillips and Blumenschein. Neither man showed an ounce of trepidation as they closed out their affairs in New York, packed up their belongings, and prepared to head West. Phillips embarked by train for Denver in mid-May 1898. Blumenschein followed a short time later, and by the last week of that month, both were experiencing the rough but friendly atmosphere of a Denver boarding house. They were also busily negotiating terms for the purchase of horses, a wagon, camping gear, and food needed for the trip southward.

They had planned to spend about $75 for a pair of horses and a wagon, but in the end they had to pay $130 for these necessities. They also bought a new tent for $6.50 and such supplies as cooking utensils and canned goods, along with paints, brushes, and canvases for the painting they would do on the journey. At the bottom of the wagon they packed Blumenschein's shotgun, which they intended to use "both for hunting and protection," according to a 1994 biography of Phillips published by Julie Schimmel and Robert R. White. In Denver they purchased a Civil War vintage revolver as an added precaution. Never having harnessed, much less driven, a team of horses, they watched carefully as the man from whom they bought their gear fit the harness and hitched up the light wagon. After observing this demonstration they practiced the feat several times on their own.

On the last day of May, they drove out of Denver, sitting high on the wagon box seat, listening and watching as the hustle and bustle of the sprawling frontier city was replaced by the silence of the plains. Their views included mountains to their right, low hills to their left, and the boulder-strewn area known as Red Rocks just ahead of them. But if they thought they had learned all they needed to know, they

were quickly disabused of that illusion when, shortly after heading south from Denver, another wagon driver called out and halted them. He gruffly, laughingly informed them that they were headed for trouble. Having failed to cross the reins on the horses, their control of the spirited steeds was limited; there was no mechanism to keep the horses from turning to the outside and toppling the wagon. Blumenschein and Phillips hastily made the necessary adjustments and drove on, somewhat sobered by this indication that they were not quite the men of the West they aspired to be.

The Red Rocks area proved to be enticing, rich with color and dramatic rock formations, and possessing good camping sites with nearby water. They agreed to set up camp there and remain in the vicinity for several weeks, sketching and painting. In Denver they had been warned about roving gangs of bandits who robbed travelers on the lonely roads stretching between the West's far-flung settlements. Despite these admonitions, they were more than a little unnerved when one night five armed robbers rode into their little camp and coolly surveyed their belongings to see what might be worth stealing. The incident left Blumenschein and Phillips with their gear intact but shaken enough to promptly rummage through the packed wagon and retrieve their weapons for readier access.

For the most part, all went well as they moved gradually south during June and July. They did lose some of their camping equipment to a sudden thunderstorm and flash flood one day, and an even more upsetting incident occurred while they were camping in Deer Creek Canyon, about twenty-five miles southwest of Denver. During the night one of their horses fell over the edge of a sharp cliff, and as they desperately tried to save it, the animal strangled to death on the rope that tethered him. With no choice but to move on, Blumenschein and Phillips soon found it necessary to trade the remaining horse and add $25 for a fresh pair of horses.

Moving farther south in July and August, the two artists followed a route that generally paralleled that of the Denver and Rio Grande Western Railroad. Enjoying the starry night skies and cool summer air, they often chose to sleep on top of the folded tent under the wagon rather than enclose themselves within the tent. They cooked over campfires, with most meals consisting of canned beans and pickles, and if they were lucky enough, they would feast on a roasted wild dove brought down by Blumenschein's shotgun. Immersed though they were in the duties associated with keeping body and soul together in a new environment, they nevertheless found time to take note of an attractive female figure riding across the plains. "We used to get a glimpse of a braid of yellow hair surmounted by a broad-brimmed felt cowboy hat, a grey mackintosh and white pony as they dashed past our camp and rattled over the wooded bridge beyond." They soon made an acquaintance with this girl of the West, who was managing her uncle's ranch "and rides after cattle as successfully as a cowboy."

By mid-August they were in Pueblo, Colorado, where they decided to follow the Santa Fe Trail across Raton Pass, a route that would take them into Santa Fe once they entered New Mexico. But as they drove south out of Pueblo, an old man they met along the way told them that if they followed the Huerfano River southwest to the town of Gardner, they would be able to "cross the mountains into the San Luis Valley and then head south into New Mexico." This route would take them directly to Taos, which lay sixty-five miles north of Santa Fe. Despite the rougher terrain of this route, said the old man, there would be better grass and water for the horses along the way.

Having always planned to visit Taos in the course of their trip, Blumenschein and Phillips accepted this advice and slowly made their way across the mountains, moving into the fertile San Luis Valley of southern Colorado. Phillips later recalled that they had crossed the mountains by way

of the Sangre de Cristo Pass. Blumenschein's more accurate account was that they had crossed La Veta Pass. Back in Colorado Springs they had bought a saddle pony so that one of them could occasionally ride alongside the wagon, but the pony then developed saddle sores and proved unfit as a riding horse. When they saw the fine grazing conditions in the San Luis Valley, they set the animal free to join a band of wild horses living there in peaceful freedom.

As they moved across the Colorado–New Mexico border in early September, Blumenschein and Phillips encountered high rugged plateau country with mountain ranges on the horizon. "A decided change came in the scenery as well as

Ernest Blumenschein, on horseback, and Bert G. Phillips, taking his turn driving their two-horse team, appear to be seasoned travelers on their three-hundred-mile trip through the American West, from May 31 to September 9, 1898, when they discovered Taos. Helen Blumenschein Collection, Palace of the Governors Photo Archives, Santa Fe (NMHM/ DCA), HP.2005.25.I.

the roads. The heavy thunderstorms of summer had ruined the mountain roads," recalled Blumenschein. "A disaster occurred each day." They had so many small accidents that their much-repaired wagon was now little more than a rattletrap on the verge of disintegration. Only at this stage of the trip did they learn why almost every traveling family in a similar wagon had a bail of wire hanging at its side. These hardy and frugal people simply wrapped wire around the broken wagon parts and damaged wheels to keep them rolling rather than spend time and money for constant repairs, as the two artists had been doing since leaving Denver.

Difficult as this approach to Taos from the north was, it was not much more hazardous than the three other established routes to the mountain village. Perhaps the easiest was the route from Denver to Taos Junction, twenty-five miles west of Taos by way of the narrow gauge Denver and Rio Grande Western railway. From Taos Junction, travelers went by coach or horseback down into the Rio Grande Gorge, across a toll bridge, up the steep eastern side of the gorge, and then on to Taos. From Santa Fe, travelers followed a rough wagon road up the western side of the Rio Grande and then crossed the river and went five miles east into Taos. And finally, travelers coming from the east could take a branch of the Santa Fe Trail that led from Cimarron Creek and crossed the Sangre de Cristo Mountains east of Taos, by way of Old Taos Pass, which lead into the village.

Blumenschein and Phillips anticipated a welcome respite from their exertions upon reaching Taos, which lay some hundred miles into New Mexico. Planning to move on southward through New Mexico to Mexico before the onset of winter, they urged on their tired team, which was now pulling its load up ever rockier hills and down more and more washed-out ravines. On the third day of September they reached the hamlet of Questa, twenty miles north of Taos. Founded in 1842 during the Mexican period, Questa lay in the foothills of the Sangre de Cristos, just north of

the Red River, winding its way from the mountains toward the Rio Grande. "After passing Questa we climbed up a steep grade on a miserable road. At the top of this [low] . . . hill, at the edge of a canon [*sic*], on narrow curve, we slid into a deep rut and the wagon suddenly sat down. One rear wheel collapsed and there we were, balancing with our precious load at an angle of forty-five degrees," Blumenschein recounted.

Frustrated but with his sense of humor intact, Phillips got out the camera packed among their belongings and took a picture of his bemused friend standing with his back against the perilously tilted wagon. While they thought through their predicament, the two sensibly sat down at the side of the road and "had refreshments—a cold can of baked beans and a pickle," recalled Blumenschein in an article for the *New Mexico Historical Review*, published more than four decades later. It was around 4:00 P.M. when they finally decided on a course of action. Knowing that Taos would have a blacksmith, they flipped a coin to see which one would take the wheel to Taos for repairs. Blumenschein won the honor and immediately began the twenty-mile trek, taking in his pocket a three-dollar gold piece, which had been a gift to Phillips from his father on Bert's twenty-first birthday—it also happened to be the only money Blumenschein and Phillips had left.

Blumenschein started with the wheel on top of the horse, while he walked alongside the animal down the road. Periodically he rode, balancing the large wheel in his arms with considerable difficulty, which resulted in muscle strain. It soon grew dark, and knowing he could not possibly reach Taos that night, Blumenschein sought shelter at the home of a local Spanish-speaking farmer. He was graciously made welcome and given a bed, an evening meal, and a breakfast. Both meals consisted of tortillas, the native flat bread, and frijoles. Blumenschein returned the family's warm hospital-

ity by doing a portrait sketch of the elderly grandfather, the family's respected patriarch.

On the morning of September 4, Blumenschein resumed his task of conveying the wheel to Taos. As the day progressed, he shifted his load from one arm to the other, while struggling to direct his horse along an uneven wagon trail. As it happened, not a single farmer with a wagon came along to provide any help. His whole body began to ache under the strain of his awkward burden, but his entire being throbbed with a soaring sense of exhilaration. Almost before he could verbalize it, or rationalize it, or analyze it, an emotional response sprang forth from him, resulting in a firm conviction: "Taos Valley and its surrounding magnificent country would be the end of our wagon trip."

The early fall air Blumy encountered was crystal clear. Luminous white clouds billowed against an azure sky. Trees and vegetation shimmered in tones of gold, green, and russet across the high plateau, which stretched westward across a huge mesa cut by the Rio Grande. Beyond the mesa on the far west, purple mountains rimmed the glowing horizon. Eastward the close and looming Sangre de Cristos rose in splendid clarity; they dominated the eastern and northern side of Taos Valley, lush with stands of aspen and fir trees. Tiny villages of clustered adobe homes and cultivated fields dotted the land; the flat-roofed earthen structures in these villages reflected rather than broke the tapestry of color woven by mesa, river, mountain, and meadow.

"Never shall I forget," Blumenschein reminisced in a 1926 article in the journal *El Palacio*,

the first powerful impressions; my own impressions direct from a new land through my own eyes. Not another man's picture this, not another's adventure. The great naked anatomy for a majestic landscape once tortured, now calm; the fitness of adobe houses to their tawny surroundings; the vastness and overwhelming beauty

of skies; terrible drama of storm; peace of night—all in beauty of color, vigorous form, everchanging light.

Calling the experience "the first great unforgettable inspiration of my life," Blumenschein said, "the color, the effective character of the landscape, the drama of the vast spaces, the superb beauty and serenity of the hills, stirred me deeply." Clearly, Blumenschein was experiencing the spiritual exaltation one can feel when a wholeness of nature draws the individual into a visceral awareness of infinity. "I realized I was getting my own impression from nature, seeing it for the first time with my own eyes, uninfluenced by the art of any other man." During those long hours on the road to Taos, "my destiny was being decided."

Central to each of Blumenschein's retellings of the broken wheel story over the years was the theme of an experience utterly new to him because of its spontaneous immediacy. No preexisting, culturally determined imagery influenced his response to what he perceived as a landscape of aesthetically integrated elements; he was convinced that for the first time, no one else's interpretation intruded on his consciousness to infect his own vision, his own judgment. Even more striking as a consistent theme in the story, however, is the emotion; perhaps for the first time in his life, feelings took precedence over intellect. He emphasizes the newness to him of this emotional response with such consistency that it would seem he lived his first twenty-four years of life without experiencing the intense feelings that can sweep an individual involuntarily into a momentarily uncontrollable yearning of joy or sorrow. Perhaps it matters less that it happened to be a particular geographical area that unblocked his emotions than that such a release occurred; these passions would add depth to his character, increase his comprehension of human life, and enrich his artistic creativity.

Blumenschein reached Taos just as twilight was descending. The village was an unprepossessing place: a central plaza edged by hitching posts, a few dusty streets, simple adobe houses sometimes joined in block formation, and a small hotel. There were also a few saloons, a courthouse, a church, a graveyard, and several mercantile establishments. Seen in the soft glow of an early fall evening, the town had an unmistakable air of serenity. Indeed, in Blumenschein's view, it had about it a self-sufficiency and symmetry with the world of nature. Fewer than fourteen hundred people lived in the village of San Fernando de Taos and its sister community, a few miles south, Ranchos de Taos. In addition, some five hundred Indians lived at Taos Pueblo three miles north of the town. Soon after entering the town, Blumenschein saw Taos Indians for the first time, "picturesque, colorful, dressed in blankets artistically draped."

Blumenschein had little difficulty finding the blacksmith shop on the plaza. Its owner, Bill Hinde, agreed to let him sleep there; Hinde would repair the wheel early the next morning. Blumenschein spent an uncomfortable night on the floor, his sleep disturbed by rats scurrying among the wagon wheels, horseshoes, and iron scraps. Hinde repaired the wheel in the morning, and Blumenschein paid him with the three-dollar gold piece. Then he returned the twenty miles north to rejoin Phillips, reaching their camp at nightfall.

While waiting for his partner, Phillips said, "I did some sketching and wasn't a bit surprised when Blumy came back with the wheel and the conviction that he had reached the end of our trek. . . . I found it a bit disconcerting," Phillips added, "when [a] lone rider came along and warned me of the horse thieves waiting to get our one horse, so I redoubled my watchfulness. But I had to leave the camp alone when I went after water for the horse and myself. I remember that I got some lovely sketches, just the same." He

had concluded, even before Blumenschein returned with the wagon wheel, that the extraordinary beauty of the Taos Valley justified taking time to explore its potential as the long-sought subject matter for their art. Eager to share with each other their responses to the new land, the two artists discussed their now rapidly changing plans as they prepared a simple meal and bedded down for another night under the stars. By morning it was clear to both that the Taos Valley marked "the end of our wagon trip. Mexico and other lands unknown could wait until the future."

In the late afternoon on September 6, they drove their wagon into Taos. Inspired by the notion of being close to the Indians whom they wished to paint, they drove to the outskirts of Taos Pueblo instead of setting up camp in the village. "The clear water of the mountain trout stream that flows through their plaza looked cool and inviting in the shade of the large cottonwood trees," recalled Blumenschein. They were unloading gear and preparing for the night when suddenly the pueblo governor approached them with an ominous look of disapproval. He did not speak English but managed nonetheless to inform them in no uncertain terms they were intruding on Indian land and would not be permitted to camp there.

The two disappointed, tired artists repacked their belongings, drove back to the village, and after some hours were able to rent a vacant field, where they set up camp and built a small fire. The next day they obtained some badly needed funds by selling the wagon, horses, and harness. Over the ensuing days, said Blumenschein, "Phillips and I pitched into work with unknown enthusiasm." The painting went well, but their living conditions proved less than tolerable. Though green and inviting, the open field where they were spending their nights was continuously damp because of local underground springs. Sleeping on wet ground while the nights were growing colder was not conducive to health or restfulness. They sold enough of their remaining equip-

ment to enable them to rent a small adobe dwelling on Bent Street, adjacent to the house where Charles Bent, the first U.S. governor of New Mexico, had lived.

Soon after moving into the house, the artists were visited by several Taos Indians. Among them were Swift Arrow and Sunshine on the Elk, or Tudl-Tur in Tiwa, who would become a model for Phillips. By the end of September the artists had been taught the rudiments of bow-and-arrow shooting and had acquired considerable knowledge about Taos Pueblo customs. When they went to the pueblo on September 30 to attend the San Geronimo Day ceremonies, they were well aware that it was the most important event of the pueblo. The occasion marked the first time Blumenschein and Phillips viewed any of the dances, races, and age-old rituals that were part of Pueblo culture. Phillips recalled, "the smell of harvest time was in the air; herds of goats and ponies were being driven round and round on many threshing floors, tramping out the golden wheat. Everywhere preparations were going on, making ready for the annual San Geronimo Festival."

The events of the day, played out against the backdrop of a crescent line of mountains in shimmering autumn tones, were a formative experience for both men. Phillips claimed that this festival played an important role in his growing desire to remain indefinitely in Taos. Blumenschein closely observed the swaying bodies, the sense of common identity, and the space created within the groups of Pueblo dancers. Their ritual not only expressed their dedication to San Geronimo, whom they revered with great piety, but also sparked competitiveness and joy in the performers, as they moved their lithe, fit bodies in intricate, rhythmic dance steps. Accompanying their movements were eagle feathers, decorative bead work, and the skilled drumming that provided an overall sense of harmony in color and movement. Throughout the day Blumenschein made one sketch after another and took notes on what he saw.

The decision to spend more time in Taos than originally planned was initially made as a result of their impressions of the landscape, well before Phillips and Blumenschein had any substantive contact with the Taos Pueblo Indians. Yet once the artists began applying their art training in Taos, painting the Pueblo Indians and Pueblo life quickly took precedence over painting the surrounding landscape. They saw that Joseph Henry Sharp had been right in singling out the viability, the vibrancy, and the stubborn continuity of this Indian community. The Taos Indians had faced penetrating waves of influence, overlordship, and intrusion from the Spanish conquerors. Then came the government of an independent Mexico and finally the current U.S. rule.

Still, neither Phillips nor Blumenschein was totally convinced during their early years here that the Pueblo culture could permanently stave off extinction, disintegration, or assimilation. Thus, they felt compelled to concentrate on painting the Pueblo peoples, not only because of their natural appeal, but also because Blumenschein and Phillips believed that time just might be of the essence in capturing on canvas a record of these remarkable survivors and possessors of an ancient culture. Neither artist ignored the landscape, however, even during this early flush of enthusiasm for the Indians. They both sought out scenes characteristic of the area and quickly came to understand that the unique qualities of light, land contours, and vegetation found in the Taos Valley were the result of an unusual amalgam of geographical features.

An upland comprising a diverse range of land forms, the Taos Valley is located between the wetter and flatter Great Plains to the east and the drier, more barren Southwest desert to the west. Pictured from the vantage point of the southern rim of the valley, looking northward, the area resembles a large bowl tilted so that its right side is higher than its left side, which is almost level with the adjoining tableland. Although it has long been known as Taos

Valley, the area is actually part of the Rio Grande Valley, which extends from north to south and across New Mexico to the Texas border. South of Santa Fe, the valley has historically been called the Rio Abajo, while the Rio Grande Valley and its tributary valleys lying north of Santa Fe, including the Taos Valley, are known as the Rio Arriba. This upper Rio Grande Valley lies within a larger natural environment of semiarid mesa country, broken by densely forested mountain ranges that contribute their waters to the Rio Grande.

Taos Valley sits 7,000 feet above sea level, with Taos itself at an altitude of 7,050 feet. The Sangre de Cristo Mountains, part of the Rocky Mountain chain, rise in sharp abruptness directly east of Taos. Meaning "Blood of Christ," the name Sangre de Cristo was given by sixteenth-century Spanish explorers after they observed the intense crimson glow that illuminated the western face of the range in the light of the setting sun. Rimming the far western horizon are other mountains, including the northern end of the Jemez range. The Sangre de Cristos rise about 6,000 feet higher than the village and the pueblo of Taos. At 13,151 feet, Wheeler Peak is the highest mountain in New Mexico. Taos Mountain, twenty miles north of Taos Pueblo, considered sacred in the Pueblo traditional belief system, is 12,282 feet high.

The focal point of the Pueblo Indians' most secret ceremonials is Blue Lake, which lies on the southern flank of Taos Mountain. West of Taos, the Rio Grande flows through its deepest gorge on its southward route. Vegetation on the dry mesa west of the river gorge is sparse and hardy, including sage, cactus, and a wide variety of desert scrub plants. Salt cedar, often referred to in New Mexico as tamarisk, and willow, cottonwood, and sycamore grow along the rivers and streams of Taos Valley, where Blumenschein, an avid angler, would later fish with great frequency. Pine, spruce, and aspen, on the other hand, are abundant at higher elevations in the mountains. The Taos Valley is distinctive from

101

most valley lands because within its circumference are found both desert and mountain land forms and vegetation.

The landscape of the valley, composed of observable physical elements, proved more amenable to the interpretive eye of the observing artist than its human population did. Observation, even of the most penetrating kind, cannot always unlock the inner realities of human subjects. Blumenschein and Phillips could bring the eyes of an artist to bear on external features and behavior but could not see motivating ideas; they could see rituals and ceremonies but not the vision and feelings animating the participants in these events. Both the Pueblo community and the Hispanic community had a certain deliberate inscrutability, were somewhat insular, had a tendency to resist penetration from outsiders, guarded their knowledge about their most cherished beliefs, and were self-contained cultures. The mentality of both communities led them to value their dissimilarity to mainstream Anglo-American society. And certainly the historical experiences of these two groups lay far outside the realm of experience for these two young artists.

The history of relations between Pueblo Indians and Spanish settlers was a mixture of confrontation and cooperation. In 1898 around ten thousand Indians were living in nineteen pueblos along the Rio Grande and its tributaries in north-central New Mexico, with Taos Pueblo being the most northerly. Taos Pueblo had been built around 1350 A.D. by Natives who had been living in the area since emigrating from the Anasazi homeland in central-west New Mexico in the 900s. The Taos Indians spoke Tiwa, one of three languages in the Tanoan grouping; the Tiwa dialect has a calm, flowing sound, almost devoid of accent. The Spanish first saw Taos during the 1540–41 expedition of Francisco Vásquez de Coronado. In the spring of 1541, while Coronado was exploring northeast New Mexico, a detachment under Captain Francisco Barrionuevo went to Taos and forced the Indians to provide food supplies. In

late 1541 Captain Hernando de Alvarado arrived with a scouting force and requisitioned winter supplies for Coronado's soldiers. In July 1598 Don Juan de Oñate, who had just founded the first Spanish colony in New Mexico, visited Taos and two months later assigned Fray Francisco de Zamora to Christianize the Taos Indians.

Colonists from Oñate's San Gabriel settlement on the Rio Grande, forty miles south of Taos, began arriving to take up land near the Taos Pueblo in the early 1600s. Intermarriage and Spanish intrusion disturbed tribal elders, and they requested that the Spaniards move at least "a league away" from the Pueblos' centuries-old settlement. By 1615 the Spanish settlers had established the separate village of Taos south of the pueblo. In 1617 the first mission church was built at the edge of Taos Pueblo; in 1631 its founder Fray Pedro de Mirando was martyred during one of several recurrent periods of animosity between Indians and Spaniards. But Christianity gradually became part of Pueblo culture, coexisting in a spirit of eclectic accommodation with Indian mythology and tradition.

Harsh treatment of the Pueblo Indians by Spanish colonial officials, however, led to a united revolt by all the pueblos in 1680. The bloody uprising was led by a leader named Popé from San Juan Pueblo, who made his headquarters at Taos Pueblo. All of New Mexico's Spanish colonists were driven south to El Paso. Don Diego de Vargas reconquered New Mexico in 1692, however, and settlers began to come back the following year. In 1694 de Vargas raided the Taos Pueblo when its elders refused to turn over requested food supplies. The Taos Pueblo was among the last to be pacified; in 1696 de Vargas again used force to quell unrest there. The village of Taos, which had been destroyed in the 1680 revolt, was rebuilt in 1710 when settlers were finally able to return.

Throughout the 1700s Taos Pueblo was the site of an important annual trade fair for Plains Indians as well as Pueblo

Indians. The village of Taos, being situated at the northern end of the El Camino Real travel route from Mexico City to New Mexico, became an important link in the trade between Mexico and its northern frontier province. Badly needed supplies of all kinds were brought north by wagon train twice each year. The wagon trains made the long, perilous journey back to Mexico City loaded with New Mexico's principal exports, wool and hides. But during this same period Taos continued to endure frequent raids from Plains Indians, including the powerful Apaches.

Family and faith were the twin sources of strength for the Spanish settlers of Taos Valley. Their religious beliefs, centered on a suffering Nazarene Christ, were expressed through the iconography and ritual of a cult brought to the New World by Spanish Franciscan friars in the sixteenth century. In New Mexico its followers were known as Los Penitentes, and they imbued their practice of Christianity with a fervor and passion that paralleled the agony of an El Greco painting. Penitentism traced its roots to St. Francis of Assisi, who started the Order of St. Francis and the Poor Clare Order of nuns, then organized the Third Order of the Brothers and Sisters of Penance for the laity in 1218. In 1598 Juan de Oñate participated in Third Order rites at San Gabriel, and the Penitentes were well established in northern New Mexico by the mid-1600s.

The influence of the Penitentes grew even stronger after Mexico gained independence from Spain in 1821 and expelled many priests of Spanish birth, leaving New Mexico with a shortage of clergymen. In 1827 only seventeen priests served the numerous Spanish settlements along the Rio Grande and in the mountain valleys, many of the priests too frail and old to serve the more remote villages. Villagers increasingly relied on Los Penitentes to provide religious services and comfort for the sick and dying. Church officials in New Mexico condemned the excessive use of physical

penance that characterized the Penitente rites and urged reform. The reenactment of the Crucifixion of Christ on Good Friday was sometimes all too real, sparking a continuing debate among historians over how much pain was inflicted on the Penitente chosen to act as Jesus. But little change occurred, and in Hispanic communities nearly every head of household was a Penitente. Blumenschein became fascinated with the Penitentes and even included them in one of his most famous paintings, the *Sangre de Cristo Mountains.*

Anglo culture came to Taos during the first quarter of the nineteenth century as fur trappers, traders, and mountain men favored the village as an ideal place to meet, socialize, and do business. Among the traders were Charles Bent, Ceran St. Vrain, and Charles Beaubien. Among the trappers and mountain scouts were James Bridger, Louis and Antoine Robidoux, and Kit Carson, who became the first Anglo to make a permanent home in Taos when he settled there in 1826. There was lively interaction and crisscrossing of influences among Indians, Hispanos, and Anglos. The Indians adopted various clothing items, assorted livestock, and the use of outdoor ovens from their Spanish-speaking neighbors, while the Spanish adopted the chile, beans, and squash of the Indians into their diet. Intermarriage was not commonplace but did occur with some regularity. In 1843 Kit Carson married Josephine Jaramillo, daughter of a successful merchant. One of her sisters became the wife of trader-merchant Charles Bent, who also established a home in Taos.

The generally amicable relations between Anglos and non-Anglos were strained to the breaking point, however, by the unexpected overthrow of the Mexican provincial government at Santa Fe by a U.S. military force, led by General Stephen Watts Kearny, in August 1846. New Mexico, a department of the Republic of Mexico, was placed under the

control of the United States, although the U.S.–Mexican War did not end until Mexico surrendered in 1848. When Charles Bent was named the first civilian American governor of New Mexico in September 1846, many Hispanos and Indians in the Taos Valley considered the act a premature imposition of foreign rule. A plot was set afoot to foment a general uprising against the Americans, with a group of Taos Indians acting in concert with Hispanic rebels. On January 19, 1847, Bent returned to his Taos home from Santa Fe for a brief visit, only to be captured, shot to death, and scalped. Some twenty people associated with the new U.S. administration were killed in Taos at this time.

Reaction to these deaths was swift. General Sterling Price, who was in charge of the U.S. Army after Kearny left for California, assembled 210 men along with five cannons and marched northward. Thirty-six rebels were killed en route to Taos, which Price reached during a heavy snowstorm on February 3. The Mexican rebels scattered, but the Indian rebels were barricaded inside the church at Taos Pueblo for two days before the walls were battered down and the Indians taken as captives. The rebellion resulted in the deaths of 150 Indians and 7 soldiers. The hanging of six of the rebels left bitter memories of this uprising for years to come.

New Mexico was made a U.S. territory in 1850, inaugurating a period of emigration from the states as well as expanded commercial activity. Small and isolated though it was, Taos shared in the benefits. As the U.S. military gradually controlled the Plains Indians, trade and travel became easier. A growing number of merchants moved their operations from Missouri to New Mexico, having participated in the Santa Fe Trail trade between 1821 and 1846. Many of them were Germans who had immigrated to Missouri, including German Jews such as the Beuthner brothers, Levi and Elias, who settled in Taos around 1860 and opened a store. In the 1870s the Alex Gusdorf family established

itself in Taos as a principal mercantile source, and in 1875 Gusdorf was named Taos postmaster, using his store as the local post office.

By 1898 Taos exhibited what amounted to an implicit balance of power among its three ethnic elements. Blumenschein and Phillips, thrust into personal contact with members of all three groups as they went about their business of painting and making living arrangements, had ample opportunity to observe this well-entrenched, de facto division of status. Anglos tended to dominate the commercial sector of the local economy. Spanish-speaking people dominated the political sphere, holding most political offices and, as the majority group, able to prevail in local elections. As for the Taos Pueblo Indians, they were by any measure living at a subsistence level. They had been lacking in adequate medical care and failing in efforts to gain the right to vote for many years. Yet, unlike the Plains Indians, they were not displaced people; they possessed their land in perpetuity as a result of a land grant made by the Spanish Crown and confirmed by subsequent Mexican and American governments. Thus, the Taos Indians reflected in their dignified bearing a pride of place and a discernible serenity as they lived in the timeless ways of their forebears.

In September 1898, during Blumenschein and Phillips's eye-opening visit to Taos, New Mexicans of all stripes were bursting with pride as they cheered the return of hundreds of New Mexicans who had fought in the Spanish–American War with Teddy Roosevelt and the Rough Riders. Many of the 340 volunteers for the Rough Rider Cavalry regiment were from the frontier territory. Among them were a sizable number of Hispanos, who welcomed the chance to show their patriotism to the nation at large; thus they refuted those charges often made in Congress that the loyalties of New Mexico's Spanish-speaking population lay with Spain rather than the United States. The struggle against Spain

lasted barely four months, with the loss of only 460 American lives, and it made the United States an international power for the first time in history.

Sensationalist prowar reporting of the conflict, by the newspapers owned by Joseph Pulitzer and William Randolph Hearst, convinced the majority of Americans that it was both necessary and beneficial to intervene in the affairs of strategic islands outside the nation's borders, such as Cuba, Puerto Rico, and the Philippines. Blumenschein may not have been among this majority, however. Many years later the artist told his daughter, Helen, that he was "shocked" when he heard that his brother, George, had volunteered to fight, and even more dismayed when he learned that George had received severe battle wounds, which eventually resulted in an early death.

Still, America's newly expansionist foreign policy, soon to be extended beyond the Caribbean to the Pacific Ocean, was of little personal consequence to Blumenschein and Phillips during the heady early days of their first encounter with Taos. The presence of the personable young artists did not go unnoticed in the town; the two did not hold themselves apart and were soon receiving invitations to social gatherings, including informal suppers that were a pleasant break from their own efforts to prepare meals. On October 19, they attended a party at the two-story adobe home of Dr. T. P. Martin and his wife, Helen, located on the tree-lined road leading north from the plaza. Doc Martin, as he was known by all, had come from Baltimore to practice medicine in the coal-mining towns of Colfax County in northeast New Mexico. He was eventually hired by the Indian Service, which in 1890 assigned him to Taos, where he also opened a private practice as the first doctor to live there. In fact, he was the only doctor in a five hundred-square-mile area, working long hours and often being paid in produce by his poorer patients. He was gruff, kind, garrulous, and not too neat in his attire but a man who knew

everything about everyone. The tireless doctor was considered a prime source of information, gossip or otherwise.

Among the guests at the party was Rose H. Martin, Doc Martin's younger sister, who was visiting from her home in Pennsylvania. She was tall, slender, dark-eyed, with long wavy hair and beautiful facial features, which were undoubtedly appreciated by Phillips. Despite her eastern upbringing, she was far from typical of young women of her time. Rose was highly independent and was known for frequently wearing a decidedly out-of-fashion straw sailor hat. She was physically strong, rode horseback well, and defied tradition by traveling unchaperoned.

On October 20 the *Taos Cresset* newspaper published its first issue and gave a lively account of the doings at Doc Martin's house, including in its coverage the presence of these two new artists. They were identified by the newspaper, soon to become notorious for misspelling names, as Phillips and "Bloomshine." Accepted readily into Taos society, particularly by the Anglos who numbered about twenty-five, Phillips and his friend with the complicated name soon met other village notables, such as the tough-as-steel man-of-the-West-made-good John Dunn. He owned the toll bridge and stagecoach service across the Rio Grande as well as several saloons in Taos. They also became acquainted with members of the large Gusdorf family and with "Mrs. Scheurich," the charming old lady with a keen mind, who was the daughter of former governor Bent.

But Blumenschein and Phillips did not conduct their social or professional lives in tandem. Each went his own way in artistic response and personal relationships. Blumenschein's activities reflected his ambition and his penchant for critical analysis, while Phillips's reflected his adventurous spirit and penchant for romanticizing history. Blumenschein, even at the high point of what had been labeled a "painting trip to the West," could not resist the urge to further his career in illustration by doing scenes sure to prove enticing to the

magazines in New York. Having run out of money, neither he nor Phillips could afford to ignore the issue of income.

On December 10, 1898, *McClure's* published "A Strange Mixture of Barbarism and Christianity—the Celebration of San Geronimo Day Among the Pueblo Indians," which the artist simply signed as "Blumenschein, Taos, N.M. 1898." On the cover of its June 17, 1899, issue, *Harper's Weekly* published "Wards of the Nation—Their First Vacation from School," also illustrated by Blumenschein. It depicted young Indians as they struggled with the dilemma of living as Indians after being separated from their culture by schooling in the white man's world. *Harper's* also published Blumenschein's black-and-white illustration titled "The Advance of Civilization in New Mexico—the Merry-Go-Round Comes to Taos." The theme of each of these illustrations is the interplay between Indian and white culture and the effects of government policy on Indian life.

Under the Dawes Severalty Act, passed during the first Cleveland administration in 1887, the goal of the Department of the Interior's Indian Service was to assimilate Indians into American society and replace their group status with an emphasis on individual property rights. The result had been the loss of much Indian land as tribal lands were sold, adversely affecting Indian self-sufficiency and cohesion. Blumenschein demonstrated, even at this early period in his life, a readiness to reach conclusions and state them unequivocally. He objected to the disruption of age-old modalities of Indian survival and productivity. He expressed the view that Indian culture had an inherent value, which was being destroyed by misguided government policy. "Let the Indians be themselves, . . . for forced acculturation can only destroy what has worked while replacing it with an unproved and possibly harmful alternative."

Ideological underpinnings aside, the Blumenschein illustrations accurately depicted Indians in their contemporary setting. The Taos Indians are shown in their traditional garb,

men with their hair in two long braids, women with heavy bangs in front and long hair tied at the neck in back. The men wore colorful shirts and trousers of cloth or hide, usually with a vertical string of fringe below their knees. They wore blankets over the shoulder or carried them. Women wore short mantas over muslin underdresses, with woven belts, moccasins with high deerskin leggings, and colored shawls to complete their outfits.

Phillips rapidly lost interest in illustrations once in Taos and concentrated on paintings of Indians in settings that conveyed the underlying ethos of their way of life. Fieldwork done in the 1880s by Adolph Bandelier and other anthropologists had provided valuable information about the origins of Pueblo culture, and Phillips soon acquired a keen interest in artifacts representing the Indian past. But the trusting relationship Phillips eventually established between himself and the Taos Indians was built only with patience and perseverance. Indians of many tribal groupings shared a persistent belief that the reproduction of their image, whether by camera or paintbrush, had the effect of lessening their life force. During his first weeks in Taos, Phillips aroused Indian suspicions when one of his models became seriously ill. Only after Phillips's own ministrations, combined with those of Pueblo medicine men, was the ailing man brought back to good health and Indian fears allayed. Phillips often posed his models in the studio he shared with Blumenschein on Bent Street, but he and Blumenschein both did on-scene sketching and painting at the pueblo, seeking to capture the artless art of pueblo construction.

Made of compacted blocks of dried mud rather than the adobe bricks used by Hispanic builders, the rooms of the Taos Pueblo were grouped into apartments connected by common walls and built to a height of two or three stories. The roof was supported by long wooden beams known as vigas and topped with a layer of mud. The interior walls were whitewashed, and a red glazed clay paste was used

for the floors. Taos Creek, originating at Blue Lake, ran through the pueblo, dividing south and north apartment blocks and providing domestic water. Ladders enabled the Indians to go to the roof and enter their homes. The lower floors had no windows. Five or six underground rooms, known as kivas, were used for secret ceremonial and leadership purposes. An adobe wall, surrounding the entire pueblo, had been built incrementally as rooms were added to the impressive structure over the years. The pueblo was, according to John Brinkerhoff Jackson in his 1993 study *A Sense of Place, A Sense of Time*, an apt expression of the timeless worldview of the Indians who "built as if the present order were going to last, untroubled by age and neglect and decay."

Phillips diverged most from his good friend Blumy in his personal feelings about Taos. He seemed to have felt at home almost from the start. Not only was he thrilled to be in the very place where his boyhood hero Kit Carson had lived and was buried, but he yearned to infuse himself with the spirit of the Old West that Carson had so vividly embodied. He did not miss the amenities of New York, even in a place whose sole link to the outside world was a single telephone line between Taos Junction and the telegraph office in Taos. Unlike Blumenschein, his interest in Taos went beyond its painting potential to encompass its economic opportunities; he soon came to believe in the possibilities of making money in the mining districts of the nearby mountains. At the age of thirty, in comparison to Blumenschein's twenty-four, he had six more years of painting experience under his belt, and he felt readier than Blumenschein did to trust his painting skills in Taos and launch a career in fine-art painting in this picturesque town.

In the end, however, it may have been simply love that drove Phillips to remain in Taos into the indefinite future rather than returning to New York as planned. When Blu-

menschein, after two months in Taos, began to talk of returning East, Phillips told him that he was not ready to go. Indeed, he did not know when or if he ever would be ready to leave this place, which was fulfilling his artistic dreams and his personal desires.

Blumenschein could not have been overly surprised by Phillips's decision, for he had watched as the mutual attraction between his friend and young Rose Martin grew quickly from friendship to romance. The two seemed meant for each other. In her late twenties, the high-spirited but even-tempered Rose was no less curious or adventurous than Bert was. Together, they explored the land and its people, and both took Spanish lessons to better communicate in the place that, they agreed, suited their ideas about how life ought to be lived. In addition, Rose became interested in art, and she accepted the notion of art as a viable career, despite its inherently uncertain financial prospects. In November, when Bert Phillips offered art classes to earn some money, Rose Martin was named in a *Taos Cresset* news item as manager of the budding art school.

Blumenschein felt as compelled to leave Taos as Phillips did to stay. He had begun to miss New York. More important, he needed New York. He missed the excitement and convenience of city life, and he needed to be near the home of so many of the nation's major publications. At this time in his life, he had no intention of giving up an illustration career that had begun well and offered experience and income, enough to pay for further training in art. His friendship with Sharp and Phillips had made him more aware than he might otherwise have been of the shortcomings in his painting skills. His daughter, Helen, always believed her father had returned to New York "to continue his illustration so he could go back again to Paris." Her father, she wrote in *Recuerdos*, "was still struggling to perfect his craft and become an excellent painter, not just an illustrator."

When Blumenschein left Taos on November 18, 1898, he and Phillips were still fast friends who envisioned future times of painting together in Taos. Despite some inevitable strain during their six months of travel, the two had managed to avoid any major disruption in their relationship. But the trip and the stay in Taos had revealed significant differences in their attitudes and priorities. Blumenschein tended to focus intently on his art as a career; Phillips saw his art as the center of a life in which he would be as far removed as possible from bourgeois society. Blumenschein could be an ironic and astute observer of the foibles of the establishment, but he nonetheless was eager for its acceptance and approval; his aim was to be an art professional rather than a man who did many things well but painting best of all. Phillips was more practical, and during their trip to Taos, he came to see himself as readier than his younger friend to do physical labor. He expressed this belief after Blumenschein used the pair's last bit of hard cash to pay the blacksmith for repairing their wagon wheel. Phillips later told his family that if he had carried the wheel into Taos, he would have worked to pay for the repair rather than use the gold coin.

Phillips was not averse to spending time on business ventures, such as the talk of lucrative mining ventures in the Sangre de Cristos. Blumenschein was more driven and art obsessed; Phillips was more centered in life itself. Nothing in the nature of these differences, however, produced any real tension in their friendship. The mutual goodwill was everywhere in evidence, such as when Blumenschein took with him several of the paintings Phillips had done in Taos and brought them to the O'Brien Gallery in Chicago. The dealer promptly purchased all of them and continued to buy artworks from Phillips for several years.

If any clear conclusion can be drawn from this trip to the West in the summer of 1898, it is that it ended in a totally unforeseen way. Although on the surface, the trip's conse-

quences seem to have been very different for Phillips than for Blumenschein, in reality, Blumenschein's thinking was changing as profoundly as Phillips's had. As Blumenschein later recalled, from this time forward, he "aimed at eventually living in Taos."

6

Professional Position versus
Artistic Ambition

By the end of the 1898 holiday season, Blumenschein was hard at work in a newly rented New York studio apartment, having renewed his ties to the city's major publishers. In January 1899 *McClure's* asked him to meet with the up-and-coming young writer Booth Tarkington, whose first novel, *The Gentleman from Indiana*, was scheduled for publication in serial form by the magazine. The two men liked each other immediately when they sat down on a blustery winter day to discuss illustrations for the new work. The middle-class midwestern background they shared no doubt helped spark what would become a lifelong friendship. Born in Indianapolis in 1869 and educated at Purdue and Princeton, Tarkington would publish forty novels as well as plays and short stories over the course of his long career. But despite his fame and worldwide travel, he never lost sight of his roots in the American heartland, and it was his realistically middle-American novel *The Magnificent Ambersons* (1918) that won him a Pulitzer Prize in 1919.

The Tarkington assignment associated Blumenschein with an author whose reputation would be made with his well-received first novel, and the commission neatly epitomized some of the rewards and risks entailed in illustration work. Life as an illustrator offered incentives in the form of adventure, travel, money, and personal contacts with talented

people in various fields, but for all its rewards, such a career was not for the faint of heart. It was a life full of unexpected twists and turns, and success came only to those who were flexible, able to adjust their viewpoint with each new commission, and ready to accept the reality that artists were not in sole control of their fate. He did not work autonomously but was a participant in a project jointly undertaken by publisher, editor, author, and artist.

The artist-illustrator had the least say in what was published and when it was published. Even public response to an illustrator's work hinged as much on response to the author's text as on the perceived quality of the artwork that accompanied it. No better example of the illustrator's lack of authority can be found than the Tarkington incident, for despite Blumenschein's natural affinity for the subject matter and amicable relationship with its author, he was powerless when an editorial decision led to publication of the novel without any illustrations.

A feel for the tenor of Blumenschein's life in 1899 can be had by taking note of some assignments he saw through to publication. In February he traveled to New Orleans to illustrate a *Harper's Weekly* article on the Mardi Gras festivities. Back in New York he provided illustrations for several articles and short stories by Hamlin Garland, a self-educated writer who was born the son of a Wisconsin farmer in 1860. Garland launched his career under the tutelage of William Dean Howells in Boston, and by the 1890s he was a staunch advocate of the new trend toward literary realism. Indeed, Garland would make the "most systematic study of the red man" in American literature from 1895 to 1905, and the author was most impressed with Blumenschein's sympathetic understanding of the Indians when the artist illustrated Garland's 1898 article in *McClure's*, "General Custer's Last Fight as Seen by Two Moon." Probing the views of Two Moon, a major Cheyenne chief at the Battle of the Little Bighorn in 1876, the article was indicative of the

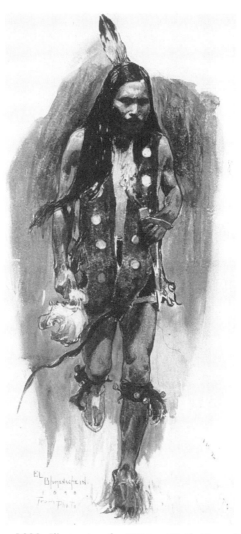

Ghost Dancer, 1898. Illustration for "Rising Wolf, Ghost Dancer," by Hamlin Garland, *McClure's Magazine*, 1899. Gouache and ink on paper, 32 × 20 inches. Collection of Cheekwood Botanical Garden and Museum of Art, Nashville.

lasting impression this battle would have on Indians as well as on the growing readership of magazines like *McClure's*.

In July *McClure's* published ten Blumenschein illustrations to accompany the article "Soldier Police of the Canadian Northwest." And in August he did on-scene sketches to illustrate a *Harper's Monthly* article, "Street Fairs in the Middle West." Never lacking for commissions, Blumenschein saw his income rise substantially over the course of a single year. By mid-1899 he was clearly among the ranks of notably successful illustrators. His income fell short of the $65,000 to $70,000 annual incomes of a small number of top illustrators, but it was still far above that of a typical successful businessman and strikingly higher than the average of $600 a year earned by a male head of household in the working-class neighborhoods of Manhattan's East Side.

By 1899 modernization was proceeding rapidly in the nation's urbanized areas, as new inventions found their way into mass production and brought beneficial changes in daily life. Nowhere was the pace of change more visible than in New York City, where gas stoves were replacing coal stoves and electric light bulbs were supplanting kerosene lamps and gas jets. As he moved about the city and traveled on assignments, Blumenschein was operating in an increasingly mobile, more convenient world made possible by industrialization and technological advances. The contrast between this mainstream American city and the remote, rural world of territorial New Mexico could not have been greater. Absorbed as he was with his own priorities, Blumenschein might well have found himself thinking less and less about faraway Taos had it not been for Phillips, a frequent correspondent whose colorful letters kept Taos in all its unconventional glory alive in Blumenschein's mind.

Within weeks of Blumenschein's departure from Taos in November 1898, Phillips became a central figure in a violent event that laid bare the historical schism between the Hispanic community, with its memories of the American

conquest, and the small but economically significant Anglo community. The Anglos generally brought with them from the East their individualistic and entrepreneurial outlooks. These were sharply at odds with the worldview of Hispanos, who were more oriented to land, family, group, and church. Had Blumy remained in Taos for another month, he would in all likelihood have been at Phillips's side in an inflammatory incident resulting from these tensions. In mid-December he received a letter from Phillips giving the general outline of the affair, which could only have caused Blumenschein to feel some relief at having missed out on this dangerous episode.

It began on December 12, when Taos residents celebrated the Feast of Our Lady of Guadalupe with a religious procession and church services. For Hispanic Catholics the procession bore the same connotations of faith and devotion as the church-held mass. To Phillips and his photographer friend Lester Myers, who went to the plaza to watch the procession, it was a public event on a public thoroughfare. When a Hispanic resident asked them to remove their hats, in a manner the Anglos considered rude, they instantly refused. An argument ensued, and then a fight began, continuing as the procession and the parties in the scuffle all moved along the north side of the town plaza. Near Alex Gusdorf's general store, Sheriff Luciano Trujillo arrived at the scene. When told about the cause of the argument, he arrested Phillips and Myers, choosing to side with local sentiment despite the lack of any law requiring removal of hats on a public street. Witnesses later said the sheriff had been drinking heavily in the previous hours. Gusdorf was joined by Al Gifford, a young man who worked in a saloon at the northwest corner of the plaza, and both men requested that the sheriff release Phillips and Myers on bond, with bail raised by their friends. The sheriff refused, took Myers to the unheated iron cage in the courthouse patio, which served as the town jail, and then went to the saloon to get

Phillips, who had been rushed there by Gifford. A little after 7:00 P.M. Phillips surrendered when the sheriff pointed his drawn revolver at Gifford and him.

Even then the sheriff was not content to let the matter drop. He returned to the saloon, called the Sample Room, after he had incarcerated Phillips, this time to arrest Gifford. Gifford had a gun in his hand; by some accounts, the sheriff opened fire, and by other accounts, Gifford reached for his gun first. The sheriff's brother grabbed Gifford and wrestled him to the ground while numerous people began shooting. Some sixteen shots were fired, with the sheriff taking three of them in the hand and neck, each shot fired from a different gun. Gifford said later he had fired one shot at the sheriff after breaking free. The sheriff died of his wounds eleven days later.

The saloon fight did not end the confrontation between the Hispanic and Anglo communities. Gifford hid in the home of two granddaughters of Governor Bent, and the house was forcibly searched several times by friends of the sheriff. On December 14 Gifford surrendered to a U.S. marshal, who had been sent in response to a telegram dispatched from Taos. Taken to Santa Fe, Gifford was placed in custody by the sheriff, but no charges were filed, and he was permitted to board a train ten days later for California, where he had previously worked in gold mining camps and where he would now remain.

With help from Dr. Martin, who had removed the jail key from the sheriff's pocket while treating him at the scene of the shooting, Phillips and Myers had been released late in the night of December 12. According to an account published by Helen Blumenschein eighty years later:

> The two had joined their friends, all armed, and barricaded themselves in Gusdorf's store, even as the sheriff's friends sought to persuade the Taos Pueblo Indians to join them in "running the Anglos out of town." But the Indians, too, had their own long

121

memories and after reminding the Hispanic representatives that
Hispanos had failed to stand by them in the 1847 uprising against
the American administration the Indians said they would not join
the Hispanos in their fight.

An uneasy calm was restored in late December, and in his
January 4, 1899, letter to Blumenschein, Phillips revealed
his feelings about the confrontation, which had stemmed
largely from his own reactions to a cultural environment still
new to him. "The papers said we did not understand about
taking off our hats," wrote Phillips. "But I want to tell you
that we knew before they spoke what was wanted, but as I
had said that I would not do it for any 'blamed Mexican'
in the afternoon, and as Photo [Myers's nickname] was of
the same mind you can bet your last copper on what would
happen if they tried." Phillips had possibly been harbor-
ing resentments against local Hispanos since his first days in
Taos. In the same letter he reminded Blumenschein of the
small dog named Tip the two artists had owned when they
had first set up camp in the vacant field in Taos. When Tip
had been poisoned within days of their arrival at the new
site, Phillips had been quick to attribute the pet's death to
someone in the Hispanic community.

Although Blumenschein would have likely had a similar
reaction in the matter of removing hats, he probably would
not have felt the same as Phillips did as the event unfolded.
Blumenschein did not wholly share Phillips's inclination to
romanticize the violence-prone West. For Phillips, the affair
offered satisfying confirmation of the truth of those tales he
had long heard about the Old West. He felt a bonding with
those who protected him during the incident, and a sense
of having become part of the West; he was no longer just a
mere observer or an outsider. While in Gusdorf's store with
his friends at the height of the tension, Phillips wrote Blu-
menschein, "I began to feel as if this was real 'border life'
and only wish old Kit Carson was here with us." Influenced

by his youthful reading, Phillips seems to have regarded the entire affair as a test of his manhood. "We are 17 strong tonight," he wrote while holed up in Gusdorf's store. "We have as good a body of men to die with, if necessary, as a fellow could ask."

Phillips characterized the Hispanos angry about the shooting of the sheriff as "a mob of Mexicans" and the sheriff himself as "a dammed drunken cuss." Emphasizing his bravery and that of his newfound friends, he added, "We heard of his [the sheriff] being killed and fully realized our position but the damned cusses didn't scare us." He noted, however, that he was hoping for reinforcements "from among the miners," who were predominantly Anglo.

The views Phillips developed after the bloody clash in Taos in late 1898 would later become anathema to him. But the artist was still carried away by the battle when he wrote Blumenschein that he wanted "Marshal Law here—I really hope so as then they [the Hispanos] would have to pay their taxes and failing in that would be crowded out of the Country." When Blumenschein rather sensibly wrote back that he thought Phillips might be "overreacting" due to his "high strung" nature, Phillips promptly told him that you too might have "taken a tighter grip on the handle of the old '44' and ground your teeth a little." As a justification for his brash behavior, he added, if only "you could have seen the Mexican mob and heard that ominous rumbling sound." Although the unsettling strife of late 1898 proved to be an isolated episode in both village life and Phillips's life, it underscored for Blumy the enormous differences between his present environment and that of Taos.

Blumenschein liked New York life for something more than its creature comforts. He was footloose and fancy free, his heart uncommitted, and as his income and professional status grew, social activities became an increasingly pleasurable part of his life. While staying well within the bounds of contemporary convention, he could and did be-

come something of a man-about-town, relishing the many chances to meet young people of similar interests that a large city offered. From Taos Phillips wrote, "Not having heard from you I made up my mind that you had returned to the land of pretty girls, ice-cream and the theatres. By this time you have undoubtedly plunged into the whirlpool of dress suits, linen collars, late lunches, etc."

Blumenschein had several semiserious flirtations, and his tendency to play the role of eligible young bachelor with gusto was what prompted this comment from Phillips, whose own personal life was moving in quite the opposite direction as his relationship with Rose Martin deepened. Delighted with his own newfound happiness, the idealistic Phillips was inclined to encourage any signs of a similar emotion he sensed in Blumenschein. In truth, Blumenschein was far from ready for love, much less for commitment to a wife. But when Blumenschein wrote that he was regularly seeing a young woman named Susie Smith, whom Phillips knew from his previous time in New York, Phillips assured his friend that he was "delighted with the tone of your remarks about 'Susie.' She's a sweet girl . . . and I believe you are both [at last] settled down." He should have known better, as Susie soon proved to have been nothing more than a replacement for a girl named Kit, who had preceded Susie as the object of Blumenschein's attention.

According to Phillips's biographers, Julie Schimmel and Robert R. White, Blumenschein and Phillips were in total agreement on one subject. Within a year of their initial discovery of Taos, the two had come to see the place as the perfect location for an art colony that could hold its own against the claims of the nation's best. Their goal was similar to that of the artists who established the Hudson River School because they were enamored with the mountains and valleys of New York and adjacent states. The notion of Taos as an art center did not come to Phillips and Blu-

menschein all at once; nor did it play a role in their initial response to Taos. But by late summer 1899, they were writing to each other about attracting other artists to Taos. They envisioned the kinds of artists who, by virtue of their concentration on the same spectrum of subject matter and commitment to the same principles of artistic excellence, would compose a school of art analogous to the Barbizon School of French painters. Phillips began to speak with some confidence of the eventual development of a "Taos School" of art. Inspired by his growing commitment to the idea, he wrote Blumy, "For heaven's sake tell people what we have found! Send some artists out here. There is a lifetime's work for twenty men. Anyhow, I'm lonesome."

Intrigued by the art colony idea as much as Phillips was, Blumenschein was more than ready to spread the word about Taos. What he was not ready to do was become a participant. Notwithstanding his socializing proclivities, he was a complicated man, with a brooding, restless side. At this time in his life, he was frustrated by his simultaneous commitment to three goals, each of which was bound to conflict in some manner with the others. He liked his New York-based career and wanted to make a name for himself in illustration. He wanted to be part of Taos, and he endorsed the idea of Taos as an art colony. But he was also deeply convinced that he needed further art study abroad.

Further complicating the predicament of three coexisting goals that he could not accomplish in one place at one time was a Blumenschein trait that had been (and would continue to be) part of his persona throughout his life, particularly in 1899 and 1900. He was never completely satisfied, be it with a painting, a person, or a place. Even when he had made all the relevant choices himself, he was quick to become dissatisfied and ever ready to be critical of his decisions. These attributes could be seen as signs of an objective, clear-headed man not given to turning a blind eye

to the shortcomings inevitably present in earthly beings and earthly places or as signs of an inherent inability to be happy without reservation.

In 1899 Blumenschein liked the income available in New York but thought Paris offered better art training. He liked Taos for its painting opportunities but thought he was not ready artistically or financially to take advantage of them. By summer's end in 1899 he had made his choice—Europe. Having put aside a portion of his earnings for just such a purpose, he wrote Phillips that his desire for further training had won out against his other priorities. Phillips responded on August 11, "Glad you have the opportunity to go to Paris but am surprised it will be so soon." Blumenschein sailed from New York in early September.

No longer a novice in either art or the ways of the French, Blumenschein moved with ease back into life as an American in Paris. The money he had saved was sizable enough to permit him a relatively high standard of living. Moreover, the pleasant studio apartment he rented in the Latin Quarter was a distinct improvement over the small flat he had occupied his first two years in Paris, when his father supported him. Working under several of the same academic painters at the Académie Julian with whom he had previously studied, Blumenschein divided his time between studio classes and private study at the Louvre.

But even having chosen Paris, even having made art study his priority, he maintained an active, if long-distance, relationship with the Taos that represented his tomorrow if not his today. His ongoing engagement with Taos was largely attributable to Phillips, who was proving to be an indefatigable supporter of northern New Mexico, for not only its art potential but its economic potential as well. His efforts to convince Blumenschein to invest in local resources were not entirely successful, however, even when he made the idea more appealing by including Blumenschein's close friend Ellis Parker Butler in his somewhat grandiose plans.

Phillips envisioned contributing to the viability of an art colony with an income from gold mining, cattle and sheep, and even ownership of a local newspaper. He would spearhead the mining through an interest he had purchased at a site called Amizett, located fourteen miles northeast of Taos, in the Rio Hondo Canyon; Blumenschein would invest in livestock; and Butler, a businessman and an aspiring writer, would buy and publish the *Taos Cresset*.

Despite the disagreements over specifics that punctuated correspondence among the three, Phillips remained optimistic even when Blumenschein made it clear that investing money in the hopes of striking a rich vein of gold was not for him. "As you run to sheep and cattle," wrote Phillips on September 25, 1899,

> I doubt whether we could bring you over [to mining]. . . . But if the overall scheme goes through, we can come together better prepared for a mutual aid to each other. You & Butler with new experience of the World & I with the necessary local knowledge including Spanish. Each of us having a decided individuality in an undeveloped state gave us many misunderstandings which will not exist later. We'll then be more like the group of Barbizon painters & writers.

The Barbizon colony included Millet and Corot, who with their colleagues had established an art colony in the mid-nineteenth century in the pastoral village of Barbizon, in northern France, where they, like Blumenschein and Phillips, had hoped to focus on rural life and landscapes.

Blumenschein, however, continued to view his illustration income as more reliable than the nebulous investment plans under discussion. On November 7, 1899, he wrote Butler that his "desire to get to Taos" and settle down to work only intensified this need to secure an income through illustration. As for Phillips, he now had a more compelling reason than ever to seek a measure of financial stability, whether through art or through business ventures. On

October 11, 1899, he and Rose Martin were married in a quiet little ceremony performed, perhaps intentionally, while Rose's brother, Dr. Martin, was in Santa Fe. With Rose's family in Pennsylvania as well as Dr. Martin's wife all adamantly opposed to the marriage, the two young people probably did not wish to place the good doctor, who had given them his blessing, in the position of appearing to defy other family members.

Phillips, described by observers as having "warm, kind, brown eyes," was thirty-one, and Rose was thirty when they started married life with a honeymoon trip on horseback to Santa Fe. There they spent several days at the busy La Fonda Hotel. When they returned to Taos, Phillips spent part of the time working his mining stake with his own hands. In November he formed a partnership with Frank Staplin, owner of the *Taos Cresset*, and opened the Taos Indian Curio Shop across the road from Dr. Martin's house.

Throughout much of 1900, the investment plans of the three men living in Paris, New York, and Taos underwent numerous changes before becoming the subjects of a growing disagreement and eventually falling by the wayside. Butler, who had married in 1899, reconsidered his options after the *Taos Cresset*'s owner refused to sell the paper to him; Phillips failed to strike gold and lost money in his mining venture; and Blumenschein met with resistance when he suggested ideas that differed from those of Phillips.

Responding to Blumenschein's proposal that the Taos artist invest in a large studio where they could share space, Phillips wrote, "The big studio may possibly blossom when we irrigate it a little but at present I can't think about it." By August the correspondence between the two artists reflected a need to restore harmony and to repair what had become a somewhat strained relationship. "You, yourself and 'Bute' are more than welcomed to Taos," wrote Phillips, "but I must say that while your plans are made in Paris, mine are made right here and because I have not embraced

all your schemes don't think that implies any lack of welcome to yourself."

In late August Butler informed his friends that he and his wife had decided not to move to Taos. On September 7, Phillips wrote Blumenschein,

> Sorry I am about 'Bute' & wife not coming, the boy is making a mistake, perhaps, but if he does his duty as he sees it there will be no mistake except from our standpoint. Certainly the field for him here is rich, house-rent a mere song, & various ways to make a little money. The Cresset idea is out of the question except Staplin [the owner] would probably rent the stand for a year or two while he studies law but he would not sell[;] besides he is the only fellow in the U.S. who could succeed with it. He has a combination of experience, friends & talent.

As if all these obstacles were not enough to roil the waters, Blumenschein even managed to offend Phillips by sounding a note of unbridled pride in his own artistic abilities. Although this pride was momentary, because Blumenschein swung from confidence to discouragement with some frequency during this period, his comments led Phillips to address his friend with his usual frankness: "I don't like the way your letter started out although I'm not surprised that you still have the exalted opinion of yourself, you always did think you were the whole push." Blumy tactfully responded to Phillips with a combination of modesty about himself and praise for Phillips. "Your letter is a Jim-dandy," wrote Phillips in return, "and just what you needed to write to open the door of my heart as I feared you had changed but now I know you are the same 'old boy' only better if anything for a few more years of 'horse-sense.' Barring the fact that you laid on a little taffy & flattery the letter a gem."

By the end of summer 1899, Blumenschein had saved enough money to return to Paris for one year. His timing could not have been better; 1900 was a banner year

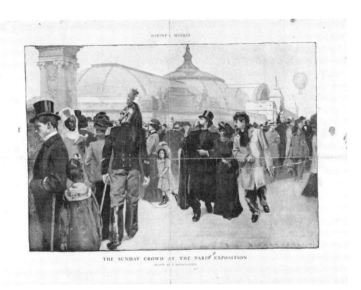

THE SUNDAY CROWD AT THE PARIS EXPOSITION

The Sunday Crowd at the Paris Exposition. Illustration for *Harper's Weekly,*
May 5, 1900. 41 × 58 centimeters. Courtesy of the Ernest L. Blumen-
schein Papers, 1889–1960, Archives of American Art, Smithsonian Insti-
tution, Washington, D.C.

for Paris as it hosted the Exposition Universelle, which sur-
passed even the highly successful 1889–90 event in size and
popularity. Capitalizing on the growing fame of France's
symbolic Eiffel Tower, the six-month exposition, starting in
April, drew large crowds and attracted the attention of many
nations, including the United States. Taking note of reader
interest, *Harper's Weekly* commissioned Blumenschein as its
on-site illustrator to provide sketches and watercolor scenes
of this cultural, scientific, and entertainment extravaganza.
Blumenschein made good use of this opportunity. Ener-
getic as ever, he took time from his studies for visits to the
exposition site, while grumbling about the "outrageous"
cost of a cab ride to get there. Curiously enough, the art-
ist was within walking distance; his illustration commissions

must have been enough to overcome the frugality that had marked his earlier years in Paris.

The portfolio of colorful scenes Blumenschein sent back to New York effectively evoked the gracious Parisian ambience, including the lively curiosity of exhibit visitors and the wonder of all things that were new by the turn of the century. *Harper's* published many of the illustrations in a single issue, giving them a high profile sure to be noticed by readers. The artist himself believed the double page spread in Harper's "helped [his] reputation back in United States considerably." During 1900 Blumenschein also illustrated several articles on French politics for *Harper's*, and he sold the magazine several scenes of the American West he had done from memory.

Intent on absorbing all he could of Europe's rich cultural heritage, Blumenschein used the proceeds from his commissions to finance a trip to Italy, where he took in the standard landmarks of classical and Renaissance architecture, sculpture, murals, and paintings. Back in Paris he continued to concentrate on mastering the Salon-endorsed academic style. At the same time, however, he did at least one private painting that hinted at a desire to break free of tradition. When he persuaded a young then little-known dancer named Isadora Duncan to pose for him, he employed nonrepresentational swirls of color around her moving figure to suggest the dynamics of dance.

Blumenschein periodically revealed a desire to break free from the formulaic demands of the illustration world as he had done in his Duncan painting. His conflicted attitude toward illustrations shows clearly in his frequently changing statements regarding his future in art. At times he saw illustration as an economic necessity; at other times, when his confidence was at a low ebb, he saw it as perhaps the best he could hope to achieve. Indeed, in a January 1900 letter to Butler, he expressed a readiness to jettison illustrations for the sake of pure art.

Am working in school and happy with my painting . . . study of the grand pictures in the Louvre. I hope I'll not have to return to il-lustration, and will make an effort to borrow money if necessary, in order to get to Taos where living is cheap and inspiration on every hand. Nature is doing the best she can for me and I'm growing in the right way at last. If I can only keep up my painting and study (which is possible in Taos) I may eventually do something in the picture line. Painting is my joy and I'm enthusiastic and interested.

Blumenschein was at least open to the possibility of mak-ing changes in his art and in his illustration career, but he was downright close-minded when it came to matters of so-cial propriety. The flouting of conventional social mores en-demic to the bohemian lifestyle found in Parisian art circles drew Blumenschein's ire. Determined that Paris would not change him, he seemed to embody the spirit of contempo-rary American Puritanism. As was so often the case, Ellis Parker Butler was the recipient of Blumenschein's bluntest and most heartfelt sentiments. " I've had my fill of Paris and its bad air," the latter wrote in late 1899.

If I'd live here a year I think I'd lose all the native refinement I ever possessed. I was improving rapidly in America, I thought, in the matter of development mentally and morally. I was just beginning to appreciate the comparative value of thoughts and their relative benefit. Here the atmosphere would cause a lily to droop her head and die of shame. I may be an idealist, but if that means to sub-merge the dirt and nastiness I'll remain one.

Blumenschein's scathing criticism of the loose moral behavior of Paris as he saw it was no doubt aimed at ele-ments of the art community. The fairly sharp line between traditional and avant-garde art in turn-of-the-century Paris might lead one to assume that conservatism in art equated with conservatism in lifestyle, while modernism begat free-living artists of a pronounced bohemian bent. But despite the example of Blumenschein, a traditionalist in both art

and social values, there was no generalized equation be-
tween art style and lifestyle. Pablo Picasso first came to Paris
in 1901 and was soon identified with both iconoclasm in
art and freedom in living, but just as revolutionary in artistic
purpose was his contemporary Matisse, who throughout his
life was the very model of reserve, self-restraint, and bour-
geois living habits.

Fear of, or contempt for, certain aspects of Parisian life
did not, of course, drive Blumenschein away. On balance,
he liked the benefits of the city's superb art training far
more than he disliked its unconventional elements. He re-
mained in Paris for a full year, and then, almost as suddenly
as he had decided to come, he decided to leave. Because he
was not accountable to anyone but himself, he never fully
explained his departure from France in September 1900.
His reasons, however, were no doubt the result of several
factors: his once adequate funds were starting to dwindle;
most of the lucrative illustration commissions could only
be fulfilled on-site in America; and he may well have begun
to miss his family. He had become particularly close to his
sister, Florence, since his early days in the East at the Art
Students League. She had married in July 1900, and he
looked forward to meeting her husband, Frank W. Rowe, at
the couple's home in Westchester County, New York, where
Rowe worked for the Johns Manville Company.

Clear, crisp autumn air brightened both the New York
skyline and Blumenschein's mood as he disembarked from
the crowded steamship that had brought him home. But
almost before he had time to plant his feet firmly again
on American soil, much less take time for family visits, he
found himself awash in temptations he could not resist.
These came not in the form of wine, women, and song
but in high-paying commissions. Any thoughts he may
have harbored of borrowing money for immediate travel to
Taos were quickly subsumed in the heady realization that
although he had been gone, he had not been forgotten;

editors were ready to give him plum assignments, offering sound prospects for enhancing his reputation. American magazines were responding to a diverse range of interests among their readers.

In 1900 the short story had widespread appeal, but so did hard-hitting articles exposing graft in government, abuse of workers by companies, or price–fixing by business cartels. At the same time, Americans on farms, no less than Americans in cities, were proud of the nation's transformation from an agrarian to an industrial society. There was, in fact, a tremendous response to articles explaining how natural resources found in specific regions became products benefiting all the country's regions. Blumenschein often commented that his participation in the journalistic effort to quench the public thirst for knowledge played an important role in his own education.

Within days of his arrival in New York, Blumenschein was asked by *Century Magazine* editor Richard W. Gilder to illustrate a series of articles on the subject of heavy industry in the Midwest. Glad of the chance to replenish his funds, even if the assignment was a far cry from the painting he had been doing in Paris, Blumenschein accepted the offer. Packing his bags, he traveled with author Wilson Fawcett to the sites the story would focus on. Working first in Duluth, Minnesota, Blumenschein displayed through his art the productivity of the nearby iron-mining region. He then moved on to the Great Lakes to illustrate the process of ore transportation. For his illustrations in the last article, he went to Pittsburgh to observe the steelmaking process at the Homestead Steel Smelter. "These illustrations were hugely successful," Blumenschein later wrote, adding that Gilder "became one of the greatest friends" of his illustration period.

Among the varied assignments that followed, one that stood out took Blumenschein to the Crow Creek Reserva-

tion, one of the Lakota Sioux reservations in South Dakota, where he spent the summer of 1901 doing a series of small oil paintings and sketches to illustrate a book titled *Indian Boyhood*. Its author was Charles Alexander Eastman, a medical doctor in his early forties who was half white and half Sioux. His book was a memoir of his experiences growing up on the reservation. Blumenschein's easy rapport with him was probably due in part to Eastman's grandfather being the frontier artist Seth Eastman.

Blumenschein was also able to win the trust of the Indian boys who posed for him. He played baseball with them, and with their goodwill he was able to depict both these young people and their families in a realistic and sympathetic manner. At the end of the summer he went to Taos and spent several weeks completing the paintings. When published in October 1902 by *McClure's, Indian Boyhood* had a full-color painting by Blumenschein on the front cover as well as a color frontispiece, three full-page illustrations, and numerous drawings. The book became a best seller and remained so popular that it was regularly reprinted in several editions over the following forty years.

The early success of *Indian Boyhood* was somewhat surprising. Although Indian crafts were popular with tourists, and paintings of Indians drew public attention, the *Santa Fe New Mexican* reflected a substantial portion of public opinion when it editorialized in its May 8, 1900, issue that the

> large Indian reservations in the west are a hindrance to the growth of the sections in which they are located. . . . The government could do nothing better for the western commonwealths than to throw open all the Indian reservations to settlement. Those Indians who could not be reconciled to more civilized modes of living might be taken to Yellowstone Park, which will remain national domain anyway, and which would make a good reservation for Indians and buffalo.

Indian Boyhood would play its part in the gradual shift in public opinion toward more favorable views of Native culture.

In November 1901, Blumenschein's work was exhibited at the Carnegie Building in New York, confirming the artist's acceptance as a respected illustrator and emerging fine-art painter. Indians and the West were the subject of many of the pieces displayed. But it was during this same period that Blumenschein's long-standing relationship with *Harper's* came to an end. No illustrations by Blumenschein appear in either *Harper's Monthly* or *Harper's Weekly* after 1901, although his work continued to be regularly featured in all the other major magazines. Records do not indicate the nature of the breach, but it is possible that Blumenschein displeased the editors in some way, for it was highly unusual for a magazine publisher to abruptly end a connection with an established illustrator. Another possibility is that *Harper's*, who also dumped Remington around this time, was acting on a shift of interest away from the West.

That Blumenschein was in good standing with his fellow artists was not in doubt. He became an enthusiastic member of the Salmagundi Club, a group of artists whose founders had initially met as the New York Sketch Club in 1876. The organization held meetings and social functions at several New York City locations over the years, such as at 47 Fifth Avenue and 14 West 12th Street in Manhattan. On April 15 and 16, 1902, Blumenschein participated in an evening of "vaudeville" given by the club, performing a skit called "Dance of the Sunflowers."

He put his free time to more serious use as well, meeting at length in May with his old friend E. Irving Couse. Blumenschein used these friendly visits to persuade Couse that no better place than Taos could be found to paint Indians. Couse remembered Sharp's similar view and was well acquainted with Phillips, not only from their Paris days but from prior study together at the National Academy of De-

sign. He was sufficiently impressed by Blumenschein's endorsement of Taos to immediately write Phillips, who not only urged Couse to come and help him found an art colony in Taos, but also found him a house in the town.

In late May, Couse, his wife, Virginia, and son, Kibbey, reached the west rim of the Rio Grande Gorge by train. They proceeded by coach eastward across the gorge into the picturesque village of Taos, where they remained for several months before deciding to make Taos their yearly summer home. The great Frederic Remington also spent a good part of 1902 working in Taos, although he never made Taos a permanent home, as Couse finally did in 1928. Highly responsive to the landscape, Remington wrote of how "the mountains scallop skyward, range after range— snow-capped—beautiful—overpowering."

Shortly before meeting with Couse, Blumenschein had signed a contract with *Century Magazine* to illustrate five articles on the "Great Northwest" to be written by the well-known Ray Stannard Baker. During the summer of 1902 the author and artist traveled to this region to work on the project. Blumenschein later said the series had required extensive research and taken "almost a year to finish." He wrote his father and stepmother in Dayton that, despite some "rough" travel and less-than-ideal food and lodging, he found it "very exciting" to see and sketch the large-scale open-pit mining around Butte, Montana; the great stretches of pristine forest in Washington; the thriving grasslands of Wyoming; and the magnificent scenery in Yellowstone National Park. William Leonard Blumenschein could hardly have doubted by now that his son was earning a respectable living.

If that was indeed his father's happy conclusion, it may have been a bit premature. No sooner had Blumenschein returned to New York from the Northwest in December 1902 than he began to have strong feelings about what he called "the limitations of illustration as a satisfying creative

art." By early 1903, he later wrote, he had "decided to go again to Paris for further study." Certainly his high income enabled him to do whatever he wished to do, but why did he not consider either moving to Taos or dividing his time between Taos and New York? He likely did not yet feel fully adequate to accomplish his goals in painting, and perhaps, even probably, his still restless nature played a role in his decision. Clearly, something pulled on his cultural instincts, convincing him that Paris had what he was seeking, despite his complaints about the city's "bad air" and "low morals."

His decision to absent himself once more from the New York publishing scene definitely did not stem from any dearth of commissions. He regularly turned down offers for lack of time, such as a request to illustrate two articles on the Southwest for *Century Magazine*. "Couldn't accept," wrote Blumenschein, because of the need "to finish 'Indian Boyhood.'" This job was then given to an unknown artist, Maxfield Parrish, who "made his reputation on these pictures." In the end only the scale of Blumenschein's ambition and his long-term approach to a career in art can account for his third sojourn to Paris. With ample time to prepare for the traditional fall sailing, Blumenschein was more than ready for his fifth Atlantic crossing. He knew what to expect, what necessities to take with him, and what costs he would incur while in Europe. And his sense of security and freedom was much enhanced by the "$3,000 in pocket" he had with him when he set sail for France in September 1903.

7

In the City of Art and Romance, 1903–1905

Throughout the years Blumenschein periodically lived in Paris, an equally dedicated young artist named Mary Shepard Greene also studied and painted there. Even though both participated in the American art community's social activities, the two had not yet met when Blumenschein returned to Paris in September 1903. Their paths had not crossed, because Mary Greene did not quite fit the mold of the typical American student in Paris, while Ernest Blumenschein was fairly representative of the art group as a whole; his acquaintances tended to be artists whose ways of life were similar to his own.

The American students who came to Paris over the years from the 1860s into the early twentieth century were admittedly a highly diverse group. They represented widely differing degrees of talent, various social backgrounds, and the differing temperaments usually found in any self-selected grouping. There was, nevertheless, an overall profile of the typical art student from the United States. The Americans who studied art in Paris were mostly male. They usually came unaccompanied by a family member, and most of them remained in Paris for no more than two or three years due to financial constraints and the need to get on with the business of earning a living. Mary Greene, on the

other hand, not only was a serious and ambitious female artist but had come to Paris with her mother. Indeed, in 1903 she was still living with her mother as she entered her fourteenth year of residency and art study in Paris. Her extended tenure was made possible by family money more than sufficient to finance a comfortable life in the world's great art capital.

As Ernest would soon discover, Mary's background differed from his own in significant ways. He had lost his mother; hers was the center of her life. He had spent his youth in an environment where there had been little extra money; she had been raised in a sheltered, indeed privileged, atmosphere in which money had never been a cause for concern. He had grown up in a town in the American heartland, while she had lived all her life in urban settings. He had an essentially negative parental relationship, in which his youthful interest in art had been discouraged by the family authority figure. Her parental relationship was essentially a supportive one, in which her interest in art was praised and nurtured.

The differences in their backgrounds may have contributed to the differences in their characters. Ernest was ever seeking to assert and prove himself, and he could be needlessly brash and outspoken. Mary tended to be passive and gentle in her responses, exhibiting a propensity for understanding, empathizing, and seeking compromise in confrontational situations.

Born in New York City on September 26, 1869, Mary was the second child of Rufus and Mary Isabel Shepard Greene. Rufus Greene was a wealthy businessman who had moved to New York from the family home in Providence, Rhode Island. He died in 1884, when Mary was fifteen years old, leaving her and an older brother, whose future seemed secure as he was already studying for a medical degree. Mary and her mother continued to live in the family brownstone in Brooklyn and became closer than ever as Isabel Greene

devoted much of her attention to providing a secure environment in which her daughter could develop the artistic talent she had shown since early childhood. Mary attended Adelphi Academy, a private girls' school, and she studied art at the Pratt Institute in Brooklyn.

When Mary was twenty years old, mother and daughter decided to go to Paris. They rented an attractive apartment in the Latin Quarter, and with servants to make their life easier in a foreign country, they soon came to appreciate the vibrant cultural sophistication of the gracious old city. Mary felt her art study was so beneficial that a year quickly became a decade. During this time Mary studied with several painters, most notably Raphaël Collin and Herbert Adams. She also took classes at the Académie Julian, although her private study with Salon painter Collin counted the most. Lasting for close to fifteen years, the experience influenced her development as a classically trained artist in the romantic realist tradition. Among the paintings Mary completed during this period were *A Fugitive Glance*, which won a medal from the Paris Salon and was exhibited in the Pennsylvania Academy of Fine Arts' Seventieth Annual Exhibition in 1901, and *A Little Story*, which won her a second gold medal from the prestigious Paris Salon in 1902. Like artist Rosa Bonheur, she was one of the first women to receive this coveted award.

In her own way Greene was contributing to the growing presence of women in fields previously dominated by men. During the time she was in Paris, Mary Cassatt, seven years her junior, was carving out a place for herself among the impressionists. At about the same time, the irrepressibly independent Bonheur was also achieving fame with her paintings. And in 1903, the very year in which Greene and Blumenschein would finally meet, Marie Curie, who had come from Warsaw in 1891 to study science at the Sorbonne, shared a Nobel Prize in physics with her husband for the discovery of radium.

By fall 1903 Blumenschein had become very comfortable with the familiar, pulsating patterns of Parisian life. Consequently, well before the onset of the cold gray winter months, he had established a workable daily regimen, alternating private painting with his work on illustrations. Given his renewed commitment to fine-art painting, his allocation of time for illustration commissions appears at first blush to be something of a contradiction. But Blumenschein did not have it in him to go cold turkey in cutting his lucrative ties to the publishing world. By this time, however, he had discovered that his unassailable status as a front-rank illustrator had given him considerable leeway in choosing which commissions to accept. From the commission offers "that continued to come from America," he said, he favored those, including some from book publishers, that allowed him to approach illustrations as paintings "done in full color as art problems." He did his work in a Latin Quarter studio apartment at 18 Rue de Boissonde, a street where gracefully stylish buildings offered living arrangements more spacious than those found along the many side streets, which featured tiny flats for the art students and down-and-out bohemians.

Perhaps showing a German penchant for discipline and organization, Blumenschein structured his fine-art painting time to avoid the drift and distraction that might easily subvert a young artist living in a city brimming over with enticements to do little more than eat, drink, and be merry. Rather than work entirely on his own during that half of each day devoted to private painting, he studied with two artists, Lucien Simon and René Menard, according to Laura M. Bickerstaff's study *Pioneer Artists of Taos*. These painters offered classes in the portraiture and landscape skills Blumenschein wished to master. The result, he said, was that his "paintings improved to the detriment of the illustrative quality."

Several of the illustrative commissions Blumenschein ful-filled, however, benefited from his growing artistic ability because of their subject matter. As a frontispiece for *In-dian Fights and Fighters*, by Cyrus Townsend Brady, Blu-menschein did a painting of Lieutenant Colonel George Armstrong Custer and his Seventh Calvary officers and sol-diers surrounded by attacking Indians at the 1876 Battle of the Little Bighorn. The artist's second effort to depict the Custer battle was one of his first forays into the historical painting genre, and he was successful enough in combin-ing the requisite amount of blood and gore with the ex-pected idealized valor of Custer's doomed troopers. The book's satisfied publisher reproduced the frontispiece as a stand-alone print. In fact, the print was widely distributed to a public still surprisingly interested, almost three decades later, in the tragic and controversial demise of Custer and his men.

During 1904 the illustrations Blumenschein had com-pleted before leaving the United States appeared in major American magazines, including those accompanying a *Cen-tury Magazine* article on Utah's Cache Valley. Indeed, Blu-menschein's illustration career flourished during his third stay in Paris. A *McClure's* editor wrote him on July 27, 1904, after receiving illustrations from him, saying the "cheque will be sent you very soon" and praising his work as "perfectly stunning! Not only far and away the best things you have ever done but among the very best things of the kind I have ever seen."

Still, the demands of illustration did not deter Blumen-schein from pursuing his goals in fine-art painting. Booth Tarkington, when making his first visit to Paris in late 1903, suggested that Blumenschein do a portrait of him, the artist agreed, armed with a growing confidence in his potential. The Tarkington portrait, completed after several months of work, captured the creative, searching nature of the newly

famous writer. Yet it also conveyed aspects of his charac-
ter open to varying interpretations, including a condemna-
tion of his moral weaknesses. There is no way of knowing
whether Blumenschein, in choosing to show Tarkington
with a lighted cigarette in hand and an empty liquor glass
by his side, was consciously or unconsciously expressing his
own view of his friend's character flaws as a drinker and con-
stant smoker. He may have seen these elements in his por-
trait as nothing more than characteristics of Tarkington's
lifestyle and therefore means of adding pictorial interest and
context to the painting.

Tarkington's response to his portrait was somewhat am-
bivalent. In taking the unusual step of writing on the por-
trait itself a dedication to his wife, Louise, was Tarkington
acting in genuine ignorance of the unwritten rule, which
Blumenschein believed, that a painting should not be de-
filed, or was he just indicating his dislike of the painting?
In any case, the incident put a temporary damper on the
friendly relationship between author and artist. The portrait
was, however, a fine likeness, and this was eventually rec-
ognized by Tarkington, who hung it in his Indiana home.
More important, he used Blumenschein's portrait as a fron-
tispiece for his last book, *Your Amiable Uncle*, a collection
of letters written from Paris to the author's nephews.

No such falling out, however temporary, marred the art-
ist's relationship with another American friend, Ellis Parker
Butler. Throughout the Paris years, Blumenschein and the
popular humorist and writer shared confidences in a series
of spontaneously written and sometimes highly opinion-
ated, but always honest, letters. In the slightly offbeat young
New York writer, whose sense of humor was as dryly acerbic
as his own, Blumenschein found a correspondent he could
trust to be discreet and nonjudgmental. His close relation-
ship with Butler dated back to 1897, when they had lived in
the same boarding house. Because Butler was not a member
of his family or in the art world, Blumenschein felt no need

to impress him, nor was he hesitant in expressing to him his most personal feelings with rare candor. Butler in the early 1900s was basking in the glow of success as such satires as his "Pigs Is Pigs" found publication in major books and magazines. The writer returned Blumenschein's friendship with unstinting admiration for his status as an artist; on one occasion he unhesitantly wired $500 to Blumenschein in Paris when he learned that his friend's finances were shaky enough to threaten his art study.

In need of moral support and comradeship in a country not known for easily integrating foreigners into the mainstream of family life, most American painters studying in Paris belonged to the American Art Association. This group provided an outlet for youthful high spirits by offering a lively mix of entertainment and social events. For Blumenschein, those evenings spent at the club's Latin Quarter meeting place were a welcome respite from the serious work done during long days of standing thoughtfully before a canvas with brush and palette in hand. He played bridge, he went to dances, and he was not averse to participating in the group's amateur theatrical shows.

Artists though they were, the American students reflected with little deviation social attitudes that prevailed in their homeland. Every year they presented a minstrel show rife with broad satire and stereotyped imitations of African American singing and dancing. Whether these shows led to the popularity of African American entertainers in Paris in later years is not known for sure, but it is certainly possible. Blumenschein cheerfully agreed to appear in blackface in a much-anticipated minstrel performance scheduled for December 1903. Playing to a friendly audience ready to overlook amateur glitches, the show's actors were greeted with applause and laughter on that appointed night. Smiling and clapping as enthusiastically as anyone was a fashionably dressed young woman whose soft brown eyes fastened more than once on the slender, energetic form of

one particular performer. As final bows were taken by the exuberant players, Mary Greene asked the friend seated beside her the name of the young man who had caught her attention. The friend responded by taking Mary's arm and guiding her backstage for a formal introduction to his longtime acquaintance Ernest L. Blumenschein.

With the festive evening rapidly drawing to a close, the two artists had time for little more than a brief exchange of pleasantries. But it was time enough to convince Mary that she had been right to follow her instincts about Ernest, and that this first meeting would not be the last. Within days they saw each other again in a more private setting, and within weeks they were regularly together for leisurely walks, long talks, and intimate suppers. They even had late afternoon teas at the home Mary shared with her mother. Mary's attraction to Ernest was such that he had no need to try to impress her. His own feelings of attraction for this woman, however, so unlike any he had known before, were strong enough to prompt him to generously spend his funds to share the glories of Paris with her in the timeless ways of an ardent courtship.

As winter 1903 turned into spring 1904, Ernest took Mary to dances sponsored by his American art club, to elegant nightclubs in the Latin Quarter, to tantalizing bistros in Montmartre, and to the best cafes on the Boulevard du Montparnasse. In later years Blumenschein would declare that he had known immediately that Mary Greene "would play a big part in his life," a claim that may have been more than mere hindsight. Indeed, as early as December 1903, only days after meeting her, Blumenschein wrote Butler to tell him about Mary. He happily confessed that he found himself drawn by her feminine attractiveness, her bright mind and gentle wit, and her knowledge and accomplishments in the field of art.

When Blumenschein met Greene, she was the more established of the two as an artist; certainly he made more

money, from his illustration commissions, but she occupied the more prestigious position as a recognized fine-art painter. Soon after he met her, in fact, Mary won a silver medal at the international art exhibition held in connection with the St. Louis World's Fair in 1904. But from the start, this successful artist never showed anything less than the utmost respect for Blumenschein's work in illustration, seeming to understand both its challenges and its possibilities as an art form.

More important, Mary genuinely believed that Ernest could succeed as a fine-art painter, an opinion that mattered to him in a way that it would not have if she were not herself a painter of proven ability. In the early months of their relationship, Greene and Blumenschein responded to each other with an intensity based equally on romantic attraction and artistic respect. He had been preparing to illustrate a novel by Jack London when he met Mary. Having previously done black-and-white illustrations for "The God of His Father's," a short story by London, Blumenschein was not unfamiliar with the stark tenor of the author's work. But he was determined to do his best for the new novel, and valuing Mary's counsel in matters of art, he took the manuscript to the Greene apartment. There he spent several evenings reading it aloud to her as they jointly considered how best to convey the dramatically stark realities of the story.

Titled *Love of Life*, the novel was the first book-length piece of fiction by an author already known for a vigorously masculine new breed of American short story. "Not a pretty story but solid and with fine possibilities for pictures," wrote Blumenschein in one of his critiques of the novel. To illustrate the harrowing tale of "a man starving and thirsting to death" who is "followed by a wolf in [the] same condition, each waiting for [the] other to die, [I] made four dramatic compositions. Got studies of [the] wolf at Paris Zoo."

London, the illegitimate son of a wandering astrologer, never knew his father and grew up in California with his

spiritualist mother, who taught piano to support the two. As a young man he sailed to Japan, read deeply, and briefly attended the University of California. In 1897, at the age of twenty-one, he went to the Klondike gold fields in Alaska, drawn there by a life of action and with scorn for what he termed the tender minded and effete. The fruit of his Alaskan experience was *The Son of the Wolf*, published in 1900, a collection of short stories set in the Yukon country of Alaska and Canada. London, an admirer of Rudyard Kipling, who also rejected the genteel tradition of much current fiction writing, was the best known of America's younger writers by 1905, when *McClure's* published *Love of Life*. An instant success with reviewers and public alike, the novel enhanced London's reputation and heightened Blumenschein's visibility in the public eye.

Blumenschein received what he called "a very complimentary letter from London." The unconventional author's handwritten note of gratitude, dated November 26, 1905, was short and sincere. "Just a line to tell you how deeply I appreciate your illustrations of *Love of Life*," he wrote. "They are of that rare sort that *helps* the text. My heartiest thanks." The full-color paintings that illustrated the novel also brought Blumenschein what he called his "first great recognition by publishers and critics."

Blumenschein probably felt he had the best of all possible worlds. He was making progress as a painter. His illustration work was bringing him renown. He was in love with a woman who returned his feelings. But problems had arisen in the personal part of this equation. Because his personal difficulties were not easy to resolve, their effect on both of them was akin to clouds that darken previously sunny skies. The first obstacle to their blossoming romantic involvement was Blumenschein himself. His relationship with Mary was the most intense and meaningful he had probably ever experienced. He loved her and wanted her in his life. But simultaneously he felt a need to preserve his emotional indepen-

dence; he was in love, but part of him resisted being in love, and for a simple reason. To love means to care deeply what another thinks, to care deeply about the words and actions of another. To care renders one vulnerable to the other; thus love diminishes, even threatens, one's autonomy.

On June 15, 1904, he wrote Mary a letter that seems to have been a preemptive strike against the loss of control over his life. Casually addressing her as "a." (he had different ways of identifying those who were close to him, but the content of the letter indicates that it was Mary), Blumenschein's words were nevertheless carefully chosen and serious. With brutal honesty, he expressed his fears and concerns about their relationship proceeding to its logical conclusion. Although his conviction in this letter that art would always come first with him no doubt arose out of an admirably objective recognition of where his true priorities lay, his warning to Mary about her place in his life must also be seen as the subconscious response of a man who as a child had loved a mother without reservation only to feel inexplicably abandoned by her withdrawal through death; perhaps he sought to evade the repetition of another such tragic vulnerability. There is also the possibility that his insistence on the centrality of art in his life was prompted by a semiconscious need to impress Mary. At this time she was the better fine-art painter, but he wanted her to know that he was destined to be the greater because he was the more dedicated of the two.

"I love you as much as it seems possible for me to love a woman. I respect and admire all your beautiful qualities, but art is more *necessary* to my life than a woman's love and companionship," he wrote. After declaring that "the artist is the artist to death," he goes on to tell her,

When I am not at work, your love seems to be the joy of my life: your presence etc. But when I return to my self and in the calm air of night come face to face with my old mistress[,] she tells me the

truth—art has the prior claims, art has the soul of the man and his
conscience. All the struggles, the disappointments and discourage-
ments have but bound me closer to my great love, my work, and
all the pent-up feelings, the unborn creations of my imagination,
all the beauties my talent tries in vain to reflect[,] demand[,] and
compel a life of servitude, a life of excruciating pleasure and pain.

To this eloquent elucidation of the artist's mission, Blu-
menschein adds practical considerations. "Do you see ahead
in the future? Do you see what can support the existence of
two artists as well as one? Do you see the possibility of trou-
ble, sickness, of lack of financial success while we try to stick
to the path of truth?" To have both his art and a woman's
love "would be ideal happiness, the fullness of joy," he tells
Mary. "But I don't even know my trade . . . and when I do
can I make a living? This is a gloomy letter, but the truth
and because of that is beautiful and must be respected."

Evidently Mary was not unduly disconcerted by either the
prospect of second-place status in Ernest's life or the specter
of financial ruin for no angry outburst followed her receipt
of this bluntly phrased missive. As the letter indicates, the
two had already spoken about marriage and a life together
as working artists, and Mary's response to her lover's cave-
ats seems to have been based on both her understanding of
the nature of the artist and the fact that she was in love with
him; in truth, she was much too in love to walk away merely
because of trepidations she may well have considered to be
expected under the circumstances.

But even as Mary wisely allowed Ernest to work through
his anxieties about commitment, another obstacle to the
relationship was proving less amenable to patience and un-
derstanding. Isabel Greene was ambitious for her daugh-
ter and zealously protective of what she believed to be the
upper-class social status of the Greene family. She consid-
ered young Blumenschein, who was neither a recognized
name in the rarified world of fine-art painters nor a wealthy

businessman, to be a man from a family of decidedly middle-class social standing. Thus, in her opinion, he was a most unlikely suitor for her daughter's hand.

The elder Greene had tolerated Blumenschein's visits and his friendship with her daughter. But when Mary confided in her mother in late spring 1904 that she was in love with the young artist and that they were thinking about marriage, she was stunned by her mother's adamant opposition. And Isabel was bolstered in her opposition by Mary's friends as well as from various family members who periodically came for extended visits to Paris. With one voice, they all expressed dismay that Mary would even consider marrying a man five years younger than herself, who was nothing more than an aggressively ambitious illustrator and had little to offer her in prestige in the art world or financial security and social position.

At thirty-five years old, Mary Greene might be expected to know her own mind. Surely she had reached an age when she might be expected to have total freedom in choosing a husband. Certainly that was Blumenschein's assessment of her situation. As for his own reaction, opposition from Mary's mother would eventually strengthen his determination to have Mary; in fact, his reluctance to commit himself probably evaporated sometime that summer. But he had not reckoned with Mary's own reaction to her mother's opposition. By September it became clear that the biggest obstacle to marriage, or even to the continuation of a close relationship, was Mary herself. It simply was not in her nature to openly defy her mother. She could not and would not precipitate an emotional break with the woman who had given her affection, protection, encouragement, and the opportunity to pursue a career in art.

Caught between her mother and her lover, Mary sought desperately for a way to bring these two opponents together in some kind of mutual compromise, even if that meant sacrificing the autonomy she and Ernest might have otherwise

had. It was not a stance he readily understood or accepted; he had no such emotional bond in his own life. He wanted his father's approval and respect, but he had never felt for him the trusting affection Mary felt for her mother. Even before he wrote his preemptive June letter to Mary, indicating that his art was his main priority in life, a discouraged Blumenschein had vented his anger and disappointment in a May 3, 1904, letter to Butler, telling him about Isabel Greene's opposition to their serious relationship: "I got all twisted with an ambitious mother with an only daughter and the mother won the game."

For about a year Blumenschein's letters to Butler mentioned his impasse with Mary and her mother's intransigent stance against all talk of marriage. He felt he could confide in Butler given their close relationship and was especially hard on Isabel. In an August 29, 1904, letter he facetiously remarked that if there was an "international race of Old Ladys [*sic*] who could raise h-ll, I would back my prospective m-th-r 'n law . . . for the money just to show how sure I was that it was a cinch." In another letter written later that year, he insisted that Mary's mother "has not any real reason to be proud, except for having helped to create such an admirable daughter, but at times she gives the impression that she is also the mother of Napoleon and Alexander the Great." His critical attitude toward her was matched by his strong feelings toward Mary. She was the "finest girl" he had ever known, he told Butler in a June 20, 1904, letter. "You'll like [her] very much I'm sure. Do you want a momma? We have an odd one to spare." Blumenschein made it clear to Butler that his former girlfriend, Susie, did not compare with Mary, who was, in his opinion, the "best woman in the world."

Characterized by deep emotion on Mary's side and intense single-mindedness on Ernest's, the relationship was strained nearly to the breaking point by sharply differing views on how to respond to Isabel Greene's stubborn re-

fusal to accept, much less approve of, their love. For him it became a simple matter of Mary being willing to emerge into the full status of womanhood, to be a "real woman" by facing the implications of her love for him and defying her mother if necessary. He expressed to Mary his feeling that it was now up to her: if she wanted him, she must act; she must be firm. In an anguished encounter in mid-September, Ernest Blumenschein told Mary Greene that she must make up her mind. If she wanted, above all else, to be "a good daughter" then she should go ahead and do it, accept her mother's will, and let all be as it had been before his intrusion into their lives.

But for Mary the words "real woman" evoked an image quite the opposite from what Ernest envisioned. For her, being a "real woman" meant taking into account the feelings of those closest to her; it meant a willingness to acknowledge what one owed to a loving parent. On September 27 she wrote an impassioned, pleading letter to the man she loved. Although clearly torn between her lover and her mother, it is equally clear that she would not, at least at this point, jeopardize the relationship with her mother for the sake of this romance. Although frightened by Blumenschein's stubbornly defiant attitude and aware that he might walk away forever if the impasse was not resolved in the near future, she reveals a temperament that yearns for harmony and will compromise to achieve it.

Blumenschein, who had abruptly left Paris and gone on holiday to Trieste, Italy, received Greene's letter while he was there. Reading her words, he could hardly have failed to sense her turmoil, as she veered between despair and hope. "Ernest, I feel as if perhaps I am writing almost my last letter to you," she wrote.

> I am beginning to feel that nothing of one's destiny is in one's own hands. . . . Perhaps if we show ourselves reasonable, and thoughtful of others, our romance may come . . . but by that time I suppose

we will be in heaven and painting halos or something. Do you wish to make the best of a difficult situation, because we must. You know I am a girl whom you can trust to help you just as long as she feels she has the same integrity from you.

She tells Blumenschein in her letter that nothing will change "until you have won for yourself a better opinion from my mother." She defends her mother, saying,

No matter what her peculiarities, and she and I have had most kind talks about it all, she is old now and tired and not strong, she has been a good and devoted mother to me, no matter what the mistakes, she has always endeavored to keep me from missing my father's care, and to make me as happy as she could. She has done all that, and I have been a willful girl in return. Because she is my mother and is all that to me, all friends of mine should be most considerate, most attentive and respectful and careful of her slightest feeling, and most of all should the man be that one who professes to love me.

Although Ernest had been a touch sarcastic when he had told her to bend to her mother's will if she must, Mary chose to interpret his words as though they were genuinely meant. "You said for me to go back and be a good daughter again. I am trying to do it, and I want your help in being that and a better woman than I have been this summer. Dear boy this is from my heart. Can we not pull together on that one thing in the future. I have humbly begged her pardon and am forgiven." Mary's goal was to achieve reconciliation with a mother who now "has to forgive us both. . . . You have no idea how badly I feel, and with what 'guiltiness' I am dealing."

The letter revealed the depth of Isabel Greene's dislike for Blumenschein. "Mother has wanted and desired for us to make up our mind not to see each other, that the feeling between us might come to an end. You find new interests which you quickly could, and for me to go about my affairs

as before." She "does not want me to go out with you this winter, but that I am to receive you here. She will make you as welcome as she can." Nearing the end of the letter, Mary summarizes the burden of her message: "If you care for me as you say you do, you must bring yourself to see as I do in this matter." She and Blumenschein must recognize "the rights of my mother and the necessity of conforming to others [*sic*] wishes besides our own."

A headstrong young Blumenschein did not come to any sudden understanding of his antagonist's hostility toward him, and the elderly and protective Greene did not take a sudden liking for her daughter's suitor. Nevertheless, each of them was forced, in effect, by the gentle Mary's insistence on a mutual accommodation to recognize a degree of legitimacy in the other's position: Ernest had a right to see Mary and Isabel had a right to prevent their rush to marriage. However much it went against his grain, Blumenschein accepted the elder Greene's terms. From fall 1904 through spring 1905, he saw Mary only at her home. There were no more blissful walks through the streets of Paris, no more evenings at bistros and nightclubs. Instead, the couple was given a limited amount of privacy to talk as they sat before a warm fire in the drawing room of the Greene apartment. This privacy occurred only after Mary's mother had greeted Blumenschein in civil but restrained tones and then retired to an adjoining room. Ernest's acquiescence to this less-than-ideal arrangement revealed both his determination not to be driven away entirely and his devotion to Mary.

In fact, if he had had any private doubts about his love for Mary, or any misgivings about his ability to commit himself, this period of imposed restraint offered him a respectable and understandable means of distancing himself from her. He could do it gradually or abruptly on the grounds of allowing Mary time for reflection and restoration of her relationship with her mother. Rather than derailing the romance, however, the restrictions only quickened its pace.

Chafing under the limitations of supervised visits, Mary and Ernest began speaking in hushed voices about an elopement. Blumenschein was serious enough about the idea to seek his father's approval as well as his help in obtaining the necessary papers. But if he believed his father would trust his judgment more than Mary's mother trusted hers, he was proven wrong. In a letter dated January 12, 1905, William Leonard Blumenschein graphically responded to his son's explanation of his situation, revealing the dimensions of the problem Ernest Blumenschein had dealt with all his life in confronting a father who often lacked a capacity for empathy.

In words that lay bare the dynamics of his mindset and psyche, the elder Blumenschein came close to being dismissively insensitive to this being his son's first real love. In addition, his word choice surprisingly revealed him to be either a man whose education was too specialized or a father whose response to his son was nothing more than a rather hurried scribble. He focused on the problems caused by Isabel Greene rather than on whether she was right or wrong in her objections to Ernest as a future son-in-law. Leonard Blumenschein was either unable or unwilling to place a priority on the real issues: namely, whether Ernest and Mary were in love, and if they were, whether they were entitled to marry even if her mother objected. The elder Blumenschein's response may have been unduly influenced by his own self-interest; his daughter, Florence, living in New York near her husband's family, was in the midst of a heated dispute with her in-laws and her father had little desire to disrupt his personal peace by listening to complaints about another possible mother-in-law problem from yet another of his children.

Blumenschein's father showed little interest in helping his son in any elopement scheme. "Monday morning broth [*sic*] your vesuvious [*sic*] eruption script and after perusing concluded I would not take action on your request for mar-

riage papers as I intended," wrote the senior Blumenschein. "Blast the mother-in-law! . . . When the old mother-in-law comes along everything is wrong from A to Z. Since this mother-in-law business is as old as history, and always an infernal nuisance—it's a device of the devil's anyhow—we—me and Mom just concluded we would not help you along to the road of misery—just now." Blumenschein's father even brought up his son's career, toward which he had long been ambivalent. "Your artistic instincts would greatly suffer, your peace of mind would only be destroyed, and your happiness would be only make-believe, and your earning powers would be nil, nil and below!"

Leonard then advised Ernest, "Go ahead with your studies and attend to the business you went abroad for. If you and the girl truly love, you can afford to wait until you are both in this country, and until her old Vesuvious [*sic*] blows off her d . . . old head for good!" He added, "Maybe you and the girl will change your minds if you do not see one another so often. Put your love to the test and see if it's 100 fine! Meanwhile take best care of yourself and don't be foolish." Blumenschein's father tended to put his own needs first, and he seems to have expected his son to do the same in conducting his own life.

The feelings of entrapment that had prompted talk of elopement abated amid small signs of softening in Isabel's stance. Although totally unaware of how near her daughter had come to running away with Blumenschein, the elder Greene was reluctantly realizing that she would not be able to separate Mary from the man she loved. Seeing a glimmer of hope at last, the couple renewed their campaign to win the approval of Mary's mother. Success was theirs when finally, in late spring 1905, she agreed to the setting of a wedding date. Blumenschein wrote Butler on April 30, 1905, that Isabel Greene "had a grand blow off" when she finally relented in her opposition to their marriage but since has "let her engines cool off."

Losing no time, Mary and Ernest announced they would be married on June 29. The simple but formal wedding ceremony took place at St. Luke's Church in the Latin Quarter. After a wedding breakfast in a nearby restaurant, the couple left Paris for a honeymoon in the village of Crecy-en-Brie. While nothing short of Ernest's failure to appear could have marred Mary's happiness on her wedding day, a small and somewhat comical incident not only affected the ceremony but coincidentally offered insight into the nature of the man to whom she was pledging her troth.

During the week preceding the wedding, Buffalo Bill's Wild West Show was in Paris, as part of its tour of major European capitals. Busy as he was with illustration assignments and wedding preparations, Blumenschein never considered not going to the show and visiting with its colorful performers, some of whom he knew personally from New York. As he enthusiastically greeted the eclectic array of actors, including Indians, who made up the touring company, he was invited to play in the company's baseball game. Physically active, restless, and inclined to throw himself into every available outlet for his excessive energy, Blumenschein was flattered. Immature as the decision would seem in retrospect, he did not think twice about accepting—even though the game would be played on his wedding day.

So the morning of his wedding day, he played baseball. He played hard enough, in fact, to injure one of his knees. As a result he arrived late for his wedding, limped into the church, and, to the great disgust of his new mother-in-law, was forced by this injury to remain standing during the parts of the ceremony when he should have been kneeling by Mary's side. This whole incident bespoke the essence of Blumenschein. He was willful, restless, self-defining, and often unable to curb or dissect the impulses that drove him.

The Blumenschein marriage and other unions at this time reflected the truism that although no two marriages are alike in their personal dynamics, all love relationships arise out of,

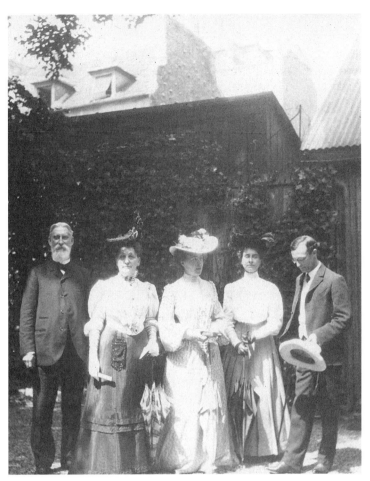

Blumenschein stands on the right of four members of the wedding party for the Blumenschein-Greene nuptials on June 29, 1905, in Paris. His bride Mary Greene stands in the middle, with her mother between her and her new husband. Palace of the Governors Photo Archives, Santa Fe (NMHM/DCA), HP.2005.25.0

and are partially shaped by, the cultural context in which they develop. The contrasting contexts surrounding marital unions contemporary with Ernest and Mary's demonstrate the diversity of options that were acceptable in an era when entrenched class distinctions coexisted paradoxically along-side rapid social change. George Blumenschein, with little of the nuanced stress that would mark his older brother's progress to the altar, divorced Fannie Miller and married his second wife, Anna Bentley, in Dayton in 1904. George's marital unions were probably not typical of common folk only three years after the rigidly conventional Queen Victoria's death, but they did demonstrate that there was diversity in marriage practices even in puritanical America during the early twentieth century.

In its own way, the marriage of Ernest and Mary was an amalgam of the old and the new. From courtship through wedding ceremony, all the traditional social proprieties had been observed. Yet the Blumenschein marriage hinted at a new world in its joining of two professional artists of equal status. With a clearly established identity of her own, Mary Blumenschein began married life without any sense of being beholden to her husband. Recognizing that he had joined forces with a woman as prepared as he to fulfill an avowed artistic purpose, Ernest Blumenschein knew he had in no sense acquired a wife as a possession but instead had chosen to link his future with a worthy partner. As auspicious a beginning as it was, it posed the question of whether a man so steeped in a family tradition of male dominance could cleave to a course through the uncharted waters of gender equality.

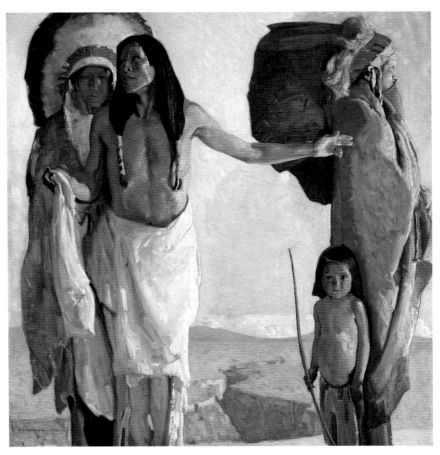

The Peacemaker (*The Orator*), 1913. Oil on canvas, 44¼ × 45 inches. Courtesy of American Museum of Western Art—The Anschutz Collection, Denver.

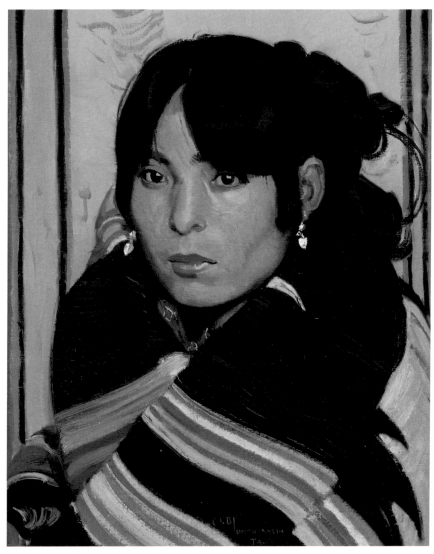

Portrait of Albedia, ca. 1918. Oil on canvas, 20 × 16 inches. Courtesy of the Gerald Peters Gallery, Santa Fe.

The Extraordinary Affray (originally *Indian Battle*, 1920), reworked 1927. Oil on canvas, 50 × 60 inches. Courtesy of the Stark Museum of Art, Orange, Texas (31.30/13).

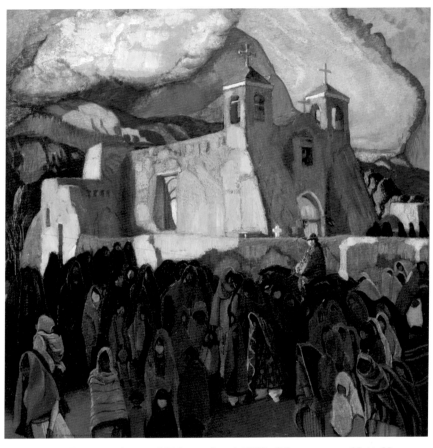

Church at Ranchos, ca. 1921, repainted 1929. Oil on canvas, 30 × 31 inches. Courtesy of the Taos Historic Museums, Taos, New Mexico.

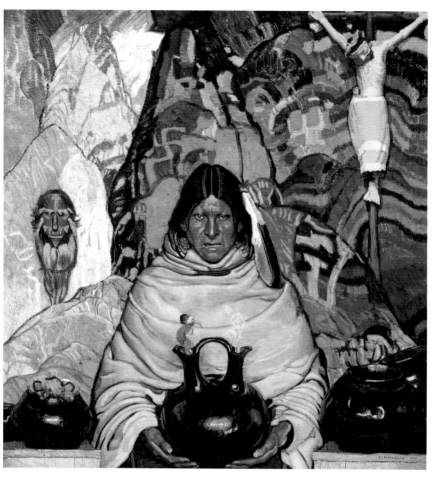

Superstition, 1921. Oil on canvas, 41¼ × 45 inches. Courtesy of Thomas Gilcrease Institute of American History and Art, Tulsa, Oklahoma.

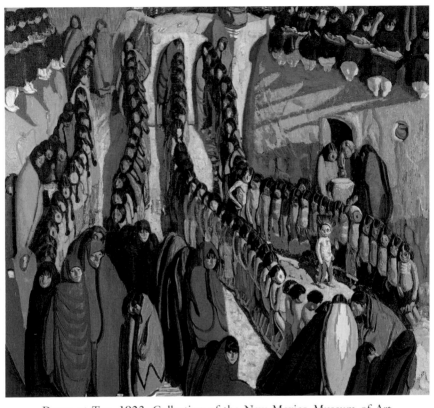

Dance at Taos, 1923. Collection of the New Mexico Museum of Art, Santa Fe. Gift of Florence Dibbell Bartlett, 1947 (97.23P).

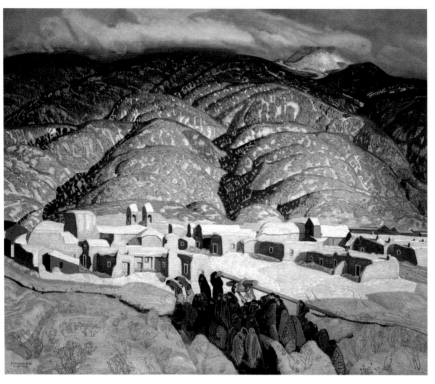

Sangre de Cristo Mountains, 1925. Oil on canvas, 50⅛ × 60 inches. Courtesy of American Museum of Western Art—The Anschutz Collection, Denver.

Enchanted Forest (*Decorative Landscape with Figures*, 1925; later *Aspen Grove*, 1929), finished 1946. Oil on canvas, 51 × 35¼ inches. Courtesy of Thomas Gilcrease Institute of American History and Art, Tulsa, Oklahoma.

Haystack, Taos Valley, prior to 1927, reworked 1940. Oil on canvas, 24 × 27 inches. Courtesy of the Fred Jones Jr. Museum of Art, University of Oklahoma, Norman. Given in memory of Roxanne P. Thams by William H. Thams, 2003.

General John Joseph Pershing, Commander in Chief of the American Expeditionary Force in World War I, ca. 1930. Mural at north entrance to Senate Chamber, Missouri State Capitol, Jefferson City.

Ourselves and Taos Neighbors (originally *New Mexico Interior* or *New Mexican Interior*, 1931), reworked 1937 and 1938, finished ca. 1948. Oil on canvas, 41 × 50 inches. Courtesy of the Stark Museum of Art, Orange, Texas (31.30/12A).

Mountain Lake (*Eagle Nest*), 1935. Oil on canvas, 29 × 39½ inches. Courtesy of the William Sr. and Dorothy Harmsen Collection, Denver Art Museum (2001.458).

Jury for Trial of a Sheepherder for Murder, 1936. Oil on canvas, 46 × 30 inches. Courtesy of the Rockwell Museum of Western Art, Corning, New York. Clara S. Fund purchase (97.13).

Afternoon of a Sheepherder, 1939. Oil on canvas, 28 × 50 inches. Courtesy of the Dickinson Research Center, National Cowboy & Western Heritage Museum, Oklahoma City (1976.32).

Bend in the River, 1941. Oil on canvas, 27 × 35½ inches. Courtesy of American Museum of Western Art—The Anschutz Collection, Denver.

Railroad Yard—Meeting Called (originally *Railroad Yard*, 1945; later *Railroad Yard, No. 3*, 1951; then *Railroad Yard, No. 5*, 1953), finished 1958. Oil on canvas, 31 × 48 inches. Courtesy of the Taos Historic Museums, Taos, New Mexico.

8

An Artist's Transition
Back to America

Even as the cultural life of Paris throbbed with a self-absorbed energy all its own, the swirl of political events in the larger world beyond went on unabated. And even as the newly-weds became absorbed with the particulars of their personal life, the well-read young Blumenscheins were not oblivious to the accelerated pace at which the forces of nationalism, militarism, colonialism, and revolution were interacting. In fact, world events were discussed as frequently as cultural events when the couple joined others in their circle for dinner or drinks at such favored meeting places as the very expensive Restaurant de la Tour d'Argent or the popular Café du Dome on the Boulevard du Montparnasse.

The American community in Paris felt some pride that President Theodore Roosevelt negotiated the treaty ending the 1904–1905 naval war between Japan and Russia. Russia's defeat at sea was followed by disorder at home, as the repressive Czar Nicholas II struggled to maintain the old order in the wake of the Revolution of 1905. War and political change marked the early years of the century in England as well. Queen Victoria's death in 1901 ushered in the Edwardian Era. During the reign of Edward VII, the British won the Boer War in South Africa, and in 1906 a newly elected Liberal Party government enacted far-reaching

reforms, including unemployment insurance, wage and hour regulations, and old age pensions.

The French government of 1905, under the Third Republic, was dominated by moderate to conservative politicians representing a powerful middle class that kept the republic true to its bourgeois principles. But French society was not immune to political stress, and the Blumenscheins were undoubtedly aware of the divisive effect on all of France of the bitterly contentious Dreyfus Affair. Accused of passing information to foreign enemies while serving as a military officer, the Jewish Alfred Dreyfus had been convicted without sufficient evidence of guilt. Conservative, pro-monarchy, and anti-Semitic forces were all strongly anti-Dreyfus, while Dreyfus supporters included liberals as well as many in the arts, most notably the great French novelist Émile Zola. When the charges against Dreyfus were proved false and the real culprit found, the French public was awakened to the need for an unbiased justice system, and the movement toward a more secular form of government was strengthened. In 1906 Dreyfus was exonerated by the French Supreme Court.

The Blumenscheins, avid newspaper readers both, were also cognizant of the changes that had taken place in the United States during the years they lived abroad. By the first decade of the twentieth century, America was no longer isolated from world affairs, nor could it be. The United States had become a major trading nation with interests to protect. And as the world's fastest-growing industrial nation, it could no longer avoid playing a key diplomatic role as industrialized European nations colonized foreign lands in Asia and Africa. Even more ominous, the largest European powers split into two rival alliances, with Germany and Austria on one side and France, Britain, and Russia on the other. Informed citizens, whether in Europe or America, were bound to feel both contentment in a peaceful, pros-

perous present and a vague apprehension about an uncertain future.

Although never averse to rendering self-assured opinions on the more serious events of the day, the friends of the Blumenschein couple were on the whole a merry band of partygoers, people whose personal lives were marked by relatively high levels of income and success. Indeed, Ernest had his illustration commissions, and Mary had never needed to worry about money. Their friends were not penniless artists but consisted primarily of a wide assortment of authors, artists, journalists, and a sprinkling of businessmen interested in the arts. Most, if not all, of them were established enough in their fields to feel more optimism than pessimism as they contemplated a modernizing world. After Ernest Blumenschein and Mary Greene married, his friends became hers, and he became part of her sophisticated social circle. In addition to Tarkington and Butler, the Blumenschein entourage included writer Harry Leon Wilson; illustrator and painter James Montgomery Flagg; Thomas Nelson Page, a novelist soon to become U.S. ambassador to Italy; newspaperman William Hereford; and Vance Thompson, founder and editor of *M'lle New York* and author of romance novels and biographies. Blumenschein relished the "stimulation" offered by such an eclectic group, calling his new friends true "companions" and a "great influence in [my] career."

Indeed, Blumenschein seems always to have interpreted the events of his life in terms of their effects on his artistic career. And though his marriage in no way freed him from entanglement in a psychological dynamic mixing ambition, hope, and fear, the union with Mary Greene had a salutary effect on Blumenschein's personal and professional attitude that even he would have been hard-pressed not to recognize as beneficial. Beyond her influence in expanding his social contacts, Mary fell almost immediately into a role for which

she was by temperament suited: she became and remained the nurturing, supportive, encouraging figure in her husband's life. She filled the space that might have been occupied by a mother if Blumenschein's mother had not died so young.

With Mary by his side, Ernest renewed his commitment to study all the great masterworks in Paris. Because she praised, approved of, and was eager to participate in his illustration work, his confidence as an illustrator was bolstered; she dissuaded him from his old tendency to denigrate illustration as harmful to his fine-art prospects. Without any conscious intent on either side, they fell into a natural symmetry of support for each other in the early years of the Blumenschein marriage.

Mary was rewarded for her empathetic devotion by her husband's implicit recognition of her status as an artist. He characterized her art work to Butler in an April 30, 1905, letter as being "pretty and feminine," causing some of the American male artists to be jealous of "her Solon medals." Describing her as a small woman who "dresses with taste and is quite a lady," he lauded her steady determination in art and faulted her only for not being aggressive enough in selling her paintings. There was a clarity, a simplicity, a harmony in their relationship. In truth, strong shared personal interests—especially unchanging ones—are not common within the institution of marriage. An idyllic glow surrounded the couple early in their marriage; creativity and love went hand in hand in a manner reminiscent of the married life Robert and Elizabeth Browning enjoyed in the nineteenth century.

The Blumenscheins lived in a large, comfortable studio apartment on the fifth floor of a building in the Latin Quarter, across the street from the building where Mary's mother lived. Like most of the art district's studio apartments, the room used for painting had a north-facing window. Each morning when Mary poured coffee for Ernest at a well-set

breakfast table, it was only the start of a day that would be spent together. They planned their days with happy anticipation, no doubt taking into account a desire to minimize how often they had to climb the long flights of stairs to their abode. The stairs did, however, provide something of a shield of privacy, for Isabel Greene would not have readily climbed them for unexpected visits.

Together, the Blumenscheins began "the serious study of the great masterpieces of art and architecture of Paris," recalled Ernest. "Visited Louvre, and would for the remaining four years living in Paris." It became their custom to visit the Louvre for several hours each week. After selecting one work for special attention, they would closely observe it, discuss and analyze it, and commit its elements and stylistic features to memory, although not to make a copy of it. At home in their studio, both worked on paintings that reflected primarily the traditional realism of the French salons, but also incorporated some elements of impressionism and post-impressionism that occupied the artwork of a growing number of painters in Paris.

They began to work together on joint illustration assignments for books and magazines, though each also accepted independent commissions. One of the books Mary illustrated was *Bambi*, which would become a best seller. She continued to show her paintings at the Paris salons, and she occasionally sent her work on European tours. One of her best paintings was *The Princess and the Frog*, based on the Grimms's fairy tale about a frog that restores a golden ball to a princess; Blumenschein characterized the work as her "chef-d'oeuvre" in a February 4, 1909, letter to Butler. She also began to work on her own as an illustrator more often and accepted frequent commissions from *American Magazine*, noted for its regular publication of popular short stories.

Despite her latest successes as an illustrator, Mary was in no danger of overshadowing her husband in commercial

art. By the end of 1905, following the success of his illustrations in London's *Love of Life*, Blumenschein was firmly established as one of America's leading illustrators. And as if to cap a year in which personal factors converged favorably in blessed respite from strife and anxiety, William Leonard Blumenschein, inexpressive and nondemonstrative as he was, finally felt sufficiently impressed by his son's accomplishments to declare approval and love in his own somewhat roundabout way. After *McClure's* published *Love of Life*, word of its quality of prose and artwork reached Dayton, Ohio, and the elder Blumenschein wrote his son in Paris: "We have heard many favorable and extravagant comments. Everybody has seen your work and everybody is proud of you. We too!" Several days later, on December 11, 1905, he wrote again, saying "I am being 'held up' daily on the streets by all sorts o' people desirous of saying something nice about your work in Dec. McClure's. The most of them say: 'Aren't you proud of him.'"

In spring 1906 Mary became pregnant. The welcome news brought about a subtle but distinct change in the way the couple regarded their life in Paris and their future in America. Until the pregnancy, neither had felt any sense of urgency to return to their American roots, which both knew must someday take place. Mary in particular had wished to extend their time in Paris into a somewhat indefinite future. Moreover, her satisfaction with the status quo had led Ernest to avoid pressing this issue, even at those times when he felt renewed desire to get on with the business of establishing himself as an American painter of American subjects. But Mary began to shorten the time horizon for remaining in Paris once she discovered she was expecting her first child. She was concerned that French medical care might not be the best quality, and she thought it might be wiser for the baby to be born in the country of his or her citizenship.

Blumenschein was prompted to think about his patriotism and his country in a new way, for once not related to

his art, but as the formative influence in his own character. Writing in a new vein to Butler, he seems almost to be seeking a way to bridge the gap between the elitist, critically analytical artist in him and the plain citizen of egalitarian America that was so much a part of him. "I want to be an American in America," he assured his friend. "Not withstanding all the ugliness of our cities, all the crudeness that characterizes the American all over the world, I can't help loving him."

Despite the shift in attitude from complacency in Paris to commitment to America, this thought did not easily translate into action. During seventeen years of living abroad, Mary and her mother had accumulated numerous pieces of furniture, along with books and highly valued art objects, so arranging a permanent move to the States was an arduous undertaking. The months of Mary's pregnancy passed quickly, and by December it became clear that the birth of Ernest and Mary's baby would take place in Paris because it was too late to risk an Atlantic crossing.

On December 26, 1906, Mary gave birth to a baby boy. All seemed well with mother and child. A proud and exhilarated Blumenschein honored his country, his heritage, and his mother's side of the family by naming his first born Ethan Allen Blumenschein, after the most famous member of Leonora's bloodline. But a mere forty-eight hours after his birth, the baby unexpectedly died. Lacking an adequate explanation for the death from the doctors, the Blumenscheins placed the blame for their inexplicable loss squarely on those doctors' shoulders.

Over the ensuing months the Blumenscheins' bitterness toward the French medical system tended to darken their view of all things French. In directing their anger and sorrow outward rather than inward, they seem to have avoided the kind of self-recrimination and resentment of each other that can threaten a marriage in the wake of a child's death. Mary did not torture herself with feelings of failure;

Blumenschein avoided asking himself whether he had done all he could to ensure a stateside birth. Although their mood was understandably somber, Blumenschein and Mary were not driven apart by the strain of their child's death, and both sought solace in their work and in the sublimating nature of art itself.

During this period of his life, Blumenschein approached his work with an attitude verging on fatalism. Despite Mary's encouragement, and despite his powerful ego, he was not entirely convinced that either his study of the masters or even his own progress would be enough to move him from the status of illustrator to that of painter. In a 1905 letter to Butler he conveyed an air of resignation, along with a touch of hope: "I'm not painting great pictures, but I'm sure I am progressing in a direction that will develop me. I have given up all ideas of doing anything but excellent illustration. That is my line and I know it." He had forgotten neither Taos nor his grand vision of a new American art. But the fact remained that he relied heavily on illustration for income, and fine-art painting was not yet a viable alternative to commercial art.

Blumenschein was fortunate to have established his reputation by the early 1900s. The field of illustration was changing rapidly during these years, and only the most talented illustrators were able to make the transition from one publishing era to another. Better cameras and reproduction techniques were enabling newspapers and magazines to print more photographs and fewer illustrations. At the same time, however, book illustration became an increasingly important and lucrative activity for illustrators whose work had genuine artistic value. In fact, the years between 1900 and 1930 were a high-water mark in the annals of book publishing as newly illustrated editions of the classics as well as books by emergent authors of note were printed regularly. Among American illustrators of the classics was

N. C. Wyeth; in Britain, the highly imaginative illustrations of London-born Arthur Rackham (1867–1939) had made him famous as well as wealthy.

Blumenschein was among the favored few regularly commissioned by the leading publishing houses to provide cover art and illustrative paintings for their finest publications. Authors whose books he illustrated between 1905 and 1919 include Tarkington, London, Willa Cather, Stephen Crane, Hamlin Garland, and Joseph Conrad. He was kept steadily at work: in 1906 he illustrated *The Praying Skipper and Other Stories*, by Ralph D. Paine, and *Come and Find Me*, by Elizabeth Robins. Other illustration work included *The Brute*, by Joseph Conrad, in 1907, *The Complete Tales of Edgar Allan Poe* in 1909, *Something Else*, by John Breckenridge, in 1911, and *Mothers of Men*, by William Henry Warner, in 1919.

During these years he also illustrated magazine short stories and numerous other books, such as several volumes of short stories by the hugely popular O. Henry. By simplifying his compositions and employing receding frontal planes in limited depth, Blumenschein heightened the dramatic impact of his illustrations. The relatively flat modeling of his figures seems to reflect the influence of American artist James A. M. Whistler, whom he admired but probably did not know. Whistler made full use of light and dark contrasts but favored the soft, muted hues preferred by academics. Although the Blumenschein paintings done for books and short stories often exhibited the sentimentality and idealization characteristic of early-twentieth-century illustrations, they also showed a consummate craftsmanship in depiction of the human figure.

Between 1902 and 1912 portraits composed a significant portion of Blumenschein's fine-art painting. He was well aware that more than technical proficiency was needed to create accomplished portraiture. Slowly he began to combine

his mastery of craft and his innately analytical intelligence, bringing these qualities into effective balance as he explored the portrait genre in one painting after another. The influence of his Académie Julian instructor, the great portraitist Benjamin-Constant, is clearly evident in the Blumenschein portraits of this period. What is most notable about these paintings when considered as a group is that they showed a marked progress toward the standards established by Leonardo da Vinci when he wrote that a portrait should reveal "the motions of the mind."

By 1907 Blumenschein was rising to the challenge of portraying character deftly in physiognomy. His *Portrait of a German Tragedian* exhibited a new level of insight and won for him the respect of his peers in the art world when it was shown at the Paris Salon of 1908. Blumenschein's model was an aging Austrian actor willing to pose for artists while temporarily stranded in Paris. The portly and somewhat pompous man of the theater went to the Blumenschein apartment and posed while seated on an upholstered stool in a small reception room. Done in warm gray and rose tones against a dark background, the Blumenschein portrait blends realism, empathy, and caricature to subtly depict the dissonance between a bravura public façade and impenetrable inner emptiness. Tarkington bought the picture after viewing it at the Paris exhibit in 1910 and allowed it to be shown at the National Academy of Design in New York. Art critics took note of Blumenschein's "originality and force," and in a *New York Times* article, the artist was praised for his "sound craftsmanship and unhackneyed presentation."

In September 1907 Ellis Parker Butler arrived in Paris with his wife, Ida, and his small daughter, Elsie, for a visit that lasted until spring 1908. Blumenschein, having recovered much of his old spirit with the passage of time since his child's death, greeted his longtime confidante with genuine enthusiasm. He was eager for Butler to become acquainted with Mary, then get ready for a round of socializing and

Portrait of a German Tragedian, 1907. Oil on canvas, 57½ × 33 inches. Courtesy of the Indianapolis Museum of Art (41.32). Gift of Booth Tarkington.

tours of the city's landmarks. But Butler, glad as he was to see Blumenschein, had something more than pleasant get-togethers in mind: he wanted his artist friend to paint a portrait of his family. Blumenschein obliged him by setting up a series of modeling sessions with the young family and doing preparatory studies for what would be his first group portrait.

Completed in late 1908, the Butler family portrait provided fresh evidence that, despite the academic training he had so diligently pursued, Blumenschein possessed an artistic independence that enabled him to break with convention. To create a visually compelling canvas and to express a motivating idea about its subject, Blumenschein was able to capture the unity of the Butlers by compositionally joining them in a single flowing design, in which the father's face is partly hidden by his wife's elegant fur hat. The colors he used were warm and soft in hue, conveying the security engendered by mutually felt affection. The portrait was received favorably by Butler and by the public when it was reproduced in the December 1909 issue of *Century Magazine*. It was also accompanied by an editorial note declaring it to be "one of the finest examples of recent American art." Exhibited at the Carnegie Art Show of 1910, the Butler portrait won the Isidore Medal for best figure painting.

While visiting in Paris, Butler no doubt asked Blumenschein when he would return to America. In a June 8, 1908, letter written shortly after Butler's departure, Blumenschein seems to be continuing an ongoing discussion about life in Europe versus life in America. Preparing himself for a change he knows is coming, he expresses his patriotism almost as if it were a matter of family pride. "Blood is the thickest tie and we love our Americans and the ugly U.S.A. It's big and grand and inspiring in many ways. And the people are too!" He finds an interpretive construct for the essentially materialistic culture of his country positive enough to enable an invigorating identification as opposed

to a crippling alienation. "We can't have what Europe has, we don't want it. After a pleasant meal off delicious and gentle Europe, we are glad to get back into the bee-hive and bustle. We love it because—because I suppose, we're brought up on it, and it's part of our formation."

And yet, lulled by the easy momentum of a comfortable routine, the Blumenscheins remained in Paris. French phrases had crept into their daily speech; loaves of crusty French bread had become part of every meal; and French wine and flowers and parks and museums were increasingly part of their everyday pleasures. The momentous decision—because both knew it meant permanent change—about precisely when to leave remained unmade, until fate intervened and made the decision for them. In early 1909 Mary became pregnant again. With no need for debate or discussion, the Blumenscheins set the wheels of action in motion. They immediately began making arrangements for a journey home that both agreed absolutely must take place before the baby's expected late fall arrival.

Mary was now forty years old; she did not have to be told that this pregnancy might well be her last. Not only did she want a child badly, but she still bore within herself the ache of having lost her firstborn son. She was determined not to repeat the medical scenario of 1906, believing the finest of care at the time of childbirth to be the first line of defense against a second loss. Ernest, too, was convinced that a return to the United States was the only responsible way to begin what he hoped would be the start of life as a family rather than as a carefree couple. Mary's mother, reconciled to the marriage despite lingering misgivings about the future of her son-in-law, longed for a grandchild. And the Blumenscheins were united in their feeling that nothing could surpass a grandchild as a gift to Mary's mother and a means of permanently resolving any remaining strain in the relationship between Blumenschein and his mother-in-law.

Boxes packed full of books and paintings, china and glassware, clothing and art supplies began to pile up in the rooms and the small foyer of the Blumenschein apartment. Ticket agents were contacted for train and ship passes. Financial affairs were set in order. And at last, when Mary was in her seventh month of pregnancy, she and her mother and husband arrived at the port of Le Havre on France's northern coast, ready to sail for home. As they boarded their ship on a mild May day, all three, but Ernest and Mary especially, undoubtedly felt a keen awareness of and excitement about the future and a sorrow about the vanishing past.

Indeed, the couple must have realized that one phase of their marriage had ended and another was about to begin. Just as people around the world would later say "after the war" when referring to the post–World War I era, the Blumenscheins in later years would often use the phrase "after Paris," the implication being that nothing would ever be quite the same thereafter. The Atlantic crossing was calm, and Mary suffered no ill effects from the journey. The days at sea allowed time for a gentle transition from the Old World to the New World, and by the middle of June 1909, the Blumenscheins were ensconced in New York as Americans in residence, never again to be expatriates in Europe.

9

Part-Time Taos Artist

When the Blumenscheins departed for New York on May 29, 1909, Blumy began an intense search for a place where he and Mary would be comfortable. His old friend Ellis Parker Butler invited him to stay with his family in Flushing, where they could recover from the trip, and Mary could visit with Butler's congenial wife, Ida. By mid-June Blumenschein had found and rented an apartment at 22 West Ninth in New York City, along with a double studio, that could meet the needs of both serious artists. Because of the humid heat that summer, the two decided to travel to the New England coast. They found an ideal place in Ogunquit, Maine, where they could paint, swim, and just relax. Blumenschein was even given the opportunity to play a violin solo at a Methodist church concert during this happy respite, which he knew his father would be greatly pleased to know.

Their vacation ended in late August as Blumenschein decided to return to his New York studio to fulfill important illustration commissions he had negotiated with Scribner's, Century, and American Magazine. About two months later, on November 21, he and Mary became the proud parents of a daughter, whom they named Helen; no problems similar to those that had caused the tragic loss of their infant son in 1907 occurred this time.

Blumenschein soon plunged right back into his artwork, despite Mary's need to share with him and her mother the upbringing of the new baby. He was anxious to publicize his more recent Paris paintings to a public much more familiar with his illustrations than his paintings. Special emphasis was given to his 1908 Portrait of Ellis Parker Butler and His Family. A review in the *New York Times*, on December 19, 1909, praised this portrait, displayed at the winter exhibition of the National Academy of Design, for its "many beauties that promise permanence of appeal." Recognizing Blumenschein's focus on geometric design in this well-received oil, the *Times* reviewer admired the positioning of the family with the father on the top, the mother below him, and the child at the bottom, noting that the head of Butler's young daughter was "the most vivid object of the composition, a quaint little head, seen quite simply and painted with delightful freshness of color and brushwork."

Within months of exhibiting the Butler family's portrait at the National Academy of Design, Blumenschein provided two portraits to the academy's spring show. One was the already well-received *Portrait of a German Tragedian*, which Booth Tarkington had purchased in 1910 for $1,000. The academy titled the other portrait simply *Portrait Group*, but it was probably the family portrait later given the title *Allegory in Honor of a Barrymore Child*, which would be exhibited at the Academy of Fine Arts in Philadelphia and at the Art Institute of Chicago. This painting was done for the family of actor Lionel Barrymore, Blumenschein's friend and former fellow art student. Blumenschein enjoyed Barrymore's company, according to a February 4, 1909, letter to Butler, and he was struck by the beauty of Lionel's "young and exquisite wife."

The portrait of the Barrymore family featured Lionel, his wife, Doris, their child Mary, and a nursemaid. Mary is thought to have died in Paris while Blumenschein and Barrymore were studying there, a tragedy that would have

had the Blumenscheins' heartfelt empathy. In March 1910, while the Barrymore portrait was on display, Lionel and Doris lost a second daughter, Ethel, who was only eighteen months old. Although the portrait of the famous actor and his family was probably done to celebrate Mary's short life, this tribute could have been expanded to include both children.

Ernest Blumenschein's return to America not only helped him display and eventually sell his Paris paintings, but it brought him several honors. Many of his peers recognized the talents he had been developing during his years abroad as an American expatriate artist. In spring 1910 the National Academy of Design made him an associate member. That same year the Salmagundi Club exhibited Blumenschein's Butler family painting and awarded him a $100 prize for the best portrait they had shown. This was a respectable sum of money in the early twentieth century.

Although Blumenschein was evidently counseling other artists, such as the young William Herbert Dunton, who would later become Blumenschein's fishing partner in New Mexico, to abandon illustration work, he was still gaining attention for his work in this art form. He had in recent years been doing color illustrations for the centenary edition of Edgar Allan Poe's *Tales*. Because of technological advances in the publication business, illustrations could now be reproduced in color with much greater efficiency. As Blumenschein's friend, *Century* editor Richard Gilder put it, an "extraordinary change" had taken place in commercial illustration. Because of Blumenschein's expenses in raising a new daughter, he had found less time to paint and therefore could not give up his illustration work entirely to become a full-time fine-art painter.

In early April 1910, one of Blumenschein's mentors, Joseph Henry Gest, the director of the Cincinnati Art Museum, invited him to display a couple of his paintings for the museum's annual show of American artists. To Blumenschein's

profound regret, all his paintings were tied up elsewhere, and he had nothing he could show his fellow Ohioans. The only solution he believed he had to remedy this problem was to return to Taos. In August of that year, Blumenschein was ready to travel west again to establish a pattern of art-work he would pursue for the next nine years.

Blumenschein's plan entailed visiting New Mexico every summer. "During each vacation, I would do no illustrations. Some years I had three months—sometimes less—one year I recall having only six weeks, but the short sketches were devoted entirely to painting." While he had been developing as an accomplished artist in Paris during the early 1900s, he had told his writer friend Blanche Grant that Paris and Taos were the only two places in the world for him. Moreover, Bert Phillips had never stopped urging him to come to New Mexico and help him start an art colony in Taos.

But Blumenschein, unlike the popular stereotype of an artist, was also a good businessman; he still felt he had to rely on his income from illustrations to pay his bills. The Atchison, Topeka, and Santa Fe Railway (often called just the Santa Fe Railway), eager to promote travel to the South-west, did make it possible for him and other artists to stay solvent during their trips to Taos. Through William Haskell Simpson, the railroad's advertising agent, Blumenschein was able to get free rides with the understanding that he employ some of his hard-earned talents in art to entice people to take the Santa Fe west, for trips to New Mexico or Arizona to view the region's exotic scenery.

The one problem that would be the most difficult for him to resolve would be Mary's feelings about these yearly separations. After five years of marriage, a strong intimacy bound them together and caused them to be dependent on each other, as is the case with many close couples. With the Blumenscheins destined to be living 1,500 miles apart for approximately one-quarter of each year, both would have to

develop psychological independence, which would be especially hard for Mary.

The Blumenscheins, including their daughter, Helen, were living comfortably in their New York City apartment. Mary was especially happy, having the support of a close extended family and a husband she adored. Blumenschein wanted Mary to come to Taos with him, but she refused. Her reasons were understandable. She was wary of the living conditions in Taos, which she regarded as a frontier community; the small New Mexico village had to wait until the 1930s before electricity and modern plumbing were available for most of its inhabitants. Mary was also afraid of the Indians, afraid for the safety her small child, and reluctant to leave her mother for such a long period.

Mary believed she had sound reasons for viewing Taos as a lawless place, where Indians were a threat and ethnic strife an ever-present possibility. She had read Phillips's letters from 1899 telling about the violence between Anglos and Hispanos that had occurred that year. Moreover, the letters her husband wrote to her during his first summer in Taos in 1910 seemed to confirm that little had changed, for Ernest could not resist bragging about his toughness in this frontier environment. He delighted in exaggerating everything, from flash floods and raging thunderstorms to the primitive state of the Taos Indians and the rugged extremes of the local terrain. Mary took seriously his largely fabricated tales of Indian and Hispanic hostility and became tense at the very notion of Taos as a family home. In actuality the only major disadvantage of living in Taos was its isolation from New York and the East Coast, where the galleries, art dealers, collectors, critics, and competitive art exhibits were centered. Daily life in Taos was, in fact, marked by a notable degree of civility and small-town friendliness.

Art historian Elizabeth J. Cunningham believes that Mary was also concerned that a move from New York City would

have an adverse effect on her art career. And as Helen got older, the question of schools would become another issue. Both parents were well educated and wanted the same for their daughter. Blumenschein felt he had been honest with Mary from almost the beginning, telling her in that candid letter before they were married that art would always come first for him. Mary had been completely supportive of her husband's goal of becoming a fine-art painter; she genuinely wanted him to be a happy and fulfilled person. Even so her heart sank when she realized that she would be left in New York on her own to manage a household and a child. The thought of being alone at social gatherings with no husband at her side undoubtedly disturbed her. More important, she was in love with her dashingly masculine, if difficult, husband and would miss him; in short, throughout these yearly separations, she would often be very lonely.

Mary acquiesced to Blumenschein's departure each year but never without at least some anxiety and unhappiness. Blumenschein acquiesced to Mary's decision to remain in New York, but, as his letters attest, he missed her and never ceased asking her to come west with him. However honorable their intentions, the changes in their living patterns would alter the nature of Ernest and Mary Blumenschein's personal relations. Whether these inevitable mixed feelings led to concealed resentments or even deep-seated anger is difficult to prove, but it is unsurprising that such yearly separations would affect their relationship in profound ways.

During Blumenschein's first summer in Taos, he stayed in a house and studio on Pueblo Road that his friend and fellow artist E. Irving Couse had once owned and used. The current owners rented these facilities to itinerant artists, including Oscar Berninghaus, who would eventually become closely associated with the major Taos artists; Berninghaus had been coming from St. Louis to paint during the summers since 1899.

The migration of artists to Taos had been effectively promoted by the enthusiastic writer Charles Lummis, who for two years had been boosting New Mexico as a place where artists could "begin to discover themselves." During Blumenschein's second trip to Taos during the summer and fall of 1911, he resided at the home of the widowed Teresina Scheurich on present-day Bent Street, a block north of the town's plaza. The large adobe hacienda had once been owned by Teresina's father, New Mexico's first territorial governor Charles Bent.

Phillips was particularly elated when Blumenschein arrived in August for the second straight year to paint. By this time, another Blumenschein colleague from their days together in Paris, Joseph Henry Sharp, had settled in a studio next door to Couse. Phillips, who referred to himself as "the Pioneer" of the growing Taos art colony, lived on North Pueblo Road, across from his father-in-law Dr. T. P. Martin. Frank Sauerwein, another artist, lived across the street from Phillips, and Berninghaus's current home and studio were nearby. Phillips was disappointed that Blumenschein had not yet established a permanent home in Taos, but he was hopeful that Blumy, "one of the most enthusiastic and one of the best trained artists of the group," would eventually do so. Until then, Phillips took great satisfaction in the artists, like Dunton and Couse, whom Blumenschein had already recruited to come to New Mexico and paint.

Mary would be somewhat reassured during her husband's early stays in Taos that her outgoing spouse was adjusting well in this distant western town. He lacked neither friends nor opportunities for socializing; many happy times were passed in the old Bent hacienda's flower-filled courtyard under the stars, with Blumenschein sometimes playing his violin for artists and other Taos residents. He was able to find bridge partners and companions for trout fishing along the Rio Grande.

But Mary could ask for no surer evidence that civilization was alive and well in Taos than her husband's regular participation in the community's baseball games. By 1911 Taos had two baseball teams, and Blumenschein had become the regular shortstop for the Grays, who competed in season against the Maroons every Sunday afternoon in the big field behind the Kit Carson House, east of the town plaza. The generally younger and often Hispanic men with whom Blumenschein played looked up to him as a leader.

According to Blumenschein, his fellow players included "forest rangers, artists, road surveyors and native boys." One team member, Jacopo Bernal, a Spanish teacher and the superintendent of Taos County Schools, was especially impressed with Blumenschein's athletic abilities and his easy rapport with the team. As he put it, Ernest "was a real good player. He inspired confidence in every member of the team. . . . [After] the game was over, he would have us sit down on the ground, not to find fault, but to praise us and point out the good points of our playing."

Despite Mary's fears to the contrary, New Mexico was beginning to close the gap between frontier conditions and those found in the nation at large. Still one of the least-populated areas of the country and one of only two remaining territories in the contiguous United States, New Mexico had a population of 327,301 in 1910. The population of Albuquerque had grown from 2,315 in 1880 to 11,020 in 1910, while Santa Fe that year had 5,072 residents and Taos 2,585. New Mexico's cultural resources expanded considerably when the School of American Archaeology housed its museum and school of research at the Palace of the Governors in Santa Fe in 1909. Within a short time the museum was providing a venue for visiting scientific exhibits as well as offering Santa Fe and Taos painters a place to show and publicize their work.

Many of New Mexico's artists were also proving their worth as citizens who cared deeply about the sometimes

negative effects of new settlement. In early 1904, Bert Phillips showed Vernon Bailey, a naturalist for the U.S. Biological Survey, evidence that land abuse was becoming a serious problem. Settlers were traveling through Indian lands with no regard for borders, crop fields, or pasture lands. Ignoring the law, some Anglo settlers brazenly kept their flocks of sheep on Indian lands and polluted the creek, which was the only source of domestic water for Taos Pueblo. An aggressive lumber industry was cutting down entire forests in the Sangre de Cristo Mountains. Forest fires were occurring with growing frequency, sometimes as a result of carelessness and at other times as a result of deliberate efforts to clear the land. Phillips felt so strongly about the Taos environment that he even earned a degree in forestry from the state college in Flagstaff, Arizona. He also became a leader in the creation of Kit Carson National Forest, northeast of Taos, and played a major part in the Taos art community's determined efforts to protect the legal rights of American Indians in general.

Blumenschein was especially concerned about the plight of the Taos Indians, who would soon become one of the major subjects of his artwork. He had become alarmed about the treatment of many Native tribes when he had been assigned to illustrate Charles A. Eastman's book *Indian Boyhood* for *Century Magazine* in 1901. Eastman's stories garnered much sympathy and understanding from Blumenschein regarding the often unfair treatment meted out to the Sioux Indians on South Dakota's Crow Creek Reservation. Playing baseball with Sioux boys at this time would inspire him ten years later to join one of the Taos baseball teams, in part to win over Taos Hispanos and Pueblo Indians as models for his art.

Blumenschein closely identified with Taos even as a part-time resident and made northern New Mexico and the Southwest the subject of his major works of art from 1910 onward. During his first summers in Taos, he produced

paintings of enormous aesthetic appeal, which combined the conventions of academic art with the light and color characteristics of impressionism. Among them were *Taos Indian Holding a Water Jug*, which was probably completed in 1910 and sold in 1911; *Evening at Pueblo of Taos* (1913), which was purchased by the Atchison, Topeka, and Santa Fe Railway; and *Fireplace* (1915), which was purchased by New Mexico historian and attorney William Keleher.

In 1913 the artist completed one of his largest and most striking paintings, *The Peacemaker*, probably finished in New York because a diphtheria epidemic in Taos made it dangerous to stay there too long. Although inspired by his contacts with the Taos Indians, Blumenschein's figures in the painting wear the clothing and headdresses more typical of Plains tribes. There was, of course, some trade between the Plains tribes and the more sedentary Indian groups, such as the Pueblos, so Blumenschein had some justification for the Plains regalia in the painting. Nevertheless, the conception back East and in western Europe at this time as to how the Indians looked as genuine subjects of American art was largely influenced by the Lakotas; they had worn their headdresses and breastplates during Buffalo Bill's Wild West Shows, which had been exceptionally popular during the three decades prior to Blumenschein's completion of *The Peacemaker*.

In this allegorical oil, the peacemaker stands in the center, extending his arm horizontally between two foes. One is on his right, and the other is on his left, along with a small child standing beside him. These formidable figures appear as leaders, "towering heroically like statues of classical gods." According to Charles C. Eldredge's article on the painting in the 2001 spring issue of *American Art, The Peacemaker* was "revelatory of Blumenschein's (and his generation's) involvement with artistic tradition, especially ancient Greek, Roman, and Egyptian art." The painting

also dealt with the threat to Pueblo Indian lands caused by a 1913 Supreme Court decision that jeopardized the historical rights of the Pueblo Indians by opening their lands to allotment and making the Pueblos wards of the federal government like other tribes throughout the country.

Despite the outbreak of a life-threatening disease in Taos and Blumenschein's concern for his father when a severe springtime flood along the Miami River ravaged Dayton, 1913 was a productive year for Blumy. A perfectionist who would later redo his paintings several times before he was satisfied, he continued his sketches of both buildings and people in the Taos area during his first six years as a part-time Taos artist. One of his best was *Church at Ranchos de Taos*, which he completed sometime around 1916. The historic mission south of Taos is depicted, with its twin adobe towers, behind a group of Indians, some on foot and some on horseback. They are moving away from the church, conceptually occupying the space in the lower third of the painting, closest to the viewer in terms of perspective. The animate shapes of the Indians are in contrast to the rectilinear forms of the church behind them, with the white cotton blanket of the lead rider swelling in rounded bellows in response to the wind.

Another event that made 1913 an important year in Blumenschein's life was his wife and daughter's visit. The growing number of Taos artists were delighted to have Mary join their ranks. She was regarded as "one of the most popular magazine illustrators" in the country. Ivory Soap even gave away small posters of her artwork during her varied career as an illustrator and painter.

Sixty-six years later Helen published a description of the family's visit in *Recuerdos*. She mentioned her father's glowing accounts of Taos, with its talented art community only two miles south of the Taos Pueblo, which had five hundred Indians as ideal subjects for a painter eager to capture the

Ernest L. Blumenschein

Church at Ranchos de Taos, 1916. Oil on canvas, 45½ × 47½ inches. Courtesy of American Museum of Western Art—The Anschutz Collection, Denver.

spirit of the Old West. Ever since her parents had left Paris, Helen's father had doggedly tried to persuade her mother to come to Taos, so this visit was a major triumph for him.

Unfortunately, the visit did not go well, starting with the long trip from New York to the remote New Mexico town. Helen's father had not mentioned that after travelers left the railroad station at a place called Barranca, east of the Rio Grande Gorge, they "would descend a sudden and precipitous gorge 1,000 feet deep, while riding in a surrey with a fringed top drawn by four horses over twenty-five miles of

rough dirt and rocky road!" For Mary and Helen, this rugged trip came after "a four-day and night train ride from New York City to Chicago, to Lamy, New Mexico, and then on the Chili Line to Barranca Station!"

A photo taken in 1913 of Helen behind the Ranchos de Taos Church shows a dejected little girl weeping, probably from exhaustion, in contrast to her mother, who seems most happy, "game for anything—except there was no milk nor fresh food for her daughter." Moreover, the diphtheria epidemic of that year did not improve the morale of either mother or daughter, who were staying in a rental boarding house in Taos not nearly as nice as their comfortable lodgings in New York City. Mary soon made a decisive declaration. As Helen put it, "Mother flung down the gauntlet—a house and dairy milk or no Taos for the two of us. A week later back to New York we went."

The abrupt departure of his wife and child must have been an enormous disappointment to Blumenschein. His relations with his once-close wife continued to be complicated. Yet his almost unequivocal declaration to Mary before they got married that art would always come first must have dominated his emotions. Indeed, having arrived late in the summer of 1913, he stayed in Taos until late October. During the following weeks he opened his studio so that other artists and connoisseurs could view the artwork he had completed during the lonely period after Mary and Helen left. The one-man exhibitor was a success; the Palace of the Governors in Santa Fe persuaded him to exhibit his paintings in its reception room, and he sold two of his paintings to Santa Fe's recent former mayor, Arthur Seligman. An art critic from the *New York Evening Post*, many years later, would emphasize that painting in remote western places like Taos was a "regular frontier experience." Presumably, at least some artists' spouses, other than Mary, were not always as adventuresome as their husbands.

The Taos artists faced many complications as they strug-
gled to make their growing art colony into a successful na-
tional and even international one. These included the geo-
graphical isolation of Taos, its lack of comfort resources, its
distance from the major art galleries, and its transportation
problems. One advantage for Blumenschein was the good
relationship he continued to have with the Santa Fe Railway,
which was still using western paintings in its promotions.

As early as 1910 Blumenschein was in regular contact
with William Haskell Simpson. As head of advertising at
the railroad's Chicago office, he was the man authorized to
purchase paintings for display in the company's corporate
offices and the one in charge of the reproductions of these
paintings in the Santa Fe's brochures. The relationship be-
tween Blumenschein and Simpson, an art collector as well
as a poet in his spare time, was that of two hard-headed
businessmen each seeking an advantage over the other, yet
careful to preserve cordiality and personal goodwill.

In a letter to Simpson dated September 10, 1911, Blu-
menschein expressed his disappointment that Simpson was
unable to visit Taos and meet the members of the Taos
art colony. "We were all expecting you and Couse was es-
pecially rigged for entertainment." Then later that same
month, Blumenschein wrote Simpson again, more explicitly
referring to the money problems he had during these early
days as a long-distance commuter. In a letter dated Septem-
ber 19, he told the Santa Fe executive that he was "terribly
disappointed" that he could not have the money owed him
by the railroad at once. "I'll have to borrow somewhere, as
I figure out my resources up to the last cent. Counting on
you as my best hope. Anyway do the best you can. I'll be
Chicago the morning and afternoon of Monday the 25th
and will call on you with a picture under arm."

Blumenschein was not stretching the term when he re-
ferred to Taos as an art colony in his letter to Simpson.

By 1910 when Blumenschein first made Taos his part-time home, it was already an art colony in every sense of the word and could have continued to develop as such with or without his presence. Still, Blumenschein shared in the sense of accomplishment when he and his fellow painters met for comradely meals at the old Columbia Hotel, a favored gathering place because its manager gave artists a bargain rate of twenty-one meals a week for $3.50 and was willing to extend credit to those who could not produce even that amount in cash.

Sharp, Blumenschein, and Phillips together had seen the potential in Taos, but the unflagging efforts of Phillips alone had drawn enough part-time and full-time resident artists to Taos to justify the claim of art colony status. Even then, something more than Phillips's persuasiveness bolstered the development of Taos as a center of creativity. Ironically enough, Taos was starting to thrive during the 1900–1910 decade, when New York City's dominance in art was at its peak. A parallel movement in art saw the creation of art colonies in pristine rural areas scattered throughout the country, from California to the Midwest to the New England coast. Taos benefited from a set of factors prompting painters to consider art colonies as realistic alternatives to urban living, with its subservience to instituted notions of appropriate subject matter and art style.

Among the factors that resulted in the creation of art colonies in America at this time were the declines in magazine illustration work available in New York; a shrinking market demand for portraits; and a new artistic independence engendered by the rise of post-impressionism, cubism, expressionism, and futurism. There was also a growing desire to make American art reflective of the American landscape, history, and culture. This craving resulted from disillusionment with industrialization; alienation from the values of a money-dominated middle-class America; and the belief that

in a setting of unspoiled nature, writers and artists living near one another could create an environment conducive to the full flowering of individual talent.

In one of the fortuitous coincidences that enlivened the course of history in Taos, a man from New Mexico who was as removed from the world of art as it is possible to be proved an indispensable facilitator of Taos's viability as an art colony. For all the incomparable richness of its landscape and culture, Taos was isolated and difficult to reach, with virtually no appropriate means of transporting fragile paintings to the world beyond its confines. John Dunn, a physically fearless beanpole of a man, well over six feet tall, with a craggy face adorned by a big moustache, single-handedly removed most of the obstacles to travel in and out of Taos and made it much easier to ship paintings to outside exhibits and buyers. Although his hardscrabble life story made the Taos painters seem like princes of privilege by comparison, the artists treated him with respect, and he in turn seemed to understand intuitively their concern for the safety of their paintings.

Born to dirt-poor Texas farmers in 1857, Dunn, at the age of fifteen, became a trail driver for the cattle barons. In the process he became hooked on gambling in the wide-open cattle town of Dodge City. The early life of this poorly educated man was a violent one, which included smuggling Mexican leather into the United States and killing his sister's husband after he brutally beat her while in a drunken rage. Dunn eventually ended up in the mining community of Elizabethtown, not far from Taos, where, through his earnings as a gambler, he bought the town saloon in partnership with the U.S. marshal from the area.

In the late 1880s he volunteered to carry the U.S. mail into Taos. He liked the town immediately, moved there, and opened up a gambling saloon, but when he could not raise the $15,000 needed to acquire a private bridge across the Rio Grande, west of Taos, he decided to move on un-

til he could accumulate the necessary funds. In the wild boomtown of Goldfield, Nevada, he gambled successfully enough to give him a start in this direction. To maximize his profits even more, he did something that would have made a western romantic like Bert Phillips swell with admiration; he staged a well-publicized fist fight with a large, aggressive miner to enlarge the stakes for his proposed Taos enterprise. After winning the bloody brawl, Dunn counted his winnings of $42,000 and that very night saddled up and headed back to Taos.

Upon his arrival in Taos he bought the bridge he had wanted since 1889 as well as a competing bridge built in the years since by Taos merchants Albert Miller and Gerson Gusdorf. Dunn's toll bridge and escort service up the river canyon flourished immediately, earning for the ambitious owner an average profit of $250 a day. When a flood swept away his most lucrative bridge, he built a new and better one. It might not have been a comfortable structure for Blumenschein's wife and daughter arriving for their short visit to Taos in 1913, but it made travel to and from the colorful town far less cumbersome. The artists in the growing Taos art colony also found that their paintings would reach the eastern markets faster and safer than before.

In 1899 Phillips and Sharp, with whom Dunn had become friendly, told him that they believed many more people would visit Taos if a rail station was located closer to Taos Junction. Dunn went to Denver and convinced the Atchison, Topeka, and Santa Fe to extend its chili line from Taos Junction to a new station at Servilleta, due west of Taos. Dunn also acquired the mail route from Taos Junction into Taos. It all added up to a lucrative, multifaceted business for this rustic entrepreneur. Indeed, Dunn, who knew little about art but a great deal about business, had significantly prepared Taos for the growth and fame it would enjoy through its art colony during the next several decades.

10

Proving His Patriotism

By 1913 Blumenschein's style of painting was beginning to resonate with art critics. His oil paintings, particularly *The Peacemaker*, were drawing considerable attention to his artwork. This artistic rendering with its three statuesque Indian figures, in which the one in the middle is trying to bring peace to the two on each side, caught the eye of artist and critic Ernest Peixotto, who discussed it in an evaluation of Blumenschein's art style published in the October 24, 1913, issue of the *Santa Fe New Mexican*.

Referring to the artist's focus on western subjects as an important and distinctive part of the growing American art form, Peixotto observed that Blumenschein "does not content himself with the picturesque side of Indian life, but is preoccupied with harmony of line, mass, and color, building compositions that 'carry' and please the eye with fine decorative effects." This search for the "truly decorative" value to be found in American Indian subjects, according to Peixotto, was unprecedented in American art, a "field rich in possibilities." Blumenschein's devotion to painting over his more lucrative illustration work as well as his years of rigorous training in New York and Paris were finally gaining him a reputation as an exceptional American artist.

Art historian Patricia Trenton speculated many years later that the Rio Grande Gorge, which appears at the bottom

of *The Peacemaker*, may have been emblematic of a schism between the two hostile make-believe chiefs of the Taos Pueblo. Helen Blumenschein related this interpretation of the painting to Elizabeth J. Cunningham. Art historian Peter H. Hassrick, in his collaboration with Cunningham on their comprehensive art book dealing with Blumenschein's career, *In Contemporary Rhythm*, suggested that the artist might have had even more than that in mind. Indeed, while Blumy was painting *The Peacemaker*, battle lines were being drawn in Europe. In 1913 Germany, the Austro-Hungarian Empire, and Italy formed a coalition called the Triple Alliance. To counterbalance this alliance, Czarist Russia, France, and Great Britain formed the Triple Entente.

On June 28, 1914, about a year after Blumenschein completed *The Peacemaker*, World War I started when Franz Ferdinand, the heir to the Austrian throne, was assassinated at Sarajevo in Bosnia by a Bosnian radical named Gavrilo Princip. The assassin, who represented the views of one of the discontented minority groups in the unwieldy and polyglot Austro-Hungarian Empire, was believed to have a close connection with the government of the neighboring state of Serbia. When the Austrian government made unreasonable demands on Serbia, the latter began to mobilize troops, causing Austria to declare war on July 28, 1914. The Austrian war declaration prompted Russia's involvement on Serbia's side, resulting in Germany declaring war on Russia on August 1. Honoring its Triple Entente partnership, France entered the war on August 4 followed almost immediately by Great Britain when Germany violated the neutrality of Belgium by sending troops through the small country to invade France from the north.

The German attack on France involved five armies swinging in an arc through Belgium and northern France, coming within thirty miles of Paris. The French launched a successful counterattack, which resulted in a four-year deadlock of trench warfare on the western front of what people would

eventually call the Great War. Ernest and Mary Blumenschein were undoubtedly chagrined at the prospect of German troops bombarding and occupying the beautiful city of Paris. Beyond the city's material value, the destruction of Paris was a threat to the creative life that the Blumenscheins and many other Americans had so enjoyed for more than three generations, since American artist John Vanderlyn went to Paris in 1796.

Both sides in the conflict tried to convince the countries of the world (especially the United States, which had recently become a leading industrial power) that their role in the outbreak of this disastrous war was justified. In this propaganda fight for global support, the Allies, as the French, British, and Russians were called, had a great advantage over the Central Powers of Germany and Austria. Alleged and real German atrocities in Belgium gave the Allies an early propaganda coup; the invasion of a neutral country like Belgium made nations like the United States suspicious of German aspirations.

In addition, Great Britain had the greatest navy in the world, one that could control the sea routes across the Atlantic. The British blockade of the European continent also made it difficult for the Central Powers to recognize and respect America's neutral rights. Furthermore, Germans were cut off from the aid and trade that had strengthened the Allies' position during the early years of the war. Germany struck back with submarine warfare, sinking many of the ships bringing war supplies to France and Great Britain. Unfortunately for the cause of the Central Powers, American ships bringing cargo to Europe were sunk in the process, causing many Americans to become stridently anti-German and pro-Ally. These sinkings eventually led the U.S. Congress to declare war against Germany on April 6, 1917.

The United States experienced that strong surge of patriotism so characteristic of the early stages of most wars. Many members of the large German American community would

have to deal with the growingly intolerant anti-German feeling that accompanied America's active participation in this now truly global conflict. To convert Americans from their long tradition of isolationism, President Woodrow Wilson condoned an intense propaganda drive to support the war and learn to hate the enemy. The Creel Committee, or the Committee on Public Information, was created by Congress and headed by George Creel, who enjoyed Wilson's confidence in launching this aggressive propaganda campaign. Artists like Blumenschein, along with actors, educators, historians, advertisers, poets, and photographers, were enlisted in Creel's propaganda drive. The popular silent motion pictures of the day often horrified their viewers with pictures of the barbarities perpetuated by "the Huns," as the Germans were routinely dubbed. Pamphlets and canned editorials often whipped up such strong anti-German feelings that Wilson's idealistic efforts after the war to establish a just and lasting peace became exceedingly difficult to achieve.

The net result of these moves to strengthen America's commitment to the war after almost three years of neutrality was to bring into question the loyalty of German Americans. This development would be divisive because, according to the 1910 U.S. census, foreign-born Americans of German origin numbered 8,282,618, more than British-born and Irish-born Americans combined. Prior to the country's war declaration, many persons of German descent, who understandably identified with their ancestors' homeland, lent support to the Central Powers through their efforts to shape public opinion, which was being strongly influenced by Allied propaganda.

One German American Taos artist, Walter Ufer, was close to Blumenschein in their largely shared concept of art styles and subject matter. Born in Kentucky of German parentage and, like Blumenschein, able to write and speak German, Ufer had studied art in Munich and in Dresden and

was much influenced by his training in Munich, where light and color were particularly stressed. Like many German Americans he worked for neutrality rather than American involvement in the growingly fierce European war. He even donated some of his profits, from the sale of his paintings, to the German and Austrian Relief Society for Crippled Soldiers, according to Laura M. Bickerstaff in her study *Pioneer Artists of Taos.*

Ufer's pro-German activities probably exceeded those of most people sympathetic to the German cause. Many German Americans did vote for neutrality by casting their ballots for Republican Charles Evans Hughes in his 1916 presidential bid against the often-evasive President Wilson, who, ironically enough, ran on the slogan "He Kept Us Out of War." After April 1917, however, open sympathy for Germany and her allies was no longer tolerated by "patriotic Americans."

During the country's active participation in the war, Congress became concerned about a widespread belief that the country was being infiltrated by secret agents of the German kaiser, Wilhelm II. It passed the Espionage Act of 1917, which called for fines and harsh prison terms for anyone interfering with the draft, and the Sedition Act of 1918, which made it an act of disloyalty to obstruct the sale of U.S. war bonds or utter "disloyal or abusive" language about the Constitution, the flag, or even the uniforms worn by American servicemen. Many German Americans who had sided with the Central Powers at the beginning of World War I were targeted by these new laws and attitudes. The patriotism of some was questioned, sometimes by neighbors who bore personal grudges against them. State laws were passed that forbade teaching German in the country's schools or colleges, German books were removed from public libraries, and Austrian and German musicians like Blumenschein's father were often prevented from playing in public or having their music performed.

In New Mexico, however, Blumenschein rarely had problems as a German American. The state, admitted to the Union only five years earlier, was heavily Hispanic in numbers and tradition. The population of Anglos was much smaller than it would become toward the end of the twentieth century. The German American minority blended in with the state's Hispanic heritage as well as groups of any nationality. German Jews, such as the Gusdorf family in Taos and the Staab family in Santa Fe, had met the needs of the population whether they be Anglo or Spanish-speaking through their successful mercantile businesses. (Before the virulent anti-Semitism of Hitler's Germany, German Jews during World War I would have been subject to the same discrimination as German Christians.) Tomas Jaehn, historian of the Fray Angélico Chávez History Library at the New Mexico History Museum in Santa Fe, in his 2005 study, *Germans in the Southwest, 1850–1920*, discovered no serious cases of prejudice against German Americans in New Mexico during World War I.

The discrimination problems facing Blumenschein and other Taos artists during the war years came from outside New Mexico and usually involved the sale of their art and the overall image of German American artists. Any kind of nationwide disruption, whether it be from a war or an economic downturn, seems to adversely affect the distribution and sale of artwork. Mary Ufer, Walter's wife, in a public lecture on how America's entry into the war affected art, sounded a deep note of pessimism. "What the war meant for the artists," she recalled, "I do not believe you can possibly have any conception. Every source of income cut off by one stroke—no pictures bought. The pictures under consideration returned—portrait orders cancelled; and on every hand demand for money and for contributions of work for which they receive nothing."

In the face of these economic problems and the growing discrimination against German Americans, Blumenschein

remained busy, still spending summers in Taos so that he could paint portraits of Taos Pueblo Indians and New Mexico's Hispanics living in the Taos area. In 1914, before America's involvement in the war, the artist could be reassured about his ethnicity when President Wilson proclaimed on August 4 that the "United States must be neutral in fact as well as in name . . . [and] impartial in thought as well as in action." The artist's ethnic background had little to do with how people perceived him during those early war years in Europe. His productivity was up, although his perfectionism kept him from ever being prolific.

In 1915 he painted *The Chief's Two Sons*, a kind of follow-up to his well-received *The Peacemaker*, in which he once again features Taos Indians dressed in Plains regalia. During the 1920s he separated the two Indian subjects of *The Chief's Two Sons* into two paintings: one, titled *Eagle Fan*, shows the chief's son from the left side of the original painting, and the other, titled *Eagle Feather, Prayer Chant*, shows the chief's son from the right side. In 1916, his major painting *Church at Ranchos de Taos* was becoming an acknowledged symbol of Hispanic Catholicism in New Mexico. In 1917 Blumenschein used one of his favorite Taos Indian models, Marcio Martinez, known by the nickname "the medicine man," in an oil the artist appropriately called *The Medicine Man*. In it Martinez is sitting with two other Taos Indians, who are standing, behind three pottery bowls they are hoping to sell. Blumenschein painted the aging Martinez sitting alone in another oil he completed that summer, which he titled *Old Man in White*. In 1918 he painted one of his most striking portraits, of a beautiful Taos Indian woman named Albedia Marcus, which he called *Albedia of Taos*.

Throughout the war years, Ernest Blumenschein had to work particularly hard to pay for his summer trips to Taos and to maintain the upkeep of his New York City home, the location of which appeared in a winter scene in his

1917 painting *Fifty-Seventh Street, New York*. That same year another of his Indian paintings, *The Chief Speaks*, won the Potter Palmer Gold Medal (accompanied by a $1,000 prize) at the Art Institute of Chicago. In 1918, the often frugal and businesslike artist sold that portrait for $750 to the Cincinnati Art Museum to help him meet at least some of his expenses.

Blumy, even though he was primarily a summer Taos resident, also helped found the Taos Society of Artists in 1915, along with fellow artists Bert G. Phillips, E. Irving Couse, Joseph Henry Sharp, William Herbert Dunton, and Oscar Berninghaus. The purpose of this association, which was incorporated in 1918, was to promote high art standards and to inform the public about the importance of western art. Its charter also stressed potential economic benefits, such as from participation in circulating joint art expositions and the promotion of careers for the society's hard-working membership.

On April 6, 1917, when the United States finally declared war on Germany, Blumenschein had to square his ongoing concerns about finances with his fellow Americans' suspicions about his patriotism and that of other German Americans. Doubts about German Americans were baseless for the most part, but particularly in Blumenschein's case. A German name notwithstanding, the artist was an American and was proud enough of that fact to work diligently for an American form of art, using the West as its base. Perhaps reflecting his mother's puritanical New England heritage, he was often critical of the bohemian lifestyle of many artists in Paris. He celebrated important U.S. holidays while living abroad and played baseball and other American sports.

The extent of the problem with Blumenschein's German heritage is demonstrated by an incident involving the more controversial Walter Ufer. Ufer, marked by a German name as Blumenschein and Berninghaus were, had won support

for an associate membership in the National Academy of Design, still a prestigious art organization in New York. Blumenschein, along with Taos artist Couse, wanted to bring Ufer's name up for membership, but after testing the waters, they felt it was not feasible at the time. Blumenschein put it this way in a letter to Ufer. "Couse and I talked it over and decided it would be a very risky thing for you to be proposed by me, with my German name."

Blumenschein coped with unfair attacks on his German background by becoming conspicuously prominent in his support of the war. He curtailed the energy he had been devoting to fine art and participated in such prowar activities as the Liberty Loan drives. He began painting war scenes and portraits of American war heroes. As French churches on the western front were being hit by German artillery shells, including the great Gothic cathedral at Amiens, it was not surprising that one of Blumenschein's oil paintings in 1918 dealt with the theme of mass destruction on the sacred symbols of Christianity in France. *Long Range Gun, Paris*, sometimes called *Good Friday in a Paris Church*, shows dead and wounded people scattered among the rubble of a large and beautiful church in Paris, partly collapsed by German shells. This dramatic painting was part of a war display at that popular New York City hangout for artists, the Salmagundi Club. It was later displayed as a poster for the Liberty Loan Committee to promote the war effort. Blumenschein's portrait of a first lieutenant and Purple Heart recipient named Charles Lembke is another example of the artist's effort to show his support for the war.

Blumenschein's biggest contribution to the American war effort was to produce range-finder paintings for the military. These were 50-by-70-inch landscape paintings of European scenes for machine gunners to use as targets, helping them sight and ascertain enemy positions. He began his involvement in this program as the western representative of the Salmagundi Club in February 1918, and then went to New

Long Range Gun, Paris, 1918. Oil on canvas, 52¼ × 34 inches. Courtesy of Division of Armed Forces History, National Museum of American History, Smithsonian Institution, Washington, D.C.

Mexico in the spring of that year to involve the budding art colonies of Taos and Santa Fe. In summer 1918 he spent most of his time in Taos working on range finders, using the spacious studio of fellow painter and neighbor Burt Harwood.

Blumenschein was coordinator of this range-finder project, which won many kudos for the artists in the "Taos-Santa Fe Circle." The part-time Taos artist was so dedicated to this program that when the town's artists organized a benefit art raffle connected with the Red Cross, they seemed to work together with considerable harmony. At the end of the summer, the Museum of New Mexico hosted its annual exhibit for the Taos Society of Artists, and each member of the society, except Blumenschein, presented a half dozen or more new artworks. Their colleague Blumy offered only one painting and two range finders. Interestingly enough, his one painting was the small oil *Albedia of Taos,* which was hailed by some art critics because it was so different from much of what he had been doing.

Blumenschein was clearly more dedicated to helping America in the war than other Taos artists were. Indeed, his painting *Long Range Gun, Paris,* and his portrait of Lieutenant Lembke were in the spirit of the range-finder projects. Couse considered his one range-finder contribution to be sufficient. Others were not as absorbed in the project as Blumenschein was or were too busy to cooperate. These attitudes greatly frustrated the strong-willed artist, and he vented his anger in the widely circulated *American Art News.* He claimed that prior to the range-finder project in New Mexico, hardly any war work was being done among the local artists. "The men were wrapped up in other paintings, in the usual course of a summer's labor, in their supreme egotism, feeling that their genius should be unhampered; others in plain selfishness, simply painted because they loved to paint; others producing 'pot-boilers' for the winter's market." He noted that when the call had come for the artists to pledge themselves to so many days a month to produce a range finder, these western painters with "a few exceptions were not so anxious to help . . . and really sacrifice some of . . . [their] precious summer days for the benefit of the men who were willing to sacrifice their precious lives."

Blumenschein continued his denunciation, becoming more personal in the process. The responses in behalf of the war were slow in materializing, he wrote. "One artist said (and it is actually the most outrageous example of egotism I have encountered) that 'he considered his work more important than the war!' Another said that he had given this and that and had painted a range finder back East, owned Liberty Bonds and had given generously to the Red Cross . . . and now was going to work for himself until next winter, when he would help again in war work." Blumy said to this artist that the war "isn't waiting until next winter" and that he hoped "other artists who have reasoned that way may see this letter, be moved to contribute a range finder," which would be of great value to "machine gun instruction." He concluded his blunt remarks with a more tactful assessment, telling his readers that the Taos artists "came around beautifully in the end, and inside of two weeks we had 15 completed canvases, 50 x 70, landscapes and village scenes of France, which are now on their way to help kick the Kaiser."

The response to Blumenschein's remarks in the *American Art News* was swift and angry. A special meeting was called by the Taos Society of Artists in which Blumenschein was harshly reprimanded for questioning the patriotism of his colleagues. As Hassrick and Cunningham put it in their Blumenschein study, *In Contemporary Rhythm*, "Blumenschein was forced to publish a retraction or be run out of town." The artist's tactless observations were probably not primarily an effort to distance himself from his German background, although they undoubtedly did. Rather they were a reflection of his personality and belief system. He had always held himself to a high standard in his art and this character trait probably extended to his sense of patriotism as well. His high expectations for himself and others would trouble him throughout his life, as they had when he had elicited such bitter criticism from his colleagues for his

self-righteous and caustic remarks about their loyalty to the United States in time of war.

During the years following the outbreak of World War I, Blumenschein experienced major life changes. His father died in 1916. Ernest had not seen him often since his return from Paris. On his way home from Taos in early fall 1915, he stopped in Dayton to visit his father. During this visit, he was interviewed by the *Dayton Journal* on October 3. In this meeting he praised Mary for her success as a painter and an illustrator; these comments must have been reassuring to his father, even though the elder Blumenschein had given his son little comfort when Ernest had faced such opposition from Mary's mother a decade ago. The bulk of the interview, however, was his advice to aspiring young artists. He revealed his deep satisfaction with the formal academic art training he received in both New York and Paris. He praised the solid foundation he was given by first-class artists in their instruction regarding "form, anatomy, color, and composition" in painting.

The artist, now a local celebrity, inadvertently revealed the financial dilemma caused by his travels to and stays in Taos every year. He announced that he would vacate his teaching position with the Art Students League after a three-year tenure, during which he could reciprocate for the help he had received from the league in his development as an artist. When the interviewer asked if his resignation would be a serious blow to the art school given Blumenschein's growing recognition, the artist responded that it was too time consuming to teach and at the same time improve his painting skills; these remarks were yet another example of the high standards he had set for himself.

At this time in Blumenschein's art career, his father still had some significant influence over him. The artist had completed a painting the previous year titled *The Violinist*, a clear indication that he had not completely forgotten the music career his father had wanted for him. In 1918, as part

of an advertising campaign for the music company Steinway and Sons, Blumenschein had painted an interpretation of American composer Edward A. MacDowell's *Indian Suite*. The painting dramatically portrays a battle between two enemy tribes, with a large and imaginative Indian spirit or warlike apparition above them, beating a war drum with other aroused warriors. In 1922 this oil painting, which he called *Indian Suite*, would win for Blumenschein the first medal ever awarded for the best figure painting at the New York Art Directors Show. Unfortunately, his father did not live long enough to share his son's glory in being recognized for honoring a classical music personage.

In 1917 Blumenschein's mother-in-law, Isabel Greene, died, leaving her daughter a considerable inheritance along with a comfortable home in Brooklyn. This sad event enabled the Blumenscheins to move out of their New York City apartment and settle in Brooklyn. More important for Ernest's career was the new income, which would allow him to focus solely on his paintings. The forty-year-old artist felt that Mary's inheritance was sufficient enough to permit him to give up "illustration entirely" and devote all his time to fine-art painting.

Although World War I had forced Blumenschein to spend fewer than six weeks in Taos in 1917, the postwar decade of the 1920s would be the most productive in his career. In 1919 he told an interviewer that he and Mary had made the "great decision" of their lives to locate in Taos. They had also decided to sell the Brooklyn home. Before the family could make their move, however, Blumenschein had planned a trip to New Mexico, where he would rent a studio in Albuquerque to get better acquainted with the southern Pueblo Indian culture.

Because Mary and their daughter could not leave New York until the end of Helen's school semester in June, Blumy asked his old friend and colleague Bert Phillips to join him for a six-week trip in New Mexico, which would take them

as far west as the Zuni Pueblo. The congenial Phillips had apparently forgiven his friend for his earlier diatribe against the lack of patriotism among Taos artists. Their journey together was in many ways a nostalgic one to commemorate their trip twenty-one years ago, when Blumenschein had gone into Taos to get a broken wheel repaired for the wagon they had used to travel from Denver to New Mexico.

Mary had significant reservations about this life-changing move because of her weak heart, which might give her trouble at Taos's 7,000-foot altitude, but she allowed her enthusiastic husband to take her to Albuquerque after she arrived in Taos. There they purchased an inexpensive car, probably a Model T Ford, and went on a camping trip throughout New Mexico and Colorado to acquaint Mary with the Rocky Mountain region. It was an interesting journey but somewhat spoiled for Mary because of the rainy weather. After this trip, they acquired a house in Taos, and the three of them began a brand new life in the West.

11

The Productive Twenties

In the late 1940s Ernest Blumenschein described the 1920s as the decade in which he achieved "high production" in his art and "considerable success in prizes and one-man shows and sales." Tending to be cautious when talking about the virtues of his own artwork, he was, as usual, rather circumspect in making these remarks about his successes to Reginald Fisher, the prominent director of the Museum of New Mexico's Art Division, where Blumenschein often showed his paintings. Yet during this decade, popularly called the Roaring Twenties by students of history, Blumenschein was finally free from many of his financial worries because of Mary's inheritance; he could at last focus on oil painting without the distractions of illustration work with its demanding deadlines.

In Taos, Blumenschein could also labor in an environment conducive to a painter who wanted to do oils on American rather than European art subjects. As one of the founding members of the Taos Society of Artists, who was making the slow transition to permanent town resident, he could now paint with minimal distraction in the place where he felt most creative. Throughout his early years living permanently in Taos, he continued using the Taos Pueblo Indians as one of his favorite subjects. In this effort he, along

with other Taos artists, was eager to focus on the country's last frontier, the American West.

During these promising years the ambitious and imaginative artist, now in his mid-forties, also began to expand his interests to include the landscapes of the Southwest. He was impressed by the contrasting land formations, with their striking colors and shapes, particularly as seen from the beautiful Taos Valley. Moreover, he expanded his portraits of human subjects to include more Hispanic people from Taos as well as the Taos Pueblo Indians who had been his portraiture staples.

The Blumenscheins' move to what he had once called his "little mud town in New Mexico" was a slow one, with Mary remaining somewhat reluctant. She had not been as impressed with Taos as her husband; she still recalled the primitiveness of the small frontier town from her short visit in 1913, when Blumenschein had been only a part-time resident. Nevertheless, her ambivalent feelings toward the community, which had grown in population along with its thriving art colony, were largely dispelled when she, along with her husband and daughter, drove into Taos on July 8, 1919, after their get-acquainted motor trip through New Mexico and Colorado. The *Taos Valley News* described their arrival and the enthusiastic reception they received: They were "looking fine and prosperous and their many friends in Taos rejoiced to see them."

Toward the end of the year the Blumenschein family bought a house on Ledoux Street with the hopes of moving into it the following spring. It was one of those low-lying adobe edifices so characteristic of Taos architecture. It had been owned by Blumenschein's friend and former student W. Herbert Dunton, one of the six founding members of the Taos Society of Artists; he would become Blumy's most avid fishing companion in the years to come. Mary, whose adult life had heretofore been spent in large cosmopolitan centers, such as Paris and New York, would eventually add to

this New Mexican structure, typical of the old and historical Taos, several well-conceived rooms, including studio space for herself and her husband, plus guest quarters for their many out-of-state friends. Once the sale was complete, Dunton left for his home in New Jersey for the winter, and the Blumenscheins returned to the family's Brooklyn home to make the necessary preparations for their move to Taos in the spring.

When the Blumenscheins returned to Taos in mid-April 1920, they came in style. Because of his wife's generous inheritance, the ordinarily frugal Blumenschein had arrived in town with his family in a brand new car. They had started their trip six weeks earlier in order to take a cross-country motor journey, which included an excursion to California. Now, after about three months in their new home, during which they were presumably painting the walls and arranging the furniture, they were ready for a house warming. In late July they hosted a party for seventy-five of their neighbors, featuring a lecture on Southwest Indians by Bureau of Ethnology anthropologist J. A. Jeançon and ending with a festive evening of dancing.

Mary Blumenschein, according to her daughter, worked diligently to make their adobe home a happy haven for herself and her family. Given Mary's reservations about living so far away from the big city life she truly enjoyed and her long-held apprehensions about life in a frontier town, which was still without modern plumbing and electricity, her move to Taos must be interpreted as a selfless one. She was once again accommodating herself to the desires of her strong-willed husband.

The gentle Mary, who had long since put her husband's art career above her own, was once again accepting the fact that Ernest would do as he pleased, just as he had done when he had lived away from her in Taos as a part-time resident artist after their return from Paris in 1909. How she felt deep down about these new arrangements may never be known because she was a person who made the best of

difficult circumstances without uttering any protest outside the family fold.

During the early years, she did not dress like most of the local citizens, often wearing white gloves and a black velvet band around her neck. After four o'clock each day she would insist on a proper tea time for her and her husband. But she was a gracious hostess, as she and Ernest would often entertain at their home, which, because of her keen eye as an artist, was always kept in style while exuding good taste. An exceptional artist in her own right, Mary made the new family home in Taos one that would represent the best of the architectural traditions of the Pueblo Indians and the Spanish of the Southwest. Rounded Indian fireplaces and Spanish vigas captured the simple but charming tastes of the early residents of the region. According to her daughter, she increased the light in their airy and open home by putting in horizontal windows in contrast to the vertical ones that were in the house when it was purchased. Aware of other cultures in the world, Mary, whose adult years as an art student in Paris gave her a much greater cosmopolitan perspective of life than most Taos residents, hung Japanese prints in the library and added more shelves to accommodate their impressive collection of books. In their "cool and white washed dining room," she placed Southwest Indian watercolors appropriate to the area.

Mary employed Indian carpenter Geronimo Gomez, one of her husband's favorite models, to cover the library walls with paint in a striking "Muresco hand-mixed Venetian red color." Her arrangement of furniture also showed the innate understanding of placement and balance found in the work of a truly capable classical artist. "She placed a chaise lounge in front of the fireplace, a tapestry over a Mexican bed on the east wall and an oval mahogany table opposite."

The Blumenscheins would at times display Ernest's latest oil paintings in their Taos home, given his growing prestige as a painter in oils. One of Blumy's most serious new paint-

ings at the time of the family's move to Taos was a dual portrait of two Pueblo Indians, somewhat similar to *The Chief's Two Sons* he had painted in 1915. The new painting, completed in 1920, was called *Star Road and White Sun*. It featured Geronimo Gomez as Star Road, whose image was located in the middle of the portrait, with a cowboy hat over his long braided hair and a red and blue scarf around his neck, loosely enclosed by a tan vest. Behind him, on his right side, was Juan de Jesus Martinez as White Sun, dressed in traditional Taos Indian garb with a blanket covering his head and body.

Martinez's inclusion in the painting was probably as a generational device because Gomez, or Star Road, was a decidedly modern Indian; indeed, he identified himself as one of "the peyote boys." In 1920 the peyote use in Indian religious rites was extremely controversial and opposed by the Bureau of Indian Affairs and the Catholic Church, as well as by older Taos Pueblo Indians like Martinez, Gomez's brother-in-law, who tended to be critical of Gomez and his ilk for not fully embracing the traditional manhood rites practiced in the kiva.

Star Road and White Sun was one of Blumenschein's cherished paintings; he felt it was one of his finest and that his completion of it meant that he was ready to do large oil paintings that could rank with the best. The painting stood out in its eye-catching harmony of rich orange and brown colors and in its subjects, who were not stereotyped or historical images of Indians living in harmony with nature, which characterized the paintings of some other Taos artists. Instead they were Indians living ordinary day-to-day lives in the contemporary world. The artist, along with most members of the Taos Society of Artists, was keenly interested in the Taos Pueblo Indians and hoped his portraits of them would help preserve their remarkable centuries-old culture. Yet Blumenschein was realistic enough about Taos Pueblo life to want to paint its rebels, such as Geronimo

Gomez, as well as those more dominant traditional Indians who controlled most of Pueblo life.

The artist was so enamored with *Star Road and Sun White* that he priced it quite high for the era, asking $2,000 to $2,500 for the painting and sending it on tour to the prestigious National Academy of Design in New York and to the Detroit Institute of Arts. To Blumenschein's disappointment the much-traveled painting did not sell, even when he significantly reduced the price over a long period; he finally sold it to Albuquerque High School for $250, the cost of the materials he had used to paint this still-cherished portrait. As evidence of the true value of this striking oil today, a reproduction of it graces the cover of the art book *In Contemporary Rhythm: The Art of Ernest L. Blumenschein*, a hefty volume that includes most of Blumenschein's paintings and many of his magazine and book illustrations.

That Mary Blumenschein hired Gomez to paint the library of the new family home says much about her husband's attitude toward Taos Valley's Native and Hispanic communities. When Blumenschein had first gone to Taos as a part-time artist, he had quickly made friends with several Hispanics by playing baseball with them. During his art career in Taos, he regularly used residents from the town and the pueblo as models. The practice was not unique to him; Taos painters such as Victor Higgins, Phillips, Couse, and others also used Indian models. But not all of them established such warm friendships as Blumenschein did. He went fishing and engaged in other outdoor sports with his new friends.

These personal friendships led to a deep concern for the welfare of those Indians and Hispanos who were his friends and some of them models for his best oil paintings. Many Taos Valley residents were potential victims of a strong trend toward political and social conservatism in Washington and throughout the country, which had become more vocal after World War I. One cause for this alarming development

212

was the illiberalism sparked by President Wilson's Creel Committee at the outset of America's active participation in the Great War.

American Indians became an inviting target for this mushrooming intolerance across the nation; their determined detractors had both cultural and material motives for the repressive actions they launched against the Natives. From the 1880s through the 1930s, Protestant missionaries and moral reform organizations, in concert with the Bureau of Indian Affairs (BIA), were becoming more impatient with the slow rate of assimilation into American society by reservation Indians. Their criticisms contributed to a document, which would eventually comprise about two hundred pages, that became known as the Secret Dance File, according to Skip Keith Miller, former curator and codirector of the Blumenschein home (now one of several Taos historic museums). The file was scornfully critical of what it dubbed the immoral and anti-Christian dances practiced among several Pueblo tribes.

The Secret Dance File resulted in the 1921 release of a BIA policy statement known as Circular 1665, implemented by Charles Burke, commissioner of Indian affairs under President Warren G. Harding, and condemning most traditional Indian dances. The circular insisted that all BIA reservation agents or superintendents ban them if they involved "immoral relations between the sexes and any disorderly . . . performances," which would encourage "superstitious cruelty, licentiousness, idleness, danger to health and shiftless indifference to family welfare." Because many of these dances were religious, critics of Circular 1665 claimed that it denied reservation and non-reservation Indians their First Amendment right to freedom of religion. Although U.S. citizenship was not granted to all Indians until the Indian citizenship bill was signed into law on June 2, 1924, many Indians had already become American citizens under the Dawes Act of 1887, in which Indian lands were allotted

to individual tribal members, and those tribal lands not allotted were opened to white homesteaders.

Threats to the Indian way of life had been simmering during the four decades preceding Blumenschein's move to Taos, starting with Indian children. In 1879 the uncompromising Indian reform advocate Captain Richard Henry Pratt, founder and superintendent of the Carlisle Indian Training School in Pennsylvania, convinced the secretaries of war and the interior under President Rutherford B. Hayes to establish off-reservation boarding schools for young Indians. Native minors were taken from their homes, often when they were just becoming acquainted with the most important tribal religious rites. They were then sent to an Indian school, where they were forced to dress in uniform and cut their hair, and where they were prohibited from speaking anything but English. The schools trained them to perform menial domestic tasks and learn craft skills that would prepare them for employment serving the dominant white society.

Another repressive effort in the federal government's acculturation program occurred in 1883 when President Chester A. Arthur's secretary of the Interior, Henry M. Teller, attempted to eliminate certain Indian religious practices by creating a bureaucratic judicial body called the Court of Indian Offenses, which would be staffed by Indian judges. These federal appointees were given substantial powers over the social life of their tribespeople. Even though the new courts represented yet another inroad in weakening the autonomy of Indian tribes, it did not go far enough for many advocates of tribal reform.

Not all measures to change Indian life, however, involved changing their behavior. In 1921, for instance, the year the BIA released Circular 1665, Republican senator Holm O. Bursum of New Mexico introduced a controversial bill in Congress. The measure would have taken away from the Pueblo Indians large portions of their land that had been

squatted on by non-Indian people for more than ten years prior to New Mexico's admission to the Union in 1912. Secretary of the Interior Albert B. Fall, a former U.S. senator from the state of New Mexico who had convinced Bursum to initiate the legislation for this "land grab," made an even more controversial decision. His 1922 directive ruled that Indian reservations established by executive order rather than by a treaty or act of Congress "were merely public lands temporarily withdrawn by Executive Order" and were therefore open to gas and oil interests for leasing under the General Leasing Act of 1920.

Blumenschein and other Taos artists were aware of these federal policies, and they supported legislation aimed at protecting the rights of American Indians, particularly those living in Taos Valley. All of their proposals focused on the culture of these Pueblo Indians to one degree or another. They were genuinely empathetic to the Pueblo Indians, but they also believed that their continued painting of the Indians, as individuals or in a group setting such as a dance, depended on an extension of Pueblo culture into the modern age. The American Indian was one of the strongest representations of the American subject matter they wanted for their art in lieu of the European subjects most of them had been exposed to in Paris.

In 1919, a reporter from the *Albuquerque Evening Herald* had interviewed both Phillips and Blumenschein. In the interview, which was reprinted in the popular New Mexico magazine *El Palicio* in May, Phillips, whose strong desire to paint Indians was reinforced by the income he received from his Indian curio business, stressed the commercial value of Indian art. But he also joined Blumenschein in expressing their common belief that the government's acculturation program would result in "a discouragement of racial customs which will eventually destroy their wonderful art." Such a development would be especially tragic considering "their contribution to art has [already] been invaluable."

Blumy's remarks would be less materialistic and more eloquent. His understanding of the Indian problem was more national in scope, going back to his career as a book and magazine illustrator working for such defenders of Indian rights as the prominent literary figure Hamlin Garland and the mixed-blood Sioux Indian Charles H. Eastman. Blumenschein told the *Albuquerque Evening Herald* that "if in the adoption of a 'higher civilization' the Indian gives up his own remarkable gifts to the world the loss will be irreparable." Praising the Indian contributions to art as beautiful and unique, he characterized the art as "a priceless donation to all human endeavor." He also argued that the "aboriginal American has actually contributed more to . . . [art] than two hundred years of 'civilized' occupation of North America has produced."

Other Taos artists joined Blumenschein and Phillips in their defense of the Pueblo Indians and their now-threatened culture. Two years before the publication of Blumenschein and Phillips's critical comments to the press about Indian assimilation, Taos artist Victor Higgins warned his colleagues in New Mexico that Anglo artists would be helpless without the creativity of the American Indians to inspire them. Writers also joined in this verbal assault against the controversial BIA policies. During the conservative 1920s, literary figures such as Alice Corbin Henderson, Mary Austin, Mabel Dodge Luhan, and the famous English novelist D. H. Lawrence were part of the growing opposition to those federal programs that could erode the cultural identity of the Pueblo Indians and jeopardize their sovereignty and control of tribal lands.

Mabel Dodge Luhan, a key figure among the writers who played an important role in this fight, was a wealthy, thrice-divorced woman who came to Taos in 1918 and was so overwhelmed with the beauty and diversified culture of the community that she became a permanent resident. Her fas-

cination with the Taos Pueblo Indians north of town led to her marriage in 1923 to a Taos Indian named Tony Luhan. During her productive years in Taos as a writer, the transplanted New Yorker would attract other writers and art consumers to New Mexico. Many of them had been impressed with her publications lauding the accomplishments of the Taos artists, who were successfully capturing the spirit of this picturesque community in the Taos Valley.

Probably the most famous writer drawn to Taos during the 1920s was D. H. Lawrence, author of such widely acclaimed and controversial novels as *Sons and Lovers* and *Lady Chatterley's Lover*. Mabel Dodge Luhan, truly a woman with remarkable connections, had invited Lawrence and his wife, Frieda, to Taos in 1922, when the furor over the treatment of the Pueblo Indians was at its height. Lawrence lent his prestigious voice to the criticisms coming from vocal Taos intellectuals of federal Indian policies.

Even more important in the battle to protect the cultural and economic integrity of the Pueblo Indians was Luhan's relationship with John Collier. The socially concerned Collier was the Atlanta-born son of a prominent banker, a sometime poet involved in community efforts to help unemployed immigrants find jobs. Collier would later serve as commissioner of Indian affairs, from 1933 to 1945. In the 1920s, his progressive policies as head of the California State Immigration and Housing Commission put him on a confrontation course with his many conservative critics, whose fear of a communist takeover of the nation during America's postwar years would become known as the Red Scare. When they charged Collier with aiding the spread of "Bolshevism," his position was deleted from the state's budget. Luhan heard about this setback in late 1920, and she invited Collier to come to Taos, having known him in New York City, where he had attended one of her Fifth Avenue salons focused on the radical or contentious ideas of

the day. Collier accepted her invitation and soon became so fascinated with the Taos Valley and its people that he lived with the Taos Pueblo Indians for nine months.

When Collier heard about the Bursum bill, which would wrest Pueblo lands away from the Indians, he met far into the night with Pueblo elders, using Mabel Dodge Luhan's husband, Tony, as interpreter to explain the dire implications of this bill. Collier also successfully lobbied against the Bursum bill and went on to organize the American Indian Defense Association. The activities of this group helped to bring about the All-Pueblo Council, which demonstrated that these Indians were indeed capable of self-government. Although other organizations, such as the General Federation of Women, with its national membership of two million, played their vital role in preserving and protecting New Mexico's Pueblo culture, Blumenschein and other Taos artists could take pride in their early warnings about the threats to these Indians.

Blumenschein's most effective method of protecting the Pueblo culture, however, was through his art. In this regard, his oil painting *Superstition* was one of his best weapons. In painting *Superstition* in 1921, the artist employed Taos Indian Jim Romero as a model. Romero and Blumenschein were outdoor companions who often went fishing and camping together. In *Superstition* Romero is depicted in the lower center, sitting and holding a Tiwa blackware pottery piece, probably made at the Santa Clara or San Ildefonso Pueblo, and staring confrontationally at the viewer, contrary to the customary good manners Pueblo Indians usually displayed.

The painting is in sharp contrast to the works of some Taos colleagues, like Sharp, Couse, and Berninghaus, and even to those of Blumenschein's close friend Phillips. These men often painted the Indians as romanticized and nostalgic in subject matter and focus. In *Superstition* Romero seems to be challenging the American public, telling them

that something is very wrong with the current state of affairs for him and other Pueblo Indians. Blumy's painting is obviously addressing the conflict caused by the restrictive, if not hostile, federal Indian policies being promulgated at this time.

Above Romero's left shoulder in *Superstition* is the crucified Christ, the inclusion of which may have been influenced by fellow Taos painter Walter Ufer, who had done two oils, *Hunger* and *Strange Things*, that showed stark representations of Christ on the cross. Ufer's inclusion of Christ represented his critical view of the Catholic Church's condemnation of the Penitente movement in New Mexico. The Penitentes' reenactment of the crucifixion involved its believers in painful ways, including self-flagellation, which was denounced by both the Catholic Church and the Protestant political establishment in New Mexico. Although Blumenschein and Ufer often discussed their ideas and compositions with each other, Ufer, a steadfast socialist, was much more blunt in his anti-Catholic and anti-Christian views. Blumenschein had been badly burned for his outspoken patriotism during World War I, which had been intended in part to counteract the prejudices he faced being German American, so he was much more tactful in his public and private statements regarding the alleged mistreatment of the Pueblo Indians.

Thirty years after the bitter brouhaha over such federal Indian policies as the controversial Circular 1665, Blumenschein revealed, in a somewhat confusing manner, his motives in painting *Superstition*. He insisted that his reasons for involving himself in the Pueblo Indian controversy were to be found in the painting itself. As he put it in a 1951 letter to art collector Thomas Gilcrease, "I can't say anymore with words then [*sic*] I have with paint. In fact I have tried —and all I do is confuse more than ever." Blumenschein did admit that the government's Indian policies of a generation ago threatened his "own Indian religion," with its beautiful

Indian dances, which were so important to him. He also gave one more concrete reason for his bold interpretations in *Superstition*. Jim Romero's disappointment with a medicine man outside Taos Pueblo and his dissatisfaction with a local Catholic priest had significantly influenced Blumenschein. "So I tried to paint the Indian friend's feelings— and maybe my own." He added that all these reasons "grew into the picture, which will be interpreted according to the intelligence of the onlooker."

During the early and mid-twenties, Blumenschein was busy producing several paintings to show what life was like among the Pueblo Indians of the Taos Valley. The works were, on the whole, realistic paintings about Indian lives in the present as well as in the past. Like *Superstition*, most of them were unlike the more romanticized version of Indian life, with its focus on the past, favored by most other Taos artists.

One of Blumenschein's best portraits is *The Gift*, which shows a male Pueblo Indian draped in a blanket, standing face forward and looking quite stern; the oil, painted in somewhat dark shades, is now part of the art collection at the Smithsonian American Art Museum in Washington, D.C. Another is *White Robe and Blue Spruce*, painted three years later, in 1922, which also features an Indian draped in a blanket but with an undergarment of tinted cobalt blue, creating a contrast of art nouveau elegance. In 1923 the artist painted a large oil on canvas depicting Pueblo Indian dancers, which he titled *Moon, Morning Star, and Evening Star*. This painting, which demonstrates Blumenschein's keen fascination with Indian dances, currently hangs in the Gilcrease Museum in Tulsa, Oklahoma.

At about the same time, Blumy painted several oils of the Ranchos de Taos Church, each of which showed a cluster of Taos Indians in the foreground and elevated heights in the background, marked by the clouds hovering above them. The paintings speak to the sometimes separate worlds of the

Taos Indians and the Catholic Church and are emblematic of the themes found in *Superstition* and to a lesser degree in *Star Road and White Sun*. Not to ignore the Hispanos of Taos, Blumenschein also did a painting he called *The Plasterer*, in which one of his neighbors, Epimenio Tenorio, is the model for a hard-working Hispanic laborer sitting in front of a fireplace, surrounded by Pueblo pottery to honor the Hispanic and Indian traditions in this part of the Southwest.

Helen Blumenschein, in *Recuerdos*, acknowledges the delight she felt with her father's increased productivity during his early years as a permanent Taos resident. He was "completely happy" and able to reach his full potential as an artist who could produce "large oil paintings," which were more symbolic, intense in color, and noticeably "three dimensional in their rendition." During these satisfying years for the Blumenschein family, Helen had to live in the East to finish her education. Her mother often returned to the East to be with her, and her father often traveled to the East and Midwest to promote and exhibit his oil paintings, which were among the finest of his entire career.

Sometimes Blumenschein got lonely, as he did when Mary and Helen left Taos for three months in January 1925. But even though he missed his family, during this time he completed one of his finest landscape paintings—*Sangre de Cristo Mountains*. Appropriately for the winter months in northern New Mexico, it is a nostalgic snow scene, with a party of bundled Penitentes walking toward a cozy village that occupies the bottom half of the oil. In contrast, the mountains looming above look like giant sugar loafs in the background. The artist would put a $5,000 price tag on the painting (the highest up to this time) after he won his second Altman Prize at the 1925 spring exposition at the National Academy of Design in New York.

By the mid-1920s Blumenschein seemed to be moving more toward landscapes as opposed to the portraits that

had dominated his earliest years in Taos. He liked to paint the Sangre de Cristos east of town, which in his evolving style of painting took on such colors as brown, tan, green, dark purple or blue, and gray. He would often paint people and their stock animals in the bottom foreground of his oils, as beautifully represented in his eye-pleasing *Two Burros* (1925). Another snow scene he painted around that time was *Penitente Procession*, a study in ink and watercolor, which the artist completed in preparation for his *Sangre de Cristo Mountains*. This study has the same layout as *Sangre de Cristo Mountains* except that the church in the adobe village is given more prominence.

Blumenschein's appreciation of the Sangre de Cristos never diminished during his lifetime. He also painted summer scenes in the mountains, such as *Haystack, Taos Valley*, completed sometime before 1927 and one of his most striking. The colors in this oil are particularly rich. The forested mountains are a pleasing green, and a light tan color for the steep cliffs helps define their ruggedness. In the foreground is a large haystack, its brown and yellow color darker than the cliffs above it. Below is a small group of people, one of whom is covered by a blanket with an especially rich red color, revealing Blumenschein's partiality toward glowing landscapes.

His landscapes were not all focused on the mountains around Taos. *Rock of Fire—Afternoon* and *Apache Country*, for example, both painted before 1927, depict dry, parched mountain scenes. *Apache Country* is especially interesting in that the tepees on the sides of the mountains and in the valley below are more like the romanticized and history-oriented Indian paintings of Sharp, Couse, and Phillips, who, like him, had trained in Paris as academic artists. In fact, Arnold Rönnebeck, artist and director of the Denver Art Museum, commented in 1928 on *Apache Country* and *Rock of Fire—Afternoon*, along with another Blumenschein painting titled *Rock of Fire—Morning*, that all three oils

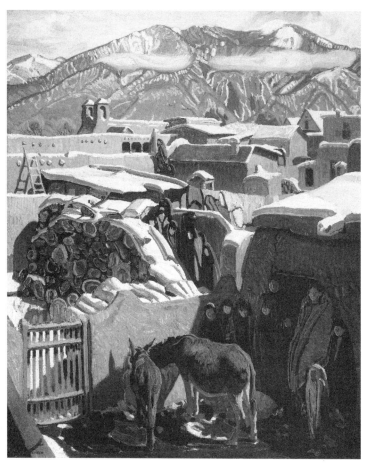

Two Burros, ca. 1925. Oil on canvas, 30 × 25 inches. Private collection.

were painted in the manner of the French impressionists. His evaluation was based on Blumy's "penetrating and passionate way" of seeking out the importance of the "light of New Mexico" and the distinctive atmosphere peculiar to much of the land in that state. Relevant to this subject of light is French impressionist Claude Monet's 1873 painting *Impression: Sunrise*, which focused on the brightness of the

morning sky and led to the name impressionism, according to William Kloss, an independent artist associated with the Smithsonian Institution.

One of Blumenschein's favorite spots to paint in the late twenties and well into the thirties was Eagle Nest Lake. This 2,400-acre body of water, located about thirty miles northeast of Taos, was created by the building of a dam in 1918. It became a popular place for fishermen, including Blumenschein, who often fished there with fellow Taos artist W. Herbert "Buck" Dunton. In 1933, Blumenschein painted Buck at the lake wearing his familiar white cowboy hat and carrying a large, recently caught lake trout. Another Eagle Nest–inspired painting, appropriately called *The Lake* (1927), is compelling for those who like mountain scenes. Large white clouds with lavender tinting almost dominate the partly forested mountains below. In the center of the oil is the placid lake, behind a small rickety-looking house, which appears lonely and out of place in the acres of green fields that surround it.

Blumenschein, still a perfectionist whose habit of redoing his paintings only increased, greatly admired the wooded scenes of the Sangre de Cristo Mountains. His best forest scene is the stunning *Enchanted Forest*, which he completed in 1929 only to redo it in its final form in 1946, when he sold it to that successful Oklahoma oilman and generous art patron Thomas Gilcrease; it now hangs in Tulsa at the Gilcrease Museum.

Blumenschein's 1920s paintings significantly increased his national recognition. He enhanced this growing attention by traveling around the country and exhibiting his paintings to an ever-widening audience. An articulate man and prolific writer, Blumy gave talks and published reviews and essays on the subject of art throughout his life. His views on the work of other American artists were becoming better known— to other painters and their critics and patrons— and soon he was influencing the owners and consumers of

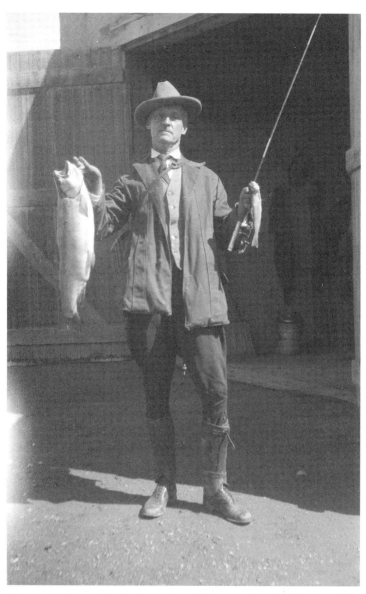

Blumenschein proudly displays a large fish he caught in 1929. One of the artist's favorite sports for relaxation was fishing, usually in the Rio Grande or on Eagle Nest Lake in the Sangre de Cristo Mountains. Portraits–Ernest Blumenschein, Palace of the Governors Photo Archives, Santa Fe (NMHM/DCA), 040421.

art, who were especially important to the growth and prosperity of those who practiced this challenging craft.

Most Taos artists liked Blumenschein, but even more people respected this man, who could be quite frank, if not blunt, in his assessments of art. For the most part, the community of painters in the small but growing southwestern town of Taos seemed to be a harmonious one. But emerging questions about the style and form of western painting could trigger heated dialogue about traditional art versus modern art. These discussions would introduce divisiveness in the 1920s, with potentially serious repercussions for the Taos Society of Artists.

12

Tensions within the Taos Society of Artists

Noted New Mexico writer Erna Fergusson, in her book *New Mexico: A Portrait of Three Peoples*, provides an interesting insight into the Taos art colony when she questions the alleged unity within the influential Taos Society of Artists. The "similarity" among the society's members, she wrote, "was always in subject matter, never in method." Fergusson is largely correct about the subject matter, for the artists had come to Taos to paint Indians and their environment in the scenic Taos Valley. The area was to them the perfect place to paint truly American subjects rather than the European ones most artists were trained to paint in such art centers as Paris and Munich. Differences in subject matter did emerge, however, as the more independently minded artists, like Blumenschein, Ufer, and Higgins, wanted to paint more realistic and contemporary aspects of Indian life, rather than the historical and sentimental ones that Sharp, Phillips, Couse, and Dunton preferred.

Another departure from the artists' original purpose for coming to the remote adobe town of Taos was the switch by some of them from painting distinctive western personalities, such as the Pueblo Indians and eventually the Hispanics of the Taos Valley, to painting the inspiring landscape of the valley and the mountains, mesas, and canyons surrounding it. In many ways Blumenschein led the way in this

new direction with his landscape paintings of the 1920s. Landscapes would in fact eventually dominate his artwork during the final decades of his life. Higgins, too, would significantly shift his emphasis from portraiture to landscape. He was fascinated by nature's "ever-changing moods" and would often wander off to sites seldom visited by his colleagues to paint those landscapes that intrigued him.

Another artist charmed by the landscape of the American Southwest was Ernest Martin Hennings, who first visited Taos in 1917, settled there in 1921, and became a member of the Taos Society of Artists in 1924. A skilled figure painter, Hennings soon became enamored with the colors and shapes of the surrounding country. "New Mexico has almost made a landscape painter out of me," he once said, "although I believe my strongest work is in figures." Indeed, in his 1924 painting *The Encounter*, showing a Pueblo woman on horseback wearing a strikingly luminous white blanket over her shoulders while visiting with a Pueblo man on foot, demonstrates an impressive ability to paint figures with light colors. As art historian Joan Carpenter Troccoli has phrased it, "Phillips, Hennings, and especially Blumenschein were . . . influenced by more modern movements, particularly French impressionism, which stimulated them to lighten and brighten their palettes." Kenneth Miller Adams, who was the last artist accepted for full membership in the Taos Society of Artists, in 1927, a few months before it was disbanded, was so overwhelmed with the challenge of painting New Mexico's varied landscape that, with the exception of just a few of his paintings, he gave up trying to capture the state's natural beauty on canvas.

A subject matter issue that did not seem to cause any unpleasant disagreement among the Taos artists was the question of whether their paintings should incorporate any controversial messages. In the forefront of message-driven painters were Blumenschein, Phillips, and Ufer. Blumen-

schein and Phillips were most vocal in their opposition to federal Indian policy as it affected the Pueblo Indians during the early twenties. Phillips expressed his criticisms primarily through words, but Blumenschein supplemented his verbal criticisms with the effective statements implied in some of his best art work, most notably *Superstition.* Since all the Taos Society artists painted the Indians of the Taos area, they were inclined to agree with the opinions of the two artists most responsible for the founding of their art colony. Ufer, less subtle than Blumenschein and Phillips in his disagreements with federal policies and other public disputes of the day, produced much more controversial paintings, such as *Strange Things,* which challenged the Catholic Church's treatment of the Penitentes, and *Hunger,* which portrayed the economic and spiritual devastation caused by World War I.

Whether the other charter members of the Taos Society supported Ufer's more radical agenda or not, it was not an important factor in their relations during the early twenties. Sharp, Phillips, Couse, and Dunton seemed intent on painting Indian portraits and later landscapes.

The even-tempered Sharp, oldest of the Taos Society's artists, was more interested in re-creating in oil the bygone days of Indian life, with a few exceptions, such as *Ration Day* (1919) and *Three Taos Indians* (1920–40). Most of the paintings of this bearded, gentle man, who was still totally deaf, were unabashedly romantic and often historical, representing the best in traditional or academic art. He was prodigious in the number of paintings he could render with his oils, and his fascination with the Plains Indians during the frontier period went back to the turn of the previous century.

In 1902 Sharp gained the support of the Indian agent on the Crow reservation in Montana to build a log cabin for a studio on government land; it was located three miles

229

from the Little Bighorn battlefield, where Custer had been defeated in 1876. There Sharp found many Indian models for his paintings.

Phillips was almost as fixated with the past as Sharp was. He too produced many nostalgic paintings of Indian life before the reservation years, such as his haunting *Moonlight Lake Song*, painted in 1924, and *Elk Hunt*, painted prior to 1912, in which he idealizes a hunt, focusing on a lone Indian hunter, who has spotted his prey in a beautiful woodland setting. Most of his activities in connection with Indians did not involve their current everyday problems, except for his opposition to repressive federal policies toward the Pueblo Indians.

Couse was also a prolific painter, who worked every day on his romanticized scenes of Indian life; he too focused on the past and employed the traditional painting techniques he had learned in Paris. Blumenschein once made the caustic observation that Couse had painted one squatting Indian for a calendar company and then had gone on depicting the same subject doing the same thing for the next thirty years. This characterization was unfair, and Blumenschein made a rather weak apology for it in a May 8, 1935, letter to Couse. Although Indians do kneel in such Couse paintings as *San Juan Pottery*, completed in 1911, the painter's art subjects are more diversified than that. His exotic, even perilous, *Moke Snake Dance—A Prayer for Rain* (1904), his *Return of the War Party* (1910), and his "distinctly academic work" in *The Corn Ceremony* (1921) are just three examples that demonstrate the artist's ability to effectively capture the romantic past of the Indian in various ways.

As successful as Couse in painting Indians was the genial Berninghaus, well liked by his colleagues as well as the other town folk because of his friendliness. A slender man in contrast to the portly Couse, whose Indian friends called him Green Mountain because of his girth, Berninghaus went by the name Bernie and signed his paintings, of which

there were many, as Bern. In his 1900 *Ignacio Train Depot*, an enigmatic Indian looks at a train station in Ignacio, Colorado, with wonderment at this change in his environment. Bernie's 1916 painting *Dance at the Pueblo* emphasizes the communal effort of the dancers at Taos Pueblo. Largely self-taught, like the cowboy artist Charles M. Russell, Berninghaus shared one of his several studios with Russell in 1912.

But the Taos artist who was most like Russell as far as his intense interest in painting cowboys was Buck Dunton. The Maine-born artist, an avid hunter and outdoorsman, had begun drawing on his own as a child. Later, he learned his craft from the man many art critics of the Taos colony regarded as the master himself, Blumenschein. Dunton's paintings tended to romanticize the life of the cowboy in much the same way as Sharp, Couse, and Phillips did for the Indians; however, Dunton's most famous cowboy painting, *The Cattle Buyer* (ca. 1921), focuses on contemporary people involved in the West's important cattle business. In his oil *The Shower* (1914), the artist demonstrates his love for New Mexico's often glorious sky in his depiction of rain materializing rapidly as three cowboys gallop for cover. One reason Dunton sold one of his early Taos homes to Blumy was to have a house with a better view of the surrounding countryside he loved. Finding such a location became quite a problem as the town grew and new homes began to block the view of the mountains and plains of Taos Valley.

Despite the variations in subject matter chosen by Taos Society members, these artists were all engrossed in painting the grandeur and spirit of this unique American location. It was the question of style, or method as Fergusson put it, that caused divisiveness among Taos's major painters. The tensions were not evident at first, although Blumenschein, Ufer, and Higgins were showing signs of modernist style in their paintings, while the other charter society members remained largely traditional.

231

A possible hint of some kind of schism might have been in the decision of Blumenschein, Ufer, and Higgins to exhibit their works of art with American sculptor Alexander Phimster Proctor. They displayed their achievements together at the Art Institute of Chicago and at the Cincinnati Art Museum in 1919 under the name of the Four Artists of Taos. Their success in these two collaborative efforts encouraged them to show their works as a group three more times, with their final exhibit, without Proctor, in spring 1920 at the Milch Galleries in Manhattan.

These separate ventures occurred about the same time that the Taos Society of Artists was mounting a series of showings in major eastern cities as well as such western communities as Santa Fe and Colorado Springs. To spark more attention the society had induced Robert Henri, a well-known painter with a style of individual portraiture very similar to Blumenschein's, to join its ranks as an associate member. Interestingly enough, Blumenschein headed a committee to promote the society's newest showings with appropriate film footage provided by the New Mexico State Land Office. Moreover, in July 1920 Blumenschein, Ufer, and Higgins were elected to the Taos Society's governing board, with Blumenschein as president and Ufer as secretary and treasurer.

By 1920 the Taos Society of Artists appeared to be the very picture of collegial fellowship. Earlier that year, a writer in the *Christian Science Monitor* had remarked that the "men at Taos are a congenial group, all marked by strong individuality and each working independently in the direction of his own ideas." He went on to commend the Taos Society for not insisting on "any set creed, any particular cult or theory of art methods." The result of these tolerant guidelines was to create a "stimulating but in no way restricting" environment for these talented artists.

The original motives for organizing the Taos Society of Artists were to provide economic benefits as well as encour-

age the quality of the group's art, so perhaps controversy was inevitable over whether the society's artists should continue focusing so much on romanticized paintings of Pueblo Indians. Sharp, who had a reliable market for his Indian paintings, believed that deviations from the traditional art produced by most of the town's artists would be economically unsound. In a letter to Los Angeles art dealer J. F. Kanst, he praised Blumenschein for his artistic innovations in the modernist style, but felt that his art was "not of the gallery *salable* sort as some of the others."

Blumenschein admitted many years later that the "principally picturesque subject matter" of Sharp and others did indeed generate a good income for them. But Blumy, for whom income was no problem after his wife received her generous inheritance, did not have too many financial worries and could, therefore, take the high ground in this debate. "The rest of us with high ideals of art," he wrote in his 1955 introduction to Laura M. Bickerstaff's *Pioneer Artists of Taos*, "had to fight it out, and we never could have won but for the prizes at shows and purchases by Museums."

For several years acrimony simmered among the charter members of the Taos Society of Artists, and Blumenschein, while president of the association, was in the center of the controversy; indeed, given his strong views on the evolutionary nature of painting styles, he was a kind of catalyst in the widening schism. Yet he wanted the Taos Society to remain an organization that spawned creativity and allowed for differing styles of art to energize it. With unity in mind, he urged his colleague and former student Buck Dunton to write an essay for the *American Magazine of Art* in 1922. In 1917 Blumenschein had successfully submitted for publication in this magazine an optimistic essay on how the Taos artists were in the process of developing a "great American School" of art.

Dunton's essay, however, which appeared in the August 1923 issue of the *American Magazine of Art*, was a rather

flowery one, praising the beauty of the Taos Valley and the quaintness of the town itself, which had inspired him and other artists in their creative endeavors. Dunton did not deal with the more philosophical issues that Blumenschein would have covered, such as the society's vision and direction. The lack of harmony by this time had permeated the meetings of the Taos Society of Artists, and in some cases civility was a casualty. The often unpredictable Ufer, for instance, called Blumy, one of his closest allies in promoting modern art, a "bald headed S.O.B.," which is curious because Blumenschein was not bald, though his hair was thinning. Fortunately, Blumy had not been present, for he was not the type of person to back down without a spirited response. One sure indication that things were not getting any better was Dunton's resignation from the society in 1923, even before his essay was published.

The relationship between Blumenschein and Ufer was complicated. The two men had few philosophical differences over the question of innovation in American art styles, which had alienated the society's more traditional artists. Ufer was known for his outrageous remarks, most of which were tongue-in-cheek. Blumenschein carried on the feud, if it could be called that, with "considerable gusto." Art historian Victor White, in the September 12, 1968, issue of the *Taos News*, published years after both men had died, brings up an incident characteristic of their rivalry. In the early 1930s, Blumy was attending a movie in Taos's ramshackle old theater, and Ufer came in after the movie had started. When some "luscious-legged female" appeared on the screen, Ufer shouted, "Hey, Blumenschein, you see that? She's not for you." Blumy tried to return the needling "with interest, but he could not succeed." Walter Ufer had the bigger voice, and he was in the back of the theater while Blumenschein was in front. Whether or not this kind of banter revealed any true animosity, however, when the spendthrift Ufer died in 1936, Blumenschein helped

raise money for his wife, Mary, who was in dire financial straits.

Even more revealing of a deteriorating situation within the Taos Society of Artists was the criticism of the society's more innovative artists and the rejection for membership of those artists oriented toward modern art. During the Taos Society's 1922 exhibit in St. Louis, B. J. O. Norfeldt, a post-impressionist painter from Santa Fe who had been accepted by the society as an associate member, found his three modernist paintings at the exhibit almost shunned by most of the members. At the summer meeting of the society that same year, two more Santa Fe devotees of modern art, painters Jozef Bakos and William P. Henderson, who had been nominated for membership by Blumenschein, Ufer, and Higgins, were voted down.

In response to these controversial actions Blumenschein, Ufer, and Higgins created a new art association, called the New Mexico Painters. It included Norfeldt, who was still smarting from the society's rebuff. Blumenschein worked hard as the secretary for this fledgling organization, which he hoped would successfully promote modern stylistic trends in New Mexican and southwestern art.

Despite Blumenschein's major role in this new art organization, which must have been viewed as a challenge to the well-established Taos Society of Artists, he still remained a member of the Taos group, still serving as president at the time. After the heated debate in which his name had been taken in vain by Ufer, he threatened to resign from the society, even though he had not been present at the meeting in question. He claimed that he and Mary had not been properly thanked for his work as president. Ultimately, he was forced out of the Taos Society in 1923, when he refused to accept the organization's post of secretary because of the huge workload involved.

The secretary was required to arrange exhibits, initiate and answer correspondence, take care of finances, and

handle other responsibilities that consumed much valuable time—time that could have been spent creating art. Because of the position's burdensome demands, every member was required to do it on a rotating basis. Blumenschein's simple refusal would have been contentious enough, but the artist's excuse was regarded as outrageous—that his position as secretary of the New Mexico Painters was too time consuming for him to assume this rotation.

According to the Taos Society's bylaws, as amended on July 23, 1923, any refusal to serve as secretary of the group would "be considered equivalent to resigning from the Society" unless there was an acceptable reason. On July 31, the Taos Society of Artists met to consider Blumenschein's refusal. Ufer, who was chairman of the gathering, bolted the meetings, declaring himself "not present." The five who remained were Sharp, Couse, Berninghaus, Phillips, and Higgins. When the vote was taken, three voted against accepting Blumenschein's excuse for not serving as secretary and two did not vote. One of the key persons in founding the Taos Society had been forced out. The easygoing Sharp was pressed to assume the arduous responsibilities of the secretarial post.

The restless and rather egocentric Blumenschein did not let his ouster from the Taos Society of Artists deter him from creating some of his best art during the remainder of the decade. He was proud of his association with the recently created New Mexico Painters, writing to a New York critic that he was "not a hard boiled academic," and boasting that he was working "along the lines that fellow artists think indicate a big step ahead toward sound art." His stance in this exercise of self-justification was strengthened when he added, "[I was] searching to create works of art, not for commerce, but because I had it in me to express."

Several of Blumenschein's paintings had already shown that the modernist style, which had made him, Ufer, and

Higgins so controversial in the society, had substantially boosted his career. His lauded *Star Road and White Sun* displays an impressionistic background, as do *Superstition* and *White Robe and Blue Spruce*. A couple of other paintings, like *Moon, Morning Star, and Evening Star*, in which he depicts Pueblo Indian dancers, and *The Extraordinary Affray*, illustrating an Indian battle scene, depart from the naturalistic mode of the more traditional artists. Blumenschein created both paintings in the early twenties and reworked them less than a decade later.

The Extraordinary Affray, which the artist painted in 1920 under the title *Indian Battle* and reworked in 1927, was an oil that put Blumenschein, the academically trained artist, above the growing furor between the representational art that was part of his Paris training and the more abstract modernist art that would characterize many of his future paintings. The reworked painting, which illustrates a crowded and brutal skirmish between two opposing Indian groups, fighting against a backdrop of tall cliffs, is regarded as one of the artist's best paintings. Blumenschein's inspiration for this oil may have been a Ranchos de Taos folk song, in which a combat scene between Comanches and Apaches is the main focus. Sarah E. Boehm, director of the Stark Museum of Art in Orange, Texas, where the painting now resides, has suggested that the artist may have deliberately changed and combined elements of the conflict, "so that he would not portray any specific ritual."

The art work was even praised by a generally unfriendly critic named Henry McBride, who felt that this high action painting, rather rare for Blumenschein, was distinguished by exceptional vigor and individuality. Perhaps an even more impressive compliment of the work was the large photograph of it that appeared in the Sunday edition of the *New York Times* on February 6, 1927, accompanied by a favorable review praising the "ebb and flow of motion" achieved

by the painter. Blumenschein would employ the modernist techniques he used in this oil for the numerous landscape paintings he went on to create in the late twenties.

After his expulsion from the Taos Society of Artists, Blumenschein worked diligently as secretary of the New Mexico Painters, arranging exhibits for the new organization and discharging other responsibilities. But as he was organizing a collective exhibit for the New Mexico Painters with the Albright Art Gallery in Buffalo, New York, he was discouraged when Higgins withdrew his paintings to use them for his own one-man show. When Ufer, too, decided to go solo in 1927, Blumenschein followed suit, and the New Mexico Painters abandoned their traveling shows that same year. In Blumenschein's first solo show in New York, at the Grand Central Art Galleries in 1927, he displayed thirty of his paintings to critical acclaim; the *New York Times* praised the exhibit as a "harvest of many years of study and work."

The Taos Society of Artists, although somewhat relieved by the absence of the often mercurial Blumenschein, would miss him at their joint art exhibitions, where he had been such a great draw. Art dealers would also miss the opportunity of selling his latest oils, knowing that the artist, who had turned fifty in 1924, was probably doing some of his best work. John H. McGinnis, in a 1927 article in the *Southwest Review*, expressed his regret that the society could now "hardly claim to have the greatest of the Taos artists on its roster."

Another critic writing for the *Southwest Review* a year earlier, the modern Santa Fe artist Frank Applegate, was critical of those artists whose traditional art style was now dominant in Taos, where tourists who knew nothing about the appreciation of art were eager to buy their paintings. As he put it, Taos was a place with a plethora of "reproducers" of romanticized subjects (obviously a reference to the work of Sharp or Couse), who make "very skillful illustrations and

reproductions of these subjects and win great local acclaim thereby." Blumenschein, who was still proud of his long-time association with Taos artists, whether he was a member of the society or not, disagreed with Applegate's assessment of tourists who buy paintings from the artists in his adopted hometown; he insisted that these consumers were genuinely interested in art.

The Taos Society was still feeling the effects of an attitude throughout much of the general art community that academic art in America, especially in the Southwest, could not succeed without including Indians in its paintings. Some in the community felt that the western artists' preoccupation with Indians was discouraging innovations in fine art in the country overall. Whether this fixation with Indians or Blumenschein's ouster was the main factor in the eventual decline of the society's fortunes is a debatable question. Despite the organization's notable successes in achieving a uniquely American art form with Taos subjects, the Taos Society was never highly successful in its initial aim to promote the art sales of its members. Perhaps these talented painters no longer found the society a necessary vehicle in advancing their careers. Whatever the reason, the members of the Taos Society met at Phillips's home one night in March 1927 and voted to disband their organization.

Blumenschein's termination as a member of the Taos Society of Artists did not do irreparable damage to the careers of its charter members. These artists and those added to the society's rolls later would continue to paint in the Taos–Santa Fe area for many years to come. Even before Blumy's expulsion, the affiliation of newer members was a looser one. Robert Henri, for example, became an associate member rather than a regular one. According to art historian Marie Watkins, the list of regular noncharter members from 1917 to 1927 comprised Walter Ufer, Victor Higgins, E. Martin Hennings, Kenneth Adams, Catherine C. Critcher, and Julius Rolshoven, while associate members,

in addition to Henri, were B. J. O. Nordfelt, Gustav Baumann, John Sloan, Randall Davey, Birger Sandzén, and Albert L. Groll, and honorary members were Frank Springer and Edgar L. Hewitt.

The months following Blumenschein's forced departure from the Taos Society of Artists in 1923 were undoubtedly stressful for the often willful and outspoken painter. They did not, however, keep him from being very busy throughout the remainder of the decade. He initiated many of the most impressive landscape paintings of his career, and although his portraiture work was less frequent than it had been, the ones he did were among his best. The artist convinced himself that the competitiveness of his craft made conflicts—such as those between traditional and modern artists—inevitable. He believed that artists from both camps subscribed to painter Thomas Eakins's injunction that they "peer more deeply into the heart of American life." He also felt that the painters of Taos and their artwork had gained mightily from their interaction and the friendly cross-fertilization that developed among them. As Blumenschein once put it, "They loved each other as much as they battled."

Two years earlier Blumy had written his friend and sometimes rival Walter Ufer a letter warmly congratulating him on a profitable deal he had made with a museum to buy his paintings, adding amicably that he would "have to paint darn well" if he were going to beat Ufer. "I'm going strong—and have recently signed my best effort," Blumenschein continued. Of course, his impressions of the Taos art community in 1921 would not necessarily reflect the attitude of society members in 1923, after he was forced out of the group. Moreover, Ufer, despite his delight in needling Blumenschein, shared a common dedication with him to deviate from academic art when impressionistic techniques would improve the quality of their paintings.

One irrevocable fact about Taos was that the town was so small, the Taos artists could not easily avoid each other when

feelings were raw and anger was up. Blumenschein once described living in Taos as dwelling in a box surrounded "on three sides" by mountains. In 1925 the quaint adobe community had approximately seven thousand people, but only about five hundred of them spoke English, and the number of artists in this category was even smaller. Indeed, in many cases, Taos Society members lived close to each other. This pattern of habitation went back at least a dozen years. When Blumenschein had been a part-time resident in 1911, he had lived one block north of the Taos plaza. Close by were the homes and studios of Sharp, Couse, Berninghaus, and his especially close friend Phillips. This kind of arrangement continued right through the mid-twenties and beyond.

The house the Blumenscheins bought from Dunton on Ledoux Street in 1919 had started with four rooms, but the Blumenscheins kept adding more. These rooms were "strung along in a straight line forming part of the south wall of the town," Helen Blumenschein wrote in *Recuerdos*. "As time went on and old occupants of the rooms on either side of us died, we would purchase those rooms, until finally we had 11 rooms, enough to supply a studio room for each of us and have bedrooms for our summer guests." Work on the Blumenschein home and on those of many Taos Society artists was done by local New Mexicans, who as a group seemed to have an abundance of skilled carpenters and roofers. Consequently, the Blumenschein family had no problem reroofing their 3,000-square-foot house.

After 1931, according to Helen, the family added a "kitchen and two baths, plus a workshop for my mother, who had switched her profession from oil painting to jewelry making in 1922." Whether a first-class artist like Mary Blumenschein had happily given up painting to take jewelry design and silversmithing classes at the Pratt Institute in Brooklyn in 1921 is still hard to fathom, but she was always adjusting her life to fit the career needs of her strong-willed husband.

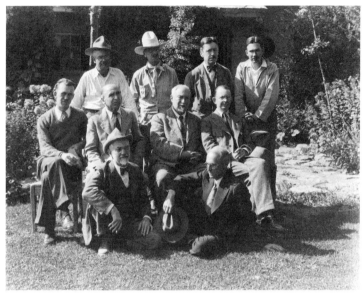

The ten artists in this 1932 photo were among the most prominent members of the Taos Society of Artists, which became defunct in 1927. They are, left to right on the top row, Walter Ufer, W. Herbert Dunton, Victor Higgins, and Kenneth Adams. On the second row, seated, are E. Martin Hennings, Bert G. Phillips, E. Irving Couse, and Oscar E. Berninghaus. Seated on the ground below are Joseph H. Sharp and Ernest L. Blumenschein. Photographer Charles E. Lord, Groups-Art-Taos Collection, Palace of the Governors Photo Archives, Santa Fe (NMHM/DCA), 028817.

One author, J. Pennington, writing for the *Mentor* in 1924, described the close community of artists in Taos as a gathering of talented painters who lived "in paradise in the South-West," where artists, "beginning with Blumenschein and Phillips," found a "simple, unrestrained, inexpensive, and unpretentious way of living." Pennington added that Blumenschein had transformed his native mud house into a "low, flower wreathed villa." The Taos Society artists purchased each other's furniture or exchanged it on occasion. The Blumenschein family had furnished their home with

the customary European-type furniture but mixed in "New Mexico couches, chairs, and a cedar dining room table that Mr. Sharp had ordered made, and did not like." In the artists' nearby studios, they sold their art to the tourists who were increasingly flocking to Taos.

Only months after Blumenschein's expulsion from the Taos Society of Artists, a major project not only would bring together many of the divided artists, but would provide Blumenschein and most of his former colleagues in the society an opportunity to do important public artwork. Oscar Berninghaus had already completed two murals for the Missouri state capitol building in Jefferson City when in 1923, John Pickard, president of the Capitol Decoration Commission and in charge of the state's mural project, asked the artist where he could find other qualified artists to complete the job. Berninghaus, showing a group pride that had not been significantly present among the strong-willed artists of the Taos Society for some time, responded, "Come to Taos next summer and I'll show you a whole colony of them." The commission did just that, arriving in Taos the following August, where it selected Berninghaus and six other Taos artists, Blumenschein, Phillips, Couse, Dunton, Ufer, and Higgins, to submit three sketches each for the large lunette murals that would be painted in the Missouri capitol's interior arches.

The involvement of these creative painters was enthusiastically received by the artists, writers, and other intellectuals who had made Taos their home. The February 9, 1924, issue of the *Taos Valley News* reported that the Capitol Decoration Commission, "after scouring the whole country," had decided to honor these seven Taos artists for their outstanding art work. "More and more the talented artists of Taos are being recognized all through the country and those who know them best will recognize the fact that nowhere in this . . . country are there more gifted canvas decorators than in our own unique town." Work on the

commissions for these murals would keep the chosen Taos artists busy for months, toiling over their canvases. The artists' competitive natures, moreover, were subordinated for a time as they were now part of a group effort that would significantly advance their careers.

In 1928 Pickard's Capitol Decorations Commission published a final report on the mural project. In it were the illustrations for Blumenschein's three murals. The mural project would become a major milestone in Blumenschein's career; indeed, the murals had already allowed the artist to draw again on his academic training in Paris, under such masters of the traditional school of art as Jean-Joseph Benjamin-Constant and Jean-Paul Laurens. The titles were rather long and cumbersome because the murals would be historical: two of them were *Washington Irving and Kit Carson at Arrow Creek Tavern* and *Return of the French Officer and His Indian Bride to Fort Orleans.*

The artist's best mural, however, had a shorter title but also a less compelling narrative. It was called *The Indian Trader at Fort Carondelet,* and in it a frontier entrepreneur, dressed in white buckskin, holds a bright red blanket for trade with a group of intrigued Indians, some of whom are stripped down to their loincloths, while others have blankets draped over them. The *Taos Valley News,* relishing its customary role as community booster, called it a "masterpiece." Although the commission's report seemed to agree with the designation of masterpiece, it did so without some of the superlatives implied in that word: "The rich deep color, the dramatic movement, the well balanced composition," it insisted, "makes this one of the most notable of this entire series of paintings."

In fact, Pickard's committee was so happy with Blumenschein's work that it extended his commission, allowing him to do full-length portraits of two of Missouri's most important historical figures. One of them was the famous frontier painter George Caleb Bingham, whom Blumenschein

would paint from his own imagination. The other was the well-known commander of the U.S. overseas expeditionary force during World War I, General John J. Pershing. In a rather ironic episode in Blumenschein's life, the German American painter, whose patriotism had been questioned because of his name and his ability to speak and write in the language of the enemy, had the privilege of having General Pershing pose for him twice.

The exiting years of the twenties had been most productive for this master artist, who, despite the controversies that surrounded him, was now a permanent fixture in the vibrant Taos community. The unity of the Taos artists so evident in the Missouri mural project during the latter part of the decade undoubtedly had a healing effect. Life was good for the Blumenschein family during most of this decade, but in 1929 the historic crash of the stock market would dramatically change Taos just as it would forever change the rest of the country.

13

Depression Times in Taos

Blumenschein's ambitions to create the best art he could had not been dimmed by his problems with the now defunct Taos Society of Artists, as he proved with his highly successful work on the mural project for the Missouri state capitol. His physical energy, which in many ways had been extraordinary for a man in his mid-fifties, was beginning to wane. He could no longer play baseball, but his tennis game remained exceptional; he won a three-state tennis tournament championship in 1927. His reputation as an athlete sometimes capped his reputation as a fine-art painter. When he visited his hometown, Dayton, in April 1927, the local newspaper not only promoted the paintings that "had made him famous throughout the country" but characterized his visit as an important homecoming reunion for one of Dayton's "former football stars."

One thing that Blumy never lost was his taste for competitive activities, as witnessed by his enthusiasm for the game of bridge, in which he proved to be formidable. In 1927 Ufer wrote the artist a self-revealing letter in which he questioned his own basic virility and that of other males who elected art as a career. He felt that because of this choice, he could never compete with "real towering men" and reminded Blumenschein that he, too, was a "damned fool" because art was also his career choice. "You started with a

violin—then switched over to the paint box—and Blumey [*sic*], such things are nothing to compete with in this Industrial and 'Modern' Age!" Obviously, Blumenschein, who had often displayed his vitality through sports and other competitive outlets, did not reflect Ufer's negative opinion about his manhood.

One significant deviation from his usual needs and personality was his growing dependence on his family. The older he got, the more he needed "his girls." Thus, when Mary and Helen sailed to Europe in December 1928 so that Helen, who had recently turned nineteen, could study art abroad like her parents had, Blumenschein felt very much alone. His daughter's education had been unusual. When she went to school in Taos during her early years, she was in classes where Anglo children "could be counted on your hands"; one of her closest schoolmates was Berninghaus's son Charles, who numbered among the children of Taos artists that made up this Anglo minority. The school in Taos was run by the Sisters of Loretto, and in one class all forty of her fellow students were Roman Catholics; Helen, the only exception, was Unitarian.

Helen described her later education as "most erratic." After an unsuccessful effort to finish her schooling in California, "where there was too much rain," she went back to Taos for one semester and then to the Packer Collegiate Institute in Brooklyn, where she continued her studies for the years 1925 and 1926. She spent her last two years of high school back East, after which she was given the choice of studying in Paris or going to college; there was not enough money to do both. Having aspired to be an artist like her parents, she had no problem choosing an art education abroad, where she spent more than two years in Paris.

After Helen and Mary's departure, Blumenschein faced months of lonely isolation from his family, along with the usual cold and snowy weather characteristic of the winters in Taos. One painting he completed in 1929, called *The*

Burro, expressed his strong yearning to be with his family. In the foreground a solitary burro grazes in yellowish fields, which extend all the way back to a dark purple mountain range. Burros had long numbered among Helen's pets as a child, so this painting was obviously an expression of the love he had for his daughter.

Another autobiographical painting he completed in early 1929 also stemmed from poignant memories of his family. *Adobe Village—Winter* depicts a snow scene in Taos, the geographically isolated town he and his family had grown to love. This oil also expressed Blumy's concern that Taos's adobe building style was not being perpetuated. In fact, the artist felt so strongly about what he regarded as the town's unwise growth that he interrupted his rigid painting schedule to speak to the local Lion's Club in February 1929 about his apprehensions.

Prior to painting the final version of *Adobe Village—Winter*, Blumenschein did a smaller one of basically the same scene, which he called *Village, Northern New Mexico.* In this rendition of a quaint New Mexico village like Taos, two trucks are driving away from the town on a road that winds toward the center of the composition. To the right of these two vehicles is what appears to be a funeral procession. To the left of this procession is a large field of snow, where a group of horseback riders are heading for the village, three of whom symbolically represent the three Blumenscheins when they had come to Taos to live a decade earlier. Indeed, this painting is a highly sentimental one executed by an obviously lonesome man.

Blumenschein's work on *The Burro* and *Adobe Village—Winter* brought him almost instant gratification as far as their recognition and final value were concerned. Both paintings were entered into competition at the National Academy of Design's 1929 spring exhibition. *The Burro* won the Henry Ward Ranger Fund Prize of $1,600, and *Adobe Village—Winter* was later shown at the Grand Cen-

tral Galleries, where it won the Frank C. Logan Prize for the best landscape oil, plus a $1,000 cash award. When the Museum of New Mexico heard about Blumenschein's success in winning the Logan Prize, it proclaimed him foremost among all southwestern artists of the day.

This artist with his Teutonic work ethic had to make some formidable physical sacrifices to paint snow scenes during Taos's cold winter season. He chronicled this challenge as he painted *Adobe Village—Winter*, thus providing significant insights into his dedication to achieve perfection in all his artistic creations. The first step in this project was to prepare "a thumb box note of the color effects" of this winter scene. Then he hurried home: "After my evening meal, [I] started my small composition in pencil and ink." This step was most important because the composition had to be built structurally. "That is, the composition of lines and masses must not only make acceptable 'architecture,' well balanced construction and good anatomy, but must convey by the 'movement' the dramatic sense of a cold winter in a rather theatrical town below the rolling mountains."

After Blumenschein's "general ideas" of the picture were developed from his initial small composition, he would return to the scene as long as the snow lasted and continue his studies in preparation for the final stages of his painting. "My chief recollection of these cold excursions is of my two suits of heavy woolen underclothes, my heavy socks, shoes and galoshes, and my cold hands." Throughout these visits Blumy would jot down "in print, pencil, and mentally" the main facts in the relationship of colors between the snow in the foreground and the mountains in the background, plus "the differences in blue between the color of the deep shadows cast by the buildings and those in the rolling hills." His biggest challenge was to paint "the foreground snow with glowing light so that it still remained a solid mass in the background." After going through those arduous procedures, he was ready to transfer his preliminary work to the

large canvas in his studio, where he completed this highly regarded painting in two months.

Blumenschein had a certain set of "fundamental principles" that he applied to almost all his art work. Color was very important; it had to "sing," as he put it. "The design should be vigorous not soft or pretty. Lines should be 'rhythmical' and 'masses large' and in 'good proportion.'" He also felt that his composition should convey a "sense of 'nobility,' 'chastity,' or 'dynamics,'" but the most important element of the painting was the "architecture of a picture and included 'rhythm of line,' 'rhythm of movement,' 'proportion of space,' and the essential building block, color." The importance of color as shown by the quality of his art was comparable to his focus as a musician on the "quality of the voice or a musical instrument." Comments like these illustrate why the title for the 2008 art book about Blumenschein's work is *In Contemporary Rhythm*, where many of these quoted remarks are found.

After his productive, though chilly, experience painting winter scenes in Taos as well as his highly acclaimed *The Burro*, Blumenschein was ready to join his family in Europe. In fall 1929, he traveled abroad to meet Mary and Helen, and they embarked on a prolonged tour of Italy and France. Although 1929 will always be associated with the stock market's great crash in October, the months prior to this fiasco appeared to be ones of continuing prosperity. The market provided such attractive opportunities for business investments that many people who had never before been shareholders began acquiring stock, often on a speculative basis. Buyers would purchase stock on margin, meaning that they did not have to come up with all the cash as the constant rise in the prices of shares would compensate for what they owed.

Stockbrokers were so confident about the country's business outlook that their brokerage houses opened branches in small communities and near college campuses. At these

outlets they were able to lure heretofore uninvolved factory workers, small storekeepers, waiters, and even widows to invest their life savings to make a "fast buck." During these prosperous times Taos artists were making good money selling their paintings. They, too, were drawn by the profits to be made on Wall Street, whether they made their purchases locally in New Mexico or back East, where the most successful artists went to exhibit and sell their paintings.

Consequently, when Blumenschein planned to leave for Europe to see his wife and daughter, times were still perceived as good, despite the disturbing overspeculation in the market and such serious problems as the growth of monopolies, the lack of effective government controls, and the cutthroat business practices resulting from the manipulation of common stock by many brokers and entrepreneurs. Most Americans had been reassured by President Calvin Coolidge's last message to Congress on December 4, 1928, in which he proclaimed that Americans, "with the help of God [will] be in sight of the day when poverty will be banished from the nation." Indeed, there was enough optimism throughout most of 1929 for Blumenschein, who had few financial worries anyway, to feel good about his return to Europe for a tour of France and the art-rich country of Italy.

The stock market had already been acting strangely when a spectacular drop in stock prices occurred during the last hour of trading on October 23, 1929. This downturn was followed by the exchange of $13 million worth of shares the next day, which became known as Black Thursday. Business spokesmen promptly reassured the country that the worst was over only to be disproved by the chaotic days of October 28 and 29, when it became evident that there would be no quick recovery.

When the economic crash came during President Herbert Hoover's eighth month in office, he showed a deep concern for those people who were unemployed because

of the numerous business failures that had resulted. But his strong belief in laissez-faire economics made him cautious about direct relief for even the neediest victims of the nation's failed economy. The embattled president's main reform in response to the economic chaos, caused by what people would later call the Great Depression, was to sign a congressional bill, passed in 1932, to create the Reconstruction Finance Corporation (RFC). This measure called for direct relief to help the railroads, banks, industries, and agricultural agencies of the nation.

Hoover's efforts to cope with the Great Depression were not effective enough for him to defeat his Democratic rival for the presidency in 1932, Franklin D. Roosevelt. When Roosevelt became the nation's chief executive in 1933, he came to the aid of seven thousand banks and trusts with monies totaling $3.5 billion. Loans amounting to $3.6 billion were also made to industrial, railroad, agricultural, mortgage, and insurance companies. But the needs were too great to bring about a miraculous recovery. During Hoover's last year as president, almost 12 million people were unemployed, which was about 25 percent of the normal labor force. The pragmatic new president was not shackled by the restraints imposed by laissez-faire economics, and in his New Deal program, Congress created what has been called an alphabet soup of agencies to help blue-collar and middle-class families survive these troubled times. Many Americans became familiar with such work relief agencies as the Works Project Administration (WPA) and the Civilian Conservation Corps (CCC).

Roosevelt's New Deal also addressed the nation's imperiled cultural resources, including the plight of the country's artists. The market for art had shrunk significantly during the 1930s, and the Taos artists struggled vigorously to sell their paintings. Major consumers and patrons of the fine arts were not buying from or donating to Taos artists to the

degree that they had during the 1920s. Tourists to Taos, formerly a large part of the consumer base for Taos artists, were no longer coming in sufficient numbers to provide a secure income. Recognizing these problems faced by artists throughout the country, Congress passed a federal program called the Public Works Art Project (PWAP). In 1934 the PWAP was largely replaced by another program under the Treasury Department called the Section of Painting and Sculpture, which was more of a work relief program than the PWAP. The newly organized Section was given the power to commission paintings and sculpture to decorate new federal buildings.

Those artists who needed help from the Section of Painting and Sculpture were required to submit sketches of their work anonymously to a jury. The jurors would award commissions to those with the best mural designs.. From 1934 to 1943 the Section provided the nation with some of its best public art in numerous federal buildings, including 1,100 post offices. New Mexico had the highest percentage per capita of artists working on these federal projects, which represented a form of governmental art patronage. The program not only helped some of the country's most talented painters in a time of great need, but also promoted a high quality of art for the nation. Four Taos artists would do a ten-panel mural for the community's new county courthouse in 1934. In the following year, Blumenschein and three other Taos artists were chosen from forty-four painters nationwide to do other mural projects for the government.

Blumenschein was selected to do a mural for the courthouse in Walsenburg, Colorado, but according to Helen Blumenschein, he was erroneously reported in the national press as receiving his commission from the PWAP not the Section. This confusion could have affected other artists who did murals under federal sponsorship. Joining Blumenschein in doing mural work in 1935 was Howard Cook, an artist

Ernest L. Blumenschein

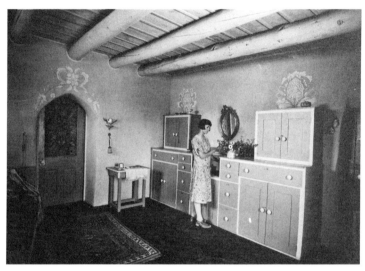

The Blumenscheins's young daughter, Helen, is admiring a flower arrangement in their New Mexico–style home in Taos. Helen became an artist like her parents and chronicled the lives of all three of them in several publications. Palace of the Governors Photo Archives, Santa Fe (NMHM/DCA), 040371.

who had first arrived in Taos in 1926; his mural project was for the San Antonio post office. Other Taos artists who did artwork for the federal government during the Great Depression include Walter Ufer, who in 1934, while working for the PWAP, did a fresco for the Taos courthouse called *Moses the Law Giver*. Another was Ernest Martin Hennings, who painted a mural on frontier migration for the post office in Van Buren, Arkansas. Kenneth Miller Adams made a similar contribution, painting a mural appropriately called *Rural Free Delivery* for the post office in Goodland, Kansas, and another called *Mountains and Yucca* for the post office in Deming, New Mexico. Of the older Taos artists, Oscar Berninghaus painted a mural for the federal building in Fort Scott, Kansas, and one for the post office in Phoenix, and

Bert Phillips did one for the Polk County courthouse in Des Moines.

The federal art commission that Blumenschein received in 1935 to do a mural for the Walsenburg courthouse in Colorado did not make him particularly happy. He was informed by Ed Rowan, who headed the Section of Painting and Sculpture, that his sketch for a mural was most acceptable. According to the terms of their contract, the artist must paint a mural appropriate to the locale and complete the project in twelve to eighteen months. Blumenschein selected as his subject those two majestic mountains called the Spanish Peaks, located southwest of Walsenburg.

From the beginning, Blumenschein had problems successfully executing this project. Because of the zero-degree weather in Walsenburg, the artist, now over sixty years of age, had to delay work on the mural until spring 1936. He was also irked when he found out that another of his Taos colleagues, Kenneth Adams, was paid $900 for a mural of comparable size, while his compensation was a mere $580. When he wrote to Rowan about this disparity, the program's administrator informed him that the compensation for both artists was based on the size of the federal facility not the size of the mural. Although Blumy did not begrudge Adams's higher remuneration, because he knew the artist needed the money, he did not believe that the criterion was fair. To encourage Blumenschein, in January 1937, Rowan sent him his contract and an advancement of $200, which was a rather handsome sum of money for those dark days of the Depression.

In mid-September of that year, with only a month and a half left on Blumenschein's contract, he asked for a two-month extension, which Rowan refused, telling the artist to finish the project without further delay. By late October Blumenschein, who had worked long hours in his Taos studio on this assignment, was ready to have his mural transported

and installed in the Walsenburg courthouse by the November 2 deadline. Even the circumstances of his mural's installation made him unhappy; he complained to Rowan about that "curious specimen of a Postmaster" in Walsenburg, who not only felt that the artist was messing up his lobby but also regarded him as "just some boob from a small town in New Mexico." Despite the problems surrounding Blumenschein's mural of the Spanish Peaks, Rowan acknowledged in December that it was a "handsome piece of work" and that it was now lodged in its proper place.

Blumenschein's delays in executing the Walsenburg mural were due not only to his frustration over the ground rules for the project, but also to his preoccupation with other art projects. One of them was a masterful figure painting project, *Jury for a Trial of a Sheepherder for Murder*, based on a murder that had occurred eight years earlier and become renowned throughout New Mexico because of the unusual circumstances surrounding it.

The tragedy involved a young Hispanic sheepherder named José Cruz Maestas, who on August 28, 1927, killed Russell DeWese, a thirty-year-old professor of modern languages, who had just taken a position at the Terrell School for Boys, a Yale-connected prep school in Dallas. DeWese and Evelyn, his bride of two months, were spending their summer vacation in the mountain town of Red River, New Mexico, and went hiking with a new friend named Henry Moberg. The trio encountered Maestas and generously shared their lunch with him, but after Moberg and the DeWeses left the picnic site, Maestas shot the two men; in DeWese's case, the wound was fatal. When apprehended, Maestas confessed to the killing, claiming during his trial in the Taos courthouse that he had been intoxicated and that the "devil within him" had made him commit the crime.

Maestas's defense counsel tried unsuccessfully to cop an insanity plea for their client but succeeded in reducing the penalty to a second-degree murder charge with life in

prison instead of death. The twelve men who made up the Taos County jury were probably influenced by the defendant's young age, but they also believed that Maestas's intoxication had cast doubt on the issue of premeditation. The county judge, Henry J. Kiker, who knew of Maestas's local reputation as a troublemaker and quarrelsome boy, was so angry with the jury's decision that he dismissed the jurors without the customary thanks and sentenced young Maestas to between ninety and ninety-nine years in prison.

Blumenschein had several possible reasons for doing a figurative painting after focusing on landscapes from the late twenties to mid-thirties. Although the artist had created some masterful landscape paintings in the decade prior to his *Jury for a Trial of a Young Sheepherder for Murder*, the sales of his art had been slow because of the profound sluggishness of the nation's economy. Perhaps he reasoned that a change of pace in his artwork would help thrust his name and his paintings before another audience of art lovers. According to art historian James Moore, paintings dealing with crime and the American justice system had been popular during the first years of the twentieth century, and artist Ben Shahn's *Bartolomeo Vanzetti and Nicola Sacco*, painted in 1931–32 as part of a Department of Justice mural competition, stimulated this long-standing interest; the controversial death sentence given to the two Italian anarchists, Sacco and Vanzetti, had given Shahn's dual portrait a topical importance beneficial to his career.

Another popular oil from this genre was *The People vs. Mary Elizabeth Smith*, painted by Louise Emerson Rönnebeck in 1936. Unlike Blumenschein's static oil painting of the Maestas case, in which he put his emphasis on the jurors and their appearance, Rönnebeck made the defendant and her wild, rifle-brandishing prosecutor the center of her painting. Moreover, in contrast to Rönnebeck's oil, Blumy's painting was more akin to a mural, predominantly public in nature, in which Gilbert Stuart's widely recognized portrait

of George Washington was featured at the top of the painting, looming over the jurors' heads. Like both Shahn's and Rönnebeck's paintings, Blumenschein's *Jury for a Trial of a Sheepherder for Murder* was highly successful, winning rave reviews and prizes; in January 1937, it was exhibited by the National Arts Club, sponsor of an art show for which the governors of all forty-eight states nominated those paintings most symbolic of their state's culture. Blumenschein's *Jury* received one of the five prizes awarded.

Another painting that contributed to Blumenschein's delay in finishing his Walsenburg mural was an unusual one. In 1931 the artist completed a canvas he called "New Mexican Interior" in his personal ledger but *New Mexico Interior* when it was exhibited at the Museum of New Mexico in Santa Fe and later at the Thirtieth International Exhibition of Paintings in Pittsburgh. *New Mexico Interior* became the basis for two art projects that he enjoyed doing more than his Walsenburg mural. In this oil, which was neither a landscape nor a typical figurative canvas, Blumenschein had painted his new studio as a backdrop.

Blumy's latest workplace, which he called the east studio, was one of the three rooms he had acquired around 1924 from the estate of his deceased neighbor Epimenio Tenorio, a model, handyman, and friend of the artist. Blumenschein later extended the size of his studio as a setting for his *New Mexico Interior*, in which he painted a solitary Pueblo Indian kneeling on the floor to straighten out a small rug. His only companion is a cat moving away from the painting's viewers with a proud tail extending upward. Blumenschein was so delighted with his new workplace, which replaced the one he had bought from Buck Dunton in 1919, that he used it for the last two major figurative paintings in his long career. One was his *Jury for the Trial of a Sheepherder for Murder*, and the other was a painting of historical significance he called *Ourselves and Taos Neighbors*, a group portrait of his family and some of the most important people in his life.

Blumenschein probably got the idea to paint himself, "his girls," and their neighbors and fellow artists in Taos in early 1935, when he painted *The Waller Family Portrait* in Winnetka, Illinois. Elsie Butler Waller was the daughter of Ellis Parker Butler, undoubtedly Blumenschein's best friend. Butler had posed with his family in 1908 for *Portrait of Ellis Parker Butler and Family*, which earned Blumenschein a $100 prize from his favorite organization, the Salmagundi Club. Elsie's daughter, Nancy, was about the same age in the Waller portrait as Elsie had been when she had posed with her parents for the Butler family portrait. Her ailing father was still alive at this time, but he died the following year.

Blumenschein's rather exhaustive efforts to paint the younger members of the Waller family in 1935 were chronicled in an August 17, 1974, memo sent to Helen Blumenschein. It revealed that while in the Chicago area to paint the Wallers, Blumy had been able to spend time with his old friend Ellis and, as a once-talented shortstop, take time to watch the Chicago Cubs play at Wrigley Field. But an overwhelming portion of his time was spent painting the Waller family in the mornings. Unfortunately, an immediate mutual dislike between the artist and Butler's granddaughter Nancy caused Blumenschein to vow that he would never "paint children again and certainly never again paint anyone except in his own studio." Butler's passing in 1936, shortly after Blumenschein left, was a great personal loss for the artist, as were the deaths of his Taos colleagues Ufer, Dunton, and Couse that same year.

Despite their rivalry, Blumenschein had been particularly close to Ufer, one of the spark plugs of the Taos colony of painters. His death in 1936 occurred despite the best efforts of other Taos artists, who raised several hundred dollars to help him meet medical expenses and to allow Martin Hennings to use his Ford and rush the ailing Ufer to St. Vincent Hospital in Santa Fe. There the artist died three days later

from a ruptured appendix, at the age of fifty-seven. A saddened Blumenschein conducted Ufer's memorial service, where Taos artists Hennings, Kenneth Adams, and Eleanor Kissell spoke in behalf of Ufer and the generous support he had given to young artists.

Dunton, Blumy's former student as well as his friend and fishing companion, had also been a frequent guest at the Blumenschein home. Helen fondly recalled many years later Dunton's colorful stories, told in his thick Maine accent. Couse, who died in April that same year, had lost much of his creative urge after his wife passed away on Christmas Eve, 1929. Despite the artistic disagreements between Blumy and Couse, they had a bond that extended back to their days as art students in Paris.

Blumenschein's return to figurative painting in his *The Waller Family Portrait* and his delight with the new studio for the artwork he was doing during the mid-thirties may have interfered with his completion of the Walsenburg mural, but they led to the creation of two of his best paintings: the one dealing with the murder trial and the other, his meticulous compositional study *Ourselves and Taos Neighbors*. Ideas for the latter painting had undoubtedly been swimming around in the artist's mind for some time, only to be reinforced by the death of three Taos colleagues and Ellis Parker Butler. Most of Blumenschein's artworks by this time had been preceded by sketches. Prior to completing his painting *Jury for the Trial of a Sheepherder for Murder*, he had studied the faces of Hispanics he encountered on the streets of Taos so he could use their features and expressions for the jurors impaneled to render a verdict on this controversial case. For *Ourselves and Taos Neighbors*, Blumenschein's compositional study was detailed, including twenty-five prospective human subjects.

In 1937 Blumenschein began painting Taos neighbors and other residents of the art-oriented town. He continued to add more figures during the following years until

his painting was finally completed around 1948. In front of this large group of neighboring friends and acquaintances are the artist and his wife and daughter. Behind them are those town artists Blumy had worked with and competed against for many years, his colleagues from the old Taos Society of Artists: Bert Phillips, Oscar Berninghaus, Walter Ufer, Victor Higgins, Joseph Henry Sharp, and Kenneth Adams. Also in this gathering are a few notable people who were not especially close to Blumenschein, such as D. H. Lawrence, Mabel Dodge Luhan, and her Taos Pueblo husband, Tony.

According to Helen Blumenschein, the only Taos artist Luhan had periodically socialized with was Howard Cook, who had become one of Blumenschein's most ardent admirers. Blumy once described the wealthy Luhan as a big spoiled baby, whose business was largely that of "building houses and upsetting plans." Helen, however, acknowledged the woman's generosity "in giving the Sisters of Loretto their Holy Cross Hospital, fully equipped." Luhan's other bequests to benefit Taos included covering the cost of a bandstand built for the town's plaza. Moreover, in 1948 Mabel Dodge Luhan published two literary works that significantly boosted the fame of the town and its art colony: *Winter in Taos* and *Taos and Its Artists*.

Skip Keith Miller, a former curator of the historically protected Blumenschein house in Taos, has raised some provocative questions about the people included in the painting of this large gathering. Although Blumy painted Ufer from memory, he did not paint Couse at all. Instead he included the deceased artist's daughter-in-law, Lucille. Equally surprising, he omitted from this painting one of his most intimate colleagues, Buck Dunton, and apparently Martin Hennings, whom he also knew quite well.

Another interesting aspect of this oil is the location of the Blumenschein family members in the painting. The artist is standing apart from Mary and Helen, both of whom

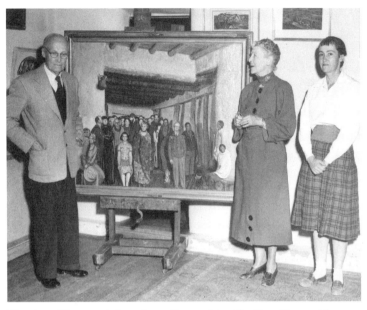

The three Blumenschein artists—Ernest; his wife, Mary Greene Blumenschein; and his daughter, Helen Greene Blumenschein—stand on both sides of Ernest's group portrait *Ourselves and Taos Neighbors*, sometime during the early 1940s. This painting is of great historical interest because it includes them and other Taos artists, along with writer Mabel Dodge Luhan, her Pueblo Indian husband, Tony, novelist D. H. Lawrence, and others. Photographer Fred M. Mazzulla, Portraits–Ernest L. Blumenschein, Palace of the Governors Photo Archives, Santa Fe (NMHM/ DCA), 040381.

are looking straight ahead, not making eye contact with the strong-willed head of the family. Miller interpreted the physical separation of this threesome and their possible aloofness as representing the "often strained nature of emotional and intellectual connections among this family of independent artists and strong personalities." But Blumenschein was very satisfied with this painting. It became one of his most treasured possessions and the one for which he received the highest price of all the paintings he executed

during his lengthy career. H. J. Lutcher Stark and his wife, Nelda, acquired it for their noted art museum in Orange, Texas, which was not built and opened until 1976.

Work on *Ourselves and Taos Neighbors* especially consumed so much of Blumenschein's time that doing the *Spanish Peaks* mural for the Walsenburg courthouse was a stressful project for him. When Rowan, the head of the government's Section of Painting and Sculpture, refused to grant the artist a time extension on his contract, Blumenschein had to work from sunup to sundown to meet his November 2, 1937, deadline. He was not happy. "You took all the joy out of life," he wrote Rowan, "and turned me into a driving mechanical machine."

Blumenschein's successes in group portraits did not discourage his continuing interest in painting landscapes. In 1932, when he was still actively involved in tennis tournaments, Blumy and Helen went to Phoenix for a tennis weekend. After the tournament they spent two weeks near the Superstition Mountains. This side trip allowed the artist to paint a landscape of the Roosevelt Dam and the "barren and magnificent" scenery of the Salt River Canyon, where the dam had been completed in 1911. Blumenschein called the painting *Arizona*, but he reworked it and renamed it *Red Symphony* in 1939 before it received its final name, *Arizona Dawn*. The following year Blumenschein inaugurated a new art procedure when he and Helen took a two-week sketching trip together. Mary stayed home, probably because of her delicate health but perhaps also because of her unhappy memories of the driving rains that had occurred during their first and ultimately last camping trip as a family in 1919, when the Blumenscheins had moved to Taos.

On another tennis trip to California in 1933, Blumenschein painted *Mojave Desert*, which he rated a "top notcher," and two of his fellow Taos artists, Cook and Adams, agreed with him. That same year Blumenschein painted an especially attractive oil called *Taos Valley*, which was characterized

by the striking depth the artist had achieved, capturing the grandeur of the Taos Valley, with its yellow and brown tones and its toylike houses in the distance. In the foreground Blumenschein painted a dark, rutted, winding road wedged between high rocks. He adroitly balanced the perspective of his painting with the brooding Sangre de Cristo Mountains in the background, the tops of which were almost immersed in dark descending storm clouds.

In February 1934, Blumenschein exhibited *Taos Valley* in his second solo show in New York City, where it eventually ended up in the Metropolitan Museum of Art. He also painted landscapes of two places where he loved to fish: Eagle Nest Lake, northeast of Taos, which he painted at least five times during the late 1920s and the early 1930s, and Rio Grande Gorge near Taos, featured in *Canyon Red and Blue*, which he gave to the Dayton Art Museum in his hometown in 1935. Toward the end of the decade, the artist did two other well-received landscapes, focusing in part on human subjects: one was *Landscape with Indians* in 1936, which he reworked in 1938 under the title *Indians in the Mountains*, and the other was *Afternoon of a Sheepherder* in 1939.

Blumenschein's landscapes during the thirties reflected a growing trend toward modernism in his artwork. According to art historian Elizabeth J. Cunningham, none of them were faithful replications of the scenery being painted; he would often move "mountains or canyon walls to create in his compositions the sensation it evoked in him." He might paint a forest in which the trees were in many ways nonrepresentational and yet leave an impression with the viewer that it was a lush woodland.

His inclination toward modern art made him most receptive to the talents of artist Emil Bisttram, who arrived in Taos in 1932, after studying in Mexico with Diego Rivera on a Guggenheim Fellowship. The outspoken Bisttram won over

Blumenschein when the longtime Taos artist discovered that both of them had given up more lucrative commercial art in favor of painting in a more modernist style. In May of that year, Blumenschein invited Bisttram to go fishing with him at Eagle Nest Lake, when the fishing season was publicly opened for dedicated anglers like Blumy. An even greater indication that the two men could become soul mates occurred in May 1933, when Blumenschein, Bisttram, and four other artists organized the Heptagon Gallery in Taos's Don Fernando Hotel. When this hotel burned down in December 1933, the gallery's artists were able to save their paintings and relocate in the La Fonda Hotel.

Because the Depression had such an adverse effect on art sales in Taos, Bisttram decided to teach art classes for compensation. He used this opportunity to teach the spiritually oriented dynamic symmetry theories he had learned from his mentors in New York. When this relative newcomer to Taos began to preach the gospel that representational art could earn a painter a living but only abstract works could be considered true art, Blumenschein had finally had enough. Indeed, he promptly left the Heptagon Gallery and turned completely around in his openness toward Bisttram, characterizing him as "a four-flushing, self-pushing, narrow-minded individual."

In his bitter break with Bisttram, Blumenschein had shown those representational artists in Taos who were still alive that he had not entirely abandoned traditional art. He was, after all, a Paris-trained classical painter, who was much more inclusive in his philosophy of other art styles than Bisttram was. In his involvement with the Art Students League, he had studied and taught various art methods. He was able to take a more middle-of-the-road approach to art in the 1930s, adopting the best, as he saw it, from the traditional and the more modern art styles, both of which were exemplified in the landscapes he painted during this often

dreary decade. He was becoming a transitional figure in an increasingly black-and-white world of conflicting tastes and opinions.

Still, the greater acceptance of abstract art that Bisttram sparked benefited the experimental, more flexible Blumenschein, who felt very comfortable entering his ever-pleasing modern oil *Canyon Red and Black* in the art competition at Chicago's successful Century of Progress Exposition, held during the Depression years of 1933 and 1934. Whether the successes of this highly competitive and hard-driving artist, who by 1940 would be in his mid-sixties, would carry over into the next decade remained to be seen.

14

An Aging Artist in an Era
of War and Peace

By 1940 America was slowly recovering from the Great Depression, but there would be little time to gloat over the mixed successes of the New Deal. Most Americans had become keenly aware of the compelling issues of war and peace that would dog the country during the forties and fifties. There was a sharp division in the nation over how the United States should react to Hitler's conquests in Europe from 1938 to 1940, ending only when what had been called a "phony war" during the initial stages of the conflict became a second global war even larger than the first. Ernest and Mary Blumenschein must have been as saddened by the Nazi occupation of their beloved Paris as they had been when German troops were close enough to bombard the city during World War I.

The prospect of American intervention in World War II badly split public opinion in the United States. President Roosevelt, sensing the magnitude of Hitler's threat to the existing world order, pushed Congress to enact legislation to help Great Britain, which had stood alone among the major powers of Europe after the fall of France. But many citizens, particularly those from the Midwest and West, were against any involvement in this second Great War; a large number of them joined the growing isolationist movement spearheaded by the powerful America First Committee.

During those divisive months preceding the attack on Pearl Harbor, on December 7, 1941, Blumenschein and other German Americans did not feel any perceptible hostility over their ethnic ties to Germany. The artist was certainly sharp enough, however, to remember that the wave of anti-German feeling during World War I had not begun in earnest until after President Wilson had asked for a declaration of war. But this time, there never was a strong anti-German sentiment to rival that of 1917, even though there were groups, such as the suspiciously pro-Nazi German American Bund, that bore watching.

As a consequence, Blumy, not having to justify his patriotism during this war, could enjoy the recognition he received during New Mexico's Cuatro Centennial, commemorating Francisco Vásquez de Coronado's 1540 exploration of New Mexico and other parts of the American Southwest. The Museum of New Mexico organized a large exposition to celebrate the four hundredth anniversary of Coronado's ground-breaking quest. Because artists and writers had played such a major role in shaping the nature and growth of the state's tricultural population, the *Santa Fe New Mexican*, in a June 26, 1940, special edition, featured a forty-four page section on New Mexico painters, sculptors, and literary figures. Blumenschein's biography was included, as well as an account he was invited to write on the founding of the Taos art colony. The artist was also honored as a speaker on Indian art in the Taos area for the Fine Arts section of the Coronado Congress, an organization established for this important commemoration.

The success of the Coronado celebration and its emphasis on art encouraged the Museum of New Mexico to send the works of Taos and Santa Fe artists to regions outside the Southwest. As part of its Forty-eighth Annual Exposition of Painters and Sculptors of the Southwest, the museum sent one painting from each of thirty-five New Mexico artists to several large cities in the East. *El Palacio*, an influential

magazine in New Mexico, in its November 1941 issue not only acknowledged the significant role of Taos and Santa Fe in the national art community but quoted a reviewer for the *Kansas City Star* who had made special mention of the "first-class landscapes" of Blumenschein and of artist Cady Wells.

On December 7 the entire nation was stunned when the Japanese bombed Pearl Harbor, resulting in a congressional declaration of war against Japan the following day. Germany and Italy, which had a pact with Japan, retaliated with a war declaration against the United States on December 11. The United States, once divided on the question of intervention in this newest global war, was now united and ready to make major sacrifices to achieve victory, from rationing gas and certain foods, such as meat and butter, to participating in the military draft established by Congress in September 1941. The war also caused a serious slump in the art market throughout the nation.

This downturn in art sales affected Blumenschein and other Taos artists, of course, but the war hit even closer to home in other ways for them and the rest of the Taos community. On April 9, 1942, for instance, about twenty thousand American troops, supported by a force of Filipinos on the Bataan Peninsula, bordering Manila Bay, were compelled to surrender to the Japanese army, which was determined to make the Philippines a part of the expanding Japanese Empire. The defeated soldiers were forced to march eighty-five miles to Japanese prison camps under circumstances so cruel that this tragic episode became known as the Bataan death march. Among the mistreated prisoners were members of the Taos County Tricultural National Guard unit, who, if they survived this long march, would be prisoners of war for the duration of the global conflict. Indeed, the final surrender of American forces on the island of Corregidor, off the coast of Bataan, on May 6 would seal the confinement of these Taoseños for more than three

years and guarantee Japanese domination over the Philippine archipelago during the entire war. The population of Taos County was so small that Blumenschein was personally affected by these atrocious Japanese acts, having developed close relationships over the years with many of the Hispanic and Pueblo members of the guard and their families.

Helen Blumenschein was thirty-two years old when Pearl Harbor was bombed, and she wanted to play a more active role in the war effort but was reluctant to leave her parents at this time. Blumenschein was in his late sixties and Mary in her early seventies. The once athletic and competitive Blumy had sought refuge from the harsh cold Taos winters by painting landscapes around Albuquerque, including buildings within the city itself, taking advantage of the mild winters south of Santa Fe, below La Bajada Hill. Beginning in the late 1930s, experiencing greater renown because of his productivity during the busy twenties, Blumenschein would often stay at Fred Harvey's historic Alvarado Hotel in the Duke City. From his hotel room he especially enjoyed painting the trucks and freight cars in the city's nearby railroad yards. Mary, whose chronic heart problems had curbed many of her travel plans, would sometimes stay with him at the hotel during these painting trips.

Despite Helen's concerns about the advanced ages and health problems of her parents, she finally decided to do her part in World War II by enlisting in the Women's Army Auxiliary Corps, popularly called the WAACs, in spring 1943. Her parents were deeply concerned with the decision of their only child to participate in this global war. Helen speculated that her father, "who would never call himself a pacifist," probably was one. She cited the shock Blumenschein had felt when his brother, George, had joined the service during the Spanish–American War, a decision that would affect him even more when George later died in a veteran's hospital as a result of wounds he had received in Cuba.

Although Blumy and Mary had made posters to sell war bonds during World War I, and he had painted large range finders for the artillery during the conflict, both of them were too old to participate in any significant way during World War II. But their ages did not make them indifferent to the ravages of this even larger struggle. Blumenschein was not only affected by the plight of the Taos National Guardsmen incarcerated in the Japanese prison camps in the Philippines, but was also concerned about the treatment of American POWs by the Germans in the country of his father's birth.

Helen's first assignment as an officer in the WAACs was to replace a male soldier as one of two typists in a Springfield, Missouri, hospital, but she was an artist not a typist. More appropriate was her second assignment, to help distribute monies from the Army Emergency Relief (AER) fund; her main job was to help army families from rural areas with their medical problems. She was "sent out in a chauffeured Army car to interview various families" about their health problems, but because of her "New England thrift," she referred them all to the "excellent hospital facilities" available rather than unnecessarily spend taxpayer money. This assignment was followed by other stateside duties, including writing scripts for a local radio station after taping conversations with soldiers wounded in the Pacific. After about a month of her discharging various tasks, the colonel who supervised her could not come up with anymore ideas about what she should do.

To her parents' relief, she was not sent overseas but was transferred to Boston and Florida for a short time before winding up in New York City, operating out of a Manhattan skyscraper. In this area she had called home as a child, she distributed more assets from the AER to army families with health problems. Nine months later the AER gave the Red Cross $10 million donated by composer Irving Berlin, from the proceeds of his musical *This Is the Army Now*.

To the acute distress of her family, Helen's next assignment was overseas, in the Pacific theater of the war. Her new job was to censor mail in Australia, much to the dismay of General Douglas MacArthur, who did not want women serving in dangerous areas of the Pacific, such as "the atrocious jungle area of New Guinea." Eventually she was stationed in a compound surrounded by five thousand abandoned Japanese soldiers who would live off the jungle throughout the rest of the war. As a feminist before the term became widespread, she was proud to serve in an unsafe place, probably feeling a certain elation that her orders were in defiance of the authoritarian MacArthur's wishes. What concerned her most was the news from home. Her parents' health problems continued to worry her. Fortunately, they wrote to their daughter regularly, and she loved hearing about Taos, where all three of them still had their art studios, plus a host of friends they loved to entertain.

Letters from home about Taos artists were especially important, such as one about Howard Cook, an artist close to Helen, who had been assigned as a war correspondent to the Solomon Islands. In October 1944, when she was transferred to the Leyte Gulf region in the Philippines, where the U.S. fleet would defeat the Japanese fleet in the greatest naval engagement ever fought, she received discomfiting news from her father. Her parents had moved to Albuquerque, where they were staying at the Alvarado Hotel, and their family cook had died from ptomaine poisoning; such reports would accelerate her concern about the future welfare of her close family.

Unsurprisingly, Blumenschein's letters to Helen often dealt with his status as an artist during these prolonged war years. One of his main complaints was the lack of interest in purchasing his paintings unless he sold them at ridiculously low prices. He claimed in his correspondence with Helen that during her first two years of service in the WAACs, his only income came from the royalties for his illustrations in

Charles A. Eastman's book *Indian Boyhood*. In a May 2, 1944, letter to Helen, he wrote about the low wartime prices: "I would rather leave the batch [of art work] to my heir and hope that some of them will fetch a decent price." Despite this vow not to sell cheaply, he marketed his classic *Star Road and White Sun* to Albuquerque High School in 1945 for one-tenth of its actual value at the time.

Helen, although frequently pressed for time, wrote her father as often as she could. In December 1944, she asked him why he had turned to pure landscape in his artwork. His response was simple, but one that accurately revealed his state of mind during much of the 1940s. He found great solace in the mountains and rolling vistas around Albuquerque, which gave him promising new images to paint.

In 1941, the artist had completed *Bend in the River*, in which he underlined the role of water rather than land in the arid beauty of New Mexico's high desert country. This landscape featured a commanding butte in the background and a gently flowing river in the foreground, with tall reeds bordering one of its banks. Eager fishermen are casting their lines along the winding course of the river. Because of Blumy's enthusiasm for fishing, Bert Phillips's son, Ralph, claimed that *Bend in the River* constituted a "self-portrait" of the artist. Although this beautiful oil has a human dimension, the largely abstract scenery dominates. Today the painting is part of the large Philip Anschutz Collection, located in the American Museum of Western Art in Denver, where it is kept with other Blumenschein works, including one of his very best landscapes, *Sangre de Cristo Mountains*.

In 1942 Blumenschein painted a landscape of the Sandia Mountains, which tower over Albuquerque's east side. Appropriately titled *Sandia Mountains*, this painting has no human element; thus, it represents the trend Helen noticed later when she asked him why he was moving toward pure landscapes in his artwork. The lower two-thirds of this oil

feature a field of large brownish sagebrush, extending to the Sandia Mountains in the distance. The mountain range is painted in various colors, including a light tan or brown dominating its slopes, splashes of purple along its base, and a slit of green on its forested crown. The name Sandia in Spanish means watermelon, and these mountains often look pink or even red in the early evening; indeed, Blumenschein, then sixty-eight years old, would find real inspiration in capturing the beauty of these mountains on canvas.

Helen, one of his two fellow artists in this talented family, could afford to be critical of her introspective father at times. She once criticized his practice of reworking or painting over previously done oils, characterizing it as the same as taking "an old egg" and repainting it. But her contemporary Howard Cook was more tolerant, interpreting Blumy's reasons for doing over some of his finest paintings as an example of his "extraordinary determination [and] a tremendous effort of will to achieve final perfection."

One example of Blumenschein's successful reworking of a painting was his *New Mexico Peon*, which he completed in 1942, before Helen became a WAAC. The original work was called *Taos Plasterer*, in which Blumenschein's neighbor Epimenio Tenorio is shown as a working man leaning against a support rail, with mud caking his pants, holding a trowel in his right hand. He is standing on a platform, and behind him are mountains and clouds painted in an abstract way, the method Blumenschein was using continually for his landscapes.

New Mexico Peon, on the other hand, provides more color and shows better style in its execution. The worker, or peon, not necessarily the disparaging term it is today, has a plastering tool in each hand. His coat and hat have been enlarged in this second version, and he has a shining gold buckle on his belt. On his right side are two green cabbage-leafed plants that match his soiled blue-green denim coat. Behind him is a golden field of wheat, stretching toward light tan

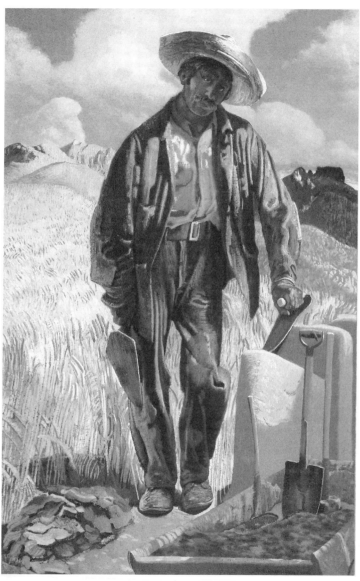

New Mexico Peon (originally *Taos Plasterer*, 1930), reworked 1934, finished 1942. Courtesy of the Gerald Peters Gallery, Santa Fe.

peaks on the left side of this vertically oriented painting and dark blue ones on the right. Above these distant mountains are bellowing cumulus clouds, which present a pleasant contrast to the rich blue sky. The final version of this supremely New Mexican figurative painting was certainly more colorful, if not more interesting, than the original.

Blumenschein's most famous reworking of an original painting, however, is his striking *Enchanted Forest*, which he finally completed in 1946. When the Carnegie Institute, founded by Andrew Carnegie in 1895 to encourage modern art, announced that it was having another international exhibit of American and European art, Blumenschein decided to embark on another figurative painting. Recalling the critical success of his *Moon, Morning Star, and Evening Star*, largely a landscape painting but with active participants in a traditional Pueblo Indian dance, he began reworking a painting he had completed in 1925, called *Decorative Landscape with Figures—Adam and Eve*. This painting, with its biblical theme, was undoubtedly influenced by another oil titled *Adam and Eve*, done earlier by one of Blumy's close allies in art, Victor Higgins. Blumenschein's newest version of this theme featured a tall primeval aspen forest dwarfing at the bottom the figures of Adam and Eve leaving the Garden of Eden. A reviewer for the *St. Louis Post-Dispatch* in 1925 characterized the painting, with its two "small and chaste figures" emerging from a glorious forest canopy, as homage to poet John Milton's *Paradise Lost*.

Blumenschein first reworked this painting in 1929, under the title *Aspen Grove*, but brought it to its final form in 1946 by having Deer Mothers join male Deer Dancers, thus replacing Adam and Eve as the human subjects found in the original form. He also gave the oil its new and enticing title, *Enchanted Forest*. As proof of the success of this artistic achievement, many of Blumenschein's art colleagues in Taos thought it was the best of all his paintings. The dancers he placed at the bottom of this impressive oil provided a

needed perpendicular slant to the magnificent forest, which swelled up toward the top of the 51-inch vertical painting, dominating the entire scene in the process.

In fall 1945, Helen Blumenschein came home after she had been mustered out of the WAACs. While she was waiting in Manila for a ship to take her and other veterans back to the United States, she and another WAAC hitchhiked to the prison camp where the Taos County POWs had been held for three miserable years. These young men from her New Mexico home, who had been converted into an antiaircraft unit before they left the country to serve overseas, were a most cheerful group of soldiers, despite their half-starved appearance; they could hardly wait to return to their families and resume a long-denied normal life. Helen sensed the historical significance of this inhumane imprisonment and the Bataan death march that had preceded it. Indeed, these injustices would result in a significant change of policy for the military during wartime. "Never again," she remarked in her 1979 family history, "did the U.S. Army take all [of] one unit from just one county in the U.S.A.!"

When Helen arrived back in Taos, her father's economic problems resulting from the poor sales of his artwork were changing for the better. The stringent sacrifices of wartime were no longer needed, notwithstanding the advent of the Cold War. The continuing governmental expenditures, along with the influx of private capital, would spark the economy of the postwar years. The needed funds for the defense of the United States against the expansionist communist state of the Soviet Union would eventually result in a booming economy during the long and uneasy truce between the two nuclear superpowers. As for artists like Blumenschein, the market for their paintings had not looked so good since the 1920s.

The growing chasm between the United States and the Soviet Union disturbed Blumenschein greatly. In separate letters from Los Angeles to his wife and daughter on

April 28, 1945, he expressed his delight that the "two great armies" from the United States and Russia had finally met near the Nazi capital, seventy-five miles south of Berlin. Blumenschein also showed real concern over the "anti Communist[,] anti Jewish hatred" he was witnessing in Los Angeles. The Cold War would present a serious challenge to the idealistic artist, after having his patriotism as a German American questioned during World War I. About three months before the Berlin Blockade, Blumenschein, becoming increasingly disenchanted with the Soviet Union, wrote on March 6, 1948, to the National Council of American Soviet Friendship in New York, asking that his name be removed from the organization's roster.

One significant boost for Blumenschein's art career occurred in 1945, when art collector Thomas Gilcrease visited Taos in search of Indian paintings for his art museum; at this time the now famous Gilcrease Museum was located in San Antonio, prior to moving to its permanent home in Tulsa. The art patron bought Blumy's 1925 painting *Ranchos Church with Indians* from the Blue Door Gallery. He also met with the artist, whom he admired but with whom he sometimes disagreed; Gilcrease preferred the more traditional representations of Indian life for his collection. Blumenschein, reflecting on his visit with Gilcrease nine years later in a letter to another art dealer, described the differences between the two men in one concise sentence. "Mr. Gilcrease," he wrote, "didn't believe I was right to take any liberties with ethnological truths, in order to make a picture that conveyed a bigger truth, as well as moved the onlooker in an emotional way." A year later the artist offered to Gilcrease his more historically correct *Taos Entertains the Cheyenne* and was disappointed when his offer was rejected.

Interestingly enough, Blumenschein's *Enchanted Forest* ended up in Gilcrease's art museum in Tulsa, despite the abstract, almost fantasy-like, forest towering over the Pueblo Indian Deer Dancers, who occupy less than a fifth of the

space at the bottom of this large canvas. Gilcrease may have been impressed by the painting's wide and enthusiastic acceptance, such as the invitation from the Carnegie Institute in 1946 to exhibit *Enchanted Forest*, sight unseen, at the Painting in the United States exhibition in Pittsburgh.

Blumenschein's spirits regarding his art sales were lifted greatly in November 1946, when four of his paintings were purchased by a Los Angeles businessman named Paul Grafe. One was his marketable *Adobe Village—Winter*, and another was his *Woman in Blue*. The latter painting was one of three oils featuring a beautiful but unnamed female Pueblo Indian model from Taos, which were exhibited throughout the United States from 1927 to 1931 under the auspices of the Grand Central Art Galleries. The other two were landscapes involving, in one way or another, the artist's favorite pastime—*The Lone Fisherman* and *Eagle Nest Lake*.

Blumenschein's joy over Grafe's purchases was subdued significantly by a serious health problem. He was diagnosed with a prostate condition requiring specialized surgery at the Good Samaritan Hospital in Los Angeles. After months of recuperation, he was faced with a follow-up operation in early 1947, requiring three more months of recovery time in Los Angeles. Especially disheartening was his doctor's gloomy prognosis that he would never again be his vital, energetic self. Blumy confided to his daughter that at seventy-two years of age, he was beginning to feel like an "old man."

Helen Blumenschein had realized by now that her role as a daughter was evolving into a caregiver one. Three years later, her mother suffered from a coronary thrombosis. Mary was told to ease up on both her social life and her art activities. For years Mary Blumenschein had largely subordinated her once highly successful art career, which was marked by the three medals she had won for her accomplishments in art while studying in Paris under the classicist painter Raphaël Collin. She did continue painting in a limited way.

The Blumenschein home in Taos, which is now one of the art museums in town, has a number of her paintings, executed primarily for her own satisfaction. These include ten artworks for her Arabian Nights series, plus her unfortunately faded painting *Lady with Fan*. In 1947 she donated one of her best post-Paris paintings, the *Acoma Legend*, to the Lovelace Clinic in Albuquerque in gratitude for the fine care the clinic had given her ailing husband.

Throughout Mary Blumenschein's Taos years, she continued to design and execute jewelry. In February 1927, for instance, nine pieces of her jewelry, in both gold and silver, were shown at the Grand Central Art Galleries, along with thirty-three of her husband's paintings. But Mary's activities were becoming increasingly restrictive because of her delicate health. Even while Helen was overseas during the war, a concerned Blumy wrote her on November 2, 1944, that her mother "was well on the way [toward] permanent invalidism." Nevertheless, Mary kept busy with her jewelry design and the remodeling of her quintessential New Mexican home. Mary was even able to travel back to New York with her daughter during the years following her coronary thrombosis.

In addition to feeling old, Blumenschein was deeply concerned about the trend toward modern art in painting. In a series of letters to Helen in late autumn 1946, he expressed his frustration over the "complete swing in Art to abstract and non-objective!" He felt he was now out of the competition like most other traditional artists, even though he had pushed for abstract designs in his own artwork. The first prize award by the Carnegie Museum for "an entirely abstract picture" and by the Pepsi Cola Company for a "wildly modern" artwork had truly discouraged him.

Six years later, an exhibition by the Colorado Springs Fine Arts Center increased Blumenschein's feelings of discouragement. He was invited to submit his 1920s *Ranchos Church*, which would hang alongside the works of eight

other early Taos artists, such as Sharp and Couse. The display would also include the painting of another ally in the art wars at this time, Emil Bisttram. The rationale behind this arrangement did not please Blumenschein, as it put him in the same category as the traditional artists with whom he was grouped. In essence, he and the older artists were characterized as constituting a foundational base for the younger artists, who could now draw on them for inspiration in the present-day artistic environment, where "all varieties of current expression" were now acceptable. To the still proud and ambitious Blumenschein, this back-up position was tantamount to categorizing them and their paintings as being passé in the world of art.

Fortunately for Blumenschein, the decrease in his artistic productivity, which was due largely to his chronic health problems, was matched by growing recognition of what he had accomplished during his six decades as an art student, illustrator, and painter bent on achieving perfection in his creations. In 1947 the University of New Mexico awarded him an honorary fine arts degree. He was in good company. Two of the other recipients to receive honorary degrees at this time were the architect John Gaw Meem and the noted scholar of New Mexico's historical heritage Fray Angélico Chávez. (A research library that bears Chávez's name is located at the New Mexico History Museum in Santa Fe, where a large collection of Blumenschein's letters, news articles, and other papers are housed.) But the best-known recipient to join Blumenschein in receiving an honorary degree at this institution in 1947 was J. Robert Oppenheimer, the scientist in charge of the development of the atomic bomb at Los Alamos, New Mexico.

Other forms of favorable publicity Blumenschein received that year included information about him in Mabel Dodge Luhan's book *Taos and Its Artists*. The Blumenschein family had never been close to Luhan. Blumy, who regarded her as extravagant and probably a hanger-on eager to be identified

with the Taos art community, was described by art historian Elizabeth J. Cunningham as Luhan's "old sparring partner" in her joint study with Peter H. Hassrick on Blumenschein's art. In her book, however, the wealthy and often generous Luhan warmly acknowledged Blumenschein's and Phillips's role in founding the Taos art colony, and the two artists were truly grateful for her support and attention.

Reginald Fisher, the curator of the Museum of Fine Arts, which was an integral part of the Museum of New Mexico, responded to the warm nostalgia sparked by Mabel Dodge Luhan's sympathetic study of the Taos art colony by organizing a series of exhibitions featuring the art of these pioneering New Mexico painters. Blumenschein was chosen as the most logical person to inaugurate Fisher's ambitious plans. Despite the artist's health problems, he worked diligently to organize the first of these exhibitions, which opened on May 30, 1948, in Santa Fe.

For this show, Blumenschein contacted galleries and museums where his earlier paintings were on display and even repainted some of his older canvases to match his high expectations of what a good Blumenschein oil should be like. In addition to *Jury for the Trial of a Sheepherder for Murder* as one of his representative paintings, he contributed *Superstition* and *Taos Entertains the Cheyenne.* Two other Blumenschein paintings acquired for the display were *The Chief Speaks*, loaned to the show by the Cincinnati Art Museum, and *Portrait of a German Tragedian*, loaned to the show by the Herron Institute of Art in Indianapolis; this 1907 painting had been originally purchased by Blumy's old friend from his Paris days, the novelist Booth Tarkington, who died in 1946.

On the afternoon of the first day of this festive art show, the seventy-four-year-old Blumenschein received the first Honorary Fellow Award that the School of American Research had ever granted to an artist. Favorable commentary on his long art career was given by fellow painters Bert Phil-

lips, Kenneth Adams, and Theodore Van Soelen. Howard Cook, in his critique of this much ballyhooed art exposition, focused on Blumenschein's role as both a national and a regional artist. He characterized Blumy's art as being a "connecting link between [art] today and the traditional art of the past." Alfred Morang, a member of the Cinco Pentores art group in Santa Fe, called the veteran artist one of America's greatest living painters and urged art students to revisit and study his paintings. Blumenschein's longtime friend and fellow art student Lionel Barrymore wrote to congratulate him for his well-deserved recognition.

Also in 1948 Blumenschein wrote Fisher about a piece of news that caused him to have decidedly mixed feelings. Gilcrease had bought for his art museum in Tulsa *Enchanted Forest; Superstition; Moon, Morning Star, and Evening Star;* and *Mojave Desert.* These purchases did not surprise the still-hard-working artist (except for *Mojave Desert,* which was the only pure landscape of the four), because Gilcrease had vowed to collect only the best of Blumenschein's available art for his collection. Blumenschein was disappointed only because he would have preferred these four oils be part of a follow-up art exhibit in Kansas City before the Gilcrease Foundation bought them.

After a year of diligent work on behalf of this New Mexico extravaganza in 1948, Blumenschein suffered from an inflamed appendix in December of that year. This illness prevented him from resuming his career as the state's best-known artist until spring 1949. When he returned to his studio, he decided to rework a five-year-old painting he called *Strength of the Earth.* This oil was his attempt to capture the beauty and grandeur of one of his favorite fishing areas, the nearby Rio Grande Gorge.

In the first draft of this painting, Blumenschein had focused on the course of the Rio Grande, which he had extended up toward the top of his canvas. He balanced this river scene by having the steep canyon walls descend dramatically

down toward the banks of the river. In his final version, which he called the *Rio Grande Cañon at Taos*, completed in 1949, the course of the river is shortened, bringing the canyon walls closer to the viewer as the river disappears behind a long diagonal slope. The sparse clusters of dark green piñon and juniper trees growing on top of both rims of the canyon provide a pleasing color contrast to its brown and tan walls. This painting demonstrates once again Blumenschein's genius in the design, structure, and color he selects for his artwork.

As the next decade approached, Blumenschein would be increasingly challenged by his own unstable health and Mary's troubling heart problems. Even though his drive as a painter was still there, the big question for him was whether he could overcome the constraints imposed by his age and his loss of vigor.

15

The Final Years and an Artist's Legacy

During the 1950s the nation's prosperity continued, not-withstanding two fairly mild recessions under the popular president Dwight D. Eisenhower. These years provided better prospects for artists like Blumenschein to sell their paintings at reasonably good prices to an art market definitely swinging toward modern abstract art as opposed to traditional forms, which Blumenschein still embraced, but with important modifications. Unfortunately, Blumy, who would reach the venerable age of eighty halfway through the decade and whose health would continue to decline, was not easily able to produce from scratch the high-quality art that he demanded of himself.

The prostate problems that had begun in the late 1940s were especially debilitating. The doctors were right—he would never return to his old vigorous self. Blumenschein, whose determination and hard work had been hallmarks of his career, responded by reworking some of his earlier paintings, which was about the only way open to him to continue his standards as a first-class artist.

Much of Blumenschein's artwork during the fifties focused on cityscapes he had painted during the winter months in Albuquerque. These stays, which according to Helen lasted six months each year and marked the final ten years of Blumenschein's life, were first spent in the city's

Hilton Hotel and later at its Elks Club before winding up at Albuquerque's historic Alvarado Hotel. The warmer climate and lower elevation seemed to agree with both of them. Moreover, Blumenschein saw this city, the largest in New Mexico, as having a landscape that could provide a more modern setting for his paintings in contrast to the artist's beloved Taos Valley.

One of Blumenschein's best oils during these last years of his life featured Albuquerque's large railroad yard, which had become an important transportation hub in the American Southwest. The artist first painted *Railroad Yard* in 1945, reworked it in 1951 and 1953, and completed it in 1958, under the name *Railroad Yard, No. 5*. The painting was more red in tone than his earlier paintings and required more physical outlay to execute it. As Helen put it, "His painting became more labored and his color redder." This large urban panorama includes darker colors than his usual palette, such as those created by billows of gray smoke belching from several smokestacks, which hover above red freight cars.

Blumenschein felt so good about this painting that he entered it as a new one in Santa Fe's Museum of Fine Arts 1953 Fiesta Show. When one viewer at the show could see no difference between this 1953 version of *Railroad Yard* and the 1945 original, Blumenschein had photos of both paintings published in the September 13, 1953, edition of the *Santa Fe New Mexican* with the caption "Look closely—There IS a difference." He claimed that in crossing the overpass on Coal Avenue above the Albuquerque freight yard, he could envision some needed changes in the original painting that would avoid the "hardness and dryness" he saw in the older version.

Despite a certain amount of criticism for reworking some of his older paintings, these efforts by the artist were usually successful in that they brought attention to some of his finest paintings from the past. In 1954, for instance, one year

after Blumenschein's participation in the Fiesta Show, the Texas millionaire H. J. Lucher Stark bought four Blumenschein oils, including his most action-oriented, the once reworked *The Extraordinary Affray*, which Stark purchased in Taos during one of the artist's absences. Stark also bought a cityscape focusing on rail transportation in Albuquerque titled *Box Cars and Railroad Tracks*, plus Blumenschein's *Taos Entertains the Cheyenne* and *Rio Grande No. 2*. In 1957 he bought one of Blumenschein's most historically important paintings, *Ourselves and Taos Neighbors*, in which Blumenschein is pictured with his wife and daughter standing among the family's artist friends and neighbors in his studio. Stark's art museum in Orange, Texas, and Gilcrease's in Tulsa, Oklahoma, together hold 20 percent of the artist's self-defined fifty best paintings.

Two more cityscapes of Albuquerque and one involving a Pueblo Indian sheepherder tending his flock, along with a painting on the subject of death, should be emphasized in any evaluation of Blumenschein's art accomplishments during the last decade of his life. His painting *Downtown Albuquerque*, for instance, presents an eye-pleasing view of this once small southwestern city. Painted largely in the red and orange colors he used for Albuquerque's low-lying buildings, the city's downtown section is in sharp contrast to the dark mesas and heavy clouds that loom above it. As detailed figure paintings tended to take a toll on Blumenschein's limited energy, the images of people involved in a street parade in the foreground are very small, putting less pressure on this perfectionist of the art world; nevertheless, these human figures are a charming addition to this view of urban life in the Southwest.

Another cityscape executed by the aging Blumenschein was *The Chief Goes Through*. This painting definitely moves Blumenschein into the modern world, with its sleek Santa Fe diesel-powered Super Chief train, which he often viewed from his rooms in the Alvarado Hotel. In this 1956 oil,

yellow and tan colors predominate as the snub-nosed Super Chief glides its way through a complex system of railroad tracks crowded with stationary freight cars. The painting's reviews were favorable. Taos artist Dorothy Brett, one of Mabel Dodge Luhan's friends, liked it, as did Howard Cook, who called it one of Blumenschein's "top works." The artist himself thought it was one of his best paintings. His loyal supporter, Stark, bought the painting with the understanding that Blumenschein would be able to first display it at two exhibitions.

Prior to purchasing Blumenschein's *Chief Goes Through*, Stark acquired an oil from the artist called *Rocky Trail*, another one of his workovers. The original painting was completed in 1944 under the title *Sheepherder among the Rocks*, or *Indian Sheepherder*. Depicting an Indian sheepherder was an interesting choice, because most sheepherders in New Mexico were Hispanic. Nevertheless, the painting reveals much of Blumenschein's devotion to brilliant colors, design, and balance, qualities that were part of the representational abstract American art that he had developed during his Taos years. Forsaking realism in favor of emotional impact, Blumenschein's shepherd stands close to the center of his canvas, a large figure, but not much larger than the robust animals in his flock. The shepherd's trail is almost enclosed by enormous boulders, which are brown and yellow, but the actual space for his flock is done in brighter colors, which draw the viewer's eyes to that portion of the painting. In fact, the artist devoted most of his time to the center of this oil when he reworked the painting in 1955.

Blumenschein's last painting, which he titled *The Cormorant Attends Funeral of His Friend the Butler*, was given its name on June 6, 1959, one year before his death. Indeed, the painting was about the ultimate demise that all humans must face. The artist had never dwelled much on the subject of death, although in 1924 he did a portrait of himself and fellow Taos artists Ufer and Higgins, which he called *Ide-*

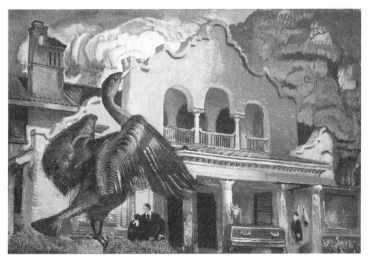

The Cormorant Attends Funeral of His Friend the Butler, June 6 1959 (originally *Alas Proud Mansion*, 1947; later *The Funeral*, 1957). Oil on canvas. Courtesy of the Taos Historic Museums, Taos, New Mexico.

alist, Dreamer, Realist, in which each artist is balanced on a pinnacle-shaped rock, while above them, a large donkey spreading angel wings hovers over a cloud on which three vultures are perched side by side, as grim representatives of death. When Henry McBride, the art editor of the *New York Herald*, ridiculed this work, the prideful Blumenschein destroyed it. This decision was not an unusual one for the artist, as he wrote once before moving to Taos that 150 of his paintings had met a similar fate because they had not lived up to his standards.

Blumenschein started his painting *The Cormorant Attends Funeral of His Friend the Butler* in 1947 as *Alas Proud Mansion*. He later reworked it under the name *The Funeral* in 1957 before he settled on its final title in 1959. This unusual painting shows a California mission-style building with a huge bird in front of it, looking as though it is about to pounce on some prey. Most ominous, however, is the

coffin Blumy drew in the foreground near the building's entrance. According to art historian Elizabeth J. Cunningham, when Blumenschein reworked this oil, he "added a man and woman looking off into the distance, away from the coffin with [an] angel depicted as a curious derby-hatted butler" standing on the other side of this casket. Cunningham attributes these additions to the good humor of the artist's now-deceased friend Ellis Parker Butler, speculating that the death of Blumenschein's wife, Mary, after this 1957 do-over was made more bearable by Butler's "transcendent humor." The cormorant in the painting, of course, was a representation of death in the tradition of Shakespeare and Milton; Blumenschein's eventual demise was probably on his mind during his convalescence from prostate surgery in Los Angeles, where he began work on this somber painting.

Blumenschein also did some illustration work during his declining years. Although he had deliberately given up book and magazine illustrations, despite his successes and the good money he could make doing them, he did have a few opportunities to use his talent for illustrating during the 1950s. In 1952, for instance, he agreed to provide illustrations for the political study *Turmoil in New Mexico*, written by his friend the well-known local historian William A. Keleher. Keleher was so pleased with Blumenschein's work that he asked him to illustrate his *Violence in Lincoln County* in 1957. In a June 9, 1951, letter, Helen Card, a woman so devoted to turn-of-the-century American illustrations that she had organized five scrapbooks of Fredric Remington illustration clippings, wanted a favor from Blumenschein. She sought the artist's permission to donate clippings about his career as an illustrator to the Metropolitan Museum of Modern Art in New York, as she had done with Remington's.

Despite Blumenschein's diminishing productivity in the 1950s as represented by his reliance on reworking earlier paintings rather than doing new ones, his good reputation, molded by years of creative artwork, remained intact. He

had always been inclined to paint oils, which would end up in big art shows back East or become the permanent property of major art museums or galleries in the Midwest, Northeast, and West. Although it turned out that the Gilcrease and Stark museums got more of his best paintings, he was proud when his *Jury for the Trial of a Sheepherder for Murder* was hung alongside those abstract paintings so much in vogue at the twenty-fifth anniversary show of the Museum of Modern Art in the mid-fifties. This painting had not only won a medal from the National Arts Club in 1937, but it was included in a 1938 Paris exhibition with the impressive title Three Centuries of Art in the United States. It had been a thrill for the hard-working Blumy, then sixty-four years old, to be numbered among younger modern artists from the United States, including another giant from the New Mexico art world, Georgia O'Keeffe.

The honors that the artist received for his art continued throughout his career in painting and illustration, which lasted more than sixty years. In 1956, at the age of eighty-two, he again won a National Arts Club medal, this time for one of his reworked paintings, *Rocky Trail*. Especially prestigious for the artist was the recognition he received when he was awarded the more coveted Benjamin Altman Prize for his 1921 painting *Superstition*. The Altman Prize was set aside for the best work of an American-born artist during any given year; consequently, winning that prize a second time in 1925 for his *Sangre de Cristo Mountains* oil was yet another example of his exceptional productivity and excellence during this decade.

Probably most important to Blumenschein, whose age was forcing him to acknowledge that he was nearing the end of his long life as an artist, was having his paintings end up in accessible places, where they could be seen by many art lovers. Indeed, he felt that the most flattering compliments he had received during his career were the respective purchases of two of his paintings by the Museum of Modern

Art and the Metropolitan Museum of Art in the country's great center for the arts, New York City.

Ernest Blumenschein was unique in many ways not only as an artist but as an intelligent and observant person as well. The Taos painter would have been bound for a career in music if his musician father had had his way. Although he wanted to please his father, he persevered in a career in art, which included studying abroad in Paris as well as at excellent art schools in the United States. By the time of his last visit with his father, in Dayton in 1915, one year before the elder Blumenschein's death, William Leonard was probably as proud of his son's achievements in art as he was of his daughter Florence's career in music as a choir director in New York.

Even though Ernest had chosen art over music as a career, he often used classical music as an elevated form of expression to achieve a visual imagery with musical qualities. For example, in doing his landscapes, he would often align his hills and trees to provide a "desired visual rhythm rather than strictly adhering to observations in nature," according to art historian Jerry N. Smith. One painting that effectively demonstrates the degree to which Blumenschein used music in his paintings was *Indian Suite*, in which he was inspired by composer Edward Alexander MacDowell's composition by the same name.

Another talent Blumenschein enjoyed was writing, particularly about the changes in art during his long career. As early as April 1, 1914, Blumenschein had published an essay in *Century Magazine*, one of the major periodicals of the country at that time, titled "The Painting of To-Morrow." It revealed his clear grasp of the newer movements in art, such as post-impressionism, for which he largely credited Claude Monet rather than Edouard Manet in its growing success. He did not write about his own paintings very often, believing that his pictures effectively told the story of

what he had aspired to do as an artist. He did, however, write about the trends in European and American art and about the work of other painters, particularly those who were interested in creating a viable and recognized American form of art. Blumenschein's observations were often insightful and forthright, although sometimes quite opinionated. Because he was the most articulate artist from the Taos colony, his printed remarks made good copy for newspapers, art magazines, and scholarly periodicals throughout the country. Because he was largely regarded as a regional artist, coverage of his activities and his frequently provocative commentary were widely featured in the Southwest, where the Santa Fe–Taos area remained competitive with New York and the rising art communities in California.

Another trait that made Blumenschein different from many of his fellow artists was his exceptional athletic ability. A high school football star in Dayton, Ohio, he was lauded by one of the city's newspapers during a 1927 visit as much for his skills in that sport as he was for the growing recognition of his painting. The artist was also an excellent baseball player, who was able to immerse himself in the life and culture of many Taos Hispanos because of his exceptional talents as a shortstop; he had been more than willing to give advice to these younger baseball players, a few of whom would become art models for Blumenschein's figurative paintings. When he grew too old to play baseball, he became a competitive tennis player, entering tournaments in southwestern cities like Phoenix and often winning the key matches. When age caught up with him, the still highly competitive Blumenschein became a dedicated bridge player, leaving as his only relaxing outdoor pastime fishing in New Mexico's lakes and rivers.

But where Blumenschein most notably defied such popular stereotypes of artists as unconventional eccentrics living from day to day in an unpredictable world was the

businesslike way he pursued his craft. Young Blumy became a sought-after illustrator for the nation's leading magazines, such as *Century, McClure's, Outlook,* and *Harper's Weekly,* to garner enough income to become a full-time painter in the fine arts; this was his ultimate career goal. When his art studies in Paris ended, he put his hard-won earnings to good use as a part-time artist, commuting between Taos and the New York area for approximately a decade.

Almost all of Blumenschein's travels then and later had a definite purpose, which involved art in one way or another. The generous inheritance following the death of his mother-in-law finally gave him a comfortable financial margin in the pursuit of his desire to paint oils. As a full-time Taos painter, he could now focus more sharply on American subjects, such as Indians, Hispanics, and southwestern landscapes, employing modernist techniques in color and design to give them his own unique artistic imprint. In the process of this innovative work, he became a transitional fine-art painter, bridging traditional art with more modern art forms. Many of the careful financial records he kept during his life are found in the collection of his papers in Santa Fe, which provide convincing proof of how businesslike he was during his many years as an artist.

One advantage Blumenschein gained in his long art career was the contacts he had with well-known people from various fields, such as writer Ellis Parker Butler and actor Lionel Barrymore; Blumy and Barrymore remained in contact by mail for many years. He did illustrations for the rising young author Jack London and the Pulitzer Prize–winning novelist Booth Tarkington, who, like Butler, became one of Blumenschein's personal friends.

The artist also illustrated articles by Stephen Crane and Indian advocate Hamlin Garland in *McClure's.* He provided illustrations for another champion of Indian rights, Charles A. Eastman, in his best-selling *Indian Boyhood.* The artist even accompanied the muckraking progressive jour-

nalist Ray Stannard Baker as the illustrator for Baker's series of articles in *Century Magazine* on economic development in the West.

Indeed, much of Blumenschein's focus as an illustrator should qualify him as a citizen artist; a good part of his illustration work was involved in analyzing fairness in the country's marketplace and fairness in governmental policies as they affected such minorities as the Indians in the American West, particularly the Pueblo Indians, whose rights he championed with paintbrush and palette as well as with words.

The artist also partnered with another public-minded person, William Allen White, the well-known small-town editor from Emporia, Kansas. He collaborated with White in detailing a controversy over a county courthouse and the political divisiveness it created; although White's story and Blumenschein's illustrations were never published, the two men enjoyed a lifelong friendship. Last but not least, when Blumy moved into the field of fine arts, he painted a portrait of an even more famous American icon than White, General John J. Pershing, the chief commander of American forces in France during World War I.

One issue involving American art, which troubled the artist during his senior years, was the rising preeminence of modern abstract art. In 1943 *Life*, one of the most popular magazines in mid-century America, asked its readers if abstractionist artist Jackson Pollock was not the greatest living artist in the nation. The exceptional prominence achieved by a nonrepresentational modern painter such as Pollock concerned Blumenschein greatly. In a letter to his daughter in the fall of 1946, he told her that for the first time in his life, he could no longer see his way as an artist because of the "complete serving in Art to abstract and non-objective" paintings. "Feel out of competition entirely," he wrote her, "while doing my best work."

Blumenschein's concern about the direction of art in this country was ironic in many ways given his strongly held

belief that the new trends in art should be encouraged not condemned. In his early essay on art in *Century Magazine* in 1914, the artist acknowledged that there was life in modern art, and "if it had life, it had beauty; for they are inseparable." He conceded that the new art would add to the total of our knowledge and would "be welded into all future art." Blumy's first exposure to modern art had occurred during his student years in Paris. In 1907 or 1908 he had an encounter with art collector Leo Stein, who had shared an apartment with his sister, the famous but controversial avant-garde writer Gertrude Stein. Leo had invited Blumenschein to the Stein apartment, where the artist had first seen some of the more modernist paintings of Matisse, along with other oils by such progressive French artists as Cezanne, Renoir, Manet, and Toulouse-Lautrec. He also saw a protocubist portrait of Gertrude Stein done by the rising Spanish artist Pablo Picasso, one of the founders of the cubist school of modern art, which used cubes and other geometric forms organized in abstract arrangements.

Blumenschein learned even more about abstract art during his attendance at the famous Armory Show, officially known as the 1913 International Exhibition of Modern Art, which was held in the Sixty-ninth Regimental Armory in New York City. Much of the art in this show was European, more specifically French, and these cultural imports were such a break from America's traditional view of what constituted good art that former President Theodore Roosevelt, a man even more outspoken than Blumenschein could be when his ire was up, referred to modern artists as part of a "lunatic fringe" in his criticisms of the Armory Show.

Notwithstanding the early criticism of modern art by notable figures like Teddy Roosevelt, which were echoed in newspaper editorials throughout the country, Blumenschein defended the new art. Perhaps his most successful effort to gain support for modern art was to use some of the painting

techniques of the impressionists and post-impressionists in his own oils; this method was especially effective in his landscapes. Indeed, the semi-modern paintings of the artist usually attracted favorable attention from most art critics. He also promoted new forms of art in a more political way. In 1923 he organized a group of like-minded artists in an association called the New Mexico Painters. Unfortunately, this move led to his break with the conservative Taos Society of Artists, the organization he had founded with Bert Phillips.

Blumenschein encountered equally discouraging results in his effort to get the National Academy of Design to set aside a separate exhibition for modern artists rather than continue the organization's policy of boycotting such art. In agitating in behalf of such a new policy, Blumy was accused of "giving aid and comfort to the enemy." When this type of pressure did not work, the artist tried to bring the two warring camps together by educational means. Having taught in the Art Students League, Blumenschein, who was familiar with all the new art trends, used his skills as a teacher and as a writer to win tolerance for the advocates of modern art. Ultimately, Blumenschein's beliefs prevailed; in 1927 the National Academy of Design did set aside a room for modern artists to display their works.

What Blumenschein did not anticipate was the explosive growth of modern art, which would dominate by the 1950s. In 1949, for instance, Lee Casey, a columnist for the *Rocky Mountain News* in Denver, criticized a modern art display at the Denver Art Museum as being "decadent" and spreading into the West. "Santa Fe has been damaged by it, and Denver has not wholly escaped its blight." By the twenty-first century the growth of abstract art was such that Charlotte Jackson, an art gallery owner in Santa Fe, was quoted as saying in the July 2011 issue of *New Mexico Magazine* that "50 percent of the galleries" in the city are "more and more" going into abstract art.

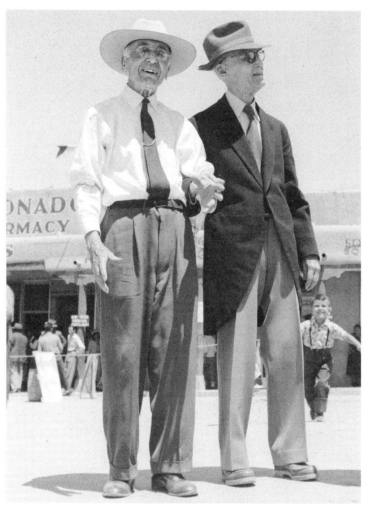

The two cofounders of the Taos art colony, seventy-nine-year-old Ernest Blumenschein on the right and eighty-five-year-old Bert Phillips, reveal their long and intimate friendship in 1953 as they take a casual walk in the Taos town plaza. Palace of the Governors Photo Archives, Santa Fe (NMHM/DCA), 40391.

The result of this trend for Blumenschein was his complete turnabout from being in favor of giving modern art its opportunity to compete with the traditional art that had been the core of his training abroad. While wintering in Albuquerque in 1952, the artist criticized the unfortunate influence of movies and television on the kind of art he had devoted his life to perfecting. Later that year he likened modernism in art to the "primitive sex appeal" of jazz. Art had become, in his opinion, "an easy escape for many; there were no scales to practice, no hours of tedious training." He concluded this dreary assessment by expressing his sympathy for the current generation being educated with these modern ideals. "They will be a pretty lop-sided lot."

Blumenschein's opposition to the expansion of modern art, particularly nonrepresentational abstract art, came to a head in 1952. This was the year when the artist's one-time ally in giving modern art a chance, Emil Bisttram, revived his Taos artist association. Bisttram and the group's new members opened an art gallery in Taos called the Stables, which featured their nontraditional art. Unhappy conservative Taos artists met with these newcomers, their "natural enemies," to reach some kind of friendly accord. A report in the *Chicago Tribune* on September 13, 1954, indicated that an agreement had been worked out among 490 artists involved in the dispute. There were, however, 17 holdouts from the traditionalist camp, led by the aging Blumenschein, who referred to the group engaged in abstract painting as having "no talent or no gift."

Blumenschein's testiness over the clash of these two forms of art led to his often opinionated views being downright rude. When attending one of the Harwood studios in Taos to look over the artwork of a modernist painter named Doel Reed, Blumy was heard by another modern artist, Wolcott Ely, as characterizing Reed's art as coming "out of the same pot." When Ely tried to quiet him, the outspoken Blumenschein repeated this unflattering assessment loud enough

for the whole room to hear it. "Reed," he said, "these all look like they came out of the same pot."

The impact of the artist's scathing criticisms of modern art on his own reputation is hard to evaluate. Modern abstract artists would naturally feel hostility toward him for his more inflammatory remarks. Yet many of them were aware of his early defense of modern art. Some knew of his efforts to help and advise young artists entering the field. Moreover, in many of his paintings, he employed the techniques of abstract art, albeit without nonrepresentational flourishes. His overall artistic techniques were hard to dismiss as being passé. His use of bright colors, heavy brush strokes, and a strong emphasis on design with its "rhythm of line—rhythm of movement—and proportion of spaces" were especially pleasing to the eye.

Given the high quality of his paintings, Blumenschein is not as well known outside the art world as he should be. Whether this is because he was not a prolific artist is difficult to answer with complete confidence. The accessibility of his art does seem to be a factor. Most of his oils are in western, not eastern, art museums, and the most recent traveling exhibition of his paintings, from 2007 to 2009, was sponsored by and shown at the Albuquerque Museum of Art and History, the Denver Art Museum, and the Phoenix Art Museum; most of its viewers would presumably be westerners who lived in the three-state area where these museums are located. Another accessibility issue is the growing practice of art museums to sell some of their paintings to private owners as part of reorganizing their holdings. A museum may be prioritizing its collection to better represent the interests of its state or region, for example, or in response to a change of policy motivated by a new mission or focus. As a result of these new policies, a few of Blumenschein's best paintings are now in private hands.

One development going back to a time when the artist still had three decades of painting ahead of him could

be a major factor in Blumenschein's lack of familiarity with much of the general public. In 1931 Virgil Barker of the Whitney Museum of American Art in New York put Blumenschein, along with Remington, Ufer, and Higgins, into the category of "painters of western life," while modernists like Georgia O'Keeffe, Marsden Hartley, John Marin, and that prominent regional artist from the Midwest Thomas Hart Benton were classified as "contemporary" artists.

Although a regionalist art focus in France, such as at the village of Arles, which inspired Vincent van Gogh, did not hurt the reputations of the prestigious continental painters, a regional focus on Taos or other parts of the Southwest could limit the audience and prestige of an American artist, even a prominent artist such as Blumenschein, who had taken the lead in establishing an American form of art.

Barker's categorization of American artists into these two camps occurred before Blumenschein painted many of his more modernist southwestern landscapes or any of his Albuquerque cityscapes. Georgia O'Keeffe's designation as a contemporary painter undoubtedly helped her reputation as an abstract artist, when modern art was in the process of achieving dominance in America. When O'Keeffe painted her *Ranchos Church No. 1* in 1929 and *Another Church, Hernandez, New Mexico* in 1931, her name became widely associated with the famous Ranchos Church near Taos, even though Blumenschein had already painted his popular *Church of Ranchos de Taos* in 1916 and *Ranchos Church with Indians* in 1925. Art historian Joan Carpenter Troccoli lauded both O'Keeffe's *Another Church, Hernandez, New Mexico* and Blumenschein's *Church at Ranchos de Taos* for their beauty and their "orientalist vision." She had to admit, however, that Blumenschein's oil was "opulent" by comparison. Perhaps O'Keeffe's edge in achieving overall fame and recognition was simply that she was much more in harmony with the trend toward modern art. Another advantage O'Keeffe enjoyed was in the marketing of her art;

being married to Alfred Stieglitz, one of the major forces for art promotion in America, had to be helpful in advancing her career.

Despite Blumenschein's growing discouragement over the strong trend toward modern art, not to mention his flagging stamina, he continued to work hard on his paintings during the last decade of his life. In 1957 he promised Stark, who remained one of his best supporters among the prominent art dealers of the 1950s, that he would uphold to the end the high standards of art he had practiced during his long career. He also expressed an optimism, probably somewhat forced, that art, along with music, literature, and architecture, would "return to the noble proportions" of that understandable form it once had.

The artist had also become keenly aware of the effects of aging on himself and on many of the artists and friends around him. Writing Stark again about six months later, he admitted that, although his mind was still active and his desire to forge ahead on his comfortable easel was still great, he doubted that he could keep on painting much longer. Referring to his historical painting *Ourselves and Taos Neighbors*, he told Stark that he could not believe that most of the people in that group portrait were dead, "excepting . . . for ourselves." He had indeed become the senior spokesman for the old, now defunct, Taos Society of Artists when Oscar Berninghaus died in 1952, Joseph Henry Sharp in 1953, and Bert Phillips in 1956.

Blumenschein was asked to memorialize Sharp in September 1953. At ninety-three years of age, Sharp had left Taos a year earlier for a trip to Pasadena, where Phillips had lived with his family prior to his death. Although Sharp had planned to return to Taos, he fell off a platform while painting and broke several ribs; the accident caused his death in Pasadena in the summer of 1953. Despite Blumy's fondness for Sharp, he questioned the accuracy of some information

about Sharp's life in an account sent to him by the Museum of New Mexico. He felt that Sharp was given more credit in this report for his role in founding the Taos Society of Artists than Bert Phillips, whom he regarded as the "anchor-pioneer" of the Taos art community. He acknowledged the fact that Sharp had advised him and Phillips during their student days in Paris to visit Taos "if [they] ever passed that way." Nevertheless, Sharp's visit to Taos in 1893 was only two weeks long, and he was not the first artist to visit this colorful adobe town.

Blumenschein's bickering in this case is yet another example of his lack of tact when expressing strongly held beliefs. Although this incident did not match in controversy the criticisms of his fellow Taos artists for their lack of robust patriotism during World War I or his indiscreet remarks about fellow artist Irving Couse and writer Mabel Dodge Luhan, questioning a deceased man's accomplishments in preparation for his memorial service is improper timing, and Blumenschein should have known it. He had a certain spontaneity that had made him an effective spokesman for his convictions in art and for the numerous causes he advanced; yet sometimes this articulate man of many talents would say and do things that undercut the basic sincerity of his actions and beliefs.

As proof that Blumenschein was determined to continue his art career, despite health and age problems, he reacted with great enthusiasm when the enterprising Reginald Fisher, director of the Museum of New Mexico, suggested in 1957 a Blumenschein retrospective to be held the following year. The artist was hard at work preparing for this traveling display when on May 24, 1958, a major tragedy occurred. The day before his eighty-fourth birthday, Mary died in St. Vincent Hospital in Santa Fe after a lengthy illness, succumbing to the fatal effects of degenerative heart disease.

Blumenschein was crushed by the loss of this talented and loyal woman, who had been his companion for fifty-three years. Although he had written her that letter before their marriage, saying that art was his first priority in life, not her, the two had managed to stay together in apparent happiness. Mary had been unwilling to move to Taos until 1919, when she gave up the luxuries and comfortable life in the city as well as her own prominent career in the fine arts. Blumenschein had sensed his wife's unhappiness in making this adjustment but was unbending in his insistence that Taos was the place where he could function best as an inspired artist. Yet he did not want to lose her. In a letter written to her near the end of World War I, the strong-willed painter acknowledged Mary's frustrations. "You really should have married a great big fine noble gent with great dignity, finesse, and fine linen . . . but as you didn't, I have had the agreeable pleasure of being your husband." In this letter, quoted in Sherry Clayton Taggett and Ted Schwarz's *Paintbrushes and Pistols*, Blumenschein praised his wife as "the class of lady a man is always proud to show off as 'his'n'; and you are a pleasing sight for the eye to rest upon. I love you; for what you've been and what you are." The conciliatory Mary loved such words and accepted life with her macho husband, whose behavior was undoubtedly influenced by his deceased domineering father.

Upon Mary's death Spud Johnson, a local poet and writer, who authored a column for the *Taos News*, expressed his admiration for Mary in words that Helen Blumenschein thought were insightful enough to appear in her family biography, *Recuerdos*. Johnson regarded Mary's "quality of understatement, reserve, and containedness" as being "exceedingly rare" attributes. "I cannot remember that she ever said anything profound or brilliant or clever, and yet I always had the feeling that she knew, understood, sympathized and was wise."

It is evident that Mary's husband dominated affairs in the Blumenschein home at their many parties, including the often lively conversations that characterized them. And yet to conclude that Mary was miserably unhappy in this subordinate role is to overlook the quiet, self-effacing nature of this gentle and highly creative person. Helen, who was devoted to both her parents, never revealed in her publications that there was serious acrimony in the family, tending to praise both of them for their creativity. She and her father arranged for a posthumous exhibition of Mary's *Girl with Fan* at the National Academy of Design in 1959; that same year they proudly gave one of her better paintings, *Husking Corn*, to the Harwood Museum, which had once been the spacious home of artist Burt Harwood and his wife, Elizabeth.

After a dreary period of mourning, Blumenschein returned to his art, the only activity that would give him comfort and respite from his grief. His first major project was to continue painting and arranging for Fisher's proposed exposition of his artwork. In cooperation with his daughter, Blumy asked those art collectors he had befriended to lend him some of his paintings for this exhibition, which he had decided to call My Life's Story. He acquired thirty-five of his paintings, ranging from his illustrations for Jack London's *Love of Life* in 1904 to his final repainting of the Albuquerque railroad yard, *Railroad Yard, No. 5*.

Although half the artist's paintings loaned for the exhibit came from private collections, the National Academy of Design and the Museum of New Mexico each loaned a painting. When the show opened at the Harwood Museum in September 1958, Helen was there, telling family members she would accompany her father at all future showings. The exhibition received favorable publicity, but a congratulatory letter from Edwin Berrie, director of Grand Central Art Galleries in New York, was the most meaningful to Blumenschein. Berrie wrote that there was no question regarding

the "originality and individuality" of Blumenschein's paintings, and that they certainly deserved "a place for all time in American Art."

In May 1959 the ailing Blumenschein and his daughter hosted a joint exhibition of their art at the Stables Art Gallery in Taos. Twelve of Ernest's paintings, many of them later ones, were on display. Helen, a good artist in her own right, displayed some of her watercolors and sketches of local subjects; some of her charcoal sketches of places and personalities in Taos were later featured in her 1972 publication *Sounds and Sights of Taos Valley*. One can only wonder what kind of genetically rich potential artists would have been born had Helen had children.

Blumenschein's last painting (symbolically, it was his *The Cormorant Attends Funeral of His Friend the Butler*, which dealt with the subject of death) would mark the beginning of the end of his long and productive life. According to Laura M. Bickerstaff, the nurse who attended to the needs of Phillips's ailing wife for many years and wrote a history of the Taos Society of Artists, Blumenschein had been wiry and energetic throughout most of his life. He tackled the often difficult art subjects he had chosen as an octogenarian with the same zest he had as a young man. But by the fall of 1959, his health was failing rapidly. Even so, he remained witty and entertaining, according to press reports, during those cherished public appearances connected with his art. For months Helen pondered what she should do for her father, who was becoming progressively weaker by the day. She had discussed this problem with two of her bankers at the First National Bank of Rio Arriba, president G. Kenneth "Bud" Brashar and the officer in charge of her account, Donna Miller. Brashar later recalled her reluctance to commit Blumenschein to a place where he could get the professional care he badly needed.

Finally, in October 1959, Helen placed her father in the Sandia Ranch Sanatorium in Albuquerque. She also with-

drew from sale those Blumenschein paintings still in her possession, wishing to keep what was left of them in Taos. Maintaining regular correspondence with his doctors, she was kept aware of his condition, his activities, and his occasional visitors.

Unfortunately, the letters Helen received from her father's primary caregiver, Dr. John W. Myers, were not encouraging. On November 21, 1959, he wrote Helen that Blumenschein "continues laboring under various delusions regarding finances, his clothing, going places, etc." Other letters sent by Dr. Myers confirm that the artist was suffering from dementia along with his other serious medical problems. In a March 1, 1960, letter he discouraged Helen from writing Blumenschein about her vacation plans, saying it would not help him and could be disturbing to him. "He does look at your letters but frankly I feel there is little understanding or appreciation of the contents." For a man whose mind was as sharp and active as Blumenschein's had been, these reports could not have been more depressing to his daughter.

On June 6, 1960, Helen's father, who had turned eighty-six during the previous month, died of bronchial pneumonia. At Blumenschein's request, Helen had his ashes scattered on the grounds of the Taos Pueblo, a sincere gesture indicating the importance to him of these Indian people and the beautiful landscape that surrounded them. Blumenschein's religious background was a mixed one. His German-born father was a Lutheran, but when he moved to Dayton, he played the organ at a Presbyterian church, which he and his family had attended. Blumy was quite pragmatic when it came to religious convictions. To play baseball on Sundays as a teenager, a practice that met with disapproval among the conservative non-Catholic German Americans in Dayton, he claimed he had become a Roman Catholic.

While living in Taos as a girl, Helen recalled that as a Unitarian, she was the only non-Catholic in an elementary school class of forty. Undoubtedly, she shared this faith with

her parents. Because Unitarianism could harmonize better with other religions than many Christian denominations could, Blumenschein's association with this creed would place him in the ecumenical category of liberal Christian theology, which could help explain his deep respect for the faith of these Pueblo Indians.

Blumenschein had made his mark as one of the West's outstanding artists, who had vowed to make his paintings part of an American rather than a European art. As a perfectionist in the fine arts and a successful illustrator for the nation's best magazines, he used his skills as an analytic thinker, a writer, and, most important of all, an innovative painter to advance his artistic goals and the goals of his profession. He was in many ways a citizen artist, who could empathize with underdog groups in the country's social structure, such as the Pueblo Indians and New Mexico's Hispanics, whom he befriended and often painted. He was not afraid to take a stand if he believed in a cause, acting as a maverick sometimes and at other times a guardian of the values and virtues of prevailing practices, particularly those related to the art world that had absorbed his energies for almost seven decades of his long life.

Indeed, assessing Blumenschein's status as an artist is complicated by the extraordinary length of his career. Trained in Paris as a classical painter, the product of a long and arduous art education, he was challenged even while in Europe by the impressionists and later by the post-impressionists, cubists, and the even more controversial nonrepresentational artists. When he began painting American portraits and landscapes in Taos, he was confronted again by abstract artists, who had gained considerable ground in America as a result of their growing acceptance in the United States during the third, fourth, and fifth decades of the twentieth century.

Blumenschein was probably one of those American painters Edward Alden Jewell had in mind as being among

the more successful, according to Jewell's 1939 publication *Have We an American Art?* Jewell, the influential art critic of the *New York Times*, rejected those opportunistic artists who were striving to create an American art at all costs as something outside themselves, existing for them as just some "external goal." To him the true American artist should be "seriously and spontaneously and unalterably and incorrigibly and joyously bent upon expressing what has come to him in his own experience as an American." Blumenschein was, indeed, an American painter overawed by his interaction with indigenous people and Hispanics in the Taos Valley and his aesthetic experiences traveling through and painting the awe-inspiring majesty of the American Southwest. He certainly met all the qualities of a true American artist, although being a perfectionist, he may have lacked in some of his artistic creations the spontaneity that Jewell extolled. But if you add Jewell's description of the ideal American artist to those elements of art that Blumenschein mastered so eloquently, such as color, line, and design, you have in him the characteristics of an American painter of true genius.

In Jewell's provocative volume he lists the paintings chosen by the Museum of Modern Art for the 1938 Paris exhibition, Three Centuries of Art in the United States. Blumenschein was the only member of the Taos Society of Artists who had a painting shown at this highly publicized international exhibition. Prominent artists like Thomas Eakins and Winslow Homer were represented, as were John Singer Sargent and James Abbott McNeill Whistler, who, though Americans, were regarded as European artists in style and subject matter. But, perhaps because of the regionalist curse, the works of popular western artists like Remington and Russell were not displayed, nor were any of the paintings of Walter Ufer or Victor Higgins, who integrated abstract techniques in their oils like Blumenschein. Modern artists, such as O'Keeffe, Thomas Hart Benton,

and John Marin, however, were well represented as con-temporary artists, who were developing as creative, if not ground-breaking, American painters.

Despite changes in the fine arts during Blumenschein's lifetime, the trends in painting during his last years and fol-lowing his death in 1960 were even greater. Some of them were facilitated by Denver artist Vance Kirkland, who was kind of a transitional figure like Blumenschein but moved even further in the direction of abstract art before his death in 1981. Abstract art, or abstract expressionism, as it was generally called during the 1940s and 1950s, began to shift from New York City to the Bay Area in California. Art-ists from both coasts, however, were active with figurative painters, as well as the more abstract ones, flourishing in an art world Blumenschein would probably have never fully understood. California-trained artists like Clyfford Still and Mark Rothko emerged as apostles of new and changing art styles; indeed, a museum built solely to display Still's artwork has been constructed adjacent to the Denver Art Museum. Other names that became familiar during this dominance of modern art in America were David Park, from Boston, and Richard Diebenkorn, from Oregon, both of whom taught art and painted in the Bay Area. They played key roles in allowing California to challenge New York as the nation's art center.

The experimental art evolving from filmmaking and tele-vision not only gave California an edge during the 1960s and 1970s, but liberated art among those painters in-volved in pop, photo realistic, and earthwork art. Pop art, of course, evokes the name of Andy Warhol, while photo realism involves artists like Chuck Close, who employed the camera and photographs for his paintings. Earthwork art, also known as the conceptual art movement, has been re-garded as superficial by some critics; nevertheless it moved art out of the confines of the museums and galleries, us-ing the actual environment for reproducing an American

landscape. Robert Smithson's 1970 *Spiral Jetty* was an enormous earthwork, presenting a "spiral roadbed of compacted rock stretching into the Great Salt Lake," to use the words of historian Richard W. Etulain.

Perhaps the best-known artist in this field is the Bulgarian-born Christo, whose *Running Fence* project with his wife, Jeanne-Claude, during the 1970s featured a fabric fence, stretching 24.5 miles along the California coast, north of San Francisco. It was controversial enough, according to an August 1, 2012, story in the *Denver Post*, to stall more recent projects, such as an effort to drape in fabric 5.9 miles of the Arkansas River in Colorado.

Another dramatic departure from the art of Blumenschein's era was the participation of Hispanic and American Indian artists. Inspired by the Mexican mural tradition, artists such as David A. Siqueiros and José Clemente Orozco searched for the cultural identity of their people, a journey sparked by the Chicano movement. As for Native artists, R. C. Gorman, a Navajo who had been trained in the art studio of Dorothy Dunn, of the Santa Fe Indian School, attracted the most attention among Indian modernists. Another of Dunn's students was the productive Chiricahua Apache artist and sculptor Allan Houser, whose father had been with Geronimo when he had surrendered to government forces in 1886. But the artist who made the most abrupt departure from the traditional art of his people was Fritz Scholder. An iconoclastic Indian artist of mixed blood, he attempted to demolish the cultural stereotypes of Native Americans in a way that would have shocked such Taos artists as Phillips, Sharp, and Couse and even challenged the views of one of the more tolerant and transitional figures of the Taos colony, Blumenschein.

An impressive response to the explosion of these new and often controversial art forms came with the 2007–2009 three-state traveling art exhibit of sixty-six of Blumenschein's best-known paintings, including *Superstition*, *Jury*

for the Trial of a Sheepherder for Murder, The Extraordinary Affray, Portrait of Albedia, and *Afternoon of a Sheepherder.* The response to his paintings was exceptionally favorable at the Phoenix Art Museum, the Albuquerque Museum of Art and History, and the Denver Art Museum.

Evaluating the exhibit in Denver, Kyle MacMillan, art critic for the *Denver Post,* wrote in the newspaper's November 9, 2009, issue that Blumenschein was "not just a pivotal artist of the Southwest but . . . [an] essential figure in the totality of 20th-century American art." Boosting the image of an artist whom many felt had been "unappreciated," the show's organizers tried "to find venues outside of the region, especially one on the East Coast, but, in the end, there were no takers." Whether the cause for these rejections from art venues outside the Mountain West was due to a still existing regional mentality toward art in America or a belief that Blumenschein's commitment to modern art was too modest for today's taste is difficult to ascertain. But given the quality of this versatile artist's paintings, there is still hope that he will eventually gain his rightful place in an American art he helped to create during his lifetime.

Note on Sources

A number of excellent sources document and explore Ernest L. Blumenschein as both an artist and a person. The major primary source is found at the Fray Angélico Chávez History Library in the New Mexico History Museum, located in Santa Fe. Ten boxes of correspondence, art reviews, newspaper clippings, and other research materials pertaining to Blumenschein are housed in this library. This collection includes items relevant to Ernest Blumenschein; to his wife, Mary Shepard Greene Blumenschein; and to his daughter, Helen Greene Blumenschein. The correspondence between the three Blumenscheins is particularly insightful. Amid the casual, everyday observations are those that reveal their innermost thoughts about their views on art and their relationships, both the close personal ones and those with artists and patrons who played a role in their active social and professional lives.

The most useful reference material in this collection is Ernest Blumenschein's correspondence, which reveals his relationships with prominent personalities connected with his art career. His correspondents include book and magazine writers for whom the artist did illustrations during

313

the early years of his career, men such as Jack London and Booth Tarkington. Perhaps the most valuable part of the artist's collection are those letters he wrote to his close friend writer and humorist Ellis Parker Butler. In his frank missives to Butler, Blumenschein revealed with unusual candor his biases, perceptions, and frustrations. His correspondence with Butler about his wife, Mary, is especially insightful, particularly before their marriage, when Mary's mother steadfastly resisted their proposed union as husband and wife. Mary's written communications are more commonplace, often dealing with family affairs after their marriage, including her concerns about her husband's health. Blumenschein's letters to his daughter, Helen, regarding his art and hers are valuable, especially those he wrote to her when she was overseas, serving as a member of the Women's Army Auxiliary Corps.

Helen's responses to her father's correspondence are also informative, especially those letters relating to her experiences during World War II, in the Pacific theater of the war, where she was stationed after being sent overseas. Helen was a more prolific writer than her mother, who was essentially a private person; Mary refused to flaunt her outstanding successes as an art student and prize-winning painter in Paris.

The Blumenschein collection in Santa Fe is organized in such a way that it can be conveniently used by researchers; categorizing Ernest's letters was particularly important because he often addressed the members of his family and his more intimate friends, such as Butler, with various nicknames. He called Butler "Bute," among other names, and also coined nicknames for Mary and Helen, with at least three terms of endearment for his daughter.

Other important primary sources in the Blumenschein collection at the Fray Angélico Chávez History Library include clippings about Ernest's career from such newspapers as the *New York Times*, *Taos Valley News*, *El Crepusculo* (Taos),

Santa Fe New Mexican, Albuquerque Journal, Rocky Mountain News (Denver), *Wichita Eagle, St. Louis Post-Dispatch, Pittsburg Press, Dayton Herald,* and *Dayton Daily News.* Magazine articles concerning Ernest Blumenschein's art career include those in *Century Magazine, McClure's, Harper's Weekly,* and *El Palacio.*

Another valuable primary source for this biography was the Ernest Blumenschein Papers, 1873–1964, located in the Archives of American Art at the Smithsonian Institution in Washington, D.C. Although these papers were originally on microfilm, many are now accessible on the Internet. Some of Ernest's most intimate correspondence with Mary before their marriage are among the more revealing sources located at the Smithsonian.

Essential in writing this biography were two books and one article published by Helen Blumenschein, which deals with family matters and with those artists who were neighbors to this talented trio. Her *Recuerdos: Early Days of the Blumenschein Family* (Silver City, N.Mex.: Tecolote Press, 1979) was one of the most important primary sources we used for this biography. For instance, in her book Helen provides intimate family information about her father and mother's adjustment to the still primitive conditions of Taos in 1919, when they became permanent residents of what would become one of America's major art colonies. More germane to the country surrounding Taos is Helen's *Sounds and Sights of Taos Valley* (Santa Fe, N.Mex.: Sunstone Press, 1972). Focusing on many of the Taos artists, whether or not they belonged to the Taos Society of Artists, is Helen Blumenschein's "Reflections of the Early Artists," in *Ayer y Hoy en Taos: Yesterday and Today in Taos County and Northern New Mexico,* Taos County Historical Society (Spring 1990), 3–6. This article incorporates several fascinating human interest items about Taos artists and their families, many of them excerpted from Helen's unpublished manuscript, "Rambling Memories."

Certainly the most valuable of the secondary sources used in this study is *In Contemporary Rhythm: The Art of Ernest L. Blumenschein*, by Peter H. Hassrick and Elizabeth J. Cunningham. This large, well-documented volume was published in 2008 by the University of Oklahoma Press in cooperation with the Albuquerque Museum of Art and History, the Denver Art Museum, and the Phoenix Art Museum. With a foreword written by James K. Ballinger, Lewis I. Sharp, and Cathy L. Wright, this book was by far the most helpful and comprehensive of the published resources available in documenting Ernest Blumenschein's art career and those life experiences that made him such a noted painter of portraits and landscapes. The value of this study is greatly enhanced by its excellent reproductions of Blumenschein's oil paintings, along with those illustrations he did for books and magazines during his career as a young artist.

The authors of *In Contemporary Rhythm* have drawn from numerous primary sources, such as the Blumenschein collections in Santa Fe and Washington, D.C. Their narration and interpretations are strengthened by the critiques of other art historians and critics included in the volume. These knowledgeable art specialists include Skip Keith Miller, who provides an analysis of two of Blumenschein's paintings, *Superstition* and *Ourselves and Taos Neighbors;* Sarah E. Boehme, who analyzes *The Extraordinary Affray;* James Moore, who examines Blumy's *Jury for the Trial of a Sheepherder for Murder;* and Jerry N. Smith, who dissects the painter's changing attitudes toward modern art.

Book-length secondary sources for this biography also include several about the other members of the Taos art colony as well as Blumenschein. One that comes closer to a primary source than most is Laura M. Bickerstaff's *Pioneer Artists of Taos* (Denver: Old West Publishing, 1938; reprinted, 1955); Bickerstaff, a nurse who cared for Bert G. Phillips's ailing wife for many years, knew a number of these Taos artists personally. Other monographs dealing with the

Note on Sources

Taos artists are Patricia Broder's *Taos: A Painter's Dream* (Boston: New York Graphic Society, 1980); Mary Carroll Nelson's *The Legendary Artists of Taos* (New York: Watson Guptill, 1980); and Julie Schimmel and Robert R. White's, *Bert Geer Phillips and the Taos Art Colony* (Albuquerque: University of New Mexico Press, 1994).

Books that deal with both the Taos and the Santa Fe art colonies are Van Doren Coke's *Taos and Santa Fe: The Artist's Environment, 1882–1942* (Albuquerque: University of New Mexico Press, 1963); Arrell Morgan Gibson's *The Santa Fe and Taos Colonies: Age of the Muses, 1900–1942* (Norman: University of Oklahoma Press, 1983); Charles C. Eldredge, Julie Schimmel, and William H. Truettner's *Art in New Mexico, 1900–1945: Paths to Taos and Santa Fe*, National Museum of American Art, Smithsonian Institution, Washington, D.C. (New York: Abbeville Press, 1986); and Kay Aiken Reeve's *Santa Fe and Taos, 1898–1942: An American Cultural Center* (El Paso: Texas Western Press, 1982).

We also consulted studies that deal with art in America generally or art in the American West specifically, including Peter H. Hassrick's *Artists of the American Frontier: The Way West* (New York: Promontory Press, 1988); E. P. Richardson's old but still useful *Painting in America* (New York: Thomas Y. Crowell, 1956); Joan Carpenter Troccoli's *Painters and the American West: The Anschutz Collection* (New Haven, Conn.: Yale University Press, 2000); and Erika Langmuir's *Dictionary of Art and Artists* (New Haven, Conn.: Yale University Press, 2000). Also helpful in understanding western art are thirty essays by art historians in *Elevating Western American Art: Developing an Institute in the Cultural Capital of the Rockies*, published in 2012 by the Petrie Institute of Western American Art at the Denver Art Museum and distributed by the University of Oklahoma Press, a comprehensive art volume edited by Thomas Brent Smith, with an introduction by Marlene

317

Chambers; one essay relevant to the Taos Society of Artists is Marie Watkins's "Bound for Taos: In Search of American Art," pages 276–95. Particularly valuable because of its numerous reproductions of important American art is Joseph S. Czestochowski's *The American Landscape Tradition: A Study and Gallery of Paintings* (New York: E. P. Dutton, 1982). Helpful in understanding the development of both European and American art are William Kloss's *A History of European Art* (2008) and *Masterworks of American Art* (2005), which are part of the Great Courses series published by the Teaching Company of Chantilly, Virginia.

Monographs on the stages of Blumenschein's career as both an illustrator and oil painter are Denny Carter and Bruce Weber's *The Golden Age: Cincinnati Painters of the Nineteenth Century* (Cincinnati: Cincinnati Art Museum, 1979), which is relevant to the artist's early studies in that bustling Ohio city, and John Milner's *The Studios in Paris: The Capital of Art in the Nineteenth Century* (New Haven, Conn., and London: Yale University Press, 1988) and David McCullough's *The Greater Journey: Americans in Paris* (New York: Simon and Schuster, 2011), which provide a wealth of information about what Blumenschein's life was like as an art student living abroad in Paris. Biographical information about Jean-Joseph Benjamin-Constant and Jean-Paul Laurens, Blumenschein's major art instructors while studying in Paris, is found in the *Dictionary of Art* (New York: Grove's Dictionary, 1996): vol. 7, 759–60, and vol. 18, 864–66, and in the French publication *Dictionnaire critique et documentaire des pientres, sculpteurs, dessinateurs et graveurs* (Paris: Gründ, 1999): vol. 2, 102, and vol. 8, 332. Pertinent to the artist's work as an illustrator is editor Walter Reed's study *The Illustrator in America, 1900–1960* (New York: Reinhold, 1966). Descriptive of the era in which Blumenschein studied art abroad and took his first major steps as an illustrator and painter is Van Wyck Brooks's *The Confident Years: 1885–1915* (New York:

E. P. Dutton, 1952). A source highlighting the continuing Franco-German rivalry during Blumenschein's Paris studies and early artwork is a story by Henry James, "Pocket Diaries, 1915," in editors Leon Edel and Lyall H. Powers's *The Complete Notebooks of Henry James*, Part II (New York: Oxford University Press, 1987), 412–32.

Useful as a reference source for Blumenschein during the same year that he and Phillips discovered Taos as a prospective art colony is editor Florence N. Levy's *The American Art Annual of 1898* (New York: McMillan, 1898). An account dealing with the aesthetic traditions of the Taos Pueblo, which inspired Blumenschein to move to Taos, is John Brinkerhoff Jackson's *A Sense of Time, A Sense of Place* (New Haven, Conn.: Yale University Press, 1998). Important in understanding the emergence of modern and other art forms in the West following Blumenschein's death is the information found in chapter nine of Richard W. Etulain's *Re-imaging the Modern American West: A Century of Fiction, History and Art* (Tucson: University of Arizona Press, 1996).

Sources that provide the necessary historical background for Blumenschein's times include Walter Havighurst's *Ohio: A Bicentennial History* (New York: W. W. Norton, 1976), pertinent to Blumenschein's boyhood years in Dayton. Another source relevant to Blumenschein's early years concerns his African American classmate Paul Laurence Dunbar, who later became an important poet; it is titled "'Denver Took Me into Her Arms': Paul Laurence Dunbar in Colorado, 1899–1900," by Gary Scharnhorst and Kadeshia Matthews, *Colorado Heritage*, Colorado Historical Society (July–August 2011), 14–23. Four books we consulted about New Mexico, where the artist spent most of his life, are Warren A. Beck's *New Mexico: A History of Four Centuries* (Norman: University of Oklahoma Press, 1962); Erna Fergusson's *New Mexico: A Pageant of Three Peoples*, with introduction by Paul Horgan (Albuquerque:

Note on Sources

University of New Mexico Press, 1973); Marc Simmons's *New Mexico: A History* (New York: W. W. Norton, 1977); and Robert W. Larson's *New Mexico's Quest for Statehood, 1846–1912* (Albuquerque: University of New Mexico Press, 1968), which deals with New Mexico's territorial years, prior to statehood. Especially helpful for its statistical information about New Mexico and other states is the *Worldmark Encyclopedia of the States* (New York: Worldmark and Harper and Row, 1981).

Two works on major national and world developments during Blumenschein's life, such as World War I, World War II, and the Great Depression, are Samuel Eliot Morison's masterful study *The Oxford History of the American People* (New York: Oxford University Press, 1965) and David M. Kennedy, Lizbeth Cohen, and Thomas A. Bailey's *The American Pageant: A History of the American People* (Boston: Wadsworth and Sun Gauge Learning, 2010). Pertinent to World War I, when Blumenschein's patriotism was questioned because of his German American background, is Tomas Jaehn's *Germans in the Southwest, 1850–1920* (Albuquerque: University of New Mexico Press, 2005). Also important to this divisive patriotism issue, because of the prominence of German Jews in New Mexico during World War I, is Henry Tobias's *A History of Jews in New Mexico* (Albuquerque: University of New Mexico Press, 1990).

Three books highlighting Blumenschein's life and career are William T. Henning, Jr.'s *Ernest L. Blumenschein Retrospective* (Colorado Springs: Colorado Fine Arts Center, 1978); Edward Alden Jewell's *Have We an American Art?* (New York and Toronto: Longmans, Green, 1939); and Sherry Clayton Taggett and Ted Schwarz's *Paintbrushes and Pistols: How Taos Artists Sold the West* (Santa Fe, N.Mex.: John Muir, 1990). Jewell, a well-known art critic for the *New York Times*, established a set of criteria as to what constitutes a genuine American artist and includes Blumenschein among the prominent artists he lists, catego-

rizes, and discusses in his book. Taggett and Schwarz, in a sometimes provocative way, delve into the lives of the painters who composed the Taos Society of Artists; the authors' analysis also covers the allies of these painters in commerce, including Fred Harvey and executives of the Atchison, Topeka, and Santa Fe Railway, who successfully promoted art and tourism in the American Southwest. Recognizing Blumenschein's leading role among the Taos artists, Taggett and Schwarz focus on both his personal and professional lives, being critical of the artist's personal life to a marked degree.

In addition to the numerous newspaper clippings from the Blumenschein collection in Santa Fe, we used a few other newspapers in writing this biography, such as Blumenschein's article "The Broken Wagon Wheel," in a September 1939 issue of the *Santa Fe New Mexican*, and Ina Ackin Reeve's article "Art and Artists of New Mexico," in a July 1932 issue of the same journal. Particularly important is Kyle MacMillan's evaluation of the special three-state 2007–2009 exhibit of Blumenschein's paintings, in the November 9, 2009, issue of the *Denver Post*, and his assessment of Indian artist Allan Houser in the May 6, 2011, issue of the *Post*. We also consulted Regina Cook's article "The Blumenscheins," in the September 25, 1952, issue of *El Crepusculo*.

Informative magazine articles include three that Blumenschein wrote himself: "The Painting of To-Morrow," *Century Magazine*, 87, no. 6 (April 1914), 845–50; "The Taos Society of Artists," *American Magazine of Art*, 8, no. 11 (September 1917), 445–51; and "Origins of the Taos Art Colony," *El Palacio*, 20, no. 10 (May 1926), 190–93. A brief article on Blumenschein and other Taos artists, focusing on their intellectual growth and development, can be found in Mary Carroll Nelson's "The Taos Art Colony," *American Artist*, 42, no. 426 (January 1978), 27. One of the artist's major achievements was his painting *The Peacemaker*, a

portrait involving a group of Taos Pueblo Indians attempting to achieve a peace accord that would resolve some serious dispute. Art historian Charles C. Eldredge interprets the impact of this painting on the art world in his "Ernest Blumenschein's *The Peacemaker*: Native Americans, Greeks and Jurisprudence circa 1913," *American Art*, 15, no. 1 (Spring 2001), 35–51. Another article relevant to Blumenschein's art is James Moore's "Ernest Blumenschein's Long Journey with Star Road" in *American Art* 9, no. 3 (fall 1995), 7–29, which deals with another of his better paintings, *Star Road and White Sun*. Magazine articles on important French artists in Paris during Blumenschein's studies abroad include Bennett Schiff's "Let's Get Drunk on the Light Once More" [George Seurat], *Smithsonian Magazine*, 22, no. 7 (October 1991), 100–110, and Richard Dorment's "Lautrec's Bitter Theater," *New York Review of Books* (December 19, 1999), 15–18.

Articles about Taos and other art centers in New Mexico were helpful in understanding Blumenschein and other artists in the state. They include Mabel Dodge Luhan's "Taos—A Eulogy," *Creative Art*, 9, no. 4 (1931), 288–95; Bob Priddy's "The Taos Connection: New Mexican Art in Missouri's Capital," *Missouri Historical Review*, 79, no. 2 (January 1985), 143–66; Dorothy Emmet's "New Mexico—Art Frontier," *El Palacio*, 74 (Autumn 1967), 17–26; and Martha Doty Freeman's "New Mexico in the Nineteenth Century: The Creation of an Artistic Tradition," *New Mexico Historical Review*, 44, no. 1 (January 1974), 5–26. More contemporary is an analysis by Wolf Schneider of the popularity of modern abstract art, which eventually drew Blumenschein's ire, and its impact on the art galleries of Santa Fe: "The Essence: Today's Abstractionists Pick Up Where O'Keeffe Left Off," *New Mexico Magazine* (July 2011), 22–25.

Finally, I conducted interviews about the Blumenschein family and their art with G. Kenneth Brashar, Helen Blu-

menschein's one-time banker, on September 17, 2010, in Taos; Tomas Jaehn, historian for the Fray Angélico Chávez History Library in Santa Fe, on September 21–24, 2010; Ana Archuleta, art specialist at the Gerald Peters Gallery in Santa Fe, on September 24, 2010; and Virginia Couse, granddaughter of Taos artist Eanger Irving Couse, in a telephone call to Taos on August 18, 2012.

Index

References to illustrations appear in italic type.

325

Index

Albuquerque Evening Herald,
215–16
Albuquerque High School, 212,
273
Albuquerque Museum of Art and
History, 300, 312
Albuquerque Symphony
Orchestra, 43
Albuquerque Tribune, 43
Alexander, John W., 33
*Allegory in Honor of a Barrymore
Child* (Blumenschein, E.),
176–77
Allen, Maria Louise. *See* Chapin,
Maria (mother of Leonora
"Nora" Chapin)
Allston, Washington, 36
Alvarado, Hernando de, 102
Alvarado Hotel (Albuquerque),
270, 272, 286, 287
America: American West in
nineteenth century, 81–86; art
colonies in, 189–90; art in,
71–73, 82–83, 293, 309–11;
in early twentieth century,
162–63; at end of nineteenth
century, 45–46, 47; in 1900,
134
America First Committee, 267
American Art, 184
*American Art Annual of 1898,
The,* 76
American Art Association (Paris),
145, 146
American Art Museum
(Smithsonian), 220
American Art News, 202, 203
American Indians: abuse of
land of, in New Mexico,
183; Acoma pueblo, 87;
All-Pueblo Council, 218;
American Indian Defense

Association, 218; and Anglo
culture in Taos, New Mexico,
105–107; Apache Indians,
104, 237, 311; as artists,
311; assimilation of, 110,
213, 216; Chippewa Indians,
70; Comanche Indians,
237; and Court of Indian
Offenses, 214; and Couse
(Eanger), 70–71; and Garland,
117–19; Indian citizenship
bill (1924), 213; Indian
Service, 108, 110; Laguna
Pueblo, 87; Lakota Indians,
184; national intolerance of,
213–19; Ojibwa Indians,
70; painting of, in New York
City, 79; peyote use by, 211;
and Phillips (Bert Geer), 79,
80; protecting rights of, 183;
reservations of, 80, 84, 134–
35, 183; and Sharp, 69, 70,
73; Sioux Indians, 183, 216; as
subjects for art, 61, 67, 68, 69,
79, 80, 82–83, 100, 110–11,
135, 136, 185–86, 192, 205,
211, 212, 215, 227, 239, 294;
Zuni Pueblo, 206. *See also*
Custer, George Armstrong;
Plains Indians; Pueblo Indians;
Taos Pueblo
American luminism, 37–38
American Magazine, 165, 175
American Magazine of Art,
233–34
American Museum of Western Art
(Denver), 273
*Another Church, Hernandez, New
Mexico* (O'Keeffe), 301
Apache Country (Blumen-
schein, E.), 222–23
Applegate, Frank, 238–39

Index

Index

Bisttram, Emil, 264–65, 266, 281, 299
Blue Lake, 101, 112
Blumenschein, Carl (half-brother of Ernest), 21, 26
Blumenschein, Ernest Leonard:
and American Indians, 80, 110, 183, 215–16, 218–19, 229; art of, in 1920s, 207–24; art of, in 1940s, 272–73; art of, in 1950s, 285–90, 302, 303, 305–306; art of, after World War II, 277; on art of Couse (Eanger), 230; as athlete, 22–23, 88, 158, 182, 183, 199, 212, 246, 247, 263, 293, 307; awards of, 27, 177, 199, 221, 248–49, 258, 259, 281, 282, 291; background/family/childhood of, 4, 11, 12–17, 19–26; birth/death of son of, 167–68; birth of, 16; birth of daughter of, 175–76; as bridge player, 246, 293; at Cincinnati Art Academy, 27–28; cityscapes of, 285, 287–88, 301; courtship/marriage of, 145–60, *159*; death of, 307; after death of his mother, 20–21; after death of his wife, 304–305; east studio of, 258; exhibiting art as one of "Four Artists of Taos," 232; exhibit of art of (2007–2009), 311–12; as fisherman, *225*, 225, 265, 273, 279, 293; friendships of, 35, 68, 69, 144–45, 208, 212, 234–35, 240, 246–47, 259–60, 294, *298*, 298; gaining reputation as American artist, 192; as German American,
197, 199–200, 203, 219, 245, 278; goals of, 125–26; health of, 272, 279, 281, 282, 283, 284, 285, 290, 303, 306–307; and historical painting genre, 143; and Indians as subjects of art, 227; influence of Benjamin-Constant on, 61; influence of Laurens on, 62; and Los Penitentes, 105; as message-driven artist, 228–29; and modernistic style of painting, 231, 233, 236–38; move to Cincinnati, Ohio, 26; and New Mexico, 85; and New Mexico Painters, 235–36, 238; and New Mexico's Cuatro Centennial commemoration, 268–69; nickname of, 88; as not well known outside art world, 300–301; physical description/personality of, 88, 158, 203–204; process/principles of painting for, 249–50; relationship of, with his father, 10, 21, 25–27, 28–31, 42, 46–47, 63, 137, 156–57, 166, 185, 204–205, 292; relationship of, with Simpson of Santa Fe Railway, 188–89; and religion, 17–18, 307–308; response of, to death of half-brother/sister, 26; reworking his paintings, 274–76, *275*, 283–84, 285; school newspaper of, 23–24; social life of, 58, 60, 124, 181; Southwest, as subject of art of (from 1910 onward), 183–84; on Soviet Union/Cold War following World War II, 277–78; on Spanish-

Index

American War, 108; travels in American West, 9, 81–82, 87–101, *92*, 107–15, 205–206; on universal absolutes, 11; with wife and daughter, 250–51, *262*, 262; and world events in early twentieth century, 161–63; and world wars, 194, 195, 200–204, 205, 219, 269–71; as writer, 292–93, 296, 308. *See also* Art Students League (New York City); Blumenschein, Ernest Leonard, as commercial illustrator; Blumenschein, Ernest Leonard, paintings of; Landscapes; Murals; Music; New York City; Paris; Portraiture; Taos, N.Mex.; Taos Society of Artists

Blumenschein, Ernest Leonard, as commercial illustrator: commitment to career, 113, 168–69; contacts made, 294; defending Indians rights, 216, 294; early success, 8, 10, 44–45, 73, 76–81, 88; *Ghost Dancer* illustration, *118*; in late career, 290, 291; in New York City, 116–19, 125, 127, 133–38, 175, 177; painting vs. illustration, 10, 131–32, 192, 205, 207, 265; in Paris, 130–31, 142–43, 147–48, 158, 163, 164, 165–66; status as artist, 308; *The Sunday Crowd at the Paris Exposition* illustration, *130*; and travels, 109–10, 178; working with journalists, 32, 294–95

Blumenschein, Ernest Leonard, paintings of, 198; *Adobe Village—Winter*, 248–49, 279; *Afternoon of a Sheepherder*, 264, 312; *Albedia of Taos*, 198, 202; *Allegory in Honor of a Barrymore Child*, 176–77; *Apache Country*, 222–23; *Arizona*, 263; *Aspen Grove*, 276–77; *Bend in the River*, 273; *Box Cars and Railroad Tracks*, 287; *The Burro*, 247–48, 250; *Canyon Red and Blue*, 264, 266; *The Chief Goes Through*, 287–88; *The Chief Speaks*, 199, 282, 301; *The Chief's Two Sons*, 198, 211; *Church of Ranchos de Taos*, 61, 185, *186*, 198, 301; *The Cormorant Attends Funeral of His Friend the Butler*, 288–90, 306; *Decorative Landscape with Figures—Adam and Eve*, 276; *Downtown Albuquerque*, 287; *Eagle Fan*, 198; *Eagle Feather, Prayer Chant*, 198; *Eagle Nest Lake*, 279; *Enchanted Forest*, 224, 276–77, 278–79, 283; *Evening at Pueblo of Taos*, 184; *The Extraordinary Affray*, 237–38, 287, 312; *Fifty-Seventh Street, New York*, 199; *Fireplace*, 184; *The Flute Player*, 63–64, 77; *The Gift*, 220; *Good Friday in a Paris Church*, 200; *Haystack, Taos Valley*, 222; *Idealist*, 288–89; *Indian Suite*, 205, 292; *The Indian Trader at Fort Carondelet*, 244; *Jury for a Trial of a Sheepherder for Murder*, 256–57, 258, 260, 282, 291, 311–12; *The*

329

Index

Index

Blumenschein, Jenny, 21, 26
Blumenschein, Johann George
(grandfather of Ernest), 13
Blumenschein, Leonora "Nora"
(mother of Ernest), 14–15,
16–17, 19–20, 29, 167
Blumenschein, Mary Greene
(wife of Ernest Blumenschein),
235, 262, *262*, 263; art of,
164, 165, 204, 279–80, 305;
background of, 139–41;
as commercial illustrator,
165–66, 185, 204; courtship/
marriage of, 145–60, *159*;
death of, 290, 303–305;
health of, 270, 272, 279,
280, 284; inheritance of, 205,
207, 209, 233, 294; jewelry
making of, 241, 280; in New
York City, 174–75, 179; in
painting by husband, 261–62,
287; pregnancies/children of,
166–68, 173–76; and Taos,
N.Mex., 178–80, 185–87,
191, 206, 208–10, 212, 241,
242–43, 280; trip to Europe
with daughter, 247–48; and
world events in early twentieth
century, 161–63; on world
wars, 194, 270–71
Blumenschein, Wilhelm Leonard
"Leonard" (father of Ernest):
background/family of, 13;
death of, 204; family life of,
16–17, 18, 19; marriages
of, 15, 21; relationship of,
with son Ernest, 22, 25–27,
28–31, 42, 46–47, 137,
156–57, 166, 204–205,
292; relationship of, with son
George, 22; response of, to
wife's death, 20. *See also* Music

Blumenschein Papers
(Smithsonian), 60
Bodmer, Karl, 83
Boehm, Sarah E., 237
Bonheur, Rosa, 141
Bourdelle, Emile Antoine, 66
Box Cars and Railroad Tracks
(Blumenschein, E.), 287
Brady, Cyrus Townsend, 143
Brashar, G. Kenneth "Bud,"
306
Breckenridge, John, 169
Brett, Dorothy, 288
Bridger, James, 105
Britain, 9, 84, 161–62, 193, 194,
267
Broder, Patricia, 18
Browning, Elizabeth, 164
Browning, Robert, 164
Brush and Pencil, 70
Brute, The (Conrad), 169
Bryan, William Jennings, 47, 76
Buffalo Bill's Wild West Show, 79,
158, 184
Bureau of Indian Affairs (BIA),
211, 213, 214, 216
Burke, Charles, 213
Burro, The (Blumenschein, E.),
247–48, 250
Bursum, Holm O., 214, 215,
218
Bursum bill, 218
Butler, Ellis Parker, 10, 11, 35,
126–27, 128, 131–32, 144–
45, 146, 152, 163, 164, 165,
167, 168, 175, 259, 290, 294;
death of, 259, 260; portrait of
family of, 172; visit to Paris,
France (1907), 170, 172
Butler, Elsie, 170, 172
Butler, Ida, 170, 172, 175
Butler, Nancy, 259

Index

Byram, Addie (wife of Joseph Henry Sharp), 69

California, art in, 310–11
California State Immigration and Housing Commission, 217
Canyon Red and Blue (Blumenschein, E.), 264, 266
Capitol Decoration Commission, 243, 244
Card, Helen, 290
Carlisle Indian Training School (Pa.), 214
Carnegie, Andrew, 16, 276
Carnegie Art Show (1910), 172
Carnegie Building (New York), 136
Carnegie Institute, 276, 279
Carnegie Museum, 280
Carolus-Duran, E. A., 64–65
Carson, Kit, 68, 105, 112
Casey, Lee, 297
Cassatt, Mary, 4, 40, 52, 141
Cather, Willa, 169
Catholic Church, 211, 219, 220, 221, 229, 247, 307
Catlin, George, 83
Cattle Buyer, The (Dunton), 231
Century Magazine, 8, 77, 134, 137, 138, 143, 172, 175, 183, 292, 294, 295, 296
Century of Dishonor, A (Jackson), 84
Century of Progress Exposition (Chicago), 266
Cézanne, Paul, 7, 66, 296
Chapin, Harvey, 14
Chapin, Leonora Alferetta "Nora." *See* Blumenschein, Leonora "Nora" (mother of Ernest)

Chapin, Lorenzo, B. (father of Leonora "Nora" Chapin), 14
Chapin, Maria (mother of Leonora "Nora" Chapin), 14
Chapin, Samuel, 14
Charge of the Rough Riders at San Juan Hill (Remington), 78
Chase, William Merritt, 33, 40
Chavannes, Pierre Puvis de, 65
Chávez, Fray Angélico, 281
Chicago Art Institute, 71
Chicago Tribune, 299
Chief Goes Through, The (Blumenschein, E.), 287–88
Chief Speaks, The (Blumenschein, E.), 199, 282
Chief's Two Sons, The (Blumenschein, E.), 198, 211
Christianity, 103, 104–105, 200, 213, 219, 307–308
Christo (artist), 311
Church, Frederic Edwin, 37, 38
Church of Ranchos de Taos (Blumenschein, E.), 61, 185, *186*, 198, 301
Cincinnati Academy of Fine Arts, 27
Cincinnati Art Academy, 7, 27, 28, 33, 51, 69
Cincinnati Art Museum, 27, 177–78, 199, 232, 282
Cincinnati May Festival Chorus, 18
Cinco Pentores art group (Santa Fe, N.Mex.), 283
Circular 1665 (BIA policy statement), 213, 214, 219
Cityscapes, 285, 287–88, 301
Civilian Conservation Corps (CCC), 252
Classicism/neoclassicism, 33, 36

332

Index

Index

Index

Index

Gifford, Sanford R., 38
Gift, The (Blumenschein, E.), 220
Gilcrease, Thomas, 219, 224,
 278–79, 283, 287
Gilcrease Museum (Tulsa, Okla.),
 220, 224, 278, 283, 287, 291
Gilder, Richard W., 134, 177
Girl with Fan (Blumen-
 schein, M.), 305
"God of His Father's" (London),
 147
Goethe, Johann Wolfgang von, 36
Gomez, Geronimo, 210, 211–12
Good Friday in a Paris Church
 (Blumenschein, E.), 200
Gorman, R. C., 311
Goupil & Cie (art gallery), 65
Goya, Francisco, 5
Grafe, Paul, 279
Grand Central Art Galleries (New
 York), 238, 248–49, 279,
 280, 305
Grant, Blanche, 178
Grays (baseball team in Taos,
 N.Mex.), 182
Great Depression, 252–53, 265,
 266, 267
"Great Northwest" series
 of articles (illustrated by
 Blumenschein, E.), 137
Greene, Mary Isabel Shepard
 (mother of Mary Shepard
 Greene), 140–41, 148–59,
 159, 165, 167, 173, 174, 176,
 179, 204, 205, 294
Greene, Mary Shepard. *See*
 Blumenschein, Mary Greene
 (wife of Ernest Blumenschein)
Greene, Rufus, 140
Gregg, Josiah, 84
Groll, Albert L., 240

Gusdorf family, 106–107, 109,
 120, 122, 123, 191, 197

Harding, Warren G., 213
Harper's, 8, 77, 110, 136
Harper's Monthly, 119, 136
Harper's Weekly, 60, 70, 77, 110,
 117, *130*, 130–31, 136, 294
Harper's Young People
 magazine, 25
Hartley, Marsden, 301
Harvest Dance, The (Sharp),
 27, 70
Harvey, Fred, 270
Harwood, Burt, 305
Harwood, Elizabeth, 305
Harwood Museum, 305
Hassam, Frederick Childe, 34,
 38, 40
Hassrick, Peter H., 57, 193, 203,
 282
Hatfield, Sharah, 15
Hauser, John, 70
Have We an American Art?
 (Jewell), 309
Hayes, Rutherford B., 214
Haystack, Taos Valley
 (Blumenschein, E.), 222
Hearst, William Randolph, 108
Henderson, Alice Corbin, 216
Henderson, William P., 235
Hennings, Ernest Martin: as
 artist, in Taos, N.Mex., 228;
 during Great Depression,
 254; omitted from *Ourselves
 and Taos Neighbors* by
 Blumenschein (Ernest), 261;
 and Taos Society of Artists,
 228, 239, *242*, 242; and Ufer,
 259, 260
Henri, Robert, 232, 239, 240

Index

Indians. *See* American Indians

Indian Sheepherder. See *Rocky Trail* (Blumenschein, E.)

Indian Suite (musical composition by MacDowell), 205

Indian Suite (painting by Blumenschein, E.), 205, 292

Indian Trader at Fort Carondelet, The (Blumenschein, E.), 244

Inness, George, 38

International Exhibition of Modern Art (1913), 296

Italy, 131, 153, 193, 250, 269

Jackson, Charlotte, 297

Jackson, Helen Hunt, 84

Jackson, John Brinkerhoff, 112

Jaehn, Tomas, 197

James, Henry, 72

Japan, 86, 161, 269, 270, 271, 272

Jaramillo, Josephine, 105

Jeançon, J. A., 209

Jeanne-Claude (artist), 311

Jewell, Edward Alden, 308–309

Johns Manville Company, 133

Johnson, Spud, 304

Julian, Rodolphe, 55, 62–63

Jury for a Trial of a Sheepherder for Murder (Blumenschein, E.), 256–57, 258, 260, 282, 291, 311–12

Kanst, J. F., 233

Kearny, Stephen Watts, 105–106

Keats, John, 36

Keleher, William A., 184, 290

Kensett, John Frederick, 37

Kern, Richard, 86

Kiker, Henry J., 257

Kipling, Rudyard, 77, 148

Kirkland, Vance, 310

Kissell, Eleanor, 260

Kit Carson House, 182

Kit Carson National Forest, 183

Kloss, William, 5, 224, 265–66

Kumlar, Jenny. *See* Blumenschein, Jenny

Ladies' Home Journal, 78

Lady Chatterley's Lover (Lawrence), 217

Lady with Fan (Blumenschein, M.), 280

La Farge, John, 39–40

La Fonda Hotel (Santa Fe, N.Mex.), 128, 265

Lake, The (Blumenschein, E.), 63, 224

Landscapes, 37–38, 82, 85–86, 100, 200–201, 229; of Blumenschein (Ernest), 142, 208, 221–22, 227–28, 238, 240, 249, 257, 263, 264, 265–66, 269, 270, 273–76, 279, 286, 292, 294, 297, 301, 308

Landscape with Indians (Blumenschein, E.), 264

Lange, Hans, 43, 44

Last of the Mohicans, The (Cooper), 61

Laurens, Jean-Paul, 6, 7, 61, 62, 65, 66, 68, 244

Lawrence, D. H., 216, 217, 261, 262

Lawrence, Frieda, 217

Leibl, Wilhelm, 28

Lembke, Charles, 200, 202

Little Story, A (Greene, M. S.), 141

Lockman, DeWitt, 43

London, Jack, 147–48, 166, 169, 294, 305–306

Index

Index

New *Mexico Historical Review*, 94
New Mexico History Museum
(Santa Fe, N.Mex.), 197, 281
New Mexico Interior
(Blumenschein, E.), 258
New Mexico Magazine, 297
New Mexico Painters, 235, 238,
297
New Mexico Peon. See *Taos
Plasterer* (Blumenschein, E.)
New Mexico State Land Office,
232
New World Symphony (Dvořák),
42, 43
New York Art Directors Show,
205
New York City: art in, 189;
Blumenschein (Ernest) in,
7, 8, 76, 79, 113, 116, 119,
123–24, 125–26, 133–38,
174–75, 179, 198–99, 205;
Blumenscheins (Ernest and
Mary) in, 174–75, 179; in
late 1800s, 31–32, 41, 75–76,
119. *See also* Art Students
League (New York City)
New York Evening Post, 187
New York Herald, 289
New York Sketch Club, 136
New York Times, 170, 176,
237–38, 309
Niagara Falls (Church), 37
Noble, Thomas Satterwhite, 27,
28, 29
Norfeldt, B. J. O., 235, 240
Norris, Frank, 41
Novum Organum (Bacon), 85
Nowottny, Vincent, 27

O'Brien Gallery (Chicago,
Illinois), 114

Ohio, 17; Cincinnati, 26–27;
Dayton, 16–19
O'Keeffe, Georgia, 291, 301–
302, 309
Old Man in White (Blumen-
schein, E.), 198
Olmstead, Frederick Law, 76
Oñate, Juan de, 103, 104
Oppenheimer, J. Robert, 281
Orozco, José Clemente, 311
Ourselves and Taos Neighbors
(Blumenschein, E.), 258–63,
262, 287, 302
Outlook, 294

Packer Collegiate Institute
(Brooklyn, N.Y.), 247
Pack Train Leaving Pueblo of Taos
(Poore), 87
Page, Thomas Nelson, 163
Paine, Ralph D., 169
Paintbrushes and Pistols (Taggett
and Schwarz), 15, 304
"Painting of To-Morrow, The"
(Blumenschein, E.), 292
Palace of the Governors (Santa Fe,
N.Mex.), 182, 187
Paradise Lost (Milton), 276
Paris, 53, 55–59; art/artists in,
4–11, 38, 51–54, 58, 60,
64–67, 70–71, 132–33, 139,
145; Blumenschein (Ernest) in
(1894–1896), 3, 4, 6, 7, 45–
51, 53–56, *59*, 59–64, 66–
69, 71, 73–74; Blumenschein
(Ernest) in (1899), 3–11,
126, 128; Blumenschein
(Ernest) in (1900), 129–33;
Blumenschein (Ernest)
in (1903), 138–58;
Blumenschein (Ernest)

Index

Paris (*continued*)
in (1907–1908), 296;
Blumenschein (Helen) in,
247; Blumenscheins (Ernest
and Mary) in, 161–74; Greene
(Mary Shepard) in, 139–41;
Three Centuries of Art in the
United States art exhibition
(1938), 291, 309–10; and
world events in early twentieth
century, 161–62; and world
wars, 194, 200, 267
Park, David, 310
Parrish, Maxfield, 138
Patterson, John, 17
Peacemaker, The (Blumen-
schein, E.), 184–85, 192–93,
198
Peale, Charles Willson, 36
Peixotto, Ernest, 192
Penitente movement, 104–105,
219, 221, 229
Penitente Procession
(Blumenschein, E.), 222
Pennington, J., 242
Pennsylvania, Pittsburgh, 13, 15, 16
Pennsylvania Academy of Fine
Arts, 141
*People vs. Mary Elizabeth Smith,
The* (Rönnebeck), 257–58
Pershing, John J., 245, 295
Philip Anschutz Collection, 273
Philippines, 269, 270, 271, 272
Phillips, Bert Geer, 68–69,
282–83, 311; and American
Indians, 80, 212, 215, 218,
227, 229, 230, 231; art
of, 222; in book by Luhan
(Mabel Dodge), 282; as
commercial illustrator, 79,
80–81, 111; and Couse
(Eanger), 71; death of, 302;

and Dunn (John), 191; and
French impressionism, 228;
during Great Depression,
255; marriage of, 128, 306; as
message-driven artist, 228–29;
and mural project, 243–44;
in New York City, 76; and
nickname for Blumenschein
(Ernest), 88; in painting by
Blumenschein (Ernest), 261;
photo of, with Blumenschein
(Ernest), *298*; relationship
of, with Martin (Rose), 113,
124; and Sharp, 73; on social
life of Blumenschein (Ernest),
124; and Taos, N.Mex., 119,
120–29, 136–37, 178, 179,
181, 183, 189, 241; and
Taos Society of Artists, 199,
235, *242*, 242, 297, 303;
travels in American West with
Blumenschein (Ernest), 9,
81–82, 87, 88–101, *92*, 107,
108–15, 205–206
Phillips, Ralph, 273
Phoenix Art Museum, 300, 312
Photography, 77, 79, 168, 310
Picasso, Pablo, 133, 296
Pickard, John, 243, 244
"Pigs Is Pigs" (Butler, E. P.), 145
Pima Indian Reservation
(Ariz.), 80
Pioneer Artists of Taos
(Bickerstaff), 142, 196, 233
Pissarro, Camille, 7, 53, 66
Plains Indians, 70, 84, 103, 106,
107, 184, 229
Plasterer, The (Blumenschein, E.),
221
Poe, Edgar Allan, *Tales* of
(illustrated by Blumen-
schein, E.), 177

342

Index

Pointillism, 38
Pollock, Jackson, 295
Poore, Henry R., 87
Pop art, 310
Popé (San Juan Pueblo Indian), 103
Portrait Group. See *Allegory in Honor of a Barrymore Child* (Blumenschein, E.)
Portrait of a German Tragedian (Blumenschein, E.), 170, *171*, 176, 282
Portrait of Albedia (Blumenschein, E.), 312
Portrait of Ellis Parker Butler and Family (Blumenschein, E.), 259
Portrait of Joseph H. Sharp (Duveneck), 70
Portraiture: in America, 36, 67, 82; of Benjamin-Constant, 61; of Blumenschein (Ernest), 61, 131, 142, 143–44, 169–70, 172, 176–77, 202, 208, 211, 221–22, 240, 244–45, 258–63, 295, 308; of Carolus-Duran, 64; of Gilbert, 257–58; of Henri, 232; of Sargent, 65; of Tarkington (Booth), 143–44
Pratt, Richard Henry, 214
Pratt Institute (Brooklyn, N.Y.), 141, 241
Praying Skipper and Other Stories, The (Paine), 169
Price, Sterling, 106
Princess and the Frog, The (Blumenschein, M.), 165
Princip, Gavrilo, 193
Proctor, Alexander Phimster, 232
Public Works Art Project (PWAP), 253, 254

Pueblo Indians, 70, 84, 100–104, 111, 183, 184, 185, 210, 211, 214–19, 229, 308; and art of Blumenschein (Ernest), 219–20, 237, 258, 276, 278–79, 287, 295, 308; relations between Spanish settlers and, 102–104; and Secret Dance File, 213; and Sharp, 230; as subjects of art, 227, 228, 233; and World War II, 270
Pulitzer, Joseph, 108
Puritan, The (Saint-Gauden), 14
Pyle, Howard, 78

Racism, 23–24
Rackham, Arthur, 169
Railroad Yard (Blumenschein, E.), 286
Railroad Yard, No. 5 (Blumenschein, E.), 286, 305
Ramona (Jackson), 84
Ranchos Church (Blumenschein, E.), 280–81
Ranchos Church No. 1 (O'Keeffe), 301
Ranchos Church with Indians (Blumenschein, E.), 278, 301
Ranchos de Taos Church, 220
Range-finder project, 200–203
Ration Day (Sharp), 229
Realism, 41, 64, 116, 165, 288
Reconstruction Finance Corporation (RFC), 252
Recuerdos: Early Days of the Blumenschein Family (Blumenschein, H.), 43, 113, 185–86, 221, 241, 304
Red Symphony. See *Arizona Dawn* (Blumenschein, E.)
Reed, Doel, 299–300

343

Index

Religion, 17–18, 219–20, 247,
307. *See also* Catholic Church;
Christianity
Remington, Frederic, 78, 136,
137, 290, 301, 309
Renoir, Pierre-Auguste, 66, 296
*Return of the French Officer
and His Indian Bride to Fort
Orleans* (Blumenschein, E.),
244
Return of the War Party (Couse),
230
Richardson, E. P., 67, 83
Riis, Jacob, 32
Ring, The (Wagner), 13
Rio Grande Cañon at Taos
(Blumenschein, E.), 284
Rio Grande No. 2 (Blumen-
schein, E.), 287
Rio Grande Valley, 101
*Rising of a Thunderstorm at Sea,
The* (Allston), 36
"Rising Wolf, Ghost Dancer"
(Garland), *118*
Ritty, John, 17
Rivera, Diego, 264
Robidoux, Antoine, 105
Robidoux, Louis, 105
Robins, Elizabeth, 169
Robinson, Theodore, 40
Rock of Fire—Afternoon
(Blumenschein, E.), 222–23
Rock of Fire—Morning
(Blumenschein, E.), 222–23
Rocky Mountain News, 297
Rocky Mountains, The
(Bierstadt), 38
Rocky Trail (Blumenschein, E.),
288, 291
Rolshoven, Julius, 239
Romanticism, 5–6, 33, 36–37,
38, 41

Romero, Jim, 218, 219, 220
Rönnebeck, Arnold, 222
Rönnebeck, Louise Emerson,
257–58
Roosevelt, Franklin D., 252
Roosevelt, Theodore, 78, 107,
161, 267, 296
Roosevelt Dam, 263
Rothko, Mark, 310
Rowan, Ed, 255, 256, 263
Rowe, Frank W., 133
Running Fence (Christo and
Jeanne-Claude), 311
Rural Free Delivery (Adams,
K. M.), 254
Russell, Charles M., 83, 231, 309
Russia, 161, 193, 194

Sacco, Nicola, 257
Saint-Gauden, Augustus, 14
Salmagundi Club, 136, 177, 200,
259
Salon art exhibits (Paris, France),
5, 54–55, 60–65, 131, 141,
170
Sandia Mountains (Blumen-
schein, E.), 273–74
Sandia Ranch Sanatorium
(Albuquerque), 306–307
Sandzén, Birger, 240
Sangre de Cristo Mountains, 101,
114, 183, 224, 225, 264
Sangre de Cristo Mountains
(Blumenschein, E.), 105, 221,
222, 291
San Juan Pottery (Couse), 230
Santa Fe Indian School, 311
Santa Fe New Mexican, 192, 268,
286
Santa Fe Railway. *See* Atchison,
Topeka, and Santa Fe Railway
Sargent, John Singer, 40, 65, 309

344

Index

Index

Index

Taos Entertains the Cheyenne (Blumenschein, E.), 278, 282, 287
Taos Indian Curio Shop, 128
Taos Indian Holding a Water Jug (Blumenschein, E.), 184
Taos News, 234, 304
Taos Plasterer (Blumenschein, E.), 274–76, *275*
Taos Pueblo, 9, 70, 97, 99, 100, 106, 111–12, 185–86, 220; and abuse of Indian land in New Mexico, 183; and art of Berninghaus, 231; and death of Blumenschein (Ernest), 307; history of, 102–104; and *The Peacemaker* by Blumenschein (Ernest), 193; and Sharp, 70, 73. *See also* Taos Pueblo Indians
Taos Pueblo Indians, 61, 99, 106, 107, 110–11, 121–22, 179, 183, 198, 207–208, 211–12, 217, 218, 220–21. *See also* Taos Pueblo
Taos Society of Artists, 199, 202, 203, 207, 208, 226, 227, 231, 238, 240–41, 297, 302, 303, 309; acrimony among members of, 233–36; and American Indians as subjects of art, 239; end of, 239; history of, by Bickerstaff, 306; members of, 228, 232, 239–40, *242*, 242; and mural project, 243–44; series of exhibits of, 232; and views of artists on federal Indian policy, 229
Taos Valley (Blumenschein, E.), 263–64
Taos Valley News, 208, 243, 244

Tarkington, Booth, 116, 143–44, 163, 169, 170, 176, 282, 294
Tarkington, Louise, 144
Teller, Henry M., 214
Templis, J., 44
Ten American Painters, 34
Tenorio, Epimenio, 221, 258, 274
Thirtieth International Exhibition of Paintings (Pittsburgh, Pa.), 258
"This Is the Army Now" (Berlin), 271
Thompson, Vance, 163
Three Centuries of Art in the United States art exhibition (1938), 291
Three Taos Indians (Sharp), 229
Tiwa (American Indian language), 73, 102
Tom Foolery (school newspaper), 23–24
Toulouse-Lautrec, Henri de, 7, 52, 54, 66, 296
Traditionalism, 10–11, 67, 132–33, 226, 231, 238, 240, 244, 265, 285, 294, 299
Trenton, Patricia, 192
Troccoli, Joan Carpenter, 228, 301
Trujillo, Luciano, 120–21, 123
Trumbull, John, 36
Tudl-Tur in Tiwa (Taos Indian), 99
Turmoil in New Mexico (Keleher), 290
Turner, Joseph Mallard William, 5
Twachtman, John, 27, 28, 33, 34–35, 40
Twain, Mark, 41
Two Burros (Blumenschein, E.), 222, *223*

347

Index

Ufer, Mary, 197, 235
Ufer, Walter, 195–200, 219, 227, 261, 288–89, 301, 309; death of, 259–60; exhibiting art as one of "Four Artists of Taos," 232; on federal Indian policy, 229; during Great Depression, 254; as message-driven artist, 228–29; and modernistic style of painting, 231, 236–37; and mural project, 243–44; and New Mexico Painters, 235, 238; relationship of, with Blumenschein (Ernest), 234–35, 240, 246–47, 259; and Taos Society of Artists, 232, 234, 239, 242, *242*, 261
Uncle Tom's Cabin (Stowe), 84
Unitarianism, 307–308
University of New Mexico, 281
U.S. Army, 106, 271, 277
U.S. Biological Survey, 183
U.S. Congress, 195, 196, 214, 215, 251, 252, 253, 267, 269
U.S. Department of Justice, 257
U.S. Department of the Interior, 110
U.S.-Mexican War, 106
U.S. Supreme Court, 185
U.S. Treasury Department, 253

Vanderlyn, John, 58, 194
Van Gogh, Theo, 65
Van Gogh, Vincent, 4, 7, 52, 54, 65, 66, 301
Van Soelen, Theodore, 283
Vanzetti, Bartolomeo, 257
Village, Northern New Mexico (Blumenschein, E.), 248
Violence in Lincoln County (Keleher), 290

Violinist, The (Blumenschein, E.), 204

Wagner, Richard, 13
Walker, Virginia (wife of Eanger Irving Couse), 71
Waller, Elsie Butler, 259
Waller Family Portrait, The (Blumenschein, E.), 259, 260
Walsenburg courthouse mural (Colo.), 255–56, 258, 260, 263
"Wards of the Nation—Their First Vacation from School" (Blumenschein, E.), 110
Warhol, Andy, 310
Warner, William Henry, 169
Washington, George, 258
Washington Irving and Kit Carson at Arrow Creek Tavern (Blumenschein, E.), 244
Watkins, Marie, 239
Weir, Julian Alden, 38
Wells, Cady, 269
Whistler, James Abbott McNeill, 169, 309
White, Robert R., 89, 124
White, Victor, 234
White, William Allen, 81, 295
White Robe and Blue Spruce (Blumenschein, E.), 220, 237
Whitney Museum of American Art (New York), 301
Whittredge, Thomas Worthington, 27, 37, 86
Wilson, Harry Leon, 163
Wilson, Woodrow, 195, 196, 198, 213, 268
Winter in Taos (Luhan, M. D.), 261
Woman in Blue (Blumenschein, E.), 279

348

Index

Women's Army Auxiliary Corps
 (WAACs), 270, 271, 277
Wordsworth, William, 36
Works Project Administration
 (WPA), 252
World War I, 4, 193–205, 229,
 245, 267, 268, 278, 295, 303,
 304
World War II, 267–72, 277

Wyant, Alexander H., 38
Wyeth, N. C., 78, 169

Your Amiable Uncle (Tarkington),
 144

Zamora, Fray Francisco de, 103
Zola, Émile, 162